MEXICO **JOURNEY TO THE LAND OF THE GODS**

MEXICO **JOURNEY TO THE LAND OF THE GODS**

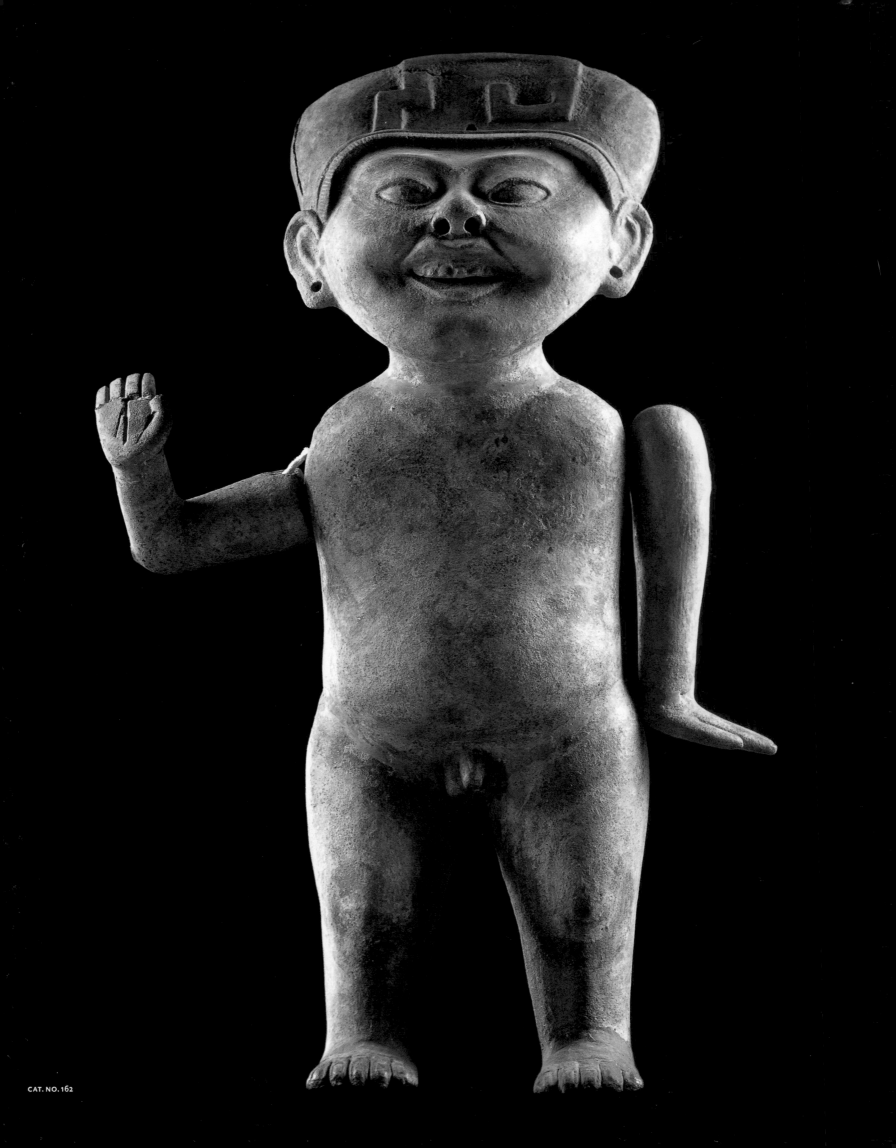

ART TREASURES OF ANCIENT

MEXICO

JOURNEY TO THE LAND OF THE GODS

AUTHORS
Fel pe Solis
Ted Leyenaar

EDITOR IN CHIEF
John Vrieze

CONTRIBUTORS
Beatriz de la Fuente
Rubén Morante López
Miguel Léon Portilla
Rudolf van Zantwijk

ASSISTANT EDITOR
Vincent Boele

TRANSLATION
Wendie Shaffer

PHOTOGRAPHY
Michel Zabé

DE NIEUWE KERK AMSTERDAM | WAANDERS PUBLISHERS | IN ASSOCIATION WITH LUND HUMPHRIES

This catalogue was published to accompany the exhibition
MEXICO
JOURNEY TO THE LAND OF THE GODS
ART TREASURES OF ANCIENT MEXICO
held in the Nieuwe Kerk, Amsterdam, from 3 March until 30 June 2002.

The exhibition was organised by the Foundation Projects of the Nieuwe Kerk, the National Council for Culture and the Arts (CONACULTA) and the National Institute for Anthropology and History (INAH), Mexico.

The exhibition was made possible thanks to the generosity of the founder sponsors and major sponsors of the Nieuwe Kerk.

FOUNDER SPONSORS

FORTIS BANK

Buhrmann

Nederlandse Spoorwegen

MAJOR SPONSORS

KPMG

Getronics
BUILDING FUTURES

STICHTING
DOEN
POSTCODE LOTERIJ
SPONSOR LOTERIJ

MEDIA PARTNER

Avro
KUNST
TRIBUNE

WE WOULD LIKE TO EXPRESS OUR THANKS TO
The City of Amsterdam
The Prince Bernhard Cultural Fund

LENDERS
Museo Nacional de Antropología, Mexico City
Museo de Antropología de la Universidad Veracruzana, Xalapa
Museo Amparo, Puebla
Museo Histórico Fuerte de San Miguel, Campeche
Museo Universitario de Arqueología, Manzanillo
Museo Regional de Yucatán 'Palacio Cantón', Merida
Fundación Cultural Televísa, A.C., Mexico City
Museo del Templo Mayor, Mexico City
Museo de Santa Cecilia Acatitlán, Mexico City
Museo de las Culturas, Oaxaca
Museo de Sitio 'Alberto Ruz Lhuiller', Palenque
Museo Regional de Puebla, Puebla
Museo Arqueológico de Estado de México, Instituto Mexiquense de Cultura, Toluca
Museo de Sitio, Teotenango
Museo de la Cultura Teotihuacana, Teotihuacan
Museo Regional de Antropología 'Carlos Pellicer', Instituto de Cultura de Tabasco, Villahermosa
National Museum of Ethnography, Leiden

MEXICO

NAYARIT

JALISCO

Huaxtecs

Toltecs

COLIMA

Tula

El Tajin ★

Totonacs

★ Teotihuacan

Tenochtitlan
(Mexico City) ★

Aztecs

Xochicalco ★

Cholula ★

Mixtecs

Tres Zapotes ★

★ La Venta

Olmecs

Palenque ★

Monte Alban ★ ★ Mitla

Zapotecs

Yaxchilan ★

Maya

BELIZE

GUATEMALA

HONDURAS

EL SALVADOR

NICARAGUA

Gulf
of
Mexico

YUCATAN

Chichen-Itza ★ ★

Uxmal ★ ★ Tulum ★

Gulf
of
Honduras

Pacific Ocean

0 km 500 1000 1500 km

5

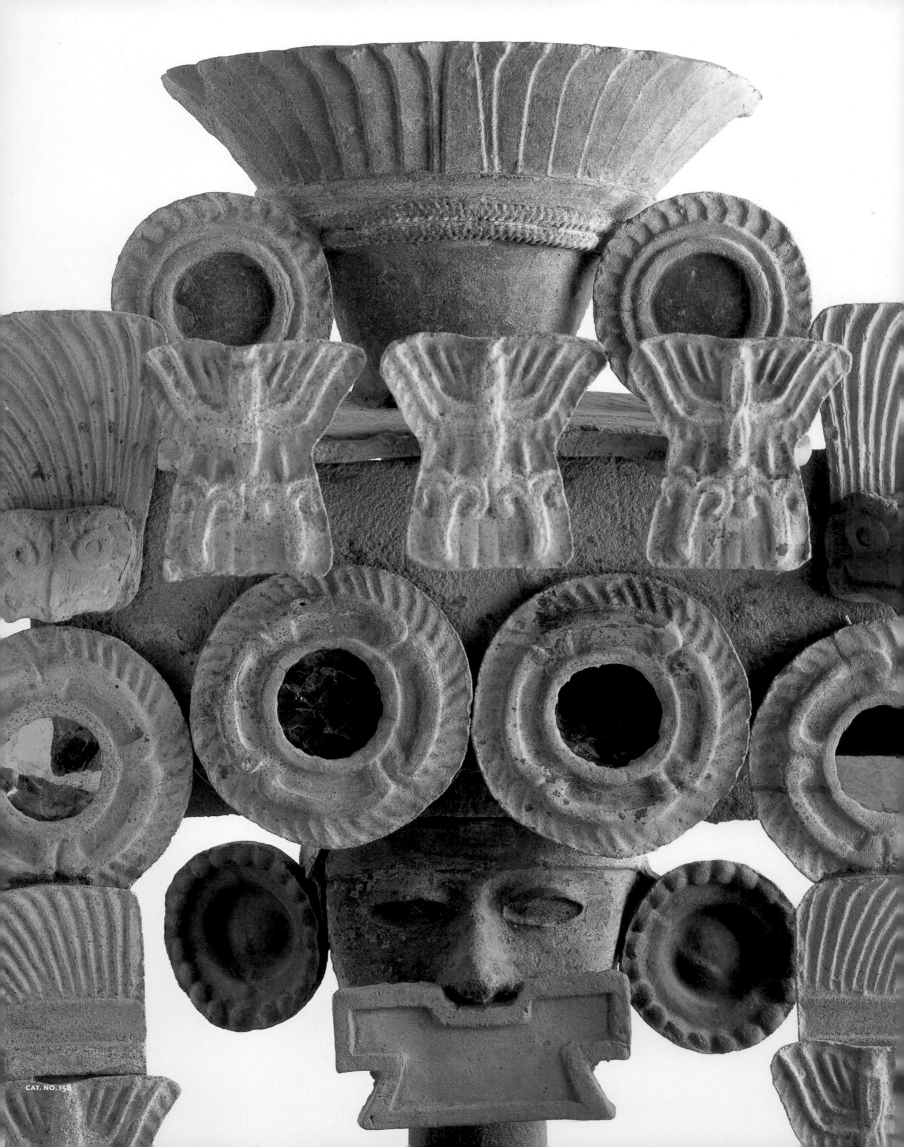

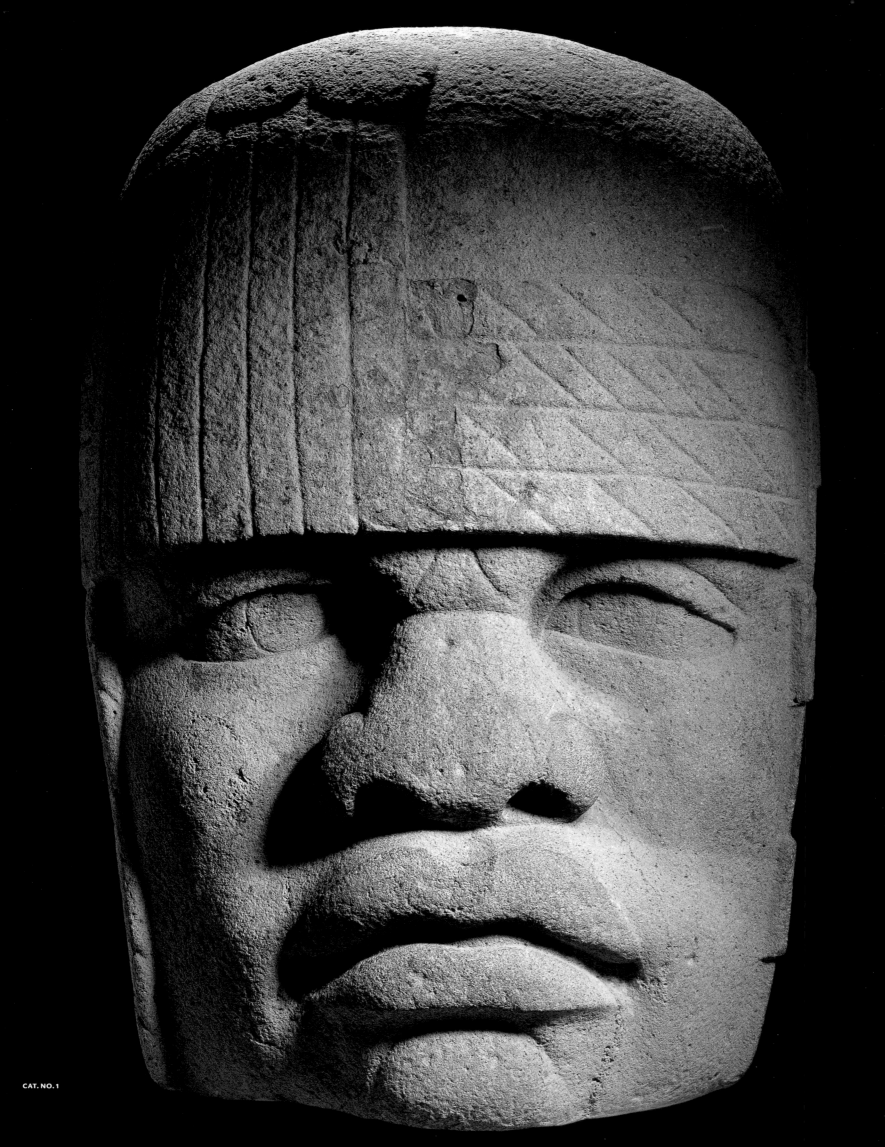

A journey to ancient Mexico is a journey to the world of the gods. There, gods and goddesses governed every aspect of existence. The deities sustained the universe they had created and maintained life on earth. Nature with its cyclical renewal was controlled by the divine powers. At every moment humankind, in life and in death, depended entirely upon the all-powerful gods.

Mexico has an extraordinarily rich history extending over many centuries. A land of sharp contrasts, it comprises almost every climate and vegetational zone. In pre-Columbian times it was a patchwork of contrasting cultures that flourished over the centuries, each blossoming in its own region.

The stream of different cultures introduced continual fresh blood and new ideas. Interestingly, in the different regions, ideas concerning the creation of the universe remained remarkably similar until the arrival of the Spaniards in the sixteenth century. The cornerstone of existence was religion and mythology, ensuring continuity between the various cultures. The world was a theatre for the gods, and people shared in the drama of the universe, venerating the higher powers in their rituals and ceremonial festivals.

The exhibition *Mexico, journey to the land of the gods* fits into the series of presentations over the past years in which the Nieuwe Kerk has been exploring and presenting the cultural heritages of other countries. This exhibition has as guest curators Felipe Solis, director of the National Museum of Anthropology, Mexico City, and Ted Leyenar, former head curator of the Museum of Ethnography in Leiden. Their unquenchable dedication, scholarly expertise and enthusiastic cooperation have helped to achieve an unforgettable production.

We would like to express our gratitude and thanks to the following:
- The Mexican Ministry of Cultural Affairs, in particular the National Council for Arts and Culture (CONACULTA) and the National Institute for Anthropology and History (INAH). This project was realized thanks to the assistance of Sari Bermúdez, President of the Council, Sergio Raúl Arroyo García, Director General of the Institute, Jaime Nualart, Director General of international affairs of the Council, José Enrique Ortíz Lanz, national coordinator of museum and exhibitions for the Institute, and Carlos A. Cordova, Director of exhibitions, also attached to the Institute.
- The Mexican Ministry of Foreign Affairs: His Excellency Santiago Oñate Laborde, Ambassador of Mexico in the Netherlands, has given us enormous support.
- The lenders, who have most generously entrusted their precious treasures to our care.
- The Embassy of the Netherlands in Mexico. We mention especially His Excellency Robert Vornis, Ambassador of her Majesty the Queen of the Netherlands in Mexico City, and Joanne Doornewaard, First Secretary to the Embassy, for their inestimable contribution to the success of this project.
- We thank especially the founder sponsors, major sponsors and sponsors of the Nieuwe Kerk. Without their generous support we would not have been able to mount this costly exhibition.
- Finally, we convey our warmest appreciation to the many people and organizations who have been involved in setting up this exhibition and have made such valuable contributions to its ultimate success.

John Vrieze

Chief curator of exhibitions

Ernst W. Veen

Director, National Foundation De Nieuwe Kerk

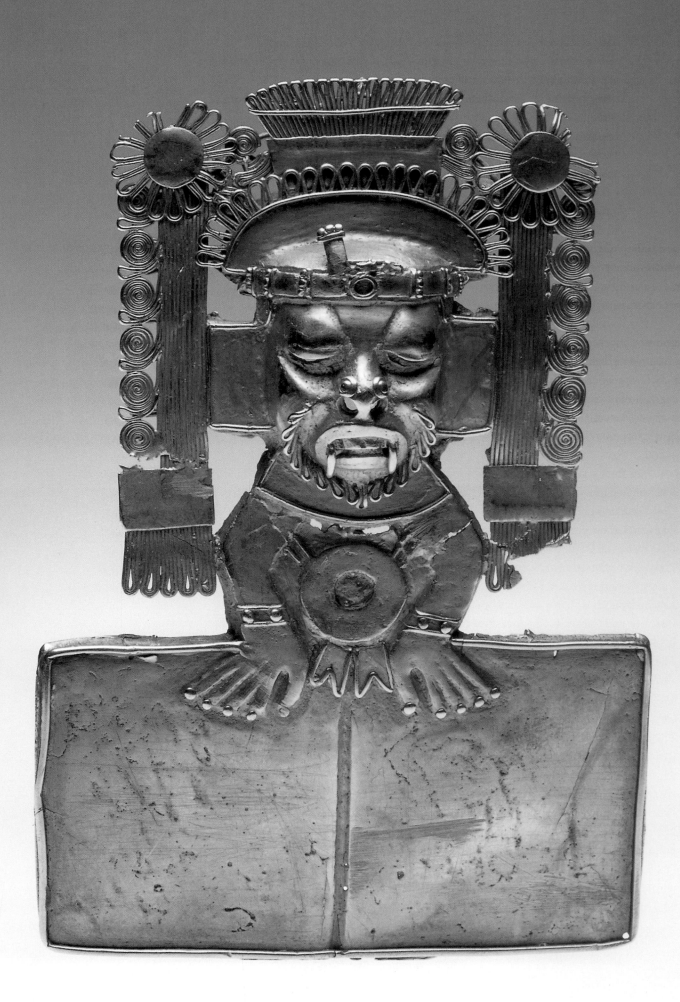

CAT. NO. 25

It gives me great pleasure to present the most important pre-Columbian art exhibition of the new millennium to date. *Mexico, journey to the land of the gods*, is a joint effort between the Nieuwe Kerk Foundation and the National Council for Culture and the Arts of Mexico, through the National Institute of Anthropology and History.

The Netherlands and Mexico have enjoyed a long tradition of cultural exchanges since the beginning of the sixteenth century when Charles the Fifth received in Flanders from the Spanish conquistador Hernán Cortés a splendid treasure from the ancient Mexican kingdoms. Strange figures, colourful exotic feathers, precious stones and gold were marvelled at by the western world for the first time.

This extraordinary encounter between your people and ours was first reported by the outstanding artist Albrecht Dürer, who wrote: 'there is nothing that has filled my heart with greater joy than to behold these beautiful objects'.

Since then, the Netherlands has hosted many exhibits on ancient Mexico as well as some of our finest shows on contemporary art.

Mexico, journey to the land of the gods is comprised of more than 250 works of art from the Mesoamerican civilizations. It includes pieces from sixteen public and private Mexican museums and foundations, as well as the National Museum of Ethnography in Leiden.

The exhibit was co-curated by Dr. Felipe Solis, Director of the National Museum of Anthropology in Mexico, and Dr. Ted Leyenaar, honorary curator of the National Museum of Ethnography in Leiden.

Thanks to the enormous support and enthusiasm of the Nieuwe Kerk Foundation and especially its Director, Ernst Veen, as well as the Dutch and Mexican embassies in close collaboration with the National Institute of Anthropology and History, a magnificent display of masterpieces as been put together to offer the people of the Netherlands a comprehensive exhibition conveying the diversity of the artistic styles of Mesoamerica.

Mesoamerica was made up of remarkable civilizations that emerged and flourished in what is now central Mexico and part of Central America. Mexico's most distinguished intellectual and poet of the twentieth century, Octavio Paz, described Mesoamerica as a constellation of nations, impressive city states, or as modern historians prefer to call them – ceremonial centres – but also political and commercial centres: San Lorenzo, Teotihuacan, Tula, Tenochtitlan, Monte Alban, El Tajin, Calakmul, Palenque….

The Spanish chronicler Bernal Diaz del Castillo, author of *The True Story of the Conquest of Mexico*, upon setting eyes on the Mesoamerican civilizations, said: 'Before us we saw many cities and towns on water and on firm land. We were wonderstruck and said that what lay before us was like the enchantments described in the legend of Amadis. Some of our soldiers even said that what they were seeing was a thing of dreams'.

We hope that you too will be wonderstruck by this major exhibition which celebrates the immense riches of the great art of Mesoamerica. Like Egypt, Greece, India, China and Mesopotamia, the ancient cultures of Mexico are today considered world heritage.

Sari Bermúdez
President of the National Council for Culture and the Arts

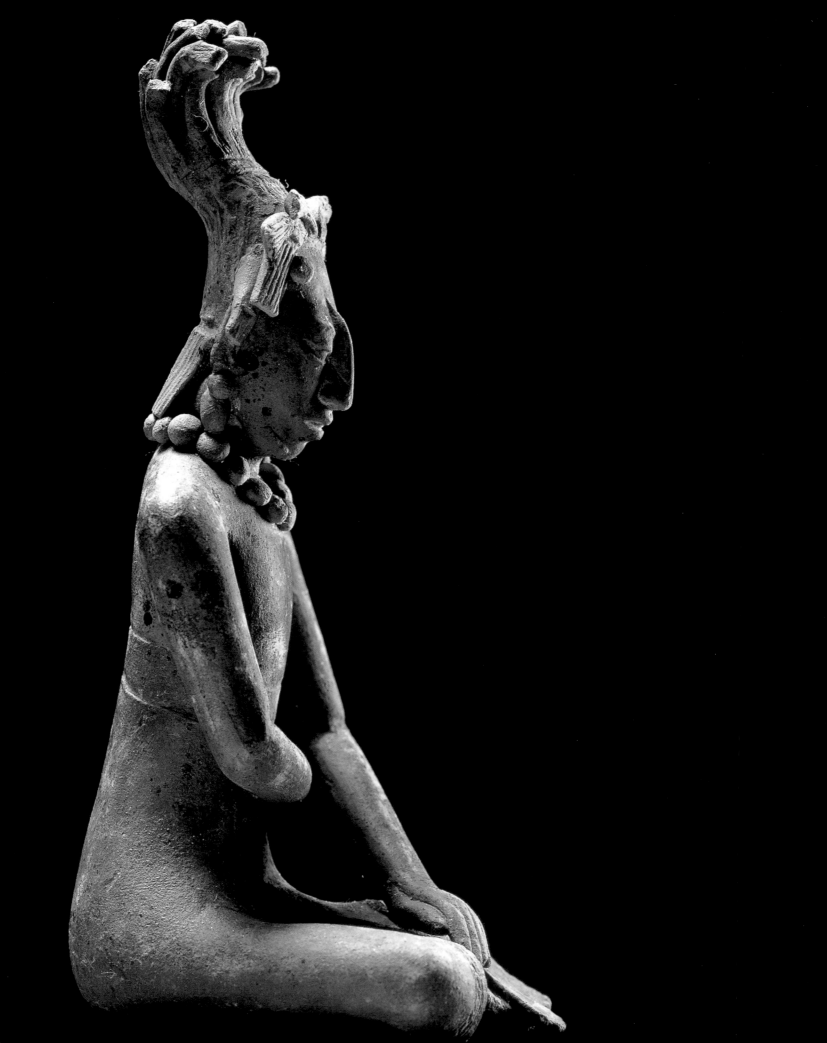

The Foundation Projects of the Nieuwe Kerk would like to express its gratitude and thanks to the following:

MEXICO

NATIONAL COUNCIL FOR CULTURE AND THE ARTS
Sari Bermúdez, President of CONACULTA
Sergio Raúl Arroyo, Director General of INAH
Jaime Nualart, Director General of international affairs, CONACULTA
José Enrique Ortíz Lanz, National Coordinator of museums and exhibitions, INAH
Carlos A. Cordova, Director of exhibitions, INAH
Felipe Solis, Director of the National Museum of Anthropology
María Teresa Márquez-Díez-Canedo, Director of cultural promotion, CONACULTA
Eduardo Matos Moctezuma, former Director of the Museo del Templo Mayor
Eduardo Rostán, assistant curator of international exhibitions, INAH

EMBASSY OF MEXICO IN THE NETHERLANDS
His Excellency Santiago Oñate Laborde, Ambassador
Juan Manuel Santín, Cultural Attaché

MANZANILLO
Froilan Ramos Perez, Director of the Museo Universitario de Manzanillo

MERIDA
Blanca González, Director of the Museo Regional de Yucatán 'Palacio Cantón'

OAXACA
Amelia Lara Tamburino, Director of the Centro Cultural Santo Dominigo
Manuel Velasco †, Director of the Museo de las Culturas

PALENQUE
Roberto López, Director of the Museo de Sitio 'Alberto Ruz Lhuiller'

PUEBLA
Ángeles Espinoza Yglesias, President of the Fundación Amparo

TEOTENANGO
Heriberto Gomez Ramirez, Director of the Museo de Teotenango

TOLUCA
Martín Antonio Mondragon, Museo Arqueológico Estado de México, Instituto Mexicuense de Cultura

VILLAHERMOSA
Rosa María Romo López, Instituto de Cultura de Tabasco
Rebeca Perales Vela, Director of the Museo Regional de Antropología 'Carlos Pellicer'

XALAPA
Victor A. Arredondo, Dean of the University of Veracruz
Rubén Bernardo Morante López, Director of the Museo de Antropologia de la Universdad Veracruzana

Claudio X. Gonzalez Guajardo, chair of the Fundación Cultural Televisa
Ignacio Pichardo Pagaza, former Ambassador of Mexico in the Netherlands

NETHERLANDS

His Excellency Robert A. Vornis, Ambassador of the Netherlands in Mexico
Joanne Doornewaard, First Secretary to the Embassy of the Netherland in Mexico
Carmen Aneiros, consultant in Mexico

AMSTERDAM
Frans Fontaine, curator for Latin America, Tropical Museum
Maarten Frankenhuis, Director of Artis Zoo
Betteke ce Gaay Fortman and Imke Marés Grijpma, Servicio Bureau voor Spaanstalige Dienstverlening
Wendie Shaffer, translator Dutch-English
Jacqueline Weg, former member of staff, Nieuwe Kerk

BREUKELEN
Jonkheer Dr. L.H. Quarles van Ufford †

GARDEREN
Rudolf M.A. van Zantwijk, consultant

LEIDEN
Steven B. Engelsman, Director of the National Museum of Ethnography
Ted J.J. Leyenaar, former curator for Central and South America, National Museum of Ethnography
Dorus P.M. Kop Jansen, registrar of the National Museum of Ethnography
Nel van Hove, coordinating secretary at the National Museum of Ethnography

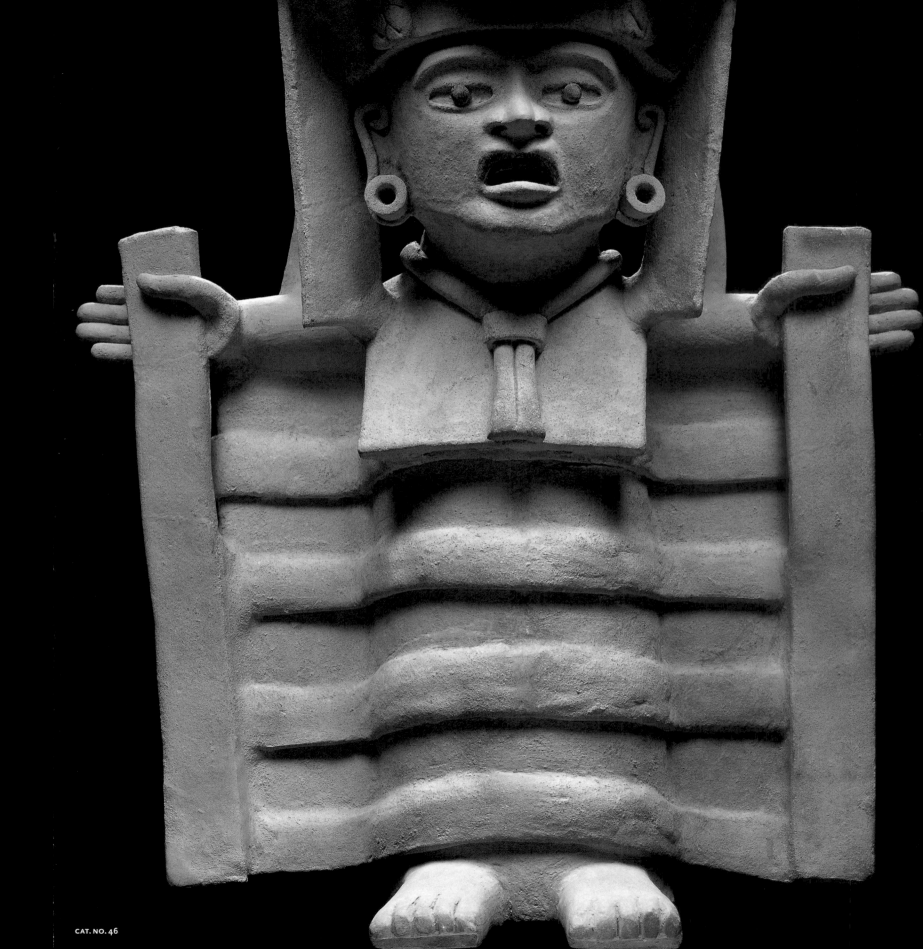

FELIPE SOLIS

THE VISUAL LANGUAGE AND THE IDENTITY OF PRE-COLUMBIAN ART

The pre-Spanish art of Mexico had a long road to travel before it was accepted by world art specialists and museums as something valid in its own right. Initially it was considered to be just one of the many expressions of primitive art. Not until Mexico gained political independence and shook itself free from the embrace of the Spanish fatherland could there be a true appreciation of Mexican art. Then came exhibitions in a national and international context.

The history of these exhibitions of pre-Columbian art starts in the nineteenth century with an exhibition organized by William Bullock in 1824 in London[1] and culminates with the opening in 1888 of the Gallery of the Monoliths in the former National Museum of Mexico, located in the historic centre of Mexico City.[2]

In the course of the nineteenth century the enormous richness and variety of the forms of art that characterize the civilizations of Mesoamerica came to be recognized. Towards the close of the century large-scale archaeological projects were set up in places such as Cempoala, Veracruz[3], the historic centre of Mexico City from 1900 – 1901[4], and later in Teotihuacan, the Maya cities, Monte Albán and many other locations.[5] These archaeological studies produced fairly accurate chronologies. Styles and shapes could be defined on the basis of scientific analyses. Thanks to these analyses, the visual language unique to the peoples of Mexico before the Spanish Conquest, could be distilled from the rich assortment of objects that was found and collected. The forms and meanings of this language provide us with insight into the ideas and customs that contribute to their complex notion of the universe, in which myth and humankind created an interwoven destiny.

In the second half of the twentieth century several eminent scholars have studied the peoples of pre-Spanish Mexico. Based on their research standard works have been written which today form the cornerstone for our understanding of the vast quantities of art objects that have been found.[6] Special mention should be made here of the work of George Kubler who devoted the final years of his life to gaining, in particular, recognition for the aesthetic quality of the ancient art of the Amerindians.[7]

Parallel with the development of projects and research studies came the wish to show the world something of the rich artistic past of our Mexican ancestors. This resulted in a series of successful exhibitions in museums in Europe and the United States.[8] This was without doubt no simple undertaking. The first exhibition was held in New York's MOMA in 1940, under the auspices of the Mexican government. Using an extensive selection of masterworks it provided an overview of three fundamental phases in Mexican art: the pre-Columbian era, the colonial world, and art from contemporary Mexico.[9] It was an overwhelming success and new projects were plotted, some to be held in the Old World which, after the devastation of World War II, arose like a phoenix from its ashes. Mexico owes a huge thankyou to Fernando Gamboa, an untiring activist for the promotion and appreciation of pre-Columbian art world-wide. In the 1950s and 60s he accepted the challenge to mount a travelling exhibition which – from every point of view – was colossal, both in the measurements, the quantity and quality of the objects presented. Thus the public in Britain, France and other European countries could get a taste of the imposing, indeed overwhelming, dramatic splendour as well as the delicate refinement of Mexican visual art. This was a retrospective exhibition which set, harmoniously side by side, objects from the pre-Spanish era and works by the major painters of the post-Revolution period.[10]

The exhibition toured various European capitals, a progress that stands on record as a major triumph for Mexican art. For the first time the distant countries were able to see a wealth of art objects from Mexico. This introduction produced among both laypeople and experts a re-evaluation of the Mexican heritage from both past and present. It should not go unmentioned that the great interest in pre-Spanish art objects arose partly from the fact that various American and European museums (by way of an exception were invited to contribute to the large-scale exhibitions by lending some of the pre-Columbian archaeological finds in their own collections.[11] At this point, remarkably enough, an extensive discussion developed about whether or not it was desirable to show these beautiful masterworks, created by people in another age, beside objects of a natural-historical nature such as rocks, skeletons or butterflies, which would suggest a primitive context.

From that moment interest started burgeoning in the peoples and the cultures that had bequeathed the Mexicans such remarkable works of art. People became particularly interested in the techniques used by these anonymous artists to create their wondrous works.[12] This interest, as already mentioned, led to large-scale archaeological digs which took off in the 1920s and are still going strong today, commissioned by the Mexican government. These excavations have laid bare the major remains of ancient places, so that now we can admire the splendid examples of indigenous architecture and – what is even more important – admire the skill with which our forefathers designed and constructed their imposing cities.[13]

parallel with the growth of the potters' traditions. During the evolution of Mesoamerica, which occupied a good three thousand years, among all the societies and civilizations involved in this immense cultural scenario pottery is to be found as a typical form of expression of every period and every people. This was a form of art in which every member of society could express their sense of identity. The shapes, the colours of the clay, and the decorative elements all contribute to a language that was understood by the people who made and used these objects.[25]

Clay was the raw material of potters in Mesoamerica and in the north of Mexico. Down the centuries, people experimented with improving the quality of the clay, filtering out or adding elements, degreasing with ground shells, mixing in plant fibres, calcite or even ground potshards. They removed defects from the clay and were able to model or to mould exceptionally beautiful objects. Initially, the objects would have been solely for domestic use, but with the passing of centuries this changed. As ritual activities gained prominence so pottery was increasingly used as a means of self-expression, of belief and worship of the gods.

In Mesoamerica there were two chief techniques used in pottery making, both so-called 'hand-built' methods. First, there are the 'pinch pots' which were made by squeezing or modelling the clay, shaping it directly by hand. A ball of clay was formed by rolling it in the palms. This was then flattened until it resembled a pancake – traditionally this is called a 'tortilla' because it resembles the maize product. Then the hole inside the pot is formed with the fingers. The pot would be finished by rubbing the outer surface with one of the hands which had been made wet (and if possible the inner surface would be finished in the same way) making the surfaces as smooth as possible.

One of the other ancient techniques of pottery making is the method using coils or rings of clay. A piece of clay would be prepared and then rolled out over a smooth surface to form a long sausage. This length of clay would then be coiled round and round, building up the walls of a pot. In this method, too, the final stage was to rub the surface smooth with the palm of the hand.[26] The use of moulds or formers is a later development. Sometime, pots that had already been fired were used to support a large tortilla of clay until it acquired the shape desired. In special cases the potter would make an individual mould or former. These moulds might be anthropomorphic (resembling a person), zoomorphic (like an animal), phytomorphic (like a plant) or symbolic. They would be fired in a kiln and then used to produce pots in series.[27]

It is also of interest to note that from a very early period in Mesoamerican history it was customary to coat the pots with another layer of highly filtered clay, before they were fired. This might be the same colour as the first layer, or different. After drying they would be polished using twigs or special flat pebbles, creating a resplendent sheen. This effect could be increased by polishing with a piece of textile or leather.

Firing the pots in huge open-air bonfires was probably introduced around 2500 BC. This method of hardening the clay is still used today by groups of Indians who create their ceramics following traditional techniques. Indisputably, the potters of ancient Mexico also had covered kilns where they could regulate the temperature, and with which they could fire the pots to great extremes of hardness and remarkable quality.[28]

From the very beginning, potters tried to give an individual touch to the clay they were moulding. So developed the decorative techniques, which we may divide roughly into two groups: those carried out before firing, and those applied after firing. Techniques employed before firing consisted largely of incising, making imprints with the fingers, textile and so on, scratching away and hollowing out, adding a figure that had been hand-shaped or moulded, and stamping.[29] Finally, pots could be decorated by painting them, for which mineral-based colours would be used. Mesoamerican pottery is striking for its use of red and black. Of all the Mesoamerican people, the Maya and the inhabitants of Cholula, who shared traditions with the Mixtecs, made the most of this black and red painting and produced many objects of art from ceramics.[30] In the Classic period the potters of the Maya territories created many exceptional objects, some with figures resembling their drawings in manuscripts.[31] What is remarkable about their technique is that they modelled, polished and painted their pieces before firing them in the kiln. In Cholula and Oaxaca the work was done in two stages: the clay was first modelled and polished, then fired to become hard, before being coated with a thin layer of white paint. On this the desired decoration would be made. Then the pots were placed once more in the kiln at a lower temperature so that the colour would melt into the surface.[32] Everything suggests that the painters of these pots worked both in ateliers, where the codices were produced, and in workshops where ceramics were made.

The major decorative techniques applied after firing included incising, hollowing out (whereby a very fine layer of red powder made from cinnabar – vermilion – was introduced), inlay work using shell, pieces of jade or flint, as well as various painting techniques such as the so-called secco-fresco, or dry fresco. This resembles the method of painting on plaster walls, but unlike true fresco, the plaster has already dried. Another technique is the so-

The specialists whose job it was to find suitable stone were not only builders and architects, but also sculptors. Once a block of stone had been hewn out, it would be shaped into a provisional form. Then, with great difficulty, it would be rolled on tree trunks to the workplace where, probably under the supervision of a highly skilled 'master' people would work in much the same way as assistants do today in an atelier, guided by a designer.[20] In this way sculptures would be made, commissioned by the city, the officials, the priests or the people. The Olmecs provide a good example of the enormous effort that went into such work. They quitted the marshy swamps of Tabasco in the south of Veracruz and travelled to the territory of the Tuxtlas, which was a volcanic area, in order to obtain huge blocks of volcanic rock. They dragged these to the beach and then transported them on rafts across the sea and rivers until they reached their own lands deep in the jungle.[21]

Archaeologists have discovered a workplace in Veracruz that illustrates the different phases in the process of sculpting. First the rock is hewn into a square, rectangular or cylindrical block. In this process it sometimes happened that a rock, because of its fragility or due to some defect, cracked to form an unusable block. In phase two the figures or relief would be carved out in more detail, the image gaining the appearance that the artist had conceived. For all this work the sculptors used chisels and hammers that made very fine chips and in this way they created detailed physical representations of people, their clothing and their decorations. In the last stage they rubbed the stone with sand and volcanic ash, excellent abrasives that they applied either with their hands or with a piece of cloth or leather. This would give the work a smooth finish.

The sculptures of the Olmecs are particularly attractive because of their superb polished surfaces which gives them a gleaming finish. Particularly good examples of this are the pieces made from greenstone, such as the *Senor de las Limas*, now in the Anthropological Museum of Jalapa. These sculptures were finished by polishing with obsidian powder which gave them their smooth gleaming surfaces, something they have retained down the centuries.[22] Another fine example is the standing figure in the Regional Museum of Puebla (CAT. NO. 3).

THE ART OF JEWELLERY

The Olmecs also discovered the art of working with precious stones. They passed this skill on from generation to generation, and it continued with little change until the arrival of the Spanish.

Jewellery of enormous value and great beauty was required to demonstrate differences in class and standing, and the hierarchical layers in politics and religion. The stones used for this jewellery would be semi-precious types such as jade, diorite, magnetite and quartz. These materials were garnered from distant regions or obtained through trade and barter. At a later date citizens were able to pay their taxes with such jewels, thereby giving the government another means by which to acquire precious stones.

The jewellers used tools that resembled smaller versions than those in the sculptors' repertoire. They had to make delicate incisions, fine perforations and cut out small notches in the jewellery they were creating. They used an awl made of bone, and drilled holes with cut stone, as well as using cords made from plant fibres. As abrasives they applied sand and volcanic ash mixed with water. With great patience they formed beads for necklaces and bracelets, decorative pectorals, ear pendants and much more besides.

It is interesting to know more about these exceptional jewellers who produced such astonishing objects. They apparently used the same techniques with materials as dissimilar as alabaster and obsidian. Alabaster is a stone somewhat resembling marble, glowing transparent with white, golden or greenish tones. It would be cut using cords dipped into wet sand or volcanic ash which would be rubbed back and forth over the stone, creating the desired shape. In order to hollow out the stone, very simple gimlets were used, and the tip of these would also be dipped into ash or sand. Thus, little by little, the object would be hollowed out to become a pot or bowl, and was finished by polishing with very fine sand.[23] Obsidian is volcanic glass that easily breaks if knocked. To make a bowl or figurine from obsidian, it had to be hollowed out using gimlets made from rolled leaves of copper or laminated bronze. The drilling was made easier by dipping the dampened point of the drill into sand or volcanic ash. The desired shape was obtained by rubbing with sand or ash, and the final gleaming surface was acquired by using very finely ground obsidian as an abrasive. This was the method used to produce the exceptionally beautiful monkey-shaped pot from Texcoco in the National Museum of Mexico. It is an exquisite example of the magical allure that these remarkable objects of the distant past still possess today.[24]

POTTERY

Clearly, the monumental and indeed smaller pieces of sculpture, such as figurines and jewellery, are chiefly connected with the ritual life and the upper echelons of pre-Spanish Mexico. While this may be so, the more modest origins of ceramics are connected with the development of agriculture in Mesoamerica. This moved

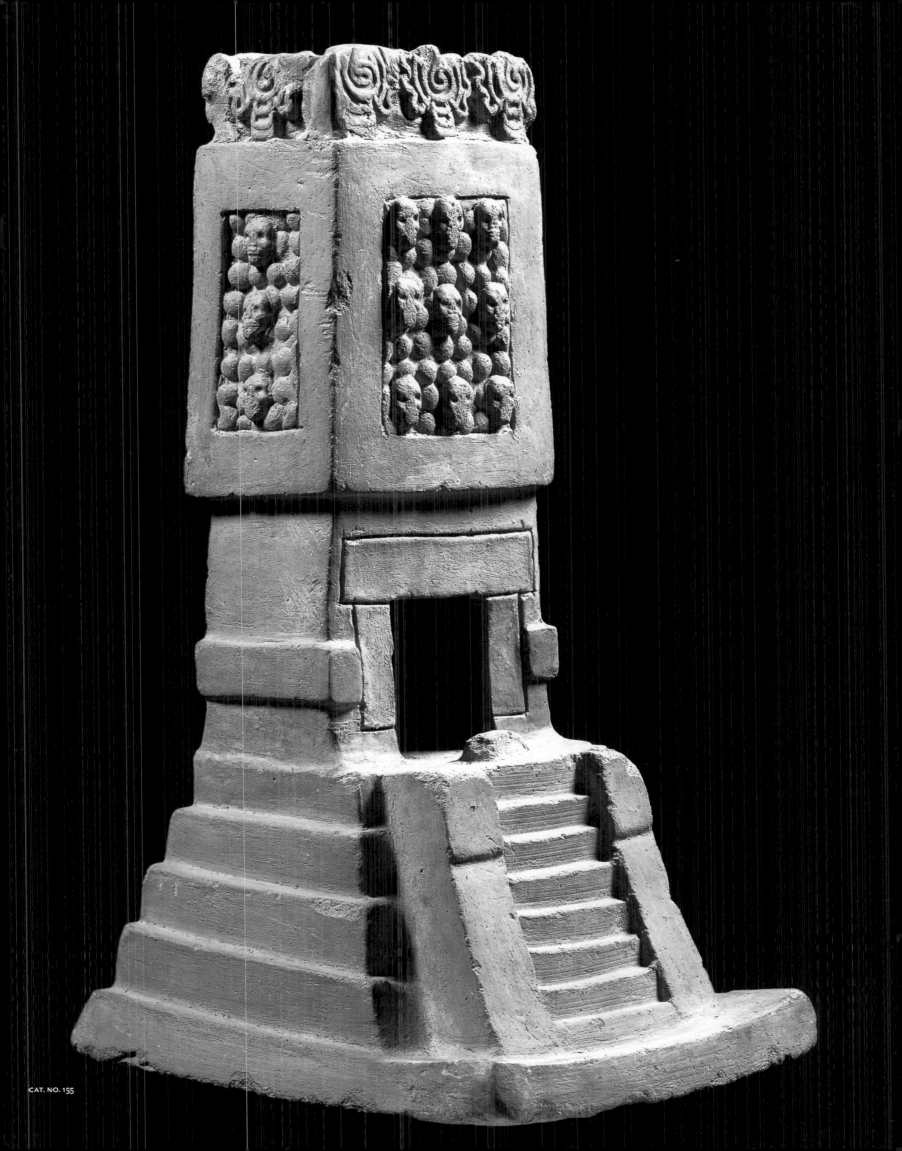

CITY PLANNING AND ARCHITECTURE

It is widely accepted today that pre-Columbian Mexico had an architectural style with its own individual characteristics. In this, the location and the positions of the buildings and open spaces within the city were largely controlled by indigenous ideas concerning the universe and the movement of the stars.[14] With its large measurements and specific characteristics, Mexican architecture is surely the most spectacular expression of Mesoamerican art, comprising as it does other art forms such as sculpture and mural painting.

In ancient Mexico from about 1000 BC on, it is clear that architecture had a consciously artistic nature, involving more than the basic necessity to offer protection form the extremities of the climate. The Olmecs, for example, built structures on the Mexican Gulf coast which are considered to be holy mountains. They are thought to have marked the presence of the gods and, in particular, they indicated the ritual areas where people were to conduct their ceremonies to strengthen the ties between humankind and the gods who had created the universe.[15]

The builders in that pre-Spanish world needed various specialists to help in their work. A huge body of labourers would dig out a space, make it flat, and then fill it with soil and stones to provide the ideal foundations. In some cases a city would be built in the marshes or a lake, as was the capital of the Aztecs, the island city of Mexico-Tenochtitlan. In such cases, the foundations were made by sinking wooden piles made from a tree called *ahuejote*, which is still to be found growing abundantly in the Xochimilco district. The wood remains water-resistant for centuries and is an excellent foundation for heavy constructions.[16]

In the society of those times there were specialists who could help devise a building programme and implement it successfully. Suitable stone for building would be sought, to be hacked out from a stone quarry. To extricate the stone a cunning method was used, also employed by sculptors. Using axes and chisels of diorite – a very hard, compact stone – they would hack out a channel in the stone quarry that delineated as well as possible the block of stone that was needed. Deep holes were drilled or hacked at points into this channel. Tight-fitting wooden wedges were placed in these holes. Boiling water was then poured over the wedges, which the wood absorbed, so expanding it and cracking loose the block of stone. After this the block would be laid on tree trunks and rolled to the place where it was to be used. There it would be hacked into smaller blocks or possibly carved by sculptors.[17]

Finally, the last touches on a building were applied according to the instructions of the architects. Colours, in particular red, made from minerals would be added, often as stripes or other geometric patterns. Sometimes beautiful and intricate designs were executed and painted in many different colours. Special schools provided training in such subjects as the traditions and language, given to both artists and writers who made the illuminated manuscripts which in the Nahuatl world were known as *tlacuilos*.[18]

Our knowledge about the building techniques of the pre-Spanish inhabitants of Mexico, and of the different elements characteristic of the architectonic style of ancient Mexico, expands daily. Thanks to this knowledge we are now able to declare that Mesoamerican architecture may be divided into five categories. The styles differ from each other in their architectural language and form, for example the combination of *taluds* and tablets, the use of niches, sculpted panels and merlons or crenellations, and the shapes of the temples. The different styles bestow their individual identity upon the Maya cities, the huge cities of the Zapotecs and Mixtecs, the people of the Mexican Gulf coast and the major cities that flourished on the Pacific coast. It is particularly true for the long and extensive building tradition of the Central Highlands that began with Cuicuilco, reached a Golden Age with Teotihuacan and achieved its pinnacle with the construction of Mexico-Tenochtitlan, today's Mexico City.[19]

SCULPTURE

Stone sculpture, because it was so widespread, is indisputably the most representative expression of ancient Mexican art. Almost every people of Mesoamerica developed a form of stone carving. The Maya and the Mexicas, just as in their architectonic activities, made use of various types of locally found stone to carve their sculptures. The Olmecs however, preferred volcanic rock, particularly basalt and andesite, for which they sometimes had to travel hundreds of miles. The chunks of rock were transported with great difficulty to the place where the Olmecs lived.

As mentioned above, building and sculpting tools were made from extremely hard stone, such as diorite or nephrite, from which razor-sharp chisels and axes could be formed. These had a haft, and so could be used like hammers. The Maya preferred to make their sculptures from limestone which becomes soft if made wet, making it easier to work with. In contrast, the Mexicas, Olmecs and Purépechas made use of harder stone such as andesite and especially basalt when expressing their artistic imagination. To work this stone they used the tools described above. From the eighth century on there is also evidence that copper and bronze chisels were used. With this variety of equipment the peoples of Mesoamerica were able to create objects that are astonishing in their beauty and perfection.

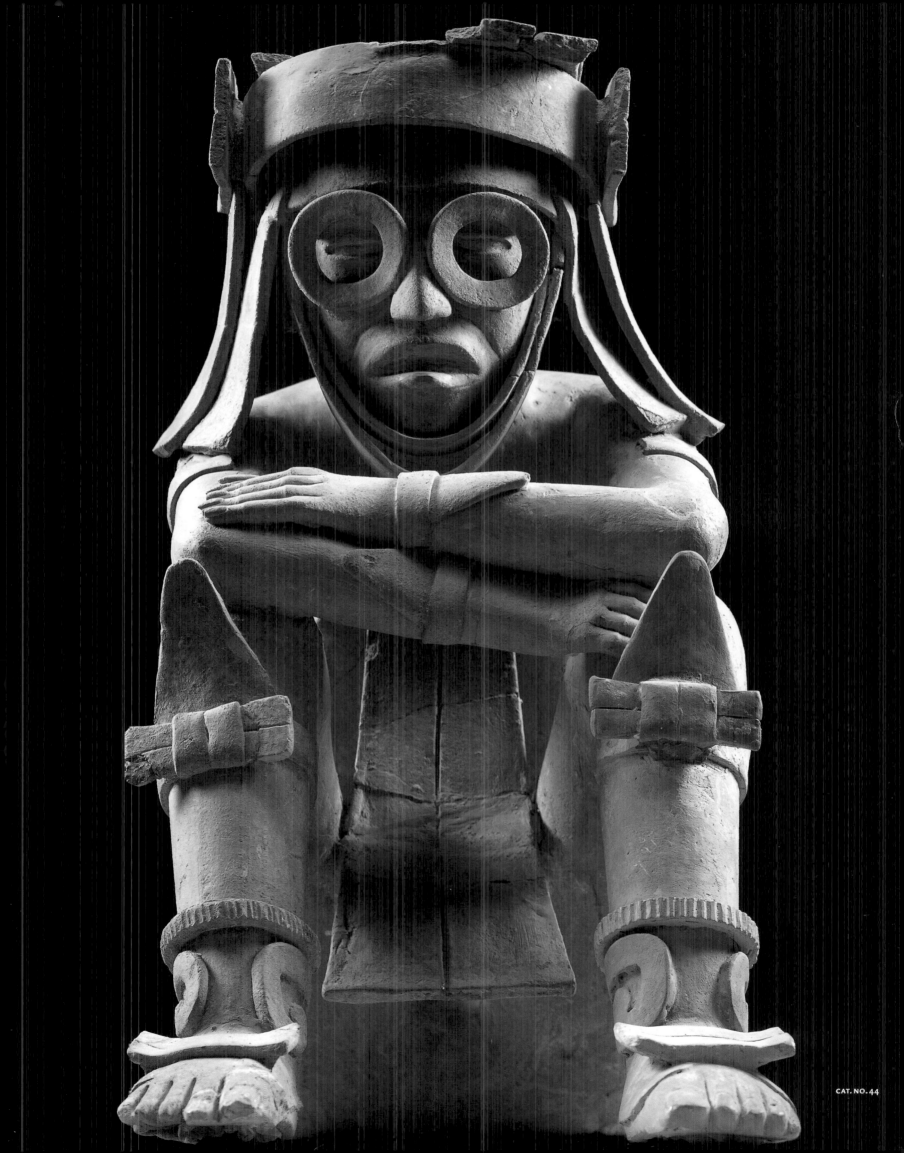

called cloisonné, decorating ceramics with different colours at different levels, and then cutting through the layers with a sharp knife. In this way the different tones stand out and contrast with each other. This technique produces a similar effect to that of Chinese lacquer ware.[33]

USING ORGANIC MATERIALS

In the category of 'minor arts' we find a whole range of artisans who down the centuries developed techniques for working with highly delicate materials including shell, wood, human or animal bone and, of course, not forgetting the multi-coloured feathers of the many birds of ancient Mexico.

There must have been a superabundance of wood, for an enormous variety of tree types is found in this region. In the course of time various sorts of axes and hatchets and chisels were developed, some from polished stone and some from metal, in order to chop down trees and carve wood. Tools made of copper and bronze were designed specially for woodwork. Although few wooden objects have survived until today, there are some pieces from the Olmec era such as the impressive busts that were recently discovered in El Manati in Veracruz. Also, some splendid musical instruments have weathered the test of time, including the upright drums called *tlapanhuehuetl* and the *teponaxtle*, which resembles the xylophone. All these instruments boast highly skilful, decorative carving undoubtedly made with metal tools.[34]

Objects and instruments made from shell or bone could be decorated using any sharp tool. Small knives or sharpened points of obsidian (volcanic glass) were most commonly used. These are highly fragile but have the great advantage that, for a short while, when they are still new, they have an excellent cutting edge which is ideal for carving out, incising and drilling holes in very delicate materials. A fine example is the sculpting on the sceptre which portrays a Maya dignitary, known as the *Halach Uinic*, remarkable for the realistic and refined facial expression, the clothing and the decorations.[35]

PAINTING

The technique used in pre-Spanish times to paint buildings consisted in applying the colours on a surface that had been prepared with a solid layer of plaster containing chalk and an anti-grease component, usually ground *tezontle*, a red volcanic stone. This technique, as has been mentioned, was applied when painting alabaster objects and other materials. The conch-shell trumpets that carry lively, many-hued tableaux on their larger curling surfaces exemplify this painting technique.

METALWORK

Probably some time during the eighth and ninth centuries, a fundamental technological change took place in the Meso-american world, when the art of metalworking became known through the influence of South American Indians. It is thought that the Valley of Oaxaca was the region where the first experiments took place using gold, silver and copper.[36] Jewellery made from these three metals immediately became the hallmark of the late stage of Indian history, known as the Post Classic.
The metal objects functioned in many areas of the higher cultural life as transmitters of a socially symbolic and ideological language, in which the major rituals and deities of the period can be recognized, as can the writing system using hieroglyphs and the calendrical system.

The techniques used resulted from the presence of precious metals in the local rivers. The nuggets or small lumps would be hammered to make them flatter, using the so-called beating technique, which shaped the metal into the desired form. Then decorative motifs would be applied, by chasing or incising with great care. The other technique was that of metal casting. In this way remarkable jewellery was created, including bells, beads for necklaces and bracelets, earrings and nose rings, the unusual ornaments that were attached under the lips, the so-called bezotes, and the splendid pectorals such as the one worn by the god Xipe Totec, patron of jewellers, which was discovered in Tomb Seven in Monte Albán, Oaxaca.[37]

The high quality of Mesoamerican jewellery may be attributed to the use of the so-called *cire perdu*, or lost wax, technique. In this method, the shape that is going to be cast is first modelled in wax. Then a cylindrical container is made from clay, into which the metal can later be poured. This cylinder is filled with soft clay surrounding the wax shape, which has casting and ventilation channels also modelled in it. Then the casting model is fired in a kiln. The wax melts away, leaving a pottery mould. The liquid metal is them poured into this hollow mould. When the metal has solidified the pottery cast is broken off and the object is revealed.[38] By means of this method, every object is unique.

BIRDS OF A FEATHER

One of the most highly-esteemed skills among the Indians of this era was the art of making feather garments and decorations. At the time of the Mexicas, when Nahuatl was spoken, the people who were officially appointed to make these feather works were called amantecas. It seems likely that there was a centuries-old tradition of working with coloured feathers, possibly dating back to the

beginning of the Christian era, when firstly Teotihuacan and then the capital cities of the Zapotecs and the Maya were being founded. Important dignitaries in particular enjoyed wearing splendid clothes and ornaments, in this way impressing both their own people and those from other tribes. Feathers would be used to create flamboyant headdresses, usually called *penachos*, as well as many articles of clothing, Interestingly, these delicate adornments were also used to decorate warriors' shields.[39]

Understandably, very few of these delicate creations of the Indian artisans have survived. Those that have are generally in European museum depots. The most famous example, the *Penacho de Moctezuma*, known as Montezuma's headdress, is presently in the Kunsthistorisches Museum in Vienna. There too you can see the fan with a butterfly shape as its central motif and the battle-shield decorated with a climbing dog-like creature, probably a coyote, symbol of war.[40]

The technique of producing feather articles consisted in choosing feathers from a wide variety of birds, thus obtaining a huge range of colours. The feathers would then be treated with a vegetable glue (one was made from a certain kind of iris that grew abundantly in the swampy regions of Mexico) and the desired shapes would be formed, stage by stage. The feathers would be stuck onto *amate*-bark paper, an indigenous product. This in turn, for example in the case of the *chimallis* (shields), was attached to circular wooden disks.[41]

To produce the magnificent headdresses a structure of twigs and bark-paper was used, the feathers of different types being arranged in layers. The most flamboyant feathers were used in jewellery. These usually came from the quetzal bird, feathers which at the slightest whisper of wind would rustle and shimmer.

In this brief overview we have presented work of the Meso-american Indian artists, so displaying the enormous wealth of the Mexican cultural heritage. The challenge we face today is not only to appreciate this remarkable heritage but also to continue and expand the work of understanding more about this past, in order to increase the knowledge and enjoyment of future generations.

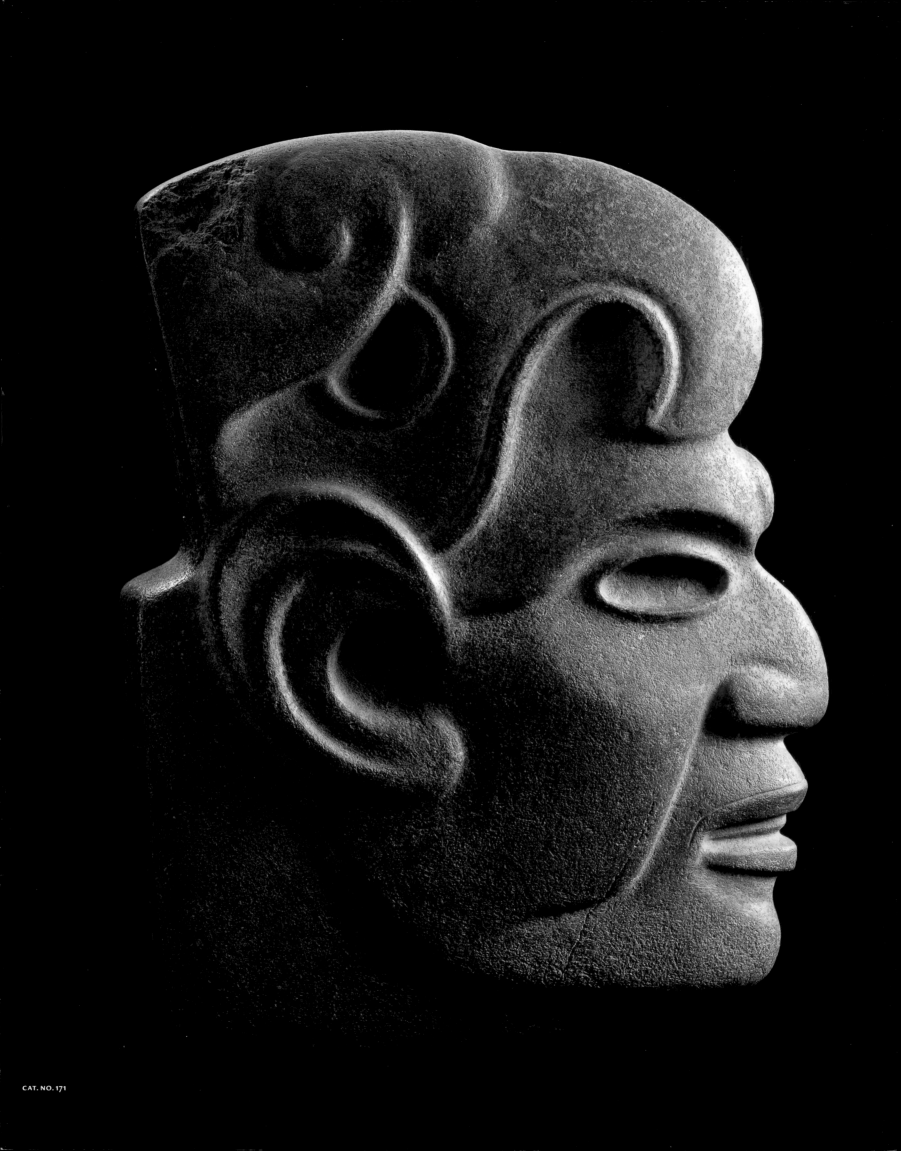

TED LEYENAAR

MEXICO AND MESOAMERICA

INTRODUCING A CULTURAL REGION

With the exception of the northern desert regions of today's Mexican Republic, Mexico forms part of the Mesoamerican cultural landscape that stretches, roughly speaking, as far south as Nicaragua or even Costa Rica (see map). The term 'Mesoamerica' was coined by the Mexico scholar Paul Kirchhoff during a congress in 1943, in order to distinguish on both geographical and cultural levels between Central or Middle America and Mesoamerica. Kirchhoff listed a number of characteristics that the Indians of Mesoamerica have in common and which, in their totality, are not found among other American Indians. The chief cultural traits of Mesoamerica are:

1 flat-topped step-shaped pyramids, whose primary function was to serve as the base for a temple (FIG. 1, AND CAT. NOS 155, 156);

2 a calendrical system based on a sun year of 360 days plus 5 'days of bad fortune' – which are referred to as 'useless fillers-up' in the essay by Zantwijk in this book – (thus 365 days) and a period of 260 days, related to the lunar cycle, with both cycles meeting each other after a 'century' – referred to as a 'bundle of years' by Zantwijk – of 52 years;

3 various writing systems (CAT. NO. 9) and the production of manuscripts, known as *codices*;

4 a sport that consisted of playing with a solid rubber ball in an I-shaped ballcourt, with the results of a match having great religious and political significance;

5 making *tortillas*, large flat pancakes made from ground corn meal (CAT. NO.106);

6 brewing pulque, a type of beer made from the agave plant (FIG. 3, CAT. NOS 198, 199).

Each item on the above list has found its reflection in the material culture of Mesoamerica. Interestingly, the artefacts that constitute the material culture of Mesoamerica, were produced in pre-Columbian times (before the arrival of Christopher Columbus) by the Indian craftspeople with implements of stone, volcanic glass (obsidian) and suchlike. They did not have iron and, although bronze items have been found, bronze tools were scarcely used. The 'ancient' Mesoamericans had discovered the wheel but only used it in a miniature form. Thus, for example, terracotta figurines have been found of animals on wheels. Although the immediate association is with children's toys, in all probability such figurines performed a ritual function.

Almost all the 'small' archaeological finds come from tombs. The objects were given to the dead to accompany them on their journey through the Underworld and their context is thus a funerary one. Unlike South America where especially the coastal areas of what is today Peru were ideal for the preservation of woven fabrics, hardly a textile has survived from Mesoamerica. Only a few dry desert regions have provided some fragments of textile. We know, however, that the art of weaving had attained a high level of sophistication. The archaeological material such as paintings on pottery (CAT. NOS 15, 20, 33), stone sculptures and reliefs (CAT. NOS 6, 7,19) and the early-colonial sixteenth-century sources, amply illustrate this. The Spanish conquerors found themselves face to face with a style of art and architecture that they had never seen before – strange new scenes and unimagined methods of presentation. Although filled with loathing and abhorrence, the Spanish could nevertheless appreciate and admire the skill and craft shown in the work of the Indians.

The archaeology of Mesoamerica can be divided into three main periods:

1 Formative or Pre-Classic: 2000 BC – AD 300

2 Classic: AD 300 – 900

3 Post-Classic: AD 900 – 1521.

Archaeologists have introduced a further refinement into this tripartite division. Thus the late Pre-Classic period, which heralds the start of the Classic Golden Age, is dated to some time between 300 BC and AD 300 and is termed the Proto-Classic. Within the Classic period, AD 300–900, the distinction is drawn between the Early Classic, AD 300 – 600, and Late Classic of AD 600 – 900. And the period from AD 400 to 700 is often known as the Middle Classic. Finally, the ninth to eleventh centuries AD, from AD 800 – 1000, may be referred to as the Epi-Classic period. These centuries form the transition from the Classic to the Post-Classic period.

THE PRE-CLASSIC PERIOD, 2000 BC – AD 300

In an area as extensive as Mesoamerica there were, not surprisingly, vast differences in styles of art, and these styles also flourished in different centuries. In the early Pre Classic, the Olmec civilization is regarded as the mother of Mesoamerican culture and traits of this style are to be found from Central Mexico as far south as El Salvador. Typical of the Olmecs' artistic expression are sculpted heads having a jaguar-like mouth (CAT. NO. 1,2) and pottery whereby the earthenware, terracotta figurines are characterized by slanted eyes (CAT. NO. 5). The pinnacle of Olmec culture was reached between 1200 and 500 BC,

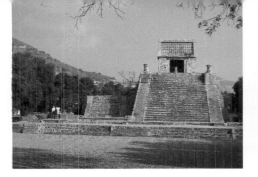

FIG. 1
Temple pyramid, Santa Cecilia Acatitlan, c. AD 1500

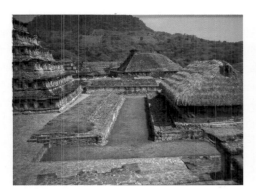

FIG. 2
Ballcourt no. 11, El Tajin AD 900-1000

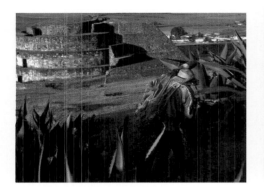

FIG. 3
Agave plants and Otomí *tlachiquero*, someone sucking out the agave sap, Calixtlahuaca

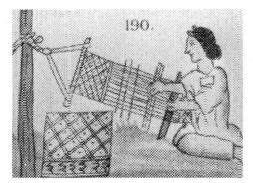

FIG. 4
Woman with back-strap loom, Codex Florentinus (Sahagún c. 1540)

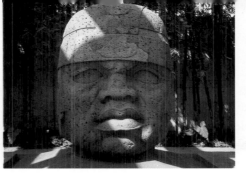

FIG. 5
Colossaal Head, San Lorenzo No. 1, Museo de Antropología de la Universidada Veracruzana, Xalapa

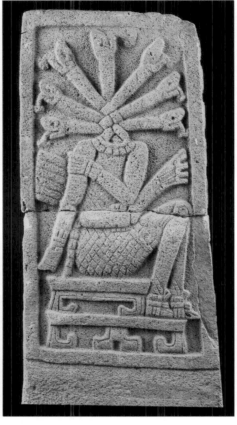

FIG. 6
Decapitated ballgame player, relief-ballcourt Aparicio, Mid Classic, RMV 3576 – 1, h. 125.0 cm

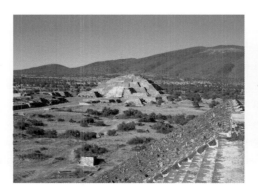

FIG. 7
Teotihuacan, looking from the 'Sun' towards the 'Moon' with the 'Avenue of the Dead' on the left

FIG. 8
Altar with talud-tablero architecture, in front of the Pyramid of the Sun, Teotihuacan, Early Classic

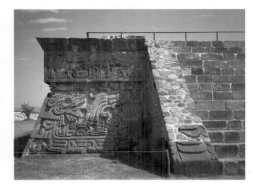

FIG. 9
Talud-Tablero architecture, Xochicalco, Epi Classic

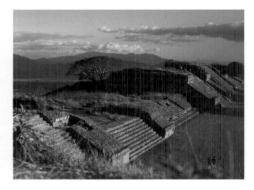

FIG. 10
Monte Alban

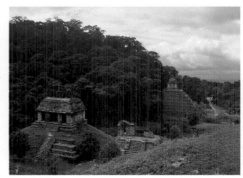

FIG. 11
Palenque, lying at the edge of the tropical jungle

but from about 1500 BC to the beginning of the Christian era the Olmecs were culturally influential throughout Mesoamerica. An intriguing legacy are the so-called Colossal Heads (CAT. NO. 1) which were discovered in the 1930s. It would seem that these heads are the portraits of men and women from the highest social ranks.[1] On the Central Mexican Highlands between the years 1000 and 500 BC, in the Pre-Classic period, small settlements such as Zacatenco and Tlatilco flourished. They are chiefly known because of the finds in their tombs and for the tombs themselves (CAT. NO. 53) since their architectural materials have perished.

THE LATE PRE-CLASSIC OR PROTO-CLASSIC PERIOD, 300 BC – AD 300

These centuries laid the foundations for the Mesoamerican cultural landscape. The Isthmus of Tehuantepec provided a corridor, or hatchway, through which trade in both objects and ideas could take place. Along this route from the Atlantic to the Pacific and back again, traders busied themselves transporting material products and spiritual baggage. Archaeological research has revealed that certain concepts represented in stone reliefs are to be found on both sides of present-day Mexico. A decapitated ballgame player whose streaming blood is represented in the form of serpents – a serpent, symbol for the phallus and fertility – is sacrificed in order to secure the fertility of the crops and the people. We first come across this type of relief in Izapa, on the border of Mexico and Guatemala close to the Pacific coast, in the Proto Classic at around the beginning of the Christian era. A few centuries later, between around AD 400 and 700 in the Mid Classic, this motif is found on four reliefs from the ballgame court in Aparicio, Municipio Vega de Alatorre, lying not far from the Atlantic coast of Mexico (FIG. 6). Also in Chichén Itzá, Yucatán, in the Post Classic, this theme of ballgame/human sacrifice/fertility is pictured, based on ideas that in the Proto-Classic time were first represented pictorially.[2] Mesoamerica, as such, was born. It was to become an intriguing component of the world's cultural heritage.

In the same Proto-Classic period the custom developed in West Mexico of burying the dead in shaft tombs. These tombs have provided a veritable treasure trove of funerary gifts offered to the dead to accompany them on their journey through the Underworld. The vast majority of these objects are of earthenware, made by the inhabitants of West Mexico – whose language incidentally we still do not know – and categorized stylistically according the present-day Mexican states of Nayarit, Colima and Jalisco.

THE CLASSIC PERIOD, AD 300 – 900

Around the beginning of the Christian era a centre grew up in the Central Mexican Highlands which was to survive until circa AD 650 as the greatest cultural and political power in Mesoamerica. We know it as Teotihuacan, meaning 'there where men become gods' or freely translated, The Place of the Gods (FIG. 7). The architects of Teotihuacan introduced an element into their building, the so-called *talud-tablero*, a sloping surface with a roofing (FIG. 8), which was imitated by other peoples right until the arrival of the Spanish in the early sixteenth century (FIG. 9). In a manner of speaking Teotihuacan also retained its religious significance among the peoples who later lived in these Central Highlands. Offerings made by the Aztecs in the fifteenth and early sixteenth century have been found here. The small pyramids and altars built along the main road through Teotihuacan, which after the destruction in circa AD 650 gradually grew into small earthen mounds, were seen by the Aztecs as grave mounds and they called the road *miccaohtli*, the road of the dead. A name, incidentally, adopted by the Spanish so that today every tourist walks down 'Avenue of the Dead' (FIG. 7) though this was never its purpose. In the mid-seventh century, about AD 650, Teotihuacan was devastated by raiding nomadic tribes. There followed the inevitable period of instability, and then, towards of the end of the Classic period and in Epi-Classic times, other centres emerged, such as Xochicalco and Cantona.

In South Mexico, in the present-day state of Oaxaca, the first centuries of the Christian era (Classic period) witnessed the flourishing of the Zapotec culture with Monte Albán as a great centre of ceremonial activities (FIG. 10). Along the Atlantic coast of the Gulf of Mexico various tribes began to gain supremacy in the north of Mesoamerica: the Huaxtecs in the state of Tamaulipas, and to their south the Nahua and possibly also Totonacs already held sway in what is today Veracruz. Particularly here, terracotta objects of all shapes and sizes have been discovered.

In Southeast Mexico in the states of Chiapas, South Tabasco and on the peninsula of Yucatán there was under the Maya a huge cultural blooming. The Maya, who also lived in the low-lying tropical rain-forests (fig. 11) reached the high point of their cultural achievements in the Classic period. At the beginning of the Christian era the Maya also started working with the numerical symbol of zero. This represented a huge mental effort for it necessitated concentrating on the somewhat abstract concept of zero, beyond one's twenty tangible fingers and toes. In western Europe it was not until the thirteenth century that the concept of

zero became generally accepted, having been 'discovered' and brought from India (where it had also first been used around the beginning of the Christian era) via Arabs to Spain.

The Maya organized themselves in city-states with a priest-king, or 'holy king', as their leader. It was a time of enormous artistic flourishing if we are to judge from the reliefs both in plaster and stone (FIG. 12, CAT. NO. 7). To Western eyes they are the equal of Greek sculpture from the time of Pericles, about 450 – 425 BC. The terracottas and the painted scenes that survive, mostly produced on earthenware, impress us with the skill of the Maya artist. This rich period of creativity ended in the ninth century AD with a series of internal wars.

THE POST-CLASSIC PERIOD, AD 900 – 1521

In the Central Mexican Highlands the Golden Age of Teotihuacan was over by the seventh century AD. As is commonly the case, there was a period of instability associated with the migration of peoples, after which the position of Teotihuacan – at least, in Central Mexico – was taken over by Tula (FIG. 13) and its inhabitants, the Toltecs. Between 900 and the early 1100s they set the tone, and under their leadership the nature of the Mesoamerican world began to change. The Toltecs had a rigidly ordered society, in which, beside the priestly caste, the warriors also played a major role. This had its impact on the arts and, more than before, a strict pattern began to emerge (CAT. NO. 34). The religious-political movement that employed human sacrifice (the blood offering) on an extremely modest scale, was forced to play second fiddle to the party that greatly favoured human sacrifice. The holy king Quetzalcoatl – Topiltzin (The Feathered Serpent – Our Beloved Son) who favoured the more gentle approach, was forced to depart for the east, bearing the prophecy that one day he would return. It was this prophecy that later stood the Spanish in such good stead, when they appeared from the east. They too were opposed to human sacrifice.

The other party in Tula, for whom Tezcatlipoca, or Smoking Mirror, was the chief godhead, gained power, and they too were more in favour of human sacrifice. After the overthrow of Tula, at the beginning of the twelfth century – conquered just as Teotihuacan had been by fierce nomadic tribes – the political scene in the highlands looked quite different. Various small kingdoms now struggled for power in the regions around lake Texcoco. At the beginning of the fifteenth century the Mexicas (known by the Spanish as Aztecs) who had withdrawn to a few small islands in lake Texcoco, gained the upper hand over the small kingdoms that surrounded them. Between 1428 and 1521 when

their capital city Mexico–Tenochtitlan fell to the Spanish, the Aztecs were the major political factor in Mesoamerica. In the course of the fifteenth century they extended their control over large areas of what is now Mexico. The conquered people had to pay tribute to the Aztecs, whose language, Nahuatl, became the lingua franca throughout Mesoamerica. The Mixtecs, who had assumed the leading position once occupied by Zapotecs in what is today the state of Oaxaca, were also subjugated by Aztecs. Monte Alban (FIG. 10), the great ceremonial centre of the Zapotecs, lost its prominent position. Only the graves remained, to be re-used by the Mixtecs (CAT. NO. 26). The city of Yagul, built like Monte Alban high in the hills (FIG. 14), initially retained its importance and was used by the Mixtecs, but in the last centuries before the arrival of the Spanish, the city of Mitla, situated in the valley, became the Mixtec capital of Central Oaxaca (FIG. 15). The present-day city of Oaxaca, which lies in the valley of that name, was founded as a fortified centre to keep the surrounding tributary states under control. The Aztecs' military supremacy also ensured the spread of the language they spoke – Nahuatl. This language spread was partly thanks to the important group called *pochtec* – that is, traders who besides their commercial function also served as 'spies' to bring more tribes under Aztec supremacy. The Maya elite also spoke Nahuatl and the Spanish, on their conquering expeditions, used Indian interpreters who could speak both Spanish and Nahuatl in order to communicate with the Maya leaders.

After the decline of their Golden Age in the Classic period, which centred mainly in the tropical lowlands, the Maya left their most impressive monuments in the Guatemalan highlands and in Yucatan, Mexico. As early as the Epi Classic – that is, the transition between the Classic and Post-Classic periods – cities such as Chichén Itzá (FIG. 16) and Uxmal flourished in Yucatán until about the middle of the Post Classic. From the time of the Proto Classic, which runs roughly parallel to the beginning of the Christian era, we know that the ceremonial rubber ballgame was played in large I-shaped ballcourts. The ballcourt might have an open end (FIG. 16) or be contained within a wall (FIG. 17).[3] At the close of the Classic period we find the earliest stone circles which were used as the goal (FIG. 17). Before this period a goal might have been made from a more perishable material such as wood. The ballgame reached its zenith in the Epi-Classic period, in this case at the close of the Classic/beginning of the Post Classic. Evidence of this is provided by places such as Cantona (Pue) which has at least 24 ballcourts, El Tajín (Veracruz) with 17 (FIG. 2) and Chichén Itzá (FIG. 16) with its 13 ballcourts. It becomes clear from examining

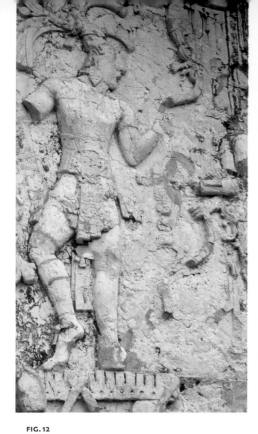

FIG. 12
Palenque, stucco relief from palace, showing Chan
Balum, son of Pakal

FIG. 15
Mitla

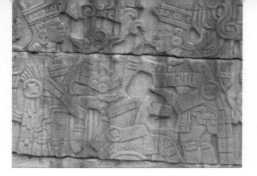

FIG. 18
Human sacrifice, 'North' Ballcourt, El Tajin

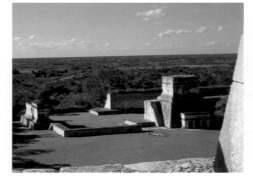

FIG. 16
Chichen Itza, seen from the castle, looking towards
the Teotlachtli, the Divine Ballcourt

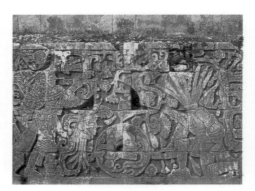

FIG. 19
Human sacrifice, Divine Ballcourt, Chichen Itza

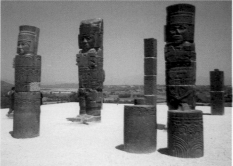

FIG. 13
Tula with a view of the statues

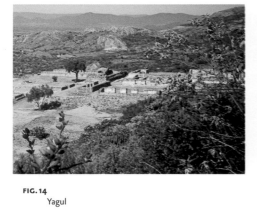

FIG. 14
Yagul

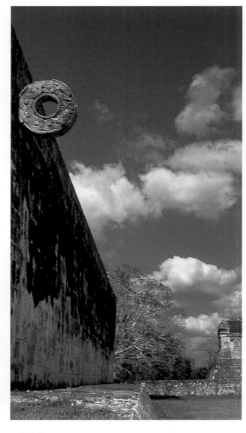

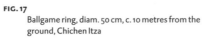

FIG. 17
Ballgame ring, diam. 50 cm, c. 10 metres from the
ground, Chichen Itza

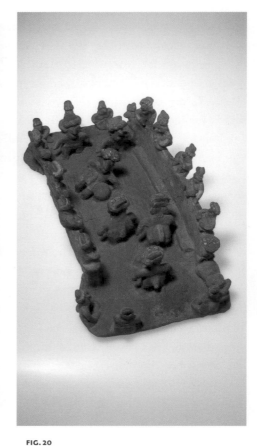

FIG. 20
Model of a ballcourt showing players and public,
Nayarit, Proto Classic, RMV 4819 – 1, l. 38.0 cm,
h. c. 18.0 cm

the reliefs in some ballcourts in El Tajín (FIG. 18) and Chichén Itzá (FIG. 19) that human sacrifice played an important part in connection with these games. The deities needed to be fed with the most precious human possession: life itself. Human hearts and blood were offered to the gods in order to ensure the cosmic status quo and to guarantee that people and crops continue to flourish in this world. It seems that the result of a ballgame could be crucially important for the future of humankind. Thus the ballcourt formed an intrinsic part of the city's architectural planning. Cantona must have had a rigidly structured society, a trait reflected in the city planning, with its 24 ballcourts. In this connection one mystery has not yet been solved and that is the purpose of the miniature ballcourt (FIG. 17) where a match could not actually have taken place. It must have had some ceremonial purpose, the details of which we no longer know.

The significance of the rubber ballgame has been revealed through archaeology. Numerous ballcourts have been excavated, some of them with elaborate reliefs that clarify the symbolic nature of the game (FIGS 18, 19). Also, large numbers of clay figures showing ballplayers have been found in graves dating from the Pre Classic onwards. The ballgame players can be recognized from the equipment they wear, such as hip protection. A leather band was worn round the hips in order to help catch and throw back the heavy, solid rubber ball – it weighed around three kilos. In stone this band is represented as a kind of yoke, and indeed the Spanish name given to it by archaeologists is *yugo* (CAT. NO. 168). Many stone *yugos* have been found in tombs as offerings accompanying the dead – presumably famous ballplayers. It is possible that the heavy *yugos* were worn during certain ceremonies or in procession but were discarded during games, since they would clearly hamper movement. Other stone ceremonial pieces of equipment or garments also bearing a Spanish name include the *hacha*, a type of axe associated with human sacrifice, the *palma*, a stylised palm frond and the *manopla*, a small type of racket. Specimens of all these three items have been found in tombs (CAT. NOS 169 – 172). Examples of ballplayers wearing their gear can be seen on stone reliefs (FIGS 18, 19 AND CAT. NO. 167), in paintings and as terracotta figurines (CAT. NOS 174 – 179).

As well as the above-mentioned examples, miniature ballcourts have also been found, sometimes with (FIG. 20) and sometimes without players (CAT. NO. 173). A seventeenth-century source provides us with more information about this latter type. We read that towards the end of his reign Topiltzin, lord of Tula, tried to ward off an impending defeat by offering his opponents

(there were three of them) a model ballcourt composed of four precious stones with a carbuncle gemstone in place of the ball. Topiltzin proposed that they should rule his kingdom with the four of them and the one who had possession of the carbuncle-ball would be the chief. The ballcourt model thus represented Topiltzin's kingdom.

In the Post-Classic period it seems that the ballgame fulfilled a recreational function, alongside its politico-religious significance. It has left its legacy – today there is still a rubber ballgame played in northwest Mexico. Indeed, there are many aspects of pre-Columbian Mesoamerican society that have endured, particularly in Mexico. These pre-Spanish roots, combined with the European contribution – the mixture is called mestizo or in Spanish *mestizaje* – provide a vital and fascinating aspect of life in Mexico.

With the arrival of the Spanish under Hernán Cortés in 1519 and the capture of the capital city Mexico-Tenochtitlan in 1521, Aztec supremacy came to an end. Interestingly, the priestly caste both of the Aztecs and of other peoples of Mesoamerica had the premonition that their era, which they termed *ollin*, or movement (see the chapter in this book by Professor Van Zantwijk) was drawing to a close. However, to maintain the world of the gods, to feed it with life, they had to offer life itself, and that life had to be human. Hence the sacrifices, which seem to increase considerably towards the end of the fifteenth and beginning of the sixteenth century. They were performed in the hope of preserving the cosmic balance and thereby maintaining the structure of society in Mesoamerica. But to the Spanish, human sacrifice was utterly abhorrent and they had no understanding whatever of the background to this apparently bloodthirsty behaviour. Ironically, the same became true for the Indians when, shortly after the Spanish conquest, the Inquisition arrived in the New World and condemned many so-called heretics to death by burning. The Mesoamerican Indians understood nothing about the background of this Christian practice.

After 1521 and a world-shattering *ollin*, a movement that ended up as more of an earthquake, embodied by the explosive force and rapidity of the Spanish conquest, the Aztec culture and the civilization of Mesoamerica came to a halt. But many aspects of this pre-Columbian world can still be found in the Mexico of today.

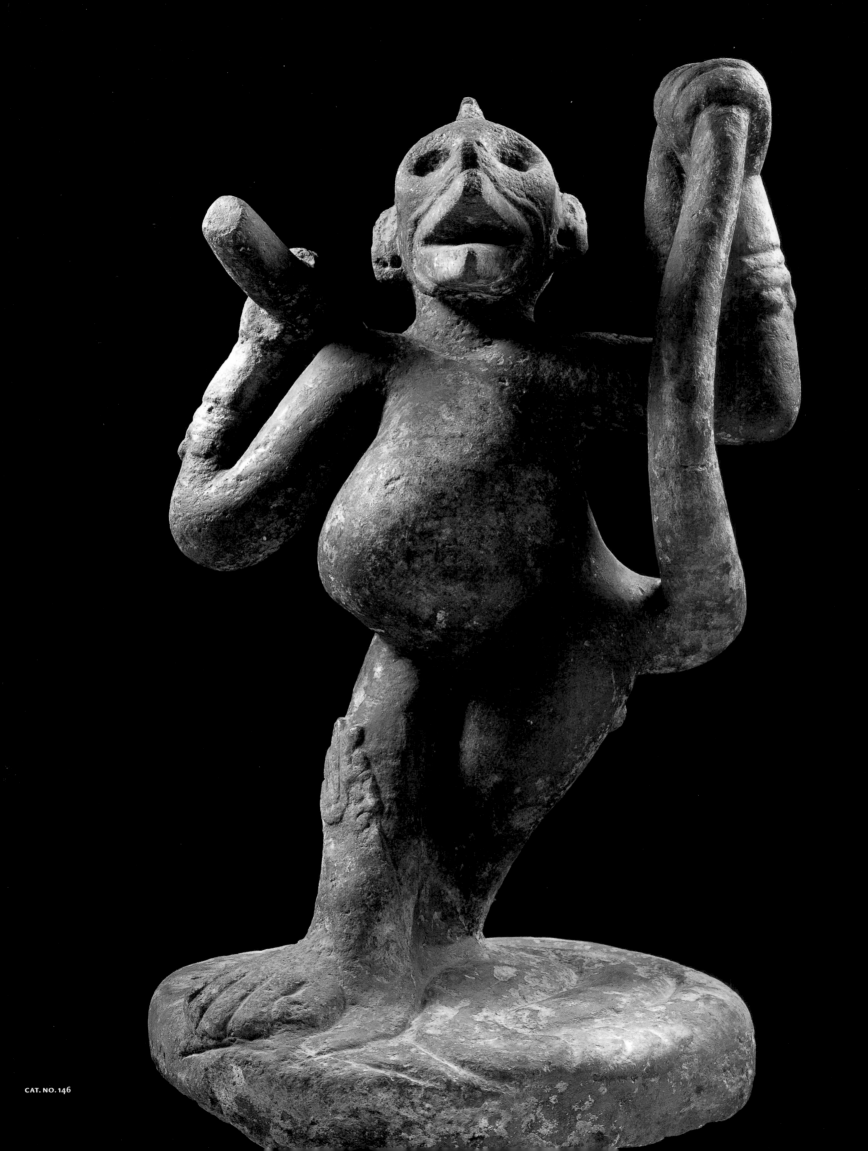

RUDOLF VAN ZANTWIJK

SOCIETY AND PHILOSOPHY OF LIFE IN MESOAMERICA

Although the experts speak of Mesoamerica as a cultural entity, thereby referring to its population as if it were one whole, there are noticeable differences between its peoples. However, in their philosophy of life, their way of thinking about time and space, their opinions about an afterlife and ideas on esoteric matters in general, there are so many remarkable similarities that it is quite plausible, on these grounds alone, to speak of one great shared cultural heritage. The knowledge that we have acquired on this subject comes largely from studying the Mesoamerican societies who have left written records. These written sources are of two types:

1 information that is inscribed in the form of glyphs (written symbols in the local languages) on material objects such as buildings, sculpture and pottery, or written in indigenous books on paper or deerskin parchment (for example, the so-called Codices).

2 information recorded about the indigenous civilizations and their history, made in the early-colonial period (sixteenth and seventeenth century) written in Roman script. Such writings are often explanations given by the local people of the sources mentioned above. Then there are also the chronicles, literature or letters of local writers, including accounts by Spaniards. Often similar information can be found in records of wills, court pleadings and legal proceedings.

In Nahuatl alone, the official language and lingua franca of the Aztec empire and adjoining territories, there are over seven hundred printed documents and books from the pre-Spanish period. In the archives and among contemporary descendants of Indians from the sixteenth century there are still countless manuscripts and even codices to be found. For example, the important Codex Xicotepec, only discovered in 1992 by Guy Stresser-Péan in the north of the Puebla state in the home of a native Indian family, was published in 1995 and so became available for study only four and a half centuries after it was written.

It is evident that when we speak about the peoples who had no indigenous form of writing before the Spanish conquest, we can only refer to the second group of documents and oral tradition. For that matter, researchers studying Mesoamerica will always have to make use of oral history, whether written down in the past or not, as an essential addition to their other material. The written sources are, after all, very limited in number, largely as a result of the destructive frenzy of the Spanish conquerors who wanted to eradicate every memory of the 'heathen' past of the indigenous population. Furthermore, the oral tradition and the study of contemporary traditions stemming from before the Spanish conquest are indispensable for interpreting the obscure written historical material and archaeological finds.

This article will deal with the non-material culture of Mesoamerica. For the material culture which is largely studied by archaeologists, I gladly refer you to Ted Leyenaar's contributions to this catalogue.

In the codices, sculptures and reliefs we find a generous collection of information about the Mesoamerican world view and the ideas concerning time and space that formed a major part of this perspective. Of supreme importance in this connection are the carved inscriptions or pictographs from the Mixtec territories in South Puebla and North and West Oaxaca and neighbouring regions, because they contain a considerable number of original pre-Spanish texts.

THE STRUCTURE OF THE WORLD AND THE UNIVERSE

The Mesoamericans thought that people were a product of the gods within a cosmic structure and constellation that was determined by a system of reciprocity. This reciprocity found its formal expression in religious ritual. The ritual gave expression to the mutual involvement of the gods and humankind with each other. Throughout almost all of Mesoamerica we find seven basic principles that govern ideas about the structure of the world and humankind, the universe and the gods.

1 THE PRINCIPLE OF DUALITY

The simplest concept but absolute cornerstone of all thinking about the structure of the world and the universe was – and still is for many Indians today – the principle of duality. The divine creator, known to the Aztecs as Ometeotl (Two-god) was both male and female and consisted of two distinguishable parts that were indissolubly bound together, namely the Omecihuatl (Two-Lady) and the Ometecuhtli (Two-Lord).

This underlying concept had important repercussions for the organization of society and everyday life. A social institution, a group, a governing body and also the (extended) family could only be considered as a separate unit provided it consisted of two parts. Thus the family was seen as a unit led inwards, into the home, by the wife or mother, while the husband represented the outward-looking aspect of the home. The wife had immediate authority over her daughters and daughters-in-law who also lived in the same house, and bequeathed her goods to her daughters,

while the husband directed his sons and bequeathed his possessions to them. The principle of duality controlled the way of thinking to such an extent that it was only possible to speak of a second generation after two children had been born to a couple. A family with only one child was considered to belong entirely to the generation of the parents.

In the ancient story that tells how the sun and the moon were created, for which the gods gathered together in the city of Teotihuacan, the powerful all-pervading notion of duality is clearly expressed. In this story the gods are asked to present themselves as a kind of sacrifice, and throw themselves into the fire, which they have lit, in order to become the sun. The only god to come forward is the prosperous and richly-dressed deity, Teucciztecatl. The gods' reaction (the logic of which is not immediately clear to us) is, we are told: ' "Who is the other one?" They then looked around the group at one another, and said among themselves, 'Now what will happen? How will we be able to continue like this?' No one seemed to be brave enough to step forward and offer himself as Teucciztecatl had done. Indeed, all were fearful, and shuffled backwards. But there was one who had not appeared before, and that was Nanahuatzin, the Worthy Leper (or one with venereal disease) who had been listening to what was being said. So the gods summoned him before them and addressed him thus: 'You are to be the one, oh Worthy Leper.' He accepted their words joyfully, saying, 'Everything will be good, oh gods, you have conferred a favour upon me!' '

The story continues and recounts how the wealthy Teucciztecatl recoils four times, not daring to throw himself into the fire. The diseased and poverty-stricken Nanahuatzin sacrifices himself without hesitation and is transformed into the Sun god. Seeing this, Teucciztecatl is shamed and at last throws himself into the flames. Thus, he becomes a feebler reflection of the sun, and is transformed into the moon.[1]

The identification of gods and goddesses with natural phenomena and heavenly bodies is not always easy for us to understand. Also, many gods like the sun and the moon are sometimes represented as male and then as female, while others maintain the same sex. The connection with the human system of relationships is also complicated. The famous Mexican expert Paul Kirchhoff exclaimed some time in the mid-twentieth century, 'I only began to understand the Mexicans once I realized that I am my own grandmother!'

In the cultures of the Maya, the Toltecs and the Aztecs who came to power after them, duality was also present throughout all forms of government. There were always two heads or lords in a village, a city or a state, exercising the highest authority. One head, or lord, represented his region to the outside world, and had authority over the groups and territories that were subject to the region over which he ruled. Beside him – and hopefully in harmonious cooperation – a second head would preside over internal affairs, which was often a more juridical and advisory function. Both men and women could hold these posts, although the former type of office was identified with masculine and military activities while the internal affairs function was considered more feminine and socially oriented. Initially, the Spanish could not comprehend this system of government. When they arrived, the highest external Aztec lord was the Great Speaker (*Hueyi Tlahtoani*) called Motecuhzoma. The Spanish invaders corrupted his name into 'Montezuma'. For them, he was the equivalent of a European monarch or emperor and at his side ruled the Female Snake or Female Companion (Cihuacoatl), somewhat like a prime minister. (The Aztec word *coatl* means both snake as well as companion, ally, close friend and suchlike.) In Mexican government, however, what we would think of as the sovereign power was invested in a Governing Council (*Tlahtocan*), of which the Female Companion or Escort was the chairperson; sovereignty did not, therefore, reside in the person whom the Spaniards perceived as king or emperor. When the Spanish conquerors under Hernán Cortés were welcomed peaceably in the capital city of Mexihco-Tenochitlan, they tried to gain power over the Mexican empire by taking their host and his chief ministers hostage. Indeed, in this way they gained control over all the subject territories. But when, counselled by Motecuhzoma, the Spanish released the Female Companion, they immediately lost their chance of having power over Mexihco, the most important of the empire's three central states. In the summer of 1520 war broke out there and in the first couple of weeks the Spanish lost about two-thirds of their men, either killed or taken prisoner. The next year, however, the tide turned against the Indians: there was a devastating smallpox epidemic (brought to the land by the Spanish) that killed many throughout the country, and the Spanish forces were strengthened with new contingents from Europe. Assisted by many Indian auxiliary forces the Spanish managed, after a ninety-day siege, to capture the Aztec capital.

Echoes of the system of duality are also frequently found in their rhetoric, sayings and proverbs, and in their poetry and narrative prose. Both the Maya, with their parallel expressions, and the Aztecs, with their diphrasism (see below), show ample evidence of this.

2 THE TRIUNE ASPECT OF THE UNIVERSE

The universe was pictured as a large whole divided into three vertical segments: heaven, earth and underworld. The Toltecs and the Aztecs applied this concept in their state government, which was ruled from three capital cities belonging to three central provinces or states.

3 TIME AND SPACE

On a horizontal plane, the world was considered to be divided into four, according to the four wind directions. The Aztecs and the Toltecs reflected this notion by dividing their government administration into four sections, which had important consequences for military organization and taxation. Sometimes the four divisions were extended to include a fifth section, which was placed in the centre of the 'picture'.

Similarly, the notion of world time was divided into sections indicated by five suns. The fifth sun is that of the government of the day. Thus the fifth sun was the *Ollintonatiuh*, the 'Sun of movement', the cosmic period in which the Aztecs were thought to be responsible for maintaining the balance in the world as well as that between the world of people and the world of the gods. The other four suns were seen as constellations that had 'had their time' and lost their position of power during a former time of chaos and disaster. Thus the fourth sun, according to some sources, represented the period of the Toltecs, while the previous three represented pre-historic orders/governments, which is where failed creations of the gods were placed.

The Mesoamericans did not see these 'sections of the sun' as merely sequential, in the way that Europeans view the sequence of history. The sections of the sun were thought to eternally co-exist, with the constellation of the fifth and central segment always in a dominant position.

This identification of time with space leads unavoidably to time occupying a relative position, and that was exactly the case with the Mesoamericans. This explains why, in various historical sources that arose under Spanish influence, the four other suns are given in various sequences. The indigenous people, when questioned by the Spanish and asked to arrange the suns in order, did not always do so in the same way.

4 IDENTIFICATION OF TIME WITH PLACE OR DIRECTION

In all the great Mesoamerican cultures we find the concept of the identification of time with place or direction. This meant that people divided up and ordered time spatially and considered time and place as thus mutually dependent. A very clear illustration of this notion can be seen on the first page of the Codex Fejérváry-Mayer (SEE FIG. 21). Were we to apply this scheme of things in the framework of European ideas about time, we should have to imagine a system in which Sunday was linked with the heavens, Monday with the earth, Tuesday with the underworld, and Wednesday, Thursday, Friday and Saturday with, in sequence, the north, east, south and west. Incidentally, the system of days was quite different for the Mesoamericans, because they had periods of thirteen and twenty days and then larger units of 260 and 365 days, all united within one greater time unit of 52 years.

5 THE FIVE COSMIC TIME DIVISIONS

As mentioned already, there were five cosmic divisions of time, known as the Suns. Influenced by European and Spanish writers, the five suns were represented as if they described five successive divisions of time. However, it seems plausible to believe that, for the Mesoamericans, the five suns should not be seen simply as five periods succeeding each other, but also as units of time and space that were always present, be it that four of the five suns 'slumbered' while one sun at a time occupied the ruling position. This order is illustrated in the so-called Calendar Stone of the Aztecs, better described as the Sacrificial Stone of Great Speaker Axayacatl, which shows with remarkable beauty in a spatial manner the division of time into five sections.

6 PEOPLE'S OBLIGATIONS

There was a generally accepted notion that the cosmos could only be well-ordered if there were a system of reciprocity between the different parts that made up the cosmos. Seen in this way, people were obliged to honour and respect the gods and to serve them with rituals and sacrifices, since it was to these gods that people owed their existence. In the Toltec creation story, the gods sacrificed themselves in order to set the sun in motion. Thus, in return, people were expected to sacrifice themselves in order to nourish and maintain the gods.

7 THE TWO ASPECTS OF A PERSON

Closely connected with the all-pervading concept of duality, the individual person was also seen as consisting of two essential parts: the *tonalli* (warmth of the sun), given to every individual through their father's sperm, and the *nahualli* ('two-escort-being' or counterpart), which usually took the form of an animal or a natural phenomenon such as a hurricane or thunderbolt; this counterpart was given at birth by the earth goddess. People with strong personalities were considered to have a powerful counter-

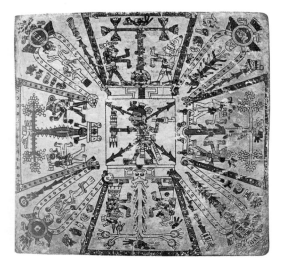

FIG. 21
Codex Fejérváry-Mayer, page one

part, and those who were able to control their counterparts, and possibly also those of other people were thought to be great magicians. Everyone shared their fate with that of their counterpart: in other words, if their counterpart suffered in some way, the person 'attached' to them was also seriously affected and usually became ill or, in the worst scenario, died.

THE MESOAMERICAN CALENDAR

In Mesoamerica, philosophy, knowledge and the cultural world-view were based on the interaction of the seven principles outlined above. The main framework for this interaction was the study of the calendar. Specially trained experts dealt with this area. The symbols used to represent the data were more than a simple means of representing the calculation of time. The hieroglyphics used represented a formulated complex of ideas. As well as the date there were countless other references, such as direction, sanctuary, god or goddess, *tonalli*, favourable or malevolent prospects in general or for some specific activity.

The Mesoamerican calendar is a wondrous and entirely indigenous invention. Just as western Europeans have seven names for the days of the week, so the Indians of Mexico and parts of Central America have twenty day-names. These names – how could it be otherwise in a civilization so permeated by the concept of duality – can never be used individually but are always connected to a number ranging from one to thirteen. This means that the same combination of day-sign and number recurs every 260 days. This calendar unit was considered to be the duration of human pregnancy. Therefore, following this logic, the day of birth was thought to be the same as the day of conception. This explains why the *tonalli* (warmth of the sun), or the day of birth, was considered to have been given by the father. It referred both to the natural father and particularly to the Father Sun. At birth the Mother Earth bestowed the other half of the individual's duality, the *nahualli*, or counterpart (escort-being).

As well as this system of counting days there was a system of counting years. The sun years consisted of 365 days, divided into 18 periods of 20 days plus five days of rest, which the Aztecs called 'useless fillers-up'. On such days people were not expected to do anything of importance. The 360th day was considered to be the last day of the year, and in a leap year the Aztecs simply had this day twice over, because otherwise the whole splendid system would be messed up. Because of this idiosyncratic custom, it was a long time before European scholars understood the system. The question of whether or not the Aztecs observed a leap year is still being passionately discussed. However, a comparison between

Aztec and Spanish dating during the war of the Conquest shows quite clearly that in our year 1520, and the Aztec year 11-Tecpatl, the 360th day of that year is counted twice. The Aztecs also used the name of the 360th day to indicate the year that had just been completed. Other peoples of Mesoamerica sometimes followed different methods of dating and would call the year after the first day. Furthermore, the Maya appear – at least for most of the time – not to have taken leap years into account. The calendrical system worked in such a way that only four of the twenty day-names could appear in the position to give their name to the whole year. Since these four signs were combined with the 13 numbers, they were perfectly sufficient to provide names for the 52 years of the so-called 'bundle of years'.

The particular way in which the Mesoamerican calendar counted days and years had the result that every 52 years both systems arrived at the same point. This is because 73 times 260 days is exactly the same as 52 times 365 days, in both cases being 18,980 days. Most Mesoamerican peoples counted only within these time schemes. However, it should be noted that the Maya, in their days of glory, counted in more varied and far larger units of time, consisting of, for example, *katuns* (periods of 7,200 days) and *baktuns* (periods of 144,000 days).

To mark the close of a 52-year period all the fires within and upon the temples and administrative buildings were extinguished. The priests of the fire god, regarded as the oldest of the gods, waited until the constellation of the Pleiades reached a certain position in the sky and then lit the new fire, which was then carried from the holy of holies and dispersed over the whole country.

The daily and annual calendar formed an important organizational system, both in the life of an individual and in society as a whole. The individual was, as it were, 'identified' by his or her birth sign, that is, the sign of the day of birth. Some of the Mesoamericans, such as the Mixtecs living in today's state of Oaxaca, did not hide the name of their birth sign and in Mixtec codices these names are commonly listed. But among other peoples, including the Aztecs, there was the custom – particularly among the higher-born – of keeping these name-days secret, presumably so that they could not be used against them in magic by an enemy. Thus we know very few of the birth dates of Aztec rulers and princes.

Public events, such as religious festivals and the celebration and rituals linked with these, often took place in accordance with the annual calendar in which the final day of every twenty-day period had a special significance. Besides these, there were important dates such as 2-reed, the day of Tezcatlepoca, 1-reed,

the day of Quetzalcoatl, 1-flint, the day of Huitzilopochtli and 4-rolling movement, the day of the son god Tonatiuh and of great significance for the whole population. But there were also festivals lasting a day or more when the celebrations were led by ethnic minorities or people with certain jobs, such as merchants, those who made feather mosaics, or gold- and silversmiths. Thus these different groups got the chance to take a leading part in the major public ceremonies. All the great kingdoms of Mesoamerica were multi-ethnic societies, and in most of the states this type of 'divided labour' in the system of ritual ceremonies was a way of channelling tensions between groups into ritual competition to show who was best at organizing public festivities. Each group in turn had a chance to show its social importance. In the colonial period the Spanish accepted this pattern by encouraging the *cofradia* organizations (Roman Catholic brotherhoods in charge of the performance of communal rituals and religious feasts) to link up with the festivities of the indigenous Indians. In this way groups or individuals vying with each other organized, and to a large extent paid for, the religious festivals. In today's indigenous societies important vestiges of this are to be found: social status and political influence within a village community are still largely determined by the role people play in this religious-ritualistic system.

DIVERGENT INTERPRETATIONS OF NATURE AND THE WORLD OF THE GODS

The many similarities in the world views of the various Mesoamerican peoples allows us to speak of one general world philosophy, but nevertheless there are major differences in certain subsections and indeed some essentially conflicting interpretations about nature and the world of the gods.

The Maya had a strictly cyclical view of past and future. Mayan learning was directed towards being able to foretell the future based on knowledge acquired from the past. This was supplemented with observations about the movement of the constellations and other natural phenomena such as hurricanes and earthquakes. Everything was considered in the context of a system assumed to be regular and orderly.

The Toltecs were in many ways greatly similar to the Maya but gave a new twist to the concept of future expectations by upholding the notion that they could partly influence what was to come. They hoped to achieve this by strengthening the gods who maintained their world system, doing so by offering them the most precious gift they could imagine – the blood and life of a human being. Groups of Toltec warriors later introduced this idea

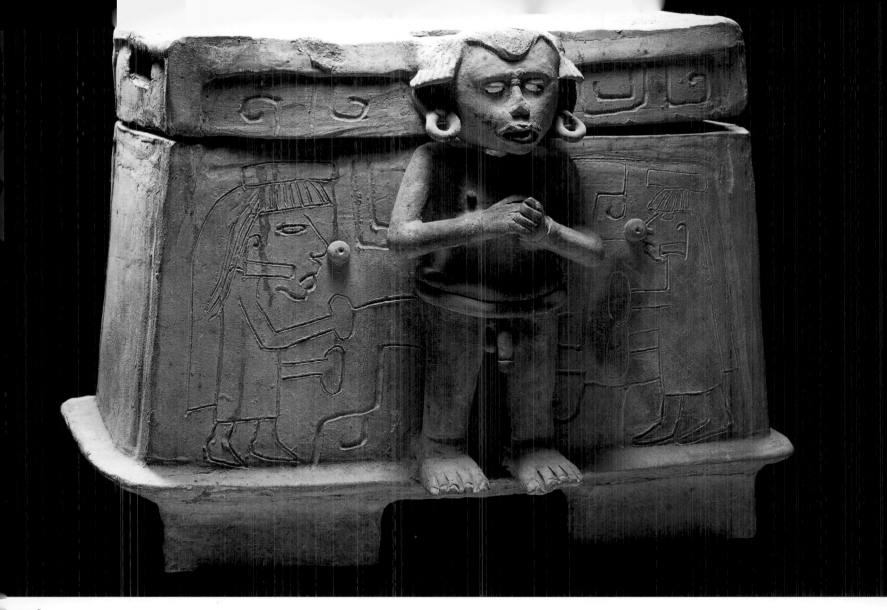

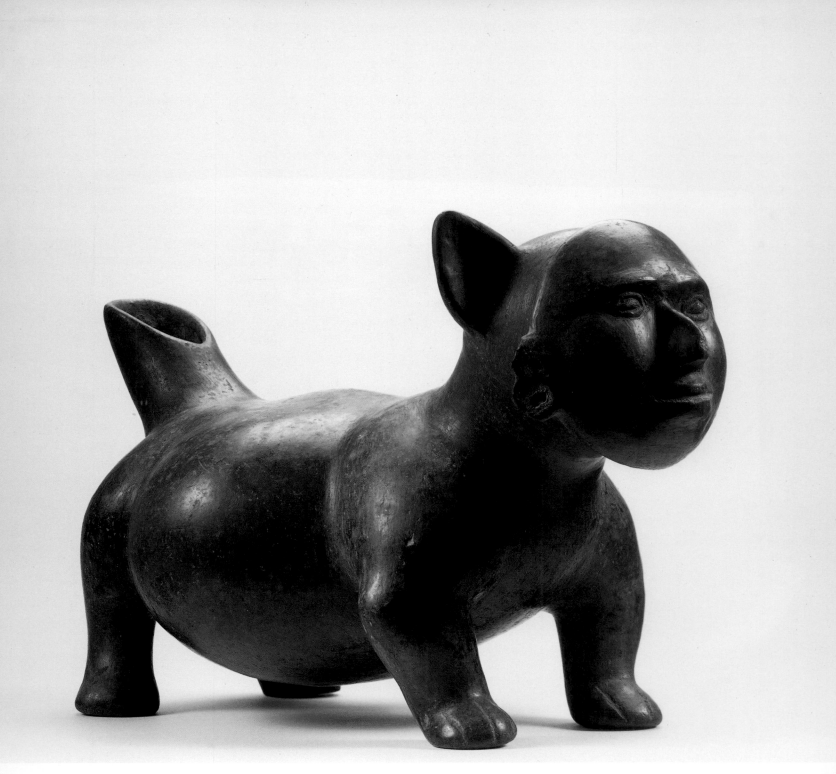

into the Mayan world, both in Yucatán and in the Guatemalan highlands. They also attempted to establish, as it were, the world system and in this way to partly make it permanent, by means of environmental organization, which was reflected in their city architecture: thus the term 'Toltec' in the time of the Aztecs acquired the meaning of 'architect' and 'artist'. Possibly this – together with their tax system – explains why the Aztecs maintained cadastral registrations of all the public buildings, houses and palaces in their villages and cities.

The Aztecs embroidered still further on the Toltec system. They recreated the ritual human sacrifice in a gigantic public display. It seems that the ascent of the social ladder was closely connected with these rituals. Indeed, so much was this the case that certain regions whose population was closely related to them were chosen as partners in the so-called 'flower wars', instead of having to pay taxes. These flower wars took place on designated battlefields at designated times, usually once every eighty days. There were four 'flower war' provinces, which implied that the warriors from the three central Aztec states of Mexihco, Acolhuacan and Tepanecapan had the opportunity of taking prisoners once every twenty days. This was what the ritual flower wars were all about. The aim was not to kill people but to capture as many prisoners as possible. Promotion in the army as well as social status were directly dependent on this. The people who had been taken prisoner were then selected to become the most acceptable, most pleasing human sacrifices for the chief deity in the constellation of the Fifth Sun, the Sun of Movement. For the Aztecs the chief god was their own Huitzilopochtli. In order to emphasize the idea that the human sacrifice came from their own people, he would first be 'adopted' by the warrior who had captured him. After the sacrifice there would be a ritual cannibalistic feast, in which the warrior would not take part, although his relatives would. During these cannibalistic meals small pieces of human flesh cut from the body of the person who had been sacrificed (and usually obscured by being dipped in quantities of herbs) would be consumed – often with great reluctance. Through this ritual the person sacrificed was included within the group of the warrior who offered him. The accompanying ritual was so complicated and time-consuming that the number mentioned – between twenty- and eighty-thousand sacrifices – in the colonial records as apparently having been sacrificed at the inauguration of the great temple of Huizilopochtli and the rain god Tlaloc in Mexihco-Tenochtitlan in 1487, comes across as totally exaggerated. Possibly one explanation is that the skulls of the 'adopted' victims were placed in the skull racks of the dead from the city, and that the Spanish

concluded that all those skulls came from human sacrifices. This explanation occurred to me after a visit in 1997 to the Day of the Dead in Mixquic, a few dozen kilometers south of Mexico City, where still today the skulls of the inhabitants are taken from the graves after four years and placed on a skull rack, or *tzompantli*. Also, the fact that the vast majority of the indigenous reinforcements for the Spanish troops deserted during the siege of the Aztec capital, when after an unsuccessful attempt to storm their positions the Aztecs sacrificed about sixty Spanish captives, does not suggest that the Aztecs were accustomed to sacrificing large numbers of prisoners. Furthermore, Aztec society would have to have been able to offer a remarkable number of opportunities to all the social climbers who would have been due for promotion as a result of all those thousands of sacrifices.

EDUCATION

In contrast to the Maya, who tended to pass on knowledge from an individual teacher to one pupil – usually a close relative – the Toltecs and the Aztecs had what might be described as comprehensive education. The Aztecs had a school for boys and a school for girls in every neighbourhood, and children from ordinary families went to these schools from the age of seven until they were of marriageable age. They were semi-boarding schools; at harvest time or if there were urgent family business, the children could go home. Parallel to this and for the same age category was a more elitist school called the *calmecac*, attended by the children of noble families, of merchants families, and highly gifted children from the 'ordinary' families. This type of school was entirely boarding and did not exist in every neighbourhood. In Mexihco-Tenochtitlan only seven out of the twenty neighbourhoods had one. This schooling was required to reach the higher echelons of the civil service, although not for all the higher military ranks. Following the *calmecac* came a higher priestly school where the temple priests received their training. So we see that in the sixteenth century the Aztecs had compulsory schooling up to the age of twenty, a cultural and social achievement not yet equalled in Europe in the twenty-first century.

The most important lessons were those in religion – chiefly learning about the ritual tasks – and the study of the calendar. Important, too, was rhetoric, as fluency and a subtle use of language were considered essential for every civil servant and priest. Further, the art of warfare, the art of handwriting, knowledge of foreign languages, writing skills and astronomy all formed part of the school curriculum. There was also a musical training on offer in the *Cuicacalli* (the Hall of Song) where you

could learn to be what we would call an opera singer. Singing formed part of many of the public festivities, as did theatrical performances. Interestingly, the Aztecs had a type of copyright and also could bequeath to close relatives the right to perform certain works.

There were theoretical subjects at school, but practical exercise was also very important. At the general schools the boys were taught how to handle weapons and had lessons in subjects such as agriculture, market gardening and hunting. The girls at such schools were taught how to perform household tasks and aspects of weaving. At the *calmecac* the boys would study the art of warfare and – depending on the ability they showed – various branches of the fine arts. Both boys and girls learnt how to serve in the temple and girls also learnt fine handwork such as painting pottery and decorating textiles.

THE LITERARY HERITAGE

Despite the virulent persecution of the colonial period, when indigenous cultural forms were quashed and there was massive destruction of books and writings, sculptural reliefs and inscriptions, the Maya, Toltecs and Aztecs in particular have left a sizeable literary heritage. Much of this provides us with our information about their view of the world, about their philosophy and ideas in general. Through their writings, we have acquired insight into these peoples and also into the ethnically related groups whom we now, for the sake of convenience, refer to collectively as Mesoamericans.

In the first part of the *Popol Vuh* the sacred book, also called the Book of Creation or the Book of Counsel, and the most important piece of ancient writing left by the Maya-Quichés of the Guatemalan highlands there is an account of the creation of the world:

'And thus was Q'uq' Kumatz (Feathered Snake) pleased: "It is good that you have come, you, Spirit of the heaven, and you, One Leg and also you, Young Fork of Lightning, New Lightning, we shall be able to make what we have planned, our creation." And so the world was created, and it was made by the Spirit of the heaven, the Spirit of the world, as they were called by the first people who ever ruminated upon such topics. Then the arch of the sky was pieced together and the world was formed in the midst of the water.'[2]

In the annals of Cuauhtitlan, also called the Codex Chimalpopoca, we find a Chichimec version of the creation of the world. The Chichimecs were a large group formed from peoples living in the north and west of today's Mexico; the later rulers of the country, the Aztecah-Mexihcah formed part of them. This Cuauhtitlan source attempts to place the ancient story of creation in a historical context:

'In the year of One Rabbit (AD 726) the kingdom of the Toltecs was established. It is recorded, so it is told, that life arose in four different sections. According to the wisdom of the old sages, in that year of One Rabbit the heavens and the earth stood still. And according to their wisdom it was so that when the heavens and earth stood still, then the life of the people living on earth manifested itself in four sections. According to their teachings the four sections were linked to the same number of suns (that is, ages or epochs). And the old sages said that the one whom they called their God, made them from ashes and so created them. This god they called Quetzalcoatl, the Plumed Serpent, or Precious Serpent, or Precious Twin. He brought them forth, he created them in his day, Seven-wind.'

And so the first Sun was established. His symbol is Four Water and he is called Water Sun. In those days it happened that everything was washed away by the waters. All the people changed into dragonfly larvae and fishes. Then the Second Sun arose; his symbol was Four Ocelot (a jaguar) and he is called Ocelot Sun. In those days it happened that the heavens collapsed. This was when the Sun no longer followed his course. It was not yet noon when suddenly all grew dark. After it became dark, people were devoured by jaguars. In those days there were giants. The sages recount that they would greet each other with the words: 'May you never fall' because if one of them were to fall down he would never get up again.

The third Sun arose; his symbol was Four Rain, and he was called Rain-sun. In those days it happened that there was a rain of fire [volcanic eruption?] which burned all the inhabitants of the place. And in those days also it rained sandstones. They say that it was then that the sandstones were scattered that we now see all around. Then too it foamed pumice stone upon the earth and in those days red crags and rocks appeared on all sides.

The fourth Sun had Four Wind as his symbol. He was the Wind Sun. In that time everything was blown away by the wind and all the people changed into monkeys. In the forests they (the people of the Fourth Sun who had been changed into monkeys) overcame the men-monkeys who lived there.

The fifth Sun had Four Rolling Movement as his symbol. He is called Moving Sun because he continues on his way with a rolling movement. But, as the wise old men recount, it will come to pass in these days that there will be earthquakes and famine. This will vanquish us.

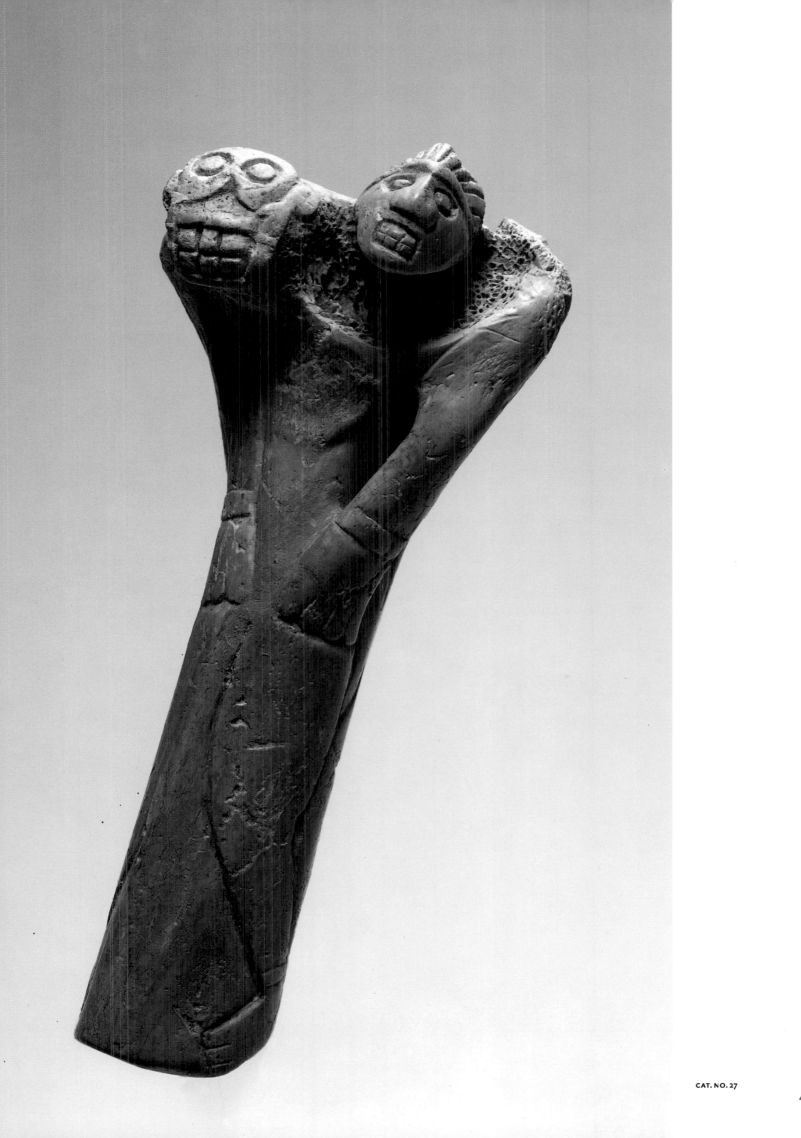

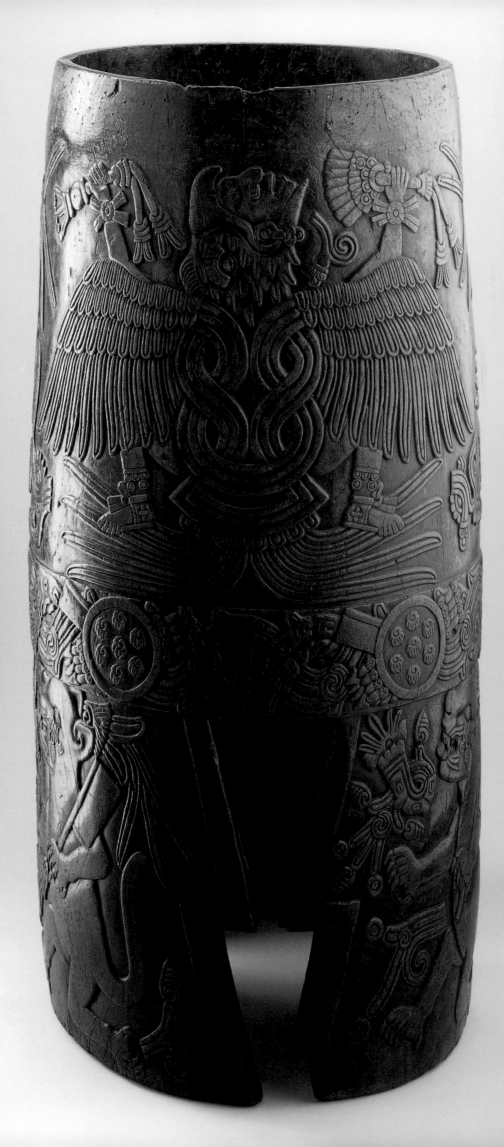

'It is said that the present Sun was born in the year Thirteen Reed (AD 751). And it was then that dawn came for the first time, that it became light.'[3]

Besides the ancient stories narrated by the wise old men and women to their children and pupils, there are also several poems that illustrate most vividly the ethnic Mesoamerican way of thinking. A fine example is the following Aztec lamentation, mourning a friend who has been killed:

> My heart detects the notes of a song,
> one that fills me with sorrow.
> I have become an orphan,
> I have lost my brother.
> You went forth, prince of flowers,
> Now suddenly life on earth is over.
> We lived as brothers upon borrowed time
> But we shall be reunited
> In the House of the Sun.[4]

And in all probability, the following poem, still sung today throughout Mexico, harks back to a verse composed before the Spanish came; it is given here in its form as an Aztec song from the nineteenth century:

> Mother dear, if I die as a soldier,
> bury me beneath your iron stove
> and when you come to cook the golden corn
> remember me, and shed a quiet tear.
> Should someone pass this way and see you cry
> And ask you why your tears are flowing here
> Say that the young tree was chopped down too soon
> And that its smoke singes your mother's eye.[5]

Apart from literature, the study of rhetoric was an important means by which to give expression to the world of the imagination. In official Aztec speeches pleonasm is clearly admired, although this makes literal translation into (possibly more analytic) European languages a somewhat lengthy business. The Nahuatl language is polysynthetic and incorporative, and repetition plays an important role in comprehension of the spoken word. Another rhetorical device that was greatly admired was what is termed diphrasism. In this way the expression for 'a local community' could be 'water and mountain' because any place where people could live in the highlands would have to lie between a source of water – river or lake – and mountains. Like-wise, the concept of 'central government' was expressed using the words 'mat and chair' because lower functionaries sat on mats when officially performing their duties, while the more higher placed were seated on chairs. The Nahuatl language also had a complicated system of addressing people in polite forms and many examples of metaphorical expression. These all contributed to a language that was at once courtly and sophisticated and highly civilized. The philosophical texts also made great use of diphrasisms. An example is the appellation of the highest god in the pantheon, called 'night and wind' because he was both invisible and intangible.

ART

The picture of the Mesoamerican world was also to be found illustrated through painting, pottery, weaving and sculpture. Almost every Mesoamerican culture produced large quantities of 'artworks', especially in pottery and stone. To a large extent art was in the service of the religion and the combatants in political power struggles, although possibly less so in West Mexico than in other regions. Nevertheless, religion, the exercise of power and the practice of magic were all sources of inspiration for artists. Interestingly, however, we find in West Mexico and among the Maya and Nahua (which includes the Toltecs and the Aztecs) examples of what we may certainly term 'art for art's sake'. The indigenous courts employed many artists from whom the highest standards of production were demanded. These artists produced objects that are frequently of exceptional quality, remarkably aesthetic and technically skilled, particularly when we think of the available tools and the often obstinate nature of the materials used.

Indeed, it is not surprising that no less an artist than the German Albrecht Dürer was moved to write about these works in his travel account when he was visiting the Low Countries between 1520 and 1521; on seeing the products of Aztec craft and skill which had been sent from Mexico to the emperor Charles V, Dürer exclaimed in delight: 'Never in my whole life did I behold anything that so rejoiced my heart!'

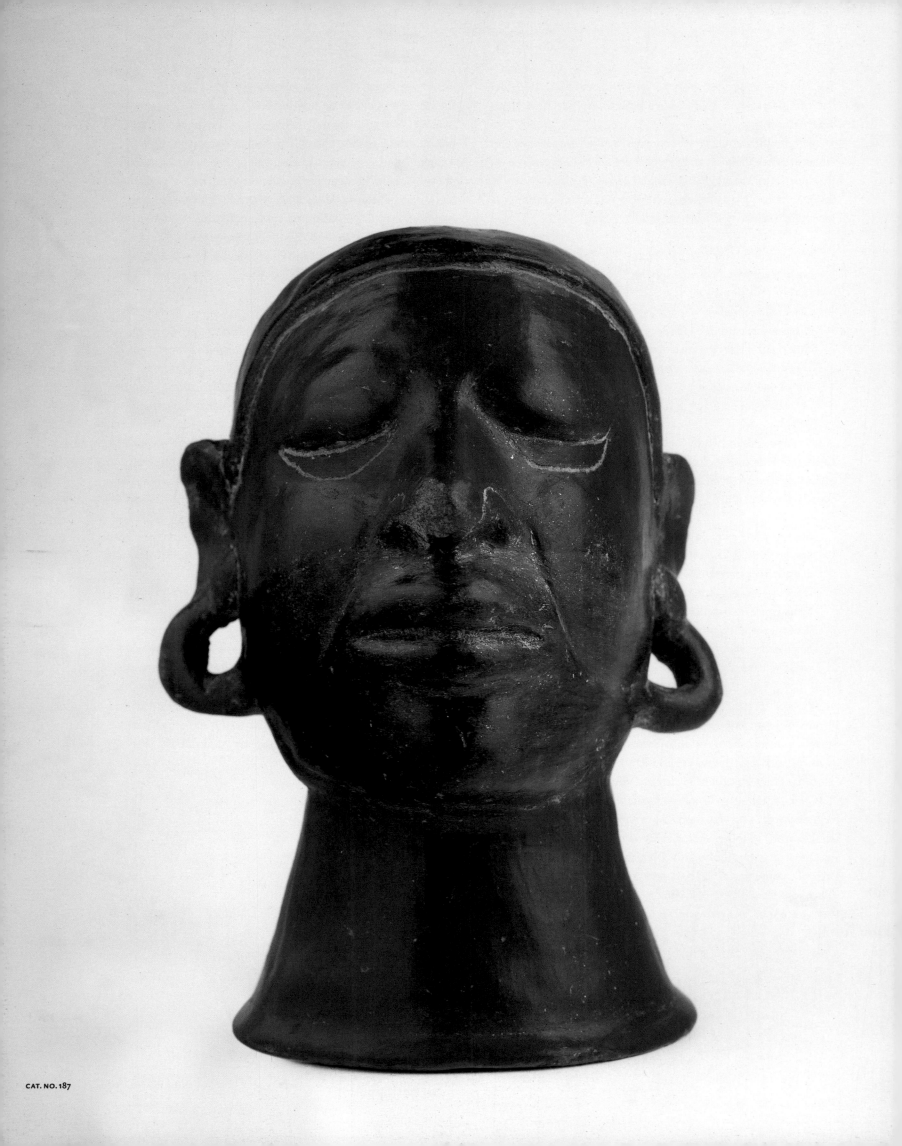

CAT. NO. 187

MIGUEL LÉON PORTILLA

A NAHUATL CONCEPT OF ART?

Did the Nahua of Central Mexico have a concept to cover the class of objects that we now term pre-Columbian art? Clearly, if such a concept existed, its implications would not have been the same as those of our contemporary idea of 'art'. Whatever the modern European connotations of 'art' may be, it would prove quite remarkable to find equivalent ideas in pre-Columbian Mesoamerica.

Nevertheless, one may suppose that the Nahua and other Mesoamericans might have developed certain concepts to refer to creations that they held in high esteem, such as monumental buildings, sculptures, paintings and other objects. Such works were produced by highly skilled craftpersons. Some of the creations represented the Mesoamericans' gods, or were intended for cultic purposes, for the exaltation of nobles, or perhaps to add beauty to everyday objects. We can say from the outset that it would be difficult to ascertain whether or not such a concept or set of concepts were indeed developed and adequately documented by the Mesoamericans. The puzzle is of an epistemological and linguistic nature and, of course, is not dissimilar to the problems encountered when studying other distant cultures such as those of classical Greece and Rome.

DISTANT ANTECEDENTS OF THE CONCEPT OF ART

We often refer to the concept of 'art' without realising its many, often subtle, implications. Usually one thinks of art as a type of creative work displaying form, beauty and great skill in its production. The accent lies on the aesthetic quality of the object. Thus one speaks of beautiful paintings, sculptures and buildings, and the work of great masters. In contrast, historians and philosophers of art have in modern times developed complex theories on the subject. None of these, nor the naive conception of art as related to beauty, coincides with the original meaning of the Latin word ars or its Greek precedent, *techne*.

Before delving into our Mesoamerican material, I will discuss briefly how the concept of art was born. This may shed some light upon what interests us here more directly. There is a dialogue in Aeschylus's *Prometheus Bound* that is crucial to our subject. The Chorus asks the chained god Prometheus what it is that he has given to mortals. His answer is that he has bestowed upon them the gift of fire. The Chorus exclaims in alarm: 'So the flamboyant fire is now in the hands of mortals?' Prometheus continues: 'And from it, they will learn innumerable arts' (Greek: *technas*).[1]

The word techne comes from the Indo-European root *teks* that connotes weaving, structuring, organizing something, doing things skilfully. Whatever was produced in such manner

– technically – deserves the name of *techne*. The Roman Cicero translated the word into Latin as ars. The original meaning can be rendered thus: *Ars est recte ratio rerum faciendarum* (Art is the appropriate way of making things). Whatever was produced in a skilful manner was art. One could speak about many different 'arts'. For example, one could refer to *Ars linguae latinae* (The art of the Latin language); *Ars medica* (The art of medicine); *Ars belli* (The art of war) and so on. The same can be said, more or less, about the meaning and use of the word *techne* in Greek.

An addition to the above-mentioned associations with the concept of art was one implied in the expression 'liberal arts': that is, those which could be practised by free persons, as opposed to the manual or mechanical activities often performed by slaves. The liberal arts were the disciplines taught in medieval schools: grammar, logic, rhetoric, arithmetic, geometry, history and music.

Another, more radical, addition was first introduced in France in the 18th century with the expression *beaux-arts*, or fine arts. Within a few decades this term became incorporated into most European languages: 'fine arts', '*bellas artes*', '*die schönen Künste*' and so on. Applied mainly to the plastic arts such as painting and sculpture, it conveyed the idea that beauty was the key attribute of such productions.

THE DISPUTED EXISTENCE OF MESOAMERICAN ART

It was a long time before the existence of pre-Columbian Mesoamerican art became generally accepted. In his seminal book *Coatlicue, estética del arte indígena antiguo* (1959)[2], Professor Justino Fernández devotes abundant space to a discussion of the critical process involved in rejecting and recognizing the existence of works of art in Mesoamerica.

During the first two centuries after the Conquest of Mexico most people described indigenous sculptures, paintings and buildings as horrible and monstrous – the products of demonic inspiration. There were a few exceptions, however, such as the artist Albrecht Dürer in his diary – he expressed deep admiration for some of the objects Hernán Cortés had sent from Mexico to the Emperor Charles V in Europe.[3]

From the early 19th century much appreciation has been expressed for Mesoamerican works of art. Interest and even admiration continued to grow so much that, finally, such a thing as pre-Columbian art was almost universally acknowledged. A good number of European, North-American and Mexican researchers focused their attention upon such manifestations of high culture. Their aim was, each in their own way, to analyze and describe the various attributes that could be considered characteristic of this

indigenous art. To do so, some of them used aesthetic concepts developed by well-known philosophers and historians of art. Undoubtedly, their contributions shed light, from different perspectives, upon the meaning of pre-Columbian art.

I myself have taken a different approach, in no way opposed to any of the various contributions referred to. My aim has been to look for the existence of possible expressions of the Meso-americans themselves in connection with the creations which are seen today as manifestations of their art.

DID THE NAHUA HAVE A CONCEPT SOMEHOW EQUIVALENT TO THAT OF ART?

We have seen how the concept of art originated and developed in Europe. Since the New World is so far from Europe, both geographically and culturally, the mere suggestion of finding a parallel concept may seem ridiculous. Nonetheless, there are some textual testimonies, transcribed in the 16th century with the alphabet adapted to represent the phonemes of the Nahuatl language, which are of particular interest with regard to our subject.

We know that these testimonies were delivered by Nahua elders and sages to some Franciscan missionaries who were deeply interested in the Indian culture. It is true that in some instances the friars elicited the testimonies following previously prepared questionnaires. Quite possibly, in eliciting statements from the Indians and in transcribing them, alien ideas may well have been interpolated. But it is equally so that, proceeding with a critical eye – comparing, for instance, testimonies obtained from different sources and consulting the few extant pre-Columbian codices or books of paintings and glyphs – one can identify the authentic essence of a given text.

This has been the procedure I have adopted. The testimonies I shall present here were obtained by the well-known Franciscan friar Bernardino de Sahagún around 1560 – 70 in Central Mexico. In carrying out his research he was closely assisted by several Nahuas who had been his students. Accompanied by them, he transcribed a rich corpus of testimonies on most aspects of the ancient culture: religious beliefs, sacred hymns, feasts, the calendar, the words of ancient wisdom, the world of nature, animals, plants and minerals, as well as a dramatic narrative about the Spanish conquest provided by elders who were alive at the time.

Among these texts are stories dealing with the exalted hero of their culture, Quetzalcoatl, ruler and pontiff in the metropolis of Tula. It was to his wisdom that the great creations of the Toltecs were attributed. The same is stated in paintings and glyphs in a pre-Columbian Mixtec codex, influenced by Toltec culture. On pages 48-9 of the *Codex Vindobonensis* (preserved in Vienna) one sees Quetzalcoatl descending from the heavens with his various adornments, pronouncing beautiful words, writing in black and red ink, receiving the messages of the elders, and holding the governor's rod, symbol of nobility and rank.[4]

Different sources can be identified in several *huehuehtlahtolli*, or speeches of the elders, transcribed in Nahuatl by friar Andrés de Olmos around 1534, and by Sahagún in 1547. The figure of Quetzalcoatl appears in these texts as founder of the Toltec lineages and the divine hero par excellence. The following texts are taken from these sources. In them one can identify an indigenous concept referring to the class of objects that we now term pre-Columbian art.

THE ORIGIN OF THE TOLTEC CREATIONS

It was during the Golden Age of the Toltecs – chronologically situated around the 10th and 11th centuries AD – that the *Toltecayotl*, or Toltec creations, the epitome of goodness, wisdom and beauty, developed. According to one Nahua testimony:

> *The Toltecs were very highly skilled.*
> *Indeed the* Toltecayotl,
> *the featherwork,*
> *proceeded from Quetzalcoatl.*[5]

To the Nahua of later times the word *Toltec*, so closely linked to the memory of Quetzalcoatl, meant not only an 'inhabitant of Tollan', but also a creator of magnificent things. The Nahua had actually coined compounds such as *ten-toltecatl*. 'Toltec of the lip', meaning 'master of the word'; *ma-toltecatl*, 'master of the hand' that is, painter or sculptor and so on. In the following text we have a description of the ideal figure of the Toltec:

> *The Toltecs were a skilful people,*
> *all of their works were good, all were precise,*
> *all well-made and admirable.*
>
> *Painters, sculptors, carvers of precious stones,*
> *featherworkers, potters, spinners, weavers,*
> *skilful in all they made, they discovered*
> *the precious green stones, the turquoise,*
> *they knew the turquoise and its mines, they found*
> *its mines and they found the mountains hiding*
> *silver and gold, copper and tin*
> *and the metal of the moon.*

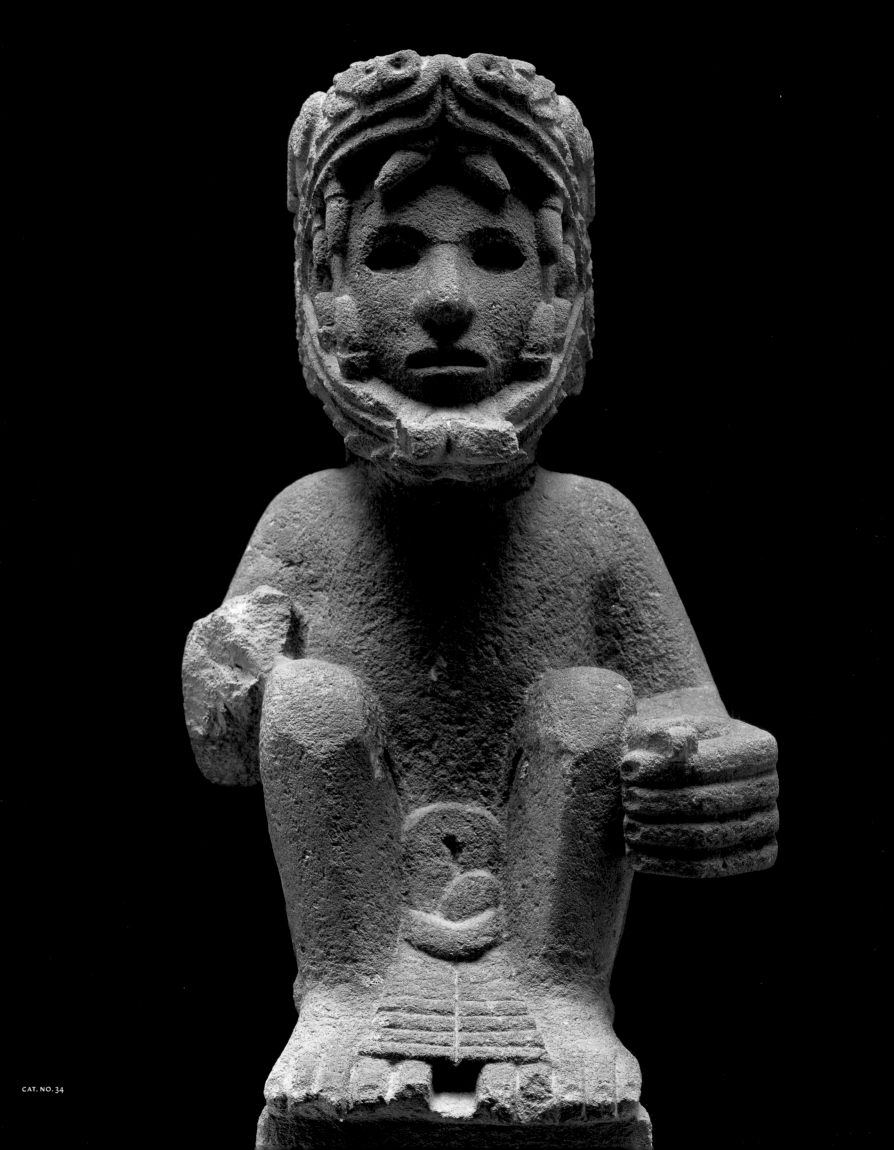

The Toltecs were truly wise,
they conversed with their own hearts…
They played their drums and rattles.
they were singers, they composed songs
and sang them among the people,
they guarded the songs in their memories,
they deified them in their hearts.[6]

These words show how highly the Nahua regarded their Toltec ancestors. They held that all their creations originated in the Toltec period, as well as their highest religious, ethical and philosophical concepts. In describing the characteristic features of singers, painters, sculptors, potters, and so on, it is always stated that they were 'Toltecs', that they worked like Toltecs, that their creations were the fruit of *Toltecayotl*.

The Toltec: disciple, abundant, multiple, energetic.
The true Toltec: capable, practising, skilful;
maintains dialogue with his heart,
meets things with his mind.

The true Toltec: draws out all from his heart,
works with delight,
makes things with calm, with sagacity,
works like a true Toltec, composes his objects.
works dexterously, invents;
arranges materials, adorns them, makes them adjust.

The carrion Toltec: works at random,
sneers at the people,
makes things opaque, brushes
across the surface of the face of things,
works without care,
defrauds people, is a thief.[7]

DESTINY OF THE ONE IN DIALOGUE WITH HIS HEART

The Nahua believed that those in dialogue with their hearts were born and not made. It was essential to be predestined in order to become like the Toltecs. Such predestination was revealed in two ways. It was necessary on the one hand to possess a series of qualities: first and foremost, one had to have a face and a heart – that is, a well-defined personality. In addition, it was expedient to have been born on one of the few days that, according to those who knew the astrological calendar, were propitious to that individual and to the production of their works. But it was also

necessary to keep personal destiny in mind, to be worthy of it and to learn to commune with one's own heart. Otherwise people would destroy their own happiness, lose their place and turn into foolish and dissolute frauds:

He who was born on those dates
Ce Xochitl: [the day named One Flower],
whether a noble or not,
became a lover of songs,
an entertainer, an actor, a Toltec.
He bore this in mind, he deserved his wellbeing,
he lived joyfully, he was contented
as long as he bore his destiny in mind,
as long as he guided himself
and made himself worthy of it.
But he who did not heed this,
if he considered it of no account,
if he scorned his destiny,
even though he was a singer, a craftsman,
he thereby ruined his happiness,
he lost it [he did not deserve it].
He held himself above others,
he squandered all of his destiny,
which means he grew conceited and insolent.
He looked down on others, he became a fool,
dissolute in appearance, in his heart,
in his songs and thoughts:
he became a composer of foolish and dissolute songs.[8]

Another testimony supports this view and explains what might be called the moral ground of the Toltec: it indicates the rewards that awaited him if he worked wisely and observed the religious traditions of his people. It shows also the solemnity with which the calendar day 'Seven Flower' was celebrated:

And the day Seven Flower
was said to be both good and bad.
When good, they celebrated it
with great devotion,
the painters honoured it,
they painted its image,
they made offerings to it.
The embroiderers were also joyful
under this day.

First they fasted in its honour,
some for eighty days, or forty,
or they fasted for twenty days.

And this is why they made these supplications
and performed these rites:
to be able to work well,
to be skilful,
to be like the Toltecs,
to order their works well,
whether embroidery or painting.

And if this day became ominous,
when an embroiderer broke her fast,
they said that she deserved
to become a woman of the streets,
this was her reputation and her way of life,
to work as a prostitute.

But for the one whose actions were good,
who worked well, who guided herself,
all was good: she was esteemed,
she made herself worthy of esteem
wherever she might be.
It was also said
that whoever was born on that day
would thereby be greatly skilled
in the several kinds of Toltec creations.
He would work like a Toltec,
he would bring things to life,
he would be wise of heart,
all this, if he guided himself well.[9]

THE VARIOUS CLASSES OF 'TOLTECS'

In the *Cantares Mexicanos*, preserved in the National Library of Mexico, there are several compositions describing meetings of poets, singers and dancers.[10] In his *Historia Chichimeca*, the Tezcocan Fernando de Alva Ixtlilxóchitl also speaks of something similar to what we might today call academies of music and of literature.[11] Several ancient chroniclers and historians also affirm that there were many classes of creators in the pre-Hispanic Nahuatl world. An entire section of the Sahagún documents is devoted to the categories of living 'Toltecs': the featherworker, the painter, the potter, the goldsmith, the silversmith.

One text describes the *amantecatl*, the featherworker, who devised the magnificent headdresses, fans, robes and draperies used by the nobles. He was expected to possess a well-defined personality, 'a face and heart', and the ability to 'humanize the will of the people.'

Amantecatl: the featherworker.
He is whole: he has a face and a heart

The good featherworker is skilful,
master of himself: it is his duty
to humanize the desires of the people.
He works with feathers,
chooses them and arranges them,
paints them with different colours,
joins them together.

The bad featherworker is careless,
he ignores the look of things,
he is greedy, he scorns other people.
He is like a turkey with a shrouded heart,
sluggish, coarse, weak.
The things that he makes are not good.
He ruins everything that he touches.[12]

The *tlahcuilo*, or painter, was of utmost importance in Nahuatl culture, for it was he who painted the codices. He knew the different kinds of Nahuatl writing as well as all the symbols of his religion and tradition. He was a master of the red and black ink. Before he began to paint, it was necessary for him to have learned how to converse with his heart. He had to become a *yolteotl*, one with a 'heart-rooted-in-his-own-god'. He should be a person filled with the creative force of the Nahua religious beliefs. With the divine inspiration in his heart, he would then become a *tlayoltehuiani*, one who communicates the divine symbolism to his paintings, codices and murals. And to be successful in this, he had to know the colours of all the flowers better than anyone else, as if he were a Toltec.

The good painter is a Toltec,
he creates with red and black ink,
with black water.
The good painter is wise,
God is in his heart.
He deifies things,
he converses with his own heart.

He knows the colours, he applies them and shades them,
he draws feet and faces,
he puts in the shadows, he achieves perfection.
He paints the colours of all the flowers,
as if he were a Toltec.[13]

The descriptions of the featherworker and the painter show us several of the traits of those who were in communion with their hearts. The *zuquichiuhqui*, or potter, is 'he who gives shape to clay,' 'he who teaches it to dissemble,' so that it will learn to take countless shapes. The clay model is not a puppy although it looks like one; it is not a squash but it seems to be one. The potter also converses with his heart. His skill gives life to things that seem dead. 'He teaches the clay to lie, or dissimilate,' until all kinds of figures take shape and live in it.

He who gives life to clay:
his eye is keen, he moulds
and kneads the clay.

The good potter:
he takes great pains with his work,
he teaches the clay to dissemble,
he converses with his heart,
he makes things live, he creates them,
he knows all, as if he were a Toltec,
he trains his hands to be skilful.

The bad potter:
careless and weak,
crippled in his art.[14]

Just as the Greeks believed that Prometheus had bestowed upon them the gift of living fire from which they could learn the many arts, so the Nahua attributed the origin of the *Toltecayotlthe* – the Toltec creations – to the figure of Quetzalcoatl. To them *Toltecayotl* was thus a sacred gift. But to profit from it, the 'new Toltecs' had to take into account their own destinies. This implied behaving with calmness and consideration, in constant dialogue with their own hearts. Only in this manner could they communicate divine inspiration to inanimate objects such as paper, stone, metal, clay or feathers, and transform them into authentic Toltec creations.

Having reached this point, I make so bold as to present a conclusion. If we examine carefully the testimonies that I have quoted and discussed, perhaps we shall be able to identify what lay at the core of a Nahuatl concept of creativity, which in some respects is comparable to a 21st-century European notion of art.

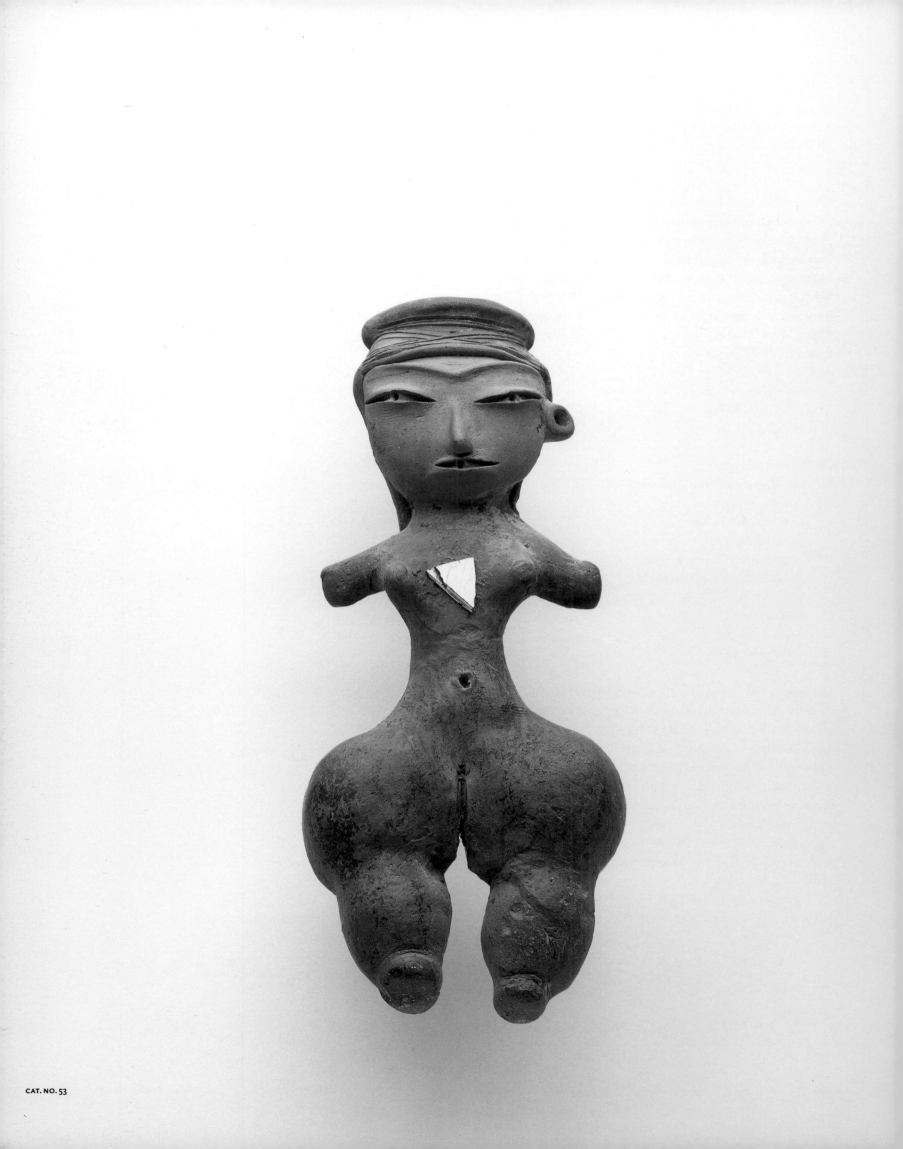

BEATRIZ DE LA FUENTE

MANY-FACETTED
HUMANIST ART

What defines a human being? What is the role of people in the universe and how do they fulfil it? How do people express themselves and what means do they use to do so? What prompts people to make certain objects and what do they wish to achieve? These are just some of the questions that arise when we consider objects of art. The answers, depending on one's perspective, are legion, and particularly if your background is couched in aesthetics and art history. By pursuing such thoughts, we gain particular insights which offer us new perspectives for addressing fundamental questions concerned with existence, the essence of life and the continuation of life across the boundaries of time.

Art as the expression of the creative ability within human beings distinguishing us from other creatures belongs to every age and every place. It is the means by which the ultimate goal of human activity can be attained: to give shape to humankind and lead people to transcendental and metaphysical perfection.

This explains why the human figure occupies such an important place in art history. From the ancient Venus shapes of the Palaeolithic Age to the most hyper-modern avant-garde movements, irrespective of whether the work is realistically true to the tiniest detail or attains the highest degree of abstraction, the human being has always been the subject of artistic representation. People mirror themselves, change shape, transform themselves and find themselves, thanks to plastic expression. For 'plastic' is connected with shaping and modelling by means of art.

The indigenous inhabitants of Mesoamerica listened to the compelling inner voice during thousands of years of cultural and artistic development. Evidence of this can be found in the many works of art that have survived from pre-Columbian times, before the conquest of the New World. The formal language that was used in this connection was both powerful and expressive.

Some while back I spent considerable time analysing a number of Mesoamerican works in which the human figure was central. I was looking for the characteristic traits that the artists in question made use of in the creative process. I demonstrated that in the pre-Spanish world during certain periods and in certain places, the human figure is a decisive motif in the art forms. There are countless examples of this, each offering clues in our attempt to unravel the profundities of the human being in bygone times, both as individual and as active participator in his social world. Leading out of this I would like to discuss a number of objects that, in differing ways, give clear evidence of their anthropocentric nature, objects that can be classified as 'humanist' in the full sense of the word.

So how did pre-Spanish people see themselves? In what shapes, in what guises, and how can we deduce our answers from their language of art?

THE PRIESTLY LORDS OF STONE

One of the first important artistic developments can be assigned to the Olmecs. In their colossal sculptures, dating to between 1200 and 600 BC, humankind is the main theme. Hundreds of works have survived, testifying to the potent self-awareness of this remarkable group of people. Of these, we can distinguish two stylistic classes.

One of these classes is unique in art history and is formed by the so-called Colossal Heads (*cabezas colosales*) of the Olmecs. In these, a part of the human being is shown (that is, the head) within the limitations of an imperfect spherical shape, resembling something confined by the space surrounding it. The sculptures have been hewn with precise strokes, creating powerful and striking features in the lump of stone. These are representations of specific individuals which I see as stone portraits. Portraits of wise leaders who led their people both in religion and in daily affairs, dictating the norms of conduct and determining political policy.

It is known that all seventeen surviving Olmec heads have elements that make them unique – things such as facial expression or headdress. However, although they are basically figurative, they provide a tangible reflection of the quest for timelessness: their formal language of shape expresses a desire to contact the sacred, and to give physical expression to this. At the same time, the strongly individual nature of these heads would suggest that they are indeed portraits of specific individuals. The heads from San Lorenzo betray quite different emotional states. Number 3, for example, is charmingly youthful, while number 4 is dignified and majestic, and number 5 emanates tremendous power. And in each face we recognize a deep self-absorbed concentration.

These colossal hewn heads were probably placed outside facing the four points of the compass and were linked with major buildings. They were set there so that the community could see them as examples of the might and majesty of the humans on whom they were modelled, to stand as timeless objects defying the demarcation between sacred and profane. Possibly they portray specific ideas held by the Mesoamericans: the head as the seat of the sacred powers, giving meaning to life; and the ruler as embodiment or deputy of the gods and leader of the people. However, as they are portraits we may also speak of a certain resemblance to their models which implies the importance of

conveying the essence of an individual within the culture. The Olmec dignitaries knew that they formed an essential link in the maintenance of the status quo, of the cosmic order as they understood it.

The other group of sculptures are complete human bodies. They are statues representing people, but lacking individual traits or particular expressions. They show introverted people in positions denoting total concentration. Probably this represents the effort to attain, by means of inner understanding, the highest state of human consciousness and union with the divine. This large group of statues contains one outstanding example, known as the Prince of Cruz del Milagro, demonstrating an exceptional quality and perfect harmony of composition.

This statue shows the human body in its entirety, with an inner, concentrated power. It is as if this seated, concentrated form permits the outside space to enter into him in an attempt to free him from the stone in which he is encased. And although this person does not attempt to break free of his stone straitjacket he speaks to us of other distresses that occupy him: he stares into the distance and stretches his arms towards the ground trying to touch it, as if attempting to maintain contact with reality. Nevertheless, it appears that he is driven on towards sacred spheres. Firmly rooted as he sits there, he emanates the majestic command of one who experiences fellowship with the gods and knows himself to be favoured by them, while at the same time being respected and honoured by people. Undeniably, the Prince of Cruz del Milagro, quite apart from his arresting appearance, contains certain metaphysical elements.

The many other examples of the Olmec representation of the human figure, using a wide variety of materials, amply illustrate how great was their interest in this form. There was no room for trivialities: in spite of the existing portraits, the representation of authority or power was always more important than that of an individual. It was a question of representing an order that would ensure social cohesion by means of clearly delineated shapes. A narrative aspect was also attempted; the tales of anecdotal happenings would serve to deflect attention from the heart of the matter. The goal of the Olmecs was to transcend earthly reality. In Olmec sculpture we find portraits of people, but the emphasis is primarily on the symbols of authority. It is an art focused on portraying human power, received from the hands of the gods.

In brief, the sculptures of people made by the Olmecs, like the art of other times and other places, speak of the values of a deeply-felt humanism: the dimension of people in relation to themselves and what they considered holy.

THE WOMANLY AND THE SACRED

In contrast to the expressive works of the Olmecs, other objects from the same period made by the peoples of the Central Highlands take the female body as a central form. This is not to say that there is no trace of the male body in their work, but it is less frequently found and appears to be limited to what are probably warriors or ballgame players. I propose, by studying the *Mujeres Bonitas* (known as Pretty Ladies), to examine one aspect of the image that the inhabitants of the Mexican Highlands held of themselves.

You could say that these small sculptures, with their schematic shapes and strict reflection of a certain pattern, form the complete opposite to the work of the Olmecs. Though the shapes vary somewhat, there is no suggestion of individuality – they look almost as if they were mass-produced. These figurines are produced with such admirable efficiency and precision, rendering in concrete shape an abstract notion, that today we can scarcely comprehend the significance and meaning of these *Mujeres Bonitas*. It is frequently suggested that they represent the fertile strength of women, bearers of a new generation, and that the large numbers of these figurines that have been found reflects the strength experienced by an agrarian people.

On the other hand, they are frequently found in tombs which would suggest that they are connected with the Underworld. Possibly they are a type of ex-voto used at funerals, prayers or litanies, encased in baked clay, the purpose of which is to ease communication between the dead and the gods. Naturally, this does not in any way dismiss the above-suggested hypothesis, but rather presupposes that each individual made their own version of a canonical form, rooted in the creative fertile force of women. This would explain the predominance of figurines with strongly emphasized hips and thighs, with extremely bland faces, simple arms and legs, and a huge variety of headdresses, jewellery, hairstyles and body painting.

Within this group are figurines with two heads or with two or more faces; these represent other religious ideas, which, according to various experts, refer to a religious system based on the concept of duality.

These small sculptures speak a totally orthodox language that requires no additions or variations (although these are in fact found). It is only by repeating the shapes that the optimal result can be obtained, that is, the liberation of the creative energy of the Cosmos.

GODS AND ANCESTORS

As early as the sixth century BC the inhabitants of the central valleys of Oaxaca (in particular in Monte Albán) were making statues with a striking resemblance to natural forms. They represent captives, their gods and in all probability, the ancestors whom they worshipped. This can be seen both in the 'Dancers' from the Pre Classic (600 to 400 BC) as on the funerary urns and paintings from the Classic (third to ninth century AD).

The first-mentioned images, according to some experts, represent captives who have been sacrificed. Here, individual characteristics and identification are unimportant; where necessary such features are referred to using the secret language of the hieroglyphics. Indeed, it was precisely by removing any individual characteristics from these figurines that the historic and ritualistic facets of their captivity and death could be emphasized. These images thus unite two aspects: on the one hand the captives are exhibited for the greater glory of the gods, and on the other hand they underline the earthly power of the conquerors. Thus the ancient inhabitants of Monte Albán present us with a picture of people who submit to both earthly and divine purposes: it is their triumph on earth.

In contrast, the funerary urns and murals from the Classic period offer us a world bursting with symbolism where people grow estranged from reality. We may thus speak of a shift in focus whereby the gods and ancestors receive greater attention. The closed shape of the urns creates a highly distinctive play of light and surface which makes possible the expression of new ways of thinking. People are now stripped of their individuality more emphatically than ever before; they become stereotypes, schematic shapes repeated time after time, static figures that are nevertheless accompanied by excessive sacred paraphernalia.

The transition from Dancers to urns had repercussions on the Zapotec vision of humankind. The urns that represent gods have 'body shapes' in a strict and conventional sense but their facial expressions betray a certain sensuality. These images bear witness to a fundamental love of life and a deep understanding of the human form without the need to represent it realistically. Finally, as ultimate step, the transition takes place to the magnificent funerary urns of which one representing the rain god *Cocijo* (CAT. NO. 139) is a classic example, showing the definitive victory of the repression of individuality.

The same thing may be observed in connection with funerary paintings, with slight differences resulting from the fact that this work is two-dimensional. Once again people are shown saturated with holy virtues in the belief that they are significant, representing the figures of ancestors who are worshipped as the roots and branches of the Zapotecs.

The magnificent processions which are painted in strict order on the walls of the tombs project the picture of the Zapotecs who know themselves to be among the gods, with the transitory world of people left far behind.

Thus the people of Oaxaca present us with a type of anthropomorphism whereby individuality and personality are scarcely any longer significant. As for the Zapotecs, they balanced, with an ancient elegance and sobriety, between the loss of the human and the gain of the godly: they were both godly and human.

Probably the generic tendency was the starting point for the way in which people were portrayed in the Post-Classic Mixteca-Puebla style (eleventh to sixteenth century AD). In this style, which is characterized by schematization and diminution of the human figure on the basis of certain conventions, the only remnant of personal identification lies in the hieroglyphics, such as can be read in the Mixtec codices. It is not irrelevant that we know detailed stories about the dynasties of Tilantongo, Tututepec and Coixtlahuaca, told by the major figures of the lord Eight Stag Jaguar (or Ocelot) Claw and his sister Nine Monkey.

SONGS OF LIFE

In the west of Mexico there was a broad range of regional styles in pre-Spanish times and we can distinguish various streams within them, according to whether the West Mexicans portrayed themselves wholly or in part. I refer here to the *Mezcala* style and funerary pottery.

In Mezcala style the chief subject for representation is faces, which are portrayed in a manner that for Mesoamerican art is highly abstract. This is achieved by constructing a geometric base whereby the features are suggested by four lines, portraying eyes, nose and mouth. By combining straight and curving lines in various ways, marked differences are created – no two faces are alike. Some faces appear portrayed in an exaggerated manner, others are bland or serene, while others are so abstract they can hardly be described as faces at all. But each one of them produces a spanning of shape and space in their own original way.

In their turn, the ceramic tomb offerings are unique in Mesoamerica for their unmistakeable spontaneity and purity. These works, remarkable for their large quantities and the astonishing true-to-life quality of the clay figurines, present us not only with a number of ritual ceremonies but also with a glimpse into everyday life. We see men, women and children

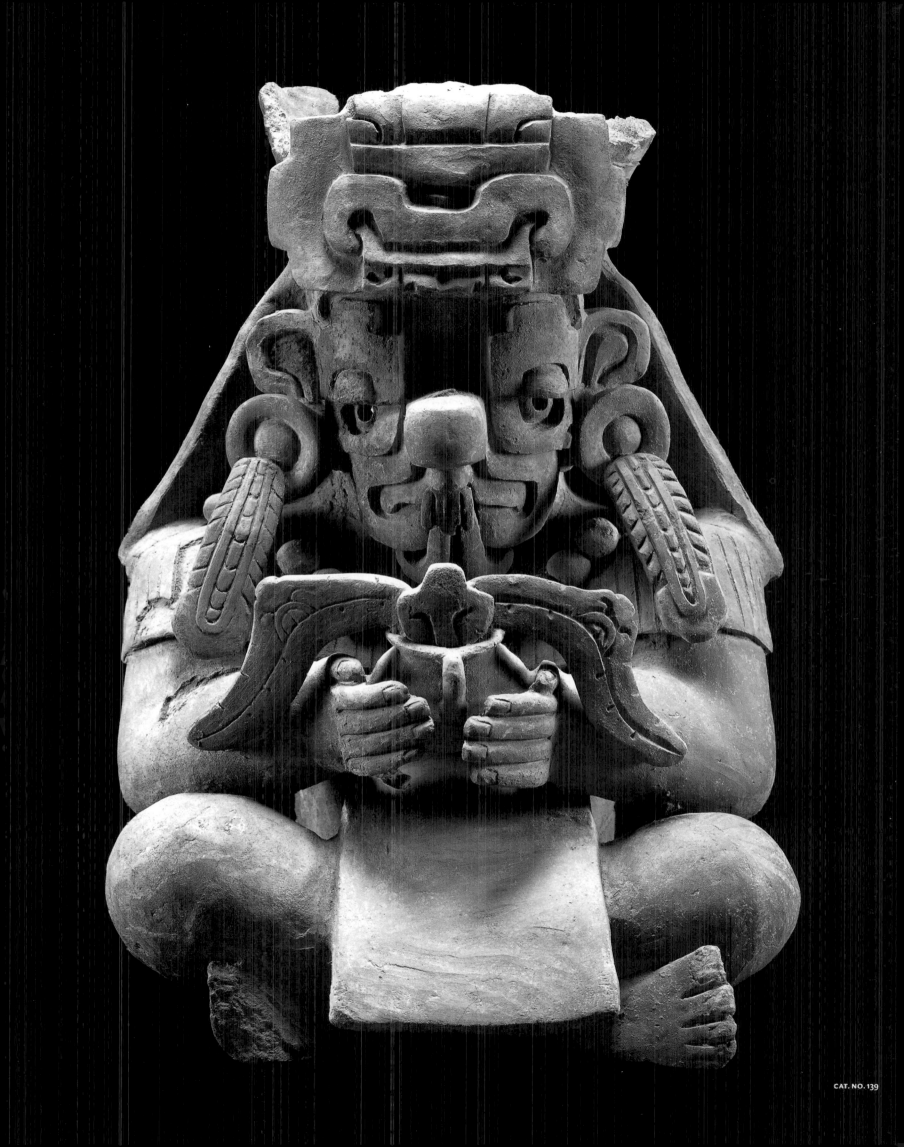

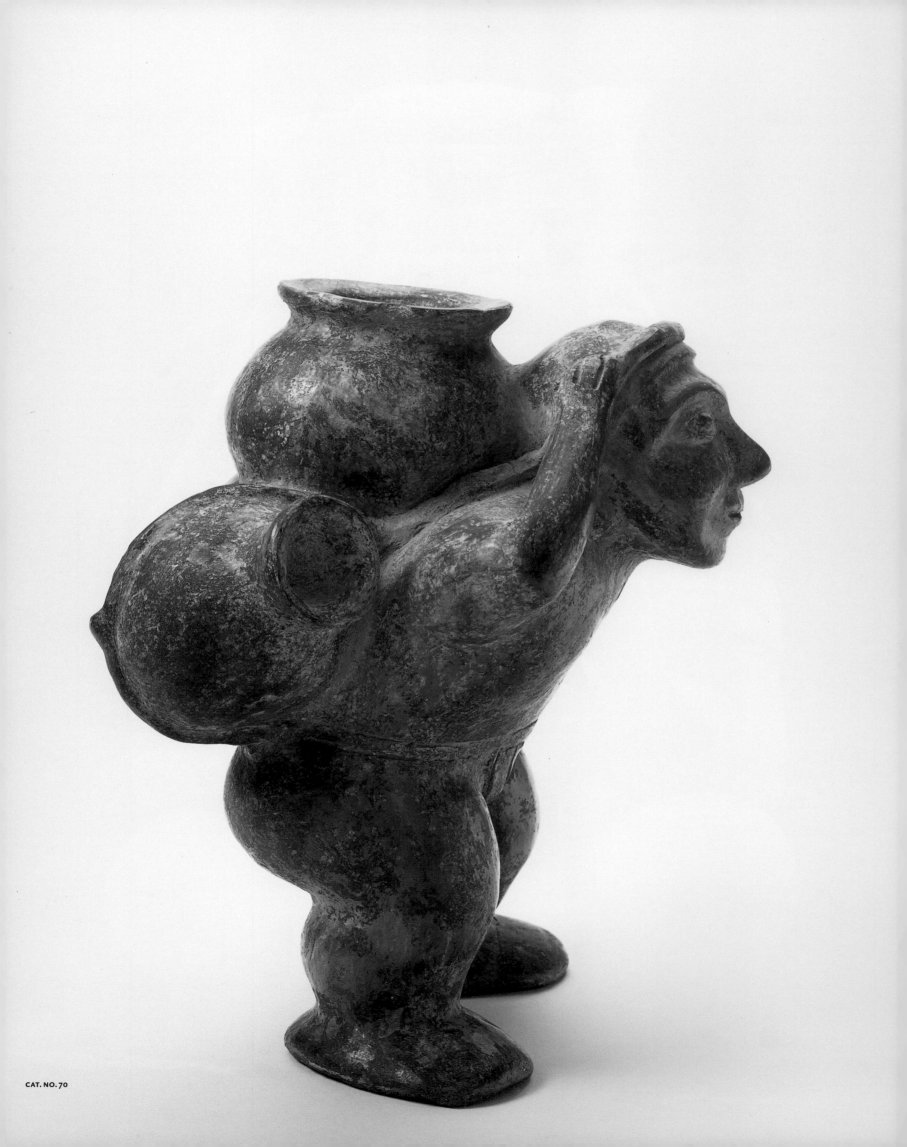

occupied with their daily affairs; the men carrying loads (on their backs) by means of a wide band round the head, or drinking from a small bowl, sitting around, talking together; the women are seen suckling their babies, carrying their children, or grinding corn; they stand around, things astonish them. And they astonish us. They are lifelike images that with their simplicity and eloquence deeply impress the viewer.

With remarkable versatility the people of West Mexico leap from the portrait of an individual to a member of a community, irrelevant in its personal features. Many of the clay figurines show a portrait of a man or woman but this does not mean that they are shown with their individual physical characteristics. They represent water-carriers, drinkers, warriors, mothers, women grinding meal, as well as groups bringing ritual offerings, people at play or sharing in communal activities.

Besides the individual figurines there are also models that offer an even more vivid picture of the communal life in a family or village. Men and women of varying ages are seen going about their business with unequalled spontaneity, their movement both natural and dynamic. They are shown in their homes, at ballgame courts, or in the village squares. They play, they talk together, they relax, they sleep, they walk, they carry loads from one place to another, they climb stairs, they live – together with their small dogs and other mascots. In other words, they perform all the countless activities that go to make up daily life within an agricultural community. They show us, true-to-life, their everyday dealings and duties while also giving a picture of the setting in which they lived and worked.

Thus it would be fair to say that the people of the West Mexican coast are presented to us in all their rich variety: fundamental, complete, vital, many-facetted, transitory. Far removed from ritual performances and the protocols of courtly behaviour, these men and women carry on a direct dialogue with the past and the present. They are the people of yesterday, today, tomorrow and forever; they have the tiny everyday details that make life into something infinitely precious. They proclaim life, sublimated and immortalized in clay.

MOSAIC FROM VERACRUZ

During the Classic period (AD 300 to 1000) there were large numbers of people living on the coast of the Gulf of Mexico who made pictures varying greatly in style, to represent people. Dangerous as it is to generalise, it may be stated that in these works a fundamental theme was the representation of the intimate bond between humans and gods. People existed only by grace of

the deities. In clay and stone the Totonacs embodied these existential desires with exceptional terseness. The same applies to the Huaxtecs and cultures such as those of the Remojadas, Xochipala, Nopiloa, El Zapotal and Cerro de las Mesas, to mention only a few.

Outstanding in all these works is the group of large poly-chrome female figures made from fired clay. With their soft but at the same time strong forms betraying a thorough knowledge of human anatomy, these figures project a powerful suggestion of a living person. They move in a space between tenderness and toughness, between youth and maturity. There is something queenly about their bearing which is underscored by the elaborate detail of their headdresses and the objects they are carrying.

We come across these women with divine qualities – or goddesses with human elements – both in Remojadas and Nopiloa as well as in Xochipala and El Zapotal. These seated images spread their arms open or bring them close to their bodies, signifying that they either welcome or reject frail mortals. Some of them – those with closed arms – are carrying a pouch containing copal or other objects symbolising status. Others, their arms spread wide, break open the space, thereby giving the impression that they are rulers over time and space. They too are confident of their exalted position as is shown in their rich and varied clothing. Some appear calm, some are moved by emotions, others wear masks made from human skin; while yet others – the most impressive of all – are portraits expressing enormous dignity and distinction.

However, these portraits do not always depict specific women despite the diversity of headdress, clothing and attributes. Rather, their significance has a more conventional nature. Depending on their appearance they may represent Mother Earth, (generic) Woman, creator and destroyer, the woman who loves life but also death. There is Tlazotéotl (the goddess who consumes waste and garbage, ed.), or the cihuateteo (women who died in childbed, who are worshipped, ed.).

Another important group of sculptures is inspired by the three accessories of the ballgame which are: yugo (yoke), hacha (axe) and palma (palm-shaped objects). Within this group there is a huge variety, from the most fantastic and excessively elaborate shapes to a restrained purity of line that challenges some works of modern European art. The hard stone is worked with unequalled skill to produce objects of supreme expressiveness with an utterly convincing play of light and shadow, combining solidity of form with an impression of etherealness. Here again we find images of people seen from a distance, divorced from earthly affairs, apparently in search of an enduring and appropriate way to

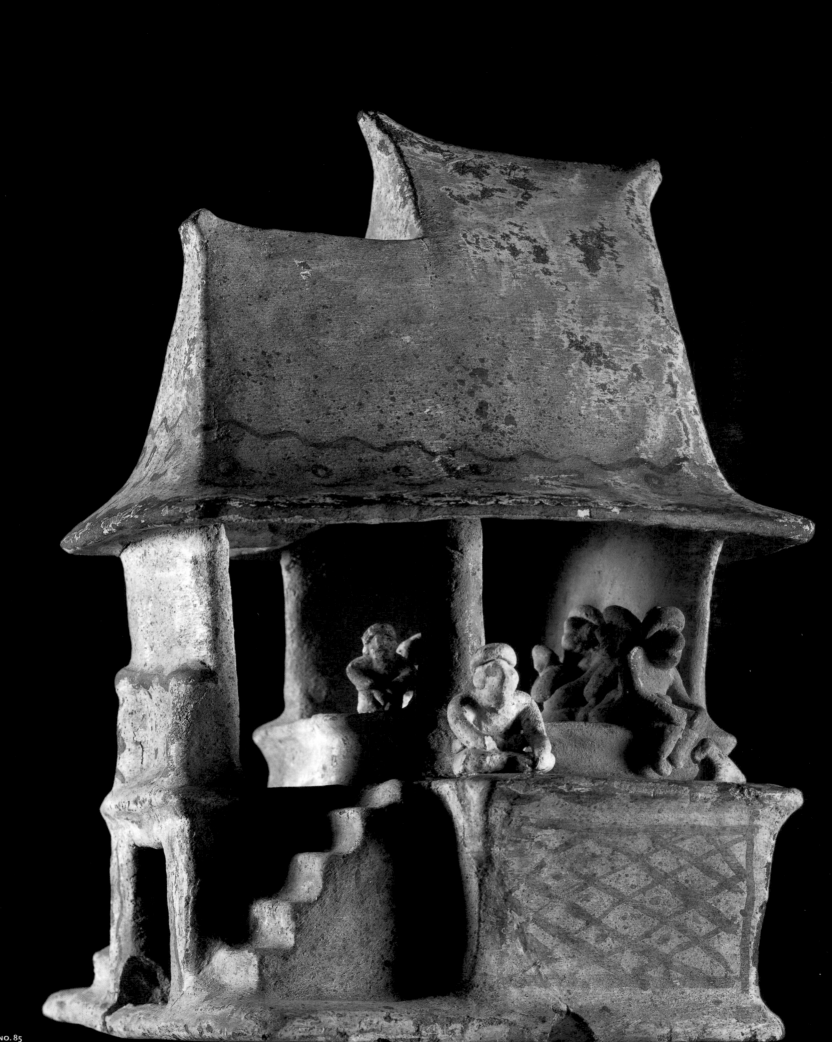

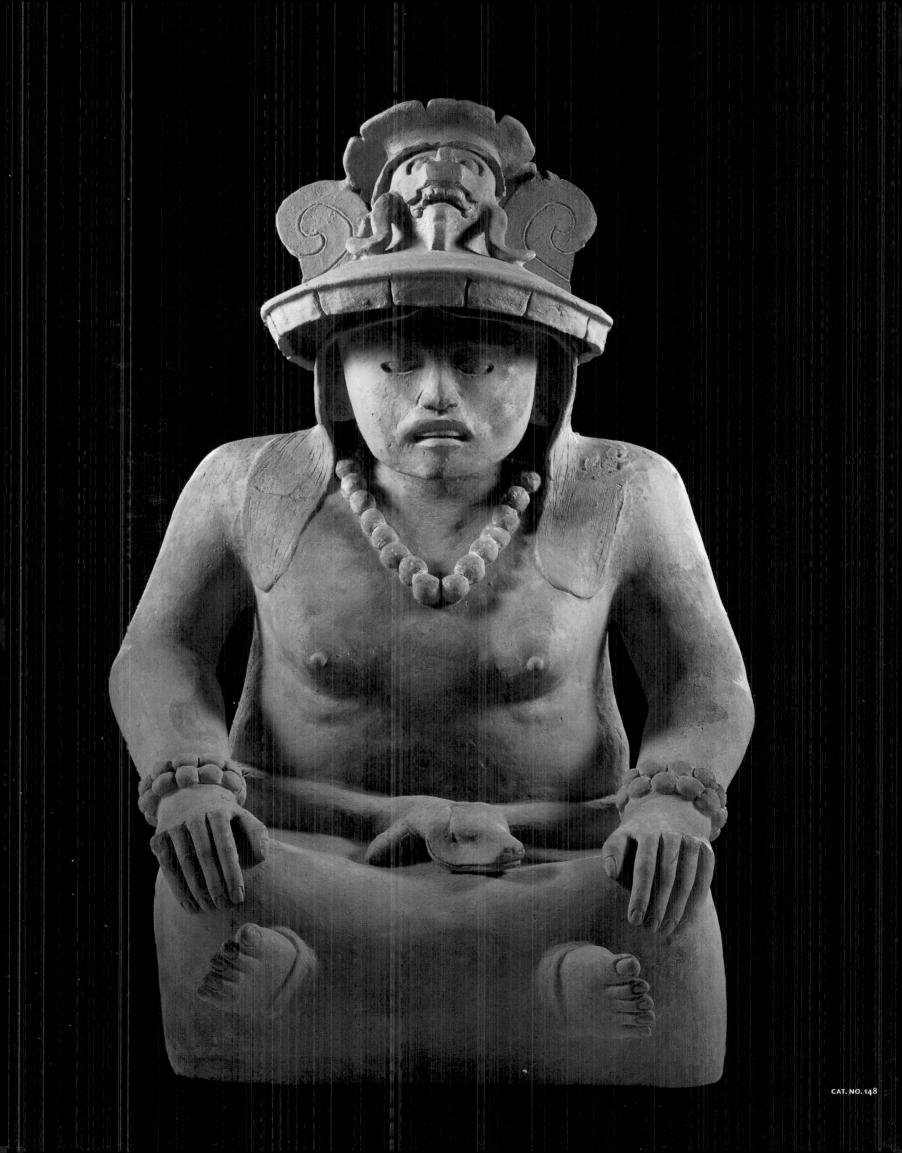

express what is eternal. Movement, if it is apparent, is considered, restrained and heavy with tension. And although the human figure is sharply delineated against the background of curling shapes and volutes, here too there is no suggestion of representing an individual. What is important are the references to social status and ritual symbolism.

Some *hachas* (axes) deserve special mention, being so non-three-dimensional as to create an impression of being a relief that has somehow worked itself free from its background. This holds for the *hacha* in which a human face is shown with a headdress representing a fish jumping upwards; headdress and fish merge into one indivisible whole.

Clearly, we are in the presence of human forms of expression whereby the sacred and profane are in prefect harmony. Women-goddesses and men-gods reveal with an unequalled feel for life how the people of Veracruz united an understanding of human sensuality with divine alienation.

In the Post Classic, that extended to AD 1521, the formal language changed. In the Huaxtec culture the stone statues represent almost exclusively young men or women and only occasionally is the subject an older figure. Countless works tell of this feeling of youthful power although we also come across signs and symbols that lend an abstract and detached quality to the human form.

These figures, fashioned to be viewed frontally, do not give the body mass much space. It is represented in a stylised fashion whereby a stereotypical symmetrical pattern is maintained. The men are shown naked, the woman wearing a flimsy loincloth. The faces are abstract with sketchy features; the half-open, fleshy lips subtly convey a veiled sensuality. It is customary for these figures to have conical shaped headdresses. Humans represented are shown calm and imperturbable, inflexible and unmoved, yet at the same time these figures express dramatic and gracious elegance. A fine example is *Adolescent* from El Consuelo: imperturbable, remote, unreal, like someone immersed in an ecstatic trance.

Thus we see how, like the Classic, so too the Post-Classic people of Veracruz broke through the boundaries of individuality to penetrate into hallowed spheres.

THE METROPOLIS AND ITS INHABITANTS
Throughout the entire Classic period Teotihuacán was the cultural centre which dictated the principles for a strongly geometric and abstract (architectural) construction of form and design. This can be perceived in every expression of a plastic nature, including human depictions. It made no difference whether they were carved from polished stone or modelled from clay, the depictions of people always pay special attention to the face. The tendency to emphasize the horizontal and conventional qualities usually attributed to a human face, which are characteristic of this culture, contribute to the calm and serenity that these figures possess, although it should be said that some of the small clay figurines have a lively and potential dynamism. In these faces we recognize features, but not an individual, for these people are prototypes, ideal humans who do not exist. They reflect a harmonious, flawless and perfect order. These dignified faces are to be found on countless death masks, their soft features forming the shape of an inverted trapezium.

When the entire body is sculpted – standing, seated or moving – there is always a marked simplification and synthesis. Thus we find large works hewn from stone such as *Chalchiuhtlicue* (goddess of running water and fertility, ed.) whose body almost dissolves into the solid architectonic shapes and whose head is adorned with a stunningly magnificent headdress. There are also other smaller figures of jadeite where we notice how schematic and static they appear, despite the fact that there is space between the limbs and the body. And again it is the face that attracts the attention. We see something comparable in the dynamic clay figures that the experts have suggested represent dancers or warriors in combat.

Nor do the human figures in wall paintings escape these conventions. Drawn in miniature with abnormal proportions, the stylization almost escapes our attention, which is distracted by the sumptuous attire. Here again we observe a strict order, as in the 'processions' of priests or people of high rank. There are other examples, such as *Tlalocan* (the paradise of the water/rain god Tlaloc, ed.), where the figures are given greater vitality and dynamic movement while not departing from the aesthetic norms.

As presented in the culture of Teotihuacán, people swing between individual destruction and collective existence; they may be introverted, inflexible, immovable, or a member of a group or collective in which there is no place for personality. They are men and women who exist beyond tangible reality, knowing they are one with the Cosmos. The integrated and harmonious conception of the Universe that we observe in these figures characterizes the period between the third and eighth century AD.

When the influence of Teotihuacán decreased in Meso-america and the city lost its cultural hegemony, new styles sprang up in which people were presented in diverse ways. An exceptionally valuable example of this is Cacaxtla, with its famous murals.

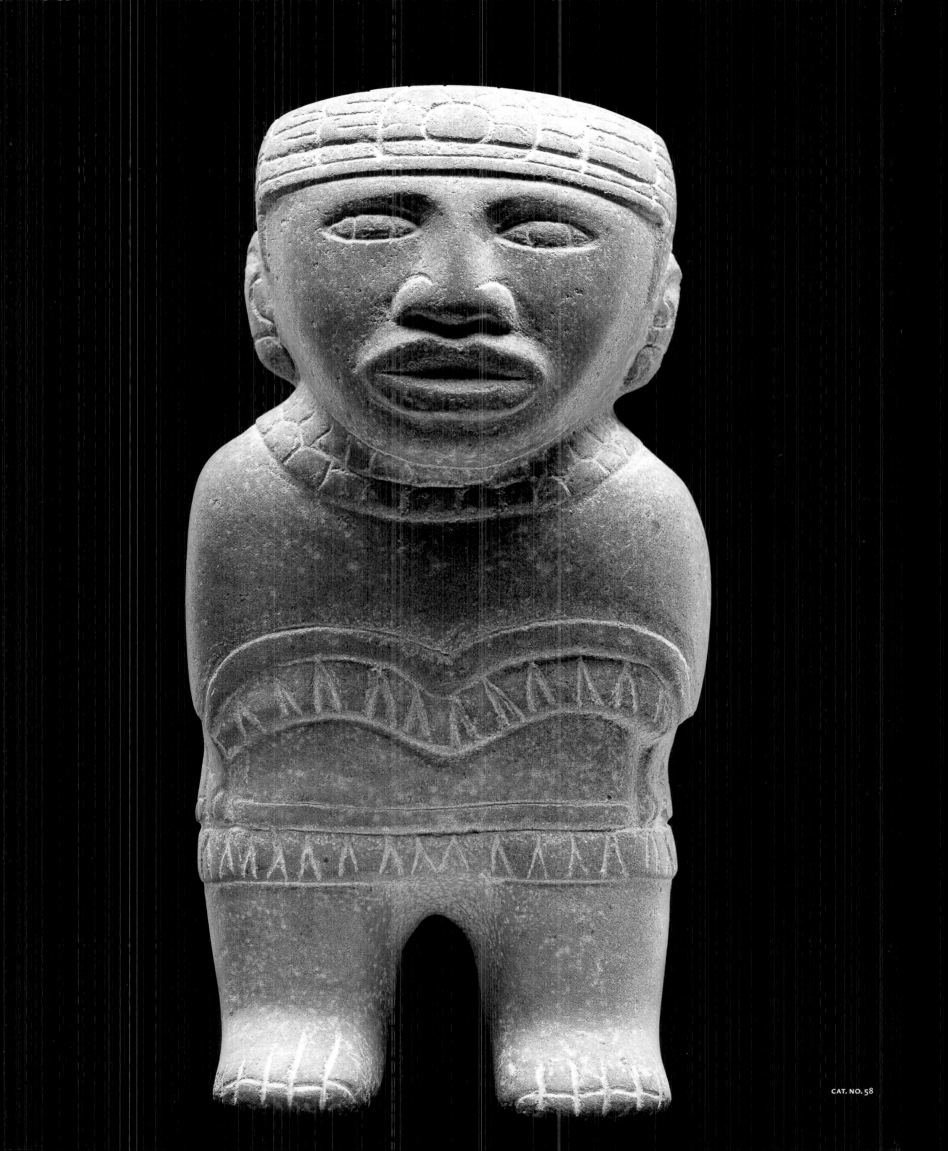

There are several complexes that have paintings of human figures: the temple of Venus, The Red Temple, the base of Portico B and Portico A. Characteristic of these paintings is a remarkable visual refinement, the result of expert and excellently-chosen use of colours. The themes are presented in a largely naturalistic manner, indeed these could be called portraits. They show people, they are representations of humankind in the fullest historical meaning of the word.

One of the wall paintings, called the Mural of the Battle, shows a pitched battle, rendered with raw and realistic detail. The scenes are remarkably expressive. The composition consists of harmoniously-grouped warriors caught in positions of vivid action – they overlap, tread upon each other, engage in hand-to-hand combat. The victors appear clad in luxurious garments while the conquered are generally naked, wearing only headdresses and jewellery. Some have deep wounds from which the blood is gushing or their intestines disgorging; others are already dead, their bodies brutally hacked into pieces. Courage, endurance, aggression, bewilderment, pain, submission and fear: these are some of the feelings aroused by the paintings. With their richly colourful two-dimensional limitations, the images yell out at us.

The images in the Temple of Venus, the Red Temple and Portico A may certainly be described as naturalistic but at the same time they reveal a deeply ritualistic symbolism. The beings who are shown here are placed in an unearthly setting and to judge from their garments they might well be representations of gods. Thus we see that the ruins of Cacaxtla show us unequivocally what people are capable of becoming being: they show people mirrored by the individual.

THE MAYA: THE HUMAN FORM DIVINE

Although the Maya made representations of the human figure at the close of the Pre Classic (about AD 300), what is particularly striking from their work are the reliefs and paintings made in the period between AD 500 and 900. An important feature of these representations is their historical slant: men, women and children of the nobility are pictured, but we also see servants, vassals and prisoners. All the distinct regional styles have this in common – Motagua, Petén, Usumacinta, Puuc, Chenes, Río Bec, Jaina. The Usumacinta district is outstanding, although it is not alone in this respect. In the images, we see people who are proud of their bodies, of their deeds and of their earthly power; people destined to live and to rule in their world. This accounts for the humanist force that is expressed in the paintings and reliefs of the Maya.

The human form is adorned with a number of symbolic attributes, giving it another, supernatural, dimension. At the same time the gods are anthropomorphised, although they always retain their distinguishing attributes. There are many ways – clothing, headdress, jewellery, objects borne in the hands – in which the authority of the pictured figures is demonstrated. We see the shapes of men and women carved into altars, stelae, lintels, tablets, jewellery or modelled in plaster on pillars, friezes and roof ridges. There are also painted representations of people found in many-coloured wall paintings on vases and in the codices. These people are sometimes shown singly, sometimes in groups; they may be standing, seated, talking, dancing, fighting, in submissive positions, playing ballgames, taking part in rituals or witnessing the appearance of a god.

As well as what is expressed through the body language and the use of symbols, the Maya were also masterly portraitists. Their pictures possess an individualization, revealing the personality with great subtlety and introducing us to the feelings experienced by the subject. The following examples deserve attention.

In Palenque there are countless representations hewn from stone or modelled in clay, such as the coronation of *Pacal* II, who reigned from AD 615 to 683. The *Lápida Oval* (oval tablet) from House E of the Palace shows the moment at which his mother, queen Sac K'uk invests him with regal authority by handing him a crown. On the *Tablero del Palacio* (Palace Tablet) we see another ceremony, in which the monarch is shown together with his predecessors: *Kan Hok' Chitam* II, who reigned from 702 to 711, regards his dead father *Pacal* II and stands with his back towards his mother, queen *Ahpo Hel*.

These two examples show how important it was to establish who had held power in the past, when establishing the authority of the present rulers. So we see that the people of Palenque, and the Maya in general, felt the need to ascertain a certain historical tradition and looked for links with the past in order to justify the present. The reliefs from Palenque illuminate in an unparalleled way the historical and humanist dimension of the classic Maya.

There are pictures of people engaged in various activities – they may be walking, talking with others, performing tasks of many different types. The historical dimension is particularly apparent in the depictions showing victories and the submission of prisoners. An incomparably fine example of this is Stelae 11 from Yaxchilan. This shows king *Pacal Bahlum* I, dressed as a deity – which can be deduced from the mask he is wearing – standing triumphantly opposite his prisoners of war. And Lintel 26 shows him together with his wife *Xoc K'abal*, dressed as a warrior, with

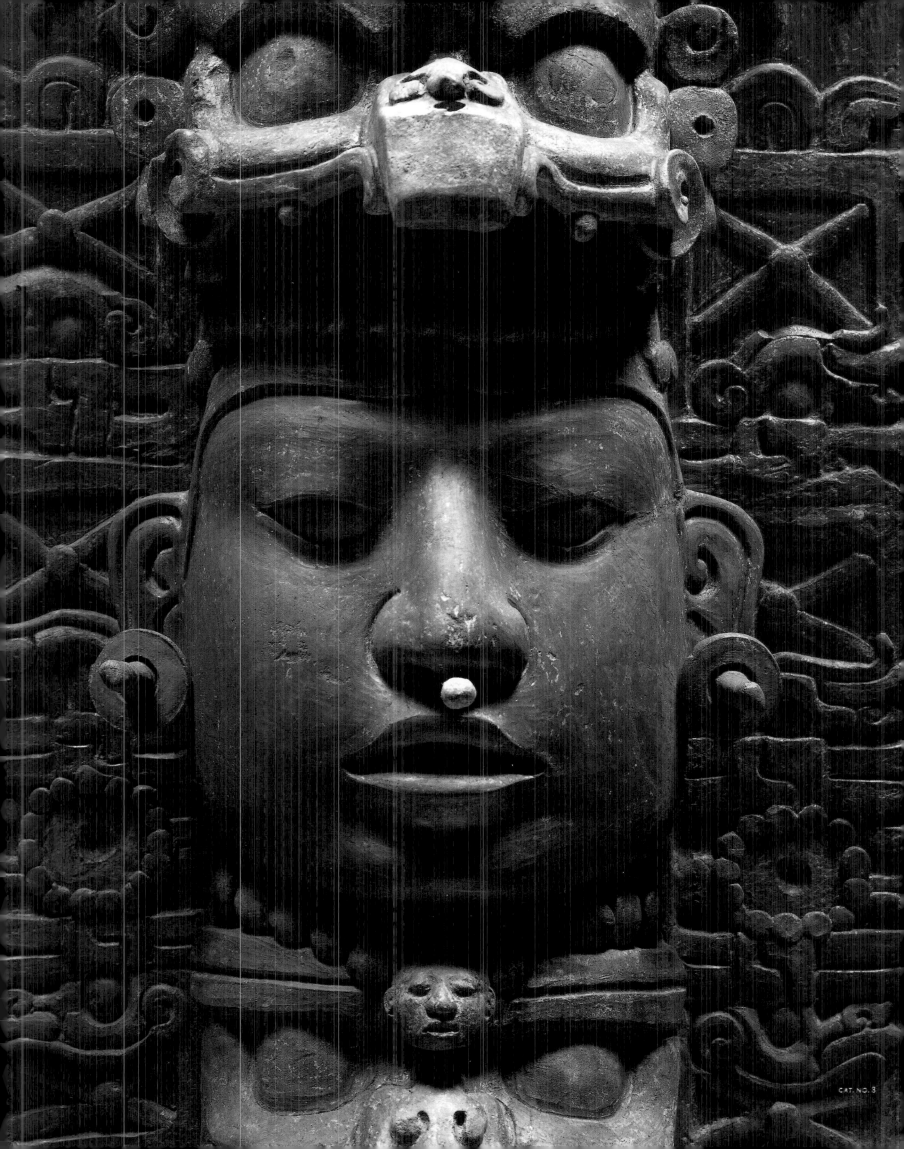

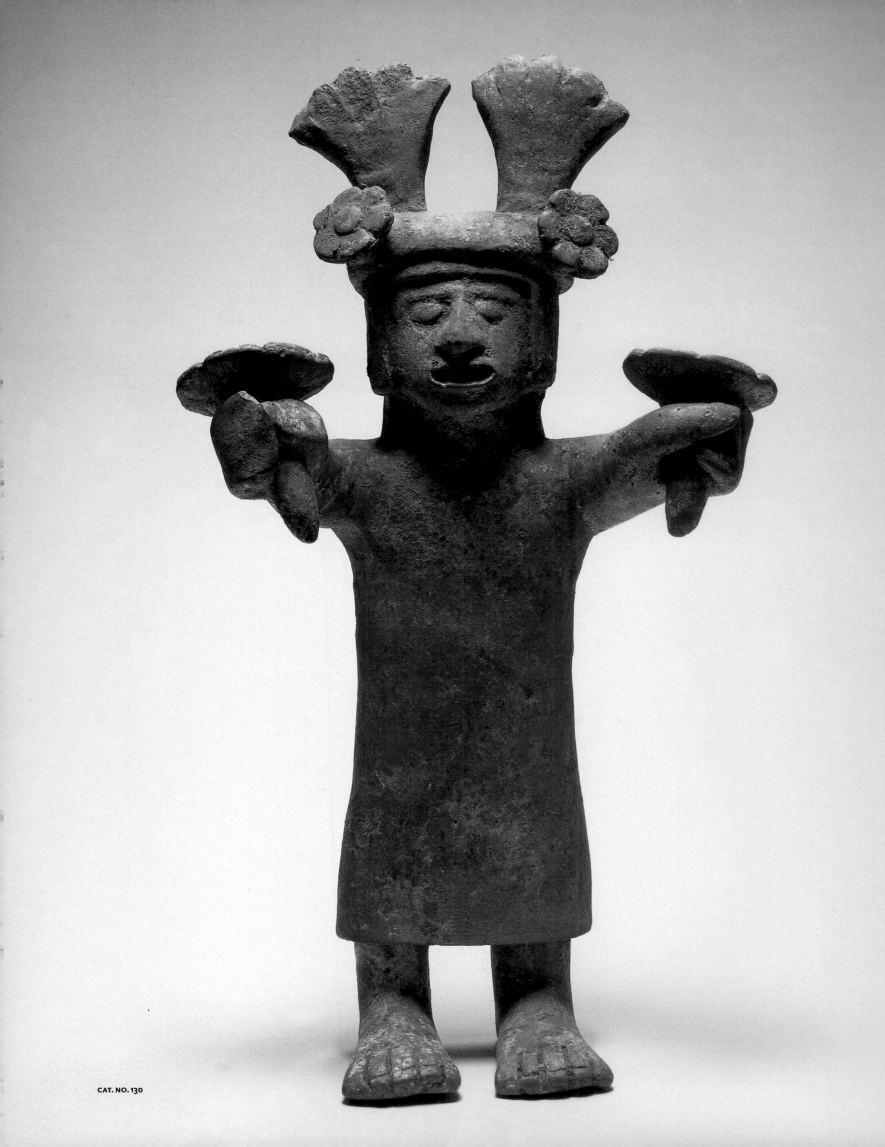

the queen handing him the headdress of a military leader. These scenes, illustrating the power and earthly dominion of a human being, enrich the art of the Maya with unequivocally humanist elements.

An excellent example of this is found in the paintings of Bonampak: here one gains the impression that the representation of people has no boundaries or limitations, both because of the countless different stances and activities portrayed and also because of the variety of meanings that are contained in them. *Chaan Muan* II is the central figure around whom everything revolves. We see him being dressed by a slave before attending a sumptuous celebration. There dignitaries chat together, musicians play their instruments and dancers perform. Warriors encounter each other in fierce combat, and lying among the groaning, heavily wounded captives we detect the crumpled body of a dead man.

Incontrovertibly, this is an exceptional artistic document, presenting every imaginable aspect of human life: there is power, communication, happiness, courage and suffering. We see people dressing themselves up in fine garments and ornaments, people as social beings sharing the enjoyment of a party or the drama of a pitched battle. And by showing all these diverse moments in peoples' lives and presenting historical happenings, the paintings of Bonampak reveal once again the deeply-rooted humanism of this culture.

I could not finish without some discussion of the remarkable clay figurines from Jaina (known as The place of the House in the Water). These small but impressive anthropomorphous sculptures provide, as it were, a catalogue that is both extensive and detailed illustrating the Maya portrayal of humankind. They are unique in that they present an accurate rendering of hierarchical, physical, spiritual and even psychological situations. Although people and the gods are sometimes combined, may indeed be welded together, the human aspect always emerges unambiguously. The Jaina figurines show us an exceptional world, peopled with rulers and noble lords and ladies, with warriors, ballgame players, weavers and scribes. Also present are couples, such as a young goddess joined with an old god in a tender and sensual embrace, individuals arising out of a flower, people accompanied by animals, and sufferers of physical deformity or disease. These small tomb offerings that with their meticulous fabrication and graceful shapes suggest such a variety of human beings are a vibrant monument to the joy of human life.

In brief, the Maya people viewed themselves in their past as objects from which to learn, in their present as major participators in the happenings of everyday, and in the future as the seed for their posterity. The Maya, portrayed through the centuries in countless different ways, occupy an exceptional place within Mesoamerica: they had a deeply felt manner of expressing the energy of life and a sense of eternity, which in turn reveals an equally deeply felt humanism.

THE EXPRESSIVE ANONYMITY OF THE TOLTECS AND MEXICAS

Between AD 1000 and 1100 new plastic shapes were used, giving expression to new accents in the consideration of the universe. The Toltecs added an entirely human concept to the artistic idiom that we see again in the *Atlantes* and *chac mool* figures, and also in the slopes with military processions.

The clothing worn by the huge stone sculptures known as the Atlantes makes it quite clear that they are warriors. Since they are shaped within the constricting cylinder of an architectural pillar, they make a somewhat cramped impression – cool and impersonal. The same thing happens with the *chac mools*: these are human figures that, as it were, turn in upon themselves, bending backwards in awkward positions. They are the anonymous members of a war-hungry society in which it seems absence and emptiness are the most eloquent voices. They are beings without a trace of humanity but who fight in order to acquire it. Sometimes they seem to wear the clothes of humanity, but they are worn as an unfamiliar mask made for someone else.

The Mexicas either inherited or resumed this cultural and artistic tradition with great pride. Their images do not try to express a personal life, but rather distance themselves from the reality of the individual. This is why the art of the Mexicas is so unambiguous and at the same time homogenous: gods and people flow into each other and can only be distinguished by their attributes. Neither men nor women reveal individual features – their bodies and their faces are stereotypes. Distant and unmoved, these massive uncompromising forms confront and observe us.

Where the identity of these figures appears, it is conveyed by their attributes. But although these attributes give the images some specificity, they appear initially as a form of disguise, a mask that conceals the face. They may add life to the figures, but it is an inner life. This explains why the art of the Mexica is so intensely contemplative, so completely devoid of external energy. The eternal prevails over the finite. It is not the intention to show individual features but to maintain conventions. The only variations we can descry on the predetermined themes are small details that have been added by way of an elucidatory marginal note.

Unity throughout the works: this has been the goal, pursued with iron determination. What I mean to convey by this is the powerful nature of this art, the vast pent-up energy and dramatic tension that they present us with. Examples include the figures of standard bearers and seated young women, remarkable for their sobriety and delicacy of shape. We find it too in the almost identical faces of the many *macehuales* (servants, ed.), the *Xilonen* (goddess of the young corn, ed.) figures and the mask of *Tezcatlipoca* (Smoking Mirror, the omnipresent creator god, ed.). And there are many other examples that illustrate in different ways and with diverse emphases, the pursuance of this goal of unity.

Individuality is destroyed for the benefit of the community, and with great energy. Even when specific individuals or historic personalities are shown, they are not presented as such, but only by means of glyphs. Two striking examples are the Stone of Tizoc and the Stone of the Archbishopric.

The Toltecs – the cultural ancestors of the Mexica – are thus engaged in a dialogue with their faces and hearts. They desire to create a personality for themselves. The quest is endless and exhausting. No sliver of freedom or spontaneity may be added. This is seen in the Atlantes and in sixteenth-century texts. Although it is a collective, indeed social, dialogue it is at the same time anonymous, directed for the benefit of the gods, subservient to the canonical prescriptions of the holy.

DIALOGUE WITH THE PAST

All through the three thousand years or so of Mesoamerican history, images of people were produced. These were sometimes with and sometimes without distinguishing marks of political or religious authority, and they were made in a range of formal languages the conventions of which altered with time and place. The human images give us insight into the ideas their makers held concerning the universe, the gods and the role of people within the cosmic order. By examining these images carefully we learn to distinguish the various styles that exist, with their differing facial features and ways of expression. All of these artefacts undoubtedly contribute to the outcome of the quest in search of explanations for existential questions. They not only divulge how those people saw their place within the cosmos but also help us to detect how a vision of the creation of life influences the contemplation of human nature. In other words, these images have an undeniably anthropocentric nature.

The most striking examples of humanism are found among the Olmecs in the Pre-Classic period and in West Mexico, in central Veracruz, in the Maya territories throughout the Classic period. With the first group we can speak of an almost total focus on the 'human'. In the western regions we encounter the complete range of possibilities, from a potential feeling of the human, which we observe in the Mezcala style as well as in the Pretty Ladies (*Mujeres Bonitas*) from the Central Highlands, to the vitality and anecdotal sensitivity of the works representing communal daily affairs. The Veracruzans enter the area where humans cooperate with the holy. The Maya, like the Olmecs and to a slightly lesser extent the Cacaxtlecs, show us the image of people who are confident, proud of their capacities, powerful, immortal. Also, the Maya reveal the greatest sense of history – people need to know about their past in order to establish their place in the present. And, conscious as they were of their ability to rule nature, the Maya figures and images show people as triumphant victors and wielders of earthly power.

In Classic Oaxaca we detect yet other aspects. People are subjected to the capriciousness of the gods, and are thus shown as reduced in stature; or else they become mere suggestions, as on funerary urns and tomb paintings. Here we are dealing with generic humankind. The images from Teotihuácan, directly opposite to those of the Zapotec, speak strongly of the ideal, the non-existent, of that which is in service of divine purposes. People as individuals are of little importance.

During the Post Classic there were definite changes. Although the Mixtecs attributed some importance to the individual personality and indicated this with glyphs, in general they portrayed people in search of an identity which had been lost in the immeasurable cosmos and, as it were, swallowed up by it. It appears as if the universe and the gods had become intolerant. That is, the formal treatment of the human figure suggests that the dialogue between people and the gods appears to have diluted into an indiscriminate bartering (*you give me this, I'll give you that*). People have become just one of the many links in the cosmic chain of life.

The great variety of representations of human beings found in Mesoamerica results from the different regional, local and also personal styles that existed. For reasons we do not know, human portraits were found most widely in the low-lying tropical regions – among the Olmecs, the Maya and in central Veracruz. Here too individuality in the images is most explicit – the images reflect individuals, they show the self-confidence of the nobility and highly-placed (*dubito*), they show individuals becoming certain of themselves (*cogito*) so that they can place themselves at the centre of a cosmos to which they can assign a personal or collective significance (*ergo sum*).

There are other cases in which individual characteristics are summarised or represented by some convention: these images see-saw between visual accuracy and schematic representation. People are shown in an eternal communion with their society and the gods. There are various examples supporting this notion. But once the prototype is securely fixed and accepted by the community, we observe a certain lack of interest in the historical significance of humankind. It seems to become sufficient to indicate the hierarchical position or activity of a person by means of attributes or symbols shown by the garments, the headdresses or the objects carried.

From the foregoing discussion it will have become clear that pre-Spanish art was indisputably a channel for humanist forms of expression. From its earliest manifestations, the human being has been one of its central themes: humankind, the embodiment of the highest degree of self-knowledge, unique beings uniting in themselves various qualities and cooperating with Higher Powers. We are in the presence of people who collaborated with the gods in order to establish and maintain the structure of their respective societies.

We learn all this from art itself. Art brings decisive moments of illumination and shows us what is indispensable in life: freedom, education, corporate and single-minded exertion.

I have tried to present a brief overview of some characteristics in the works of art that represent men and women – people from a distant past who yet speak a language that is still both powerful and comprehensible. And these people have something to tell us. We shall have to learn this language in order to enter into dialogue with them; before we can understand something of our rich and exciting human history. For it is a past that today, even though we live at hundreds of years' remove, calls us on a quest, launches in us a need to know, arouses questions both about those old makers and about ourselves, their heirs.

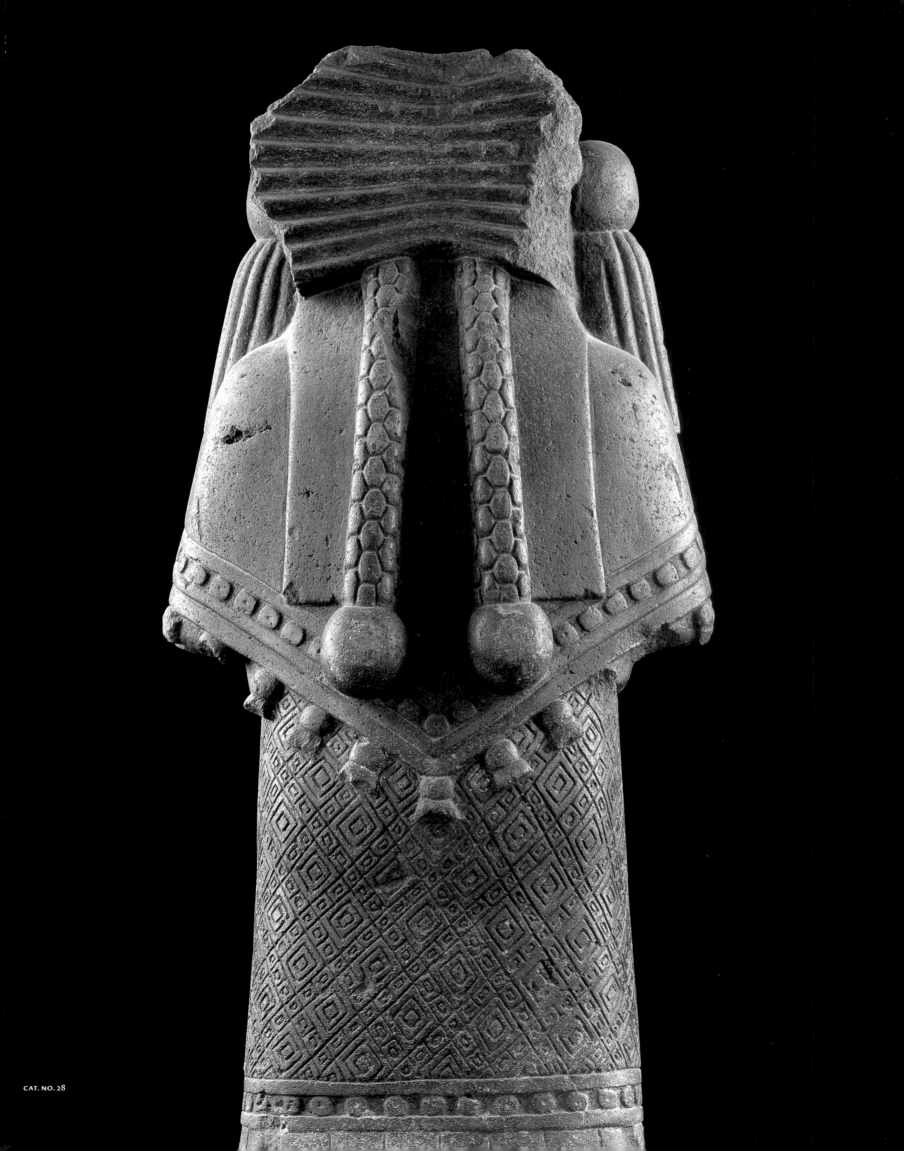

TED LEYENAAR

MEXICO TODAY: THE TRADITIONS THAT LIVE ON

In 1519 the Spaniard Hernán Cortés landed on the west coast of Mexico with a few hundred soldiers. Two years later, after a bitter struggle, the capital city of the Aztecs, Mexico-Tenochtitlan, fell to the Spanish. In those two years Cortés had been assisted by Indian allies, including the tribe of the Tlaxcaltecs. One extremely useful ally was Cortés's common-law wife, the Mexican Indian Malintzin, her name becoming Malinche in Spanish, and sometimes (Doña) Marina. They had a son, baptised Martin, who is considered to be the first mestizo, that is, a child of mixed Spanish and Amerindian blood.

CLOTHING

Written sources inform us that Malintzin did not dress according to the European fashion, à la Española, but retained the garments of her Indian tradition. As illustration of this we see, her wearing a wrap-around skirt and a huipil (see below), as she stands behind Hernán Cortés acting as his interpreter– she spoke both Nahuatl, the language of the Aztecs, and Spanish – at a meeting between Cortés and the leaders of the Tlaxcaltecs (FIG. 22). The clothes that Malintzin is pictured in are still worn by Indian women of today. Below are listed the native garments that are chiefly worn today, as they have been down the centuries.

QUECHQUEMITL

Despite the passage of time, this garment has retained its Nahuatl (Aztec) name, which is derived from the word for neck and shoulders – *quechtli* – combined with the word for garment – *quemitl*. Worn loosely, it amply covers the neck and shoulders. It is composed of two pieces of textile, usually square pieces of cotton, with a head opening. The Indian women usually wear the quechquemitl with the corners hanging at the centre of the chest and back (FIG. 23) so that it looks like a short poncho. Sometimes the quechquemitl is draped over the head (FIG. 24). A good thirty years ago the quechquemitl became very popular among the hippies and kindred spirits. Indeed it was very fashionable to wear one, and when we think back to the street scenes of the 1970s it is impossible not to imagine people wearing ponchos, as they were erroneously called –for they were in fact, Aztec quechquemitls.

HUIPIL

The (h)uipilli worn by the Indian women in pre-Columbian times continues, like the quechquemitl, virtually unchanged in the huipil of today (FIG. 25). It is a tunic-like garment made from lengths of textile that are stitched together. Sometimes it resembles a blouse because of its short length – for example, the huipils worn by the

Maya of Chiapas or the Nahua from Acatlán, Guerrero – but it may also be worn down to the ankles (FIGS 26, 27).

CUEITL

The wrap-around skirt, called cueitl in Nahuatl (Aztec) and *enredo* in Spanish, also stems from pre-Columbian times. In this it differs from the shop-bought skirts, or 'ordinary' skirts, called in Spanish *enagua or falda*. The wrap-around skirt is a simple garment composed of two long, rectangular lengths of cloth that are stitched together. This forms a wide tube-like shape which the woman then wraps around herself, gathering it in at the waist in large pleats which she arranges to suit her taste. The wrap-around skirt is then held in place with a waistband or belt (FIG. 28, CAT. NO. 28).

NELPILONI

The *nelpiloni* of the Aztecs is the *faja* of the Nahua, in essence the same garment: it is the (waist)band that holds a garment in place and stops it from slipping off. The above garments are part of the wardrobe of the Indian woman, often combined with clothing of European origin. For example, a blouse (Spanish *camisa*) may be worn under a quechquemitl (FIG. 24). In rare cases – often by older women in more remote parts – the quechquemitl is worn directly against the skin without a blouse underneath (FIG. 23). In such instances, it is as if the distant past is still alive today. The combination of quechquemitl with huipil as was sometimes seen in pre-Columbian times is never found today. The woman's dress is often complemented by a *rebozo*, a long shawl or wrap, which is a garment of European origin.

Until recently the Indian women generally went barefoot. Nowadays the plastic sandal and shoes have become very popular. Generally speaking, the clothes worn are typical of *mestizo*, combining Indian and European components. Thus the blouse, which stems from Europe, is worn beneath the quechquemitl, which is an Indian garment (FIG. 24). Another marriage of traditions is the woollen headbands plaited into the hair to create an imposing, aristocratic headdress (FIG. 24). Sheep, and thus wool, were brought to the Americas by the Spanish.

The clothing of the Indian men recalls little of the pre-Spanish world. However, there are small groups such as the Tacuates of Oaxaca and the Maya of Huistán, Chiapas, who wear trousers that are reminiscent of a loin cloth (FIG. 29). Until recently the Indian men characteristically wore leather sandals called *huaraches*, the soles of which are now made from old car tyres. Today, however, the most popular form of footwear is the

sneaker, or *Nike* (FIG. 29), which seems to have stolen the stage from the traditional sandal.

With the exception of the garments just mentioned, the everyday clothing of the Indian man, influenced in many respects by America, seems to be completely inspired by European dress. The most popular everyday garments are a kind of cotton smock (shirt) and trousers, in Spanish *camisa y calzón*, which in combination are termed *traje indio*, that is, Indian clothing (FIG. 30). Although this clothing is inspired by European wear, the garments reflect the age-old pattern of Indian life in respect of the distinct gender divisions: boys and men worked on the land, while girls and women chiefly worked in the home performing such tasks as weaving and cooking.

Interestingly, it is worth noting that the word *pantalón* is used to denote the trousers worn by the mestizo, the westernised Mexican. However, there is a world of difference between whether someone uses the expression *son gente de calzón* rather than *de pantalón* – an entirely different background is assumed. People from consciously Indian families or from westernised, forward–looking groups, use the word *calzón* in ninety-nine cases out of a hundred, in a pejorative sense. Those who are conscious of their Indian tradition will speak an Indian language, although it is noticeable that in the countryside and at markets there will be Mexicans dressed in *camisa y calzón* and wearing *huaraches* (sandals) who no longer speak one of the Indian languages, but rather use Spanish. It seems little short of absurd to label such people Spanish-speaking Indians. What they do show, in a most explicit manner, is how in Mexico the patterns of one culture have become intermingled with those of another. And whether or not the greater influence comes from Europe or from the New World, what is always apparent is the mestizo, the mixture.

Today the camisa and calzón are always made from factory-produced cotton and bought in shops. This contrasts with the traditional women's clothing discussed above, which, as in days of yore, is still woven on a back-strap loom.

WEAVING

The back-strap loom consists of the warp section holding the threads between two pieces of wood, of which one (the farthest away from the person) is attached by means of two tapes to a tree trunk, a pole or a doorpost (FIG. 31). The other piece of wood lies more or less against the woman's stomach and is attached to the person with a strap, hence its name. In Spanish it is known as *telar de cintura*, literally meaning a belt loom, and in Mexican Spanish *telar de otate*, from the Nahuatl word *otlatl* meaning a bamboo stick,

or else *telar de palitos*, a loom with wooden sticks. The weaver sits with her legs either stretched out or tucked under her (FIG. 34). It is also possible to weave standing, and as it were hang in the belt loom , or she can sit on a low stool as is often the case with older women (FIG. 32). In pre-Spanish times weaving was exclusively a women's occupation, and the little girls would be taught by their mothers at a very young age (four or five years, see Codex Mendoza) how to spin and weave (FIG. 33). A woman's skill in weaving determined whether or not she was a good housewife. In the ancient Indian society a good weaver, known as in *qualli hiquitqui*, was highly esteemed.

In our recent travels through Mexico, documenting the customs we observed, only twice did we come across a village where the men used a back-strap loom to weave. The places were Altepexi, also written as Altepeji, in the state of Puebla, and Coatepec Costales in the state of Guerrero (FIG. 34).

The method of weaving using a back-strap loom was unknown to the Spanish. Thus, as soon as life was more or less stabilised in Central Mexico after the conquest (1521 – 25) they noted down carefully how the weaver worked on such a loom. An amusing touch here is the way the Spanish illustrator has portrayed the Indian woman against a distinctly Romanesque -Spanish architecture.[1] The Spanish introduced the standing loom later known as the colonial loom or *telar colonial*, which uses the feet to work it, hence its other name of *telar de pedales*. This standing or pedal loom was chiefly worked by men. Could this possibly be because men are more intrigued than women by technical inventions?[2]

POTTERY

It is a proven fact that technical innovations introduced from Europe into the Indian culture were more readily accepted by men than by women. An interesting case here is that of the potters' wheel, brought by the Spanish in the sixteenth century to pre-Columbian America, where it was unknown. Having been introduced to its new country what we observe is that the men soon adapted to this method of pottery making, while the women retained the traditional techniques. Another innovative pottery technique brought by the Spanish was the use of glazing, then unknown in the New World, and soon widely applied in domestic pottery. However, water jugs were never glazed, since it is important that they can 'breathe' in order to keep the water cool (FIG. 35). Occasionally a water jug would be glazed, but only given a very thin layer so that it could continue to 'breathe'. The Indian potters were familiar with the technique of polishing pots,

whereby an object is rubbed with a piece of quartz before firing, and still today it is a common practice. The method of hand-building pots from clay rings, as well as the use of moulds, were both known to the Indians. Indeed, the so-called tortilla-method is still used today, whereby, using a wooden pestle, the potter flattens a piece of clay making a kind of pancake known as a *tortilla de barro* which is later placed over a mould. The pre-Columbian Indians were not, however, familiar with the use of a kiln in which to fire the pots. When this was introduced by the Spanish it was copied with great enthusiasm, although the ancient Indian method of baking earthenware in an open fire, continues. In this ancient method, the pots are covered with shards, pieces of wood or dried faeces, and the fire can be built wherever seems convenient – in the street or perhaps near a dwelling (FIG. 36). It is as true of the twenty-first century Mexican potter as it was in the sixteenth century when Sahagún noted[3]: *in qualli coquichiuhqui: tlaiximati, tlalitztlacoani, moiolnonotzani… toltecatl, momoimati* (the good potter, he understands the clay and how to shape it, he examines the clay carefully [that is, he assesses whether it is good or poor clay], he listens to his own inner understanding… he is an artist, he knows what his hands should create).

THE MEXICAN KITCHEN

The potter of today still makes the kind of kitchen equipment that has been used since time immemorial. Pestles and mortars, baking sheets, water jugs and suchlike are still widely used despite the incursions of food processors and their ilk. Also still made by stonemasons are mortars for grinding foodstuffs, called *molcajetes*, and grinding stones, or *metates*, on which to pound the corn with a rolling pin, just as in former times (FIG. 37, CAT. NO. 106).

The Mexican kitchen abounds with customs and usages stemming from pre-Columbian times. Some striking examples are the following.

First, there is the *tortilla*, a pancake made from corn meal. It can be folded double or rolled up to hold pieces of meat and/or vegetables, rather like a *taco*. When we describe it as a pancake, do not think of the European flour, egg and milk pancake. The 'old' Mexicans did not have either cows or chickens until the Spanish arrived – and, incidentally, it was the Spanirds who introduced horses, donkeys, sheep and goats.

Second is the *mole*, from the Nahuatl *molli*, meaning sauce. A mole would be made from about five kinds of dried chilli peppers (the Nahuatl word for sharp peppers is *chilli*). A further ingredient of the mole is chocolate, the word coming from the Nahuatl *xocoatl*, meaning bitter water. In rural parts the dried chilli is ground on a *metate* together with ingredients such as almonds

and raisins which come from the Old World. Coriander seed (*cilantro*), imported from Asia, is finely ground and added to the mixture which thus combines aspects of three continents, meeting today in order to create the famous Mexican *mole*, or sauce. It should be said that the major ingredient is Indian.

Third are the corn and bean dishes. Corn and peppers and the thin black or brown beans called *frijoles* form the staples of the Mexican kitchen. There are also squashes and pumpkins (CAT. NOS 195, 196) and tomatoes, whose name incidentally comes from the Nahuatl *tomatl*. The Spanish and other Europeans knew neither the tomato nor the chocolate drink and assumed the Indian names, albeit in corrupted forms. Thus tomatl became tomato while *xocoatl*, bitter water, turned into chocolate: two Nahuatl words now adopted into many European languages.

In large cities tortillas are bought at a *tortilleria* just as bread is bought from the baker's. It should be noted that bread is also eaten in Mexico. But all upright Mexicans eat their tortillas with guacamole (which has recently become wellknown in Europe). This consists of avocado made into a puree with onion, peppers, fresh coriander, and tomato to taste. Tortillas are also a must when eating *mole de guajolote*, that is, turkey with sauce. This culinary rule is observed by all social classes. Incidentally, turkey is indigenous to North and Central America (CAT. NO. 219). Speakers of English are confused by the word, believing the creature to come from Turkey. Not so. In Turkey itself, the creature is thought to come from India and thus given the name *hindi*, while in Portugal it has been baptised *peru* showing a commendable understanding that the feathered creature was of New World origin.

In the market places of the Central Mexico Highlands you can still drink pulque, the beverage called *octli* by the 'old' Mexicans. It is a fermented drink made from the juice, or *aguamiel* of the agave plant (CAT.NOS 198, 199). The pulque drink, it should be noted, is fast disappearing partly thanks to the fact that nowadays coca cola can be bought literally everywhere. Throughout the territory described as Mesoamerica, from northern Mexico to, roughly speaking, western El Salvador, it is only in Central Mexico that pulque drinking still continues.

RELIGION

It is not difficult to recognize at a quick glance many pre-Columbian traditions that are retained today, in weaving, pottery-making or culinary habits. Although this is possibly more complicated in less material spheres, such as when dealing with religious beliefs and practices, here too we find remarkable instances of a harmonious mingling of Indian and European

FIG. 22
The Indian woman Malinche wearing a *huipil* and wrap-around skirt; she stands behind Cortés, acting as an interpreter, Lienzo de Tlaxcala

FIG. 26
Nahua women from Acatlán, Guerrero, wearing short *huipils* with wrap-around skirts

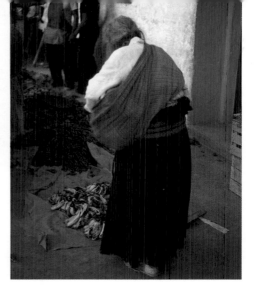

FIG. 28
Nahua woman wearing wrap-around skirt and *ixcactles*, sandals made from the fibre of agave plants, Hueyapan Morelos

FIG. 23
Nahua women with *quechquemitl*, San Pedro Coyutla, La Huasteca Veracruzana

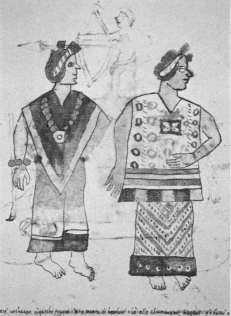

FIG. 25
Codex Vaticanus A p. 61 r. on the left a *quechquemitl*, on the right a huipil, worn with wrap-around skirt

FIG. 29
Traditional male clothing, Maya, Huistán Chiapas. One of the Huisteco is wearing sneakers

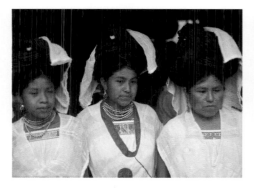

FIG. 24
Mother and two daughters with *quechquemitl*, also incorporated in hairstyle, Xalticpac family Nahua, Zacatipan, Puebla

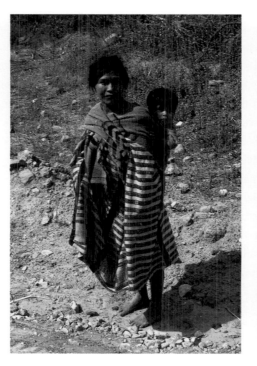

FIG. 27
Trique woman with long *huipil*, near Tlaxiaco, Oaxaca

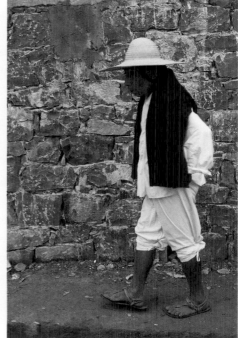

FIG. 30
Traditional male clothing, Nahua Cuetzalan, Puebla

elements. Thus we see the Roman Catholic saints grafted, as it were, onto the gods of the Indians, adopted as patron saints of towns and villages and worshipped in song and above all dance. Throughout Mexico today Indians and mestizos are to be seen dancing in the churches, often right up to the altar, in honour of their patron saint, the Virgin Mary or Jesus Christ.

DANZAS

The word *danzas* means simply dances, but in Mexico this was a religious ritual combining dancing with musical accompaniment and it formed an important aspect of the fiesta which was celebrated in honour of a patron saint. The two dances now described proved impossible for the Roman Catholic church to eradicate, no matter how hard they tried. They have continued like hardy perennials.

LA DANZA DE LOS QUETZALES

The old Mexicans had a twenty-day period called *Tepeilhuitl*, running from 20 September to 10 October which was specially reserved for the worship of the rain god, the Lord of the Mountains. In the northern mountain ridge of the Puebla state, called Sierra Norte de Puebla, two figures from the Christian tradition, the archangel Michael (whose name day is 29 September) and St Francis of Assisi (name day 4 October) were grafted onto the figure of the rain god. Of these two later additions, the figure of St Francis is most important for the people living in and around the town of Cuetzalan, a mid-point of the Nahua Indians. From far and wide, at the beginning of October, the Nahua from the villages and hamlets near Cuetzalan stream in towards the church dedicated to St Francis. They come to worship the saint whose statue is in the church, set in front of the *corona de quetzal*, or headdress of the quetzal dancers. This dance is pre-eminent among the main dances from the Cuetzalan district (FIG. 38). The dance dates to pre-Spanish times and contains a section in which the performers greet the four cardinal points, or four directions from which the wind blows. Possibly, it takes its name from the bird *quetzal*, whose long tail feathers are represented by the elaborate headdress (FIG. 38). Equally plausible is the suggestion that the name comes from the town of Cuetzalan itself which in early sources appears as Quetzal[1]an. In that case the dance would be called after 'the people of Quetzalan', which seems reasonably likely since the dance is known only in the district round Cuetzalan. Incidentally, the bird named quetzal has given its name to Quet-Cuetzalan as is apparent from the emblem both in former times and today (FIG. 39). The musical accompaniment to the dance of the Quetzalan is performed on flute and drum, both

instruments played by the same person. There are ten to twelve male dancers in a group, which may include very young boys.

The costume for the dance is worn over the *traje indio*, *or camisa y calzón*, the cotton smock-shirt and trousers worn by the Mexican farmer. It consists of two colourful *mascadas*, that is shawls crossed over the chest, and trousers that fall to below the knee, all the garments made from artificial silk. The trousers, generally coloured red, are decorated round the hem of the legs with two layers of deep yellow fringe. As an echo from pre-Columbian days the quetzal dancers also have a type of *maxtlatl*, or loincloth-cum-apron tied round the waist, matching the trousers as regards its material and trimmings. When we turn to the dance of the 'flying pole' we find virtually the same costume, only the headdresses are considerably smaller.

LA DANZA DE LOS VOLADORES

This is the dance of the flying pole, or rather, the flying-men spectacular, which is performed by the Nahua, the Otomíes and the Totonacs of the Sierra Norte of the Puebla state, as well as the Totonacs living in the valleys. In the case of the latter, the motivation for the dance – to honour Christ or one of the Christian saints – often seems now to have become replaced by the desire to make money out of the tourists. Not just once a year but once a week – weather permitting – you can watch the flying men every Sunday in Tajín. Nowadays the traditional pole, which used to be the trunk of a pine about thirty foot high, is generally replaced with a steel mast. This is used for the downward flight. In around 1970, probably influenced by anthropologists from North America, there was a revival of the bird-like elements, notably among the Otomí *voladores* from Pahuatlán and today also among the Nahua or Totonac *voladores* from Cuetzalan and Huauchinango (FIG. 40).

Even more obviously than when you watch the dance of the quetzals, you are aware as you see the voladores, or flying men, that this spectacle has its roots in pre-Columbian days.

In Cuetzalan the entertainment still only takes place in early October, in honour of St Francis of Assisi, the town's patron saint. As with the quetzal dance, here too the musical accompaniment is provided by one player on the bamboo flute and drum, playing both instruments together. Although these instruments were known in pre-Spanish times, the pentatonic scale used by the Indians (five whole tones) has been replaced by the European octave with its whole tones and semi-tones. The musician *volador*, known as the capitán, is the leader of the other four flying men. These have now found their nests one on each side of the frame around the pole, and each man has tied round his waist one of

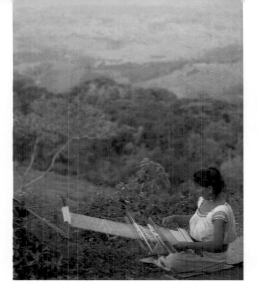

FIG. 31
Cihuatzin Juana at sunrise, busy with the strap-loom, Zacatipan, Sierra Norte de Puebla

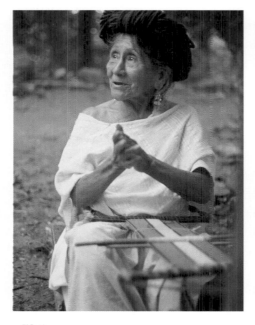

FIG. 32
Maria Petrona Xalticpac seated on a stool, weaving a *paltel*, or pouch, Zacatipan

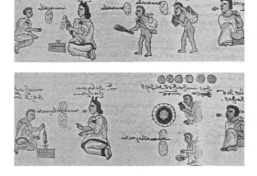

FIG. 33
Codex Mendoza, six-year-old being taught how to spin

FIC. 34
Celacio Jiménez, weaving a *morral*, or bag, Coatepec Costales Guerrero

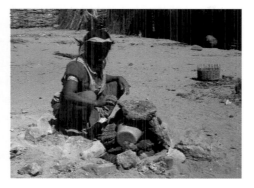

FIG. 35
Tzotzocolli, pitcher, San Agustín Huapan, Guerrero

FIG. 36
Margarita González, a potter, at her 'kiln', San Agustín Huapan, Guerrero

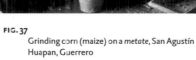

FIG. 37
Grinding corn (maize) on a *metate*, San Agustín Huapan, Guerrero

FIG. 38
Quetzal dancers on their way to church, San Andrés Tzicuilan, Sierra Norte de Puebla

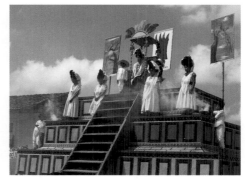

FIG. 39
Quetzal emblem for Quetzallan-Cuetzalan, seen behind *La Reina*, the queen of 'native' costume

the ropes which is coiled around the pole just beneath the *tecomate*, or small platform. So while the four flying men are preparing for their descent, the fifth (the captain) begins to make music and dance, bending backwards and bowing towards each point of the compass as he does so. This form of greeting, as also seen in the quetzal dance, is typically pre-Spanish. At a sign given by the captain the four flying men launch themselves, headfirst, and with arms outspread like an upside-down crucifix (FIG. 41). The watching crowd gasps, the mestizo microphones are silent, and in a tense breathlessness the *voladores* begin their flight. The ropes unwind around the mast as the frame moves in a circle, and spinning in ever wider loops the men fly down to earth, to land with a final twist and spring, feet first. Once the captain has also safely reached the ground the group dance into the church and up to the altar where they offer thanks to St Francis, patron saint of Cuetzalan.

In pre-Columbian days there were precisely thirteen turns around the pole or mast before the voladores landed. Old colonial sources refer to the connection between the four voladores, each with his thirteen revolutions, and the Mesoamerican 'century' or 'bundle of years' consisting of 52 years, and the curious fact that 4 x 13 = 52.[3] In pre-Spanish codices there are illustrations of the voladores, as in the Códice Fernández Leal where they are shown wearing masks to represent birds (FIG. 42). In an eighteenth-century drawing by the historian Francisco Clavijero (1731 – 1787) more than four voladores are shown in bird costumes, although it states that there are only four (FIG. 43). Not surprisingly, the Catholic church was not wildly enthusiastic about the pre-Columbian and, in other words, pagan practices pictured in the *danza de los voladores*. But although they tried, it was impossible to eradicate it. The dance went on. We can consider it as a cosmic happening which is reflected not only in the greeting given to all four points of the compass but also in the downward hurtling of the flying men whose task it is to join together heaven and earth. There is an amusing drawing in the sixteenth-century colonial Códice Durán in which the flying men are represented as cheerful cherubs (FIG. 44).

Summing up, the *danzas* of the quetzals and the flying men appear as deeply indigenous events, an ancient heritage of the Indians of Mexico. But dancing to honour patron saints, the Christian saints and the holy figures of the Virgin Mary and Christ, finds no finer expression than in the homage given in honour of Our Lady of Guadalupe who is not only the patroness of Mexico but of the whole of Latin America.

OUR LADY OF GUADALUPE

The Aztecs, in the period following the Spanish conquest of their capital, Mexico-Tenochtitlan, were filled with hatred and bitterness towards their conquerors. This seems to have softened somewhat in 1524 when the first twelve Franciscan monks arrived in Mexico city. The monks, who included Bernardino de Sahagún among their number, had travelled barefoot all the way from Veracruz, and apparently their self-abnegating attitude greatly impressed the Indians. When Cortés and the Spanish conquerors fell to their knees before the Franciscan monks, the Aztecs who were present at the reception did the same. But for the Indians Christianity remained more of an outward show than an inner experience. The change only began once there was a fusion between indigenous beliefs and the Christian faith. In 1531 the Virgin Mary appeared on several occasions to a baptised Indian called Juan Diego. Mary, a brown-skinned girl, spoke to him in Nahuatl, the language of the Aztecs. She told him to build a church and dedicate it to her (FIG. 45). It so happened that the place where Diego had his visions was already sacred to the Aztecs before the Spanish arrived. On the hill of Tepeyac, now called Guadalupe, the Indians worshipped there no less a figure than *Tonantzin*, Nahuatl for 'Our Honoured Mother', the mother of the gods. Juan Diego's visions tipped the balance in the conversion of the Indians and 12 December, the day on which the most important vision appeared to Diego, is now a national holiday in Mexico. Tonantzin became Our Lady of Guadalupe, Patroness of Mexico. Christianity had become grafted onto the local beliefs, the *mestizo* or mixture, of the two cultures was given a solid basis.

Another event that was to contribute greatly to the cementing of the two cultures, mixing pre-Spanish and Christian elements was the so-called Days of the Dead, falling at the same time in October and November as the Christian celebrations of all saints and all souls.

THE DAYS OF THE DEAD

When the Catholic church introduced 1 and 2 November as All Saints and All Souls Day, times in which to honour the memory of one's forefathers, there was scarcely any objection from the Indians. In pre-Spanish times ancestor worship had already been an element of the Indian culture. The above-mentioned Franciscan monk Sahagún (Book II: 125, 126) describes such a ceremony as it took place among the Indians on the fifth day of their fourteenth 'month' of twenty days, called *Quecholli*.[5] This period covered the last ten days of October and the first ten of

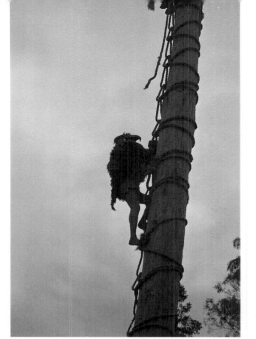

FIG. 40
Otomí volador (flying man) wearing bird costume, Pahuatlán

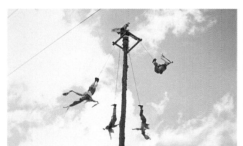

FIG. 41
Capitán with four flying men (*voladores*) at the start of the 'flight', Cuetzalan

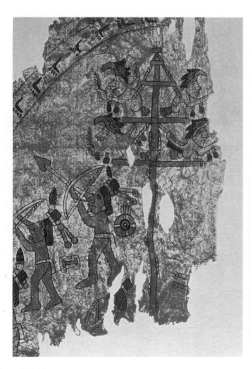

FIG. 42
Voladores (flying men) wearing bird headdresses. *Códice Fernández Leal*, pre-Spanish, c. 1500

FIG. 43
Clavijero, 18th-century drawing showing flying men (*voladores*)

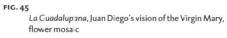

FIG. 44
Códice Durán, 16th century, *voladores* pictured as cherubs (after Mompradé de Gutierrez)

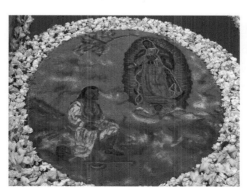

FIG. 45
La Guadalupana, Juan Diego's vision of the Virgin Mary, flower mosaic

FIG. 46
Bread of the Dead, the 'spirit in the bottle' variation

FIG. 47
Sempasóchitl, house altar on 2 November, Mixquic

FIG. 48
Grave with the plants *sempasóchitl*, or African marigold, gypsophila and Rooster Crest

FIG. 49
Mixquic at night, 2 November, All Souls Day

November. Thus it was not too difficult for the Catholic clergy to inaugurate the celebration of All Saints and All Souls on 1 and 2 November. During the Days of the Dead, *los dias de los muertos* as the Mexicans prefer to call them, they remember their dead in a way that for outsiders is both emotionally moving and impressive. The remembrance is not limited to these two days, but starts a while before in October and continues after 2 November for several more days. Sometimes even before the beginning of October special articles appear for sale in the markets, connected with the decoration of house altars and the celebrations on the actual days of remembrance. The general custom in Mexico is to remember children who have died, on 1 November, and adults on the next day. For these ceremonies the markets sell large quantities of articles such as incense burners and candlesticks made from earthenware, sometimes glazed and sometimes not.

For the Mexican, Death is a familiar figure, a partner and companion, someone to share a joke with. Children are given skull-shaped candy and there are special typewriters at the markets for printing whatever child's name you want onto strips of paper that can be stuck to the candy. The special 'bread of the dead' is made from dough without yeast so that it will last a long time and is often shaped like a 'genie in the bottle' (FIG. 46). Bread rolls decorated with bones, shaped like animals or in rings with pink sugar decoration, are placed upon the house altars as decoration.

After all, the souls of the dead return and will be hungry. At the market there are miniature coffins, graves and house altars on sale, together with figurines of sheep, angels, babies, saints and even Our Lady of Guadalupe, all of them represented as dead. They are generally made of *alfeñique*, a kind of candy, or of a kind of paste made of calabash seeds and known as *jamononcillo*. This is reminiscent of the small figures from pre-Columbian times made as offerings for the gods, from *tzoalli*, a paste produced from the seeds of the amaranth plant.[6] The amaranth was very important in pre-Spanish times, as was the African marigold (genus *Tagetes*) which held a significant place in all the religious ceremonies. The cultivation of the red-purple amaranth was opposed by the Catholic church because of its pagan associations, which probably explains why it was replaced by the red-purple so-called Rooster Crest (genus *Celosia Cristata*). The yellowy-orange African marigold – incidentally a native of Mexico and not of Africa – has in fact retained its old pre-Columbian religious function.[7] For the Mexicans of today, the marigold, now known as *sempasóchitl*, is pre-eminently the 'flower of the dead'. The graves of the dead and the house altars are largely adorned with the marigold,

sempasóchitl, (FIG. 47) often in combination with the dark red-purple Rooster Crest and sometimes also with the white Baby's Breath (genus gypsophila) (FIG. 48). This combination of plants seen both on graves and in the homes (FIG. 47) takes a different emphasis from village to village. In certain villages the remembrance is centred on the cemetery, often at night (FIG. 49), while in another village the celebrations will centre in the home.

This period, *los dias de los muertos*, represents the most important annual religious experience for every Mexican, be they mestizos or so-called 'pure' Indian, who make up four to five percent of the total population. Indian, mestizo and Caucasian join together during these days, united by a common feeling, a common realization: that life and death are one and inseparable.

From the low to the lofty, from the culinary habits to the religious celebrations, the Mexican culture of today is permeated with fragments from a distant past. The cultural mixture, or *mestizo*, has contributed a fascinating richness to Mexican society. There is a Mexican saying, *como México no hay dos*, meaning, 'there's no place like Mexico.' And indeed, that's very close to the truth.

SOCIETY

Two distinct groups lived in ancient Mexico before the coming of the Spanish in the sixteenth century. The peoples living in the western part had a virtually classless society. Tribal chieftains and shamans held the leading positions.

The peoples of Central and South Mexico, however, had a more complex social structure. A small group held sway, consisting of families who were mutually related in an intricate network. This group included kings and queens, nobles, priests and warriors. Proud of their positions they made a grand impression with their elaborate headdresses, flamboyant jewellery and splendid clothing. The ordinary people dressed more simply. Indeed, they were forbidden to own or to wear jewellery or ornaments. In particular, there was a taboo against their having jaguar skins, or feathers.

RULERS

In the period 1500 to 200 BC, a ruling class developed which had shamanistic roots. Illustrative of this development are the colossal heads carved by the Olmecs.

During the next period, until around AD 900, links can be found between the royal families, particularly in the territories of the Maya and the Zapotecs. Dating to this period are reliefs from these regions, showing portraits and providing information about the deeds of these kings.

In the Aztec era, the fifteenth and early sixteenth century, there were two authorities — one for home affairs and another for foreign affairs. Both would be richly clothed, symbolizing their power.

The ruling class was thought to be the closest to the gods. This also involved many responsibilities.

It was the 'lofty' duty of rulers to wage war. This was prompted by the political consideration that it was desirable to suppress all the neighbouring tribes and peoples. Waging war also had a religious dimension. Noble-born prisoners of war could be sacrificed to the gods.

Furthermore, a victory increased the winner's status. The Aztecs in fact expected a new ruler to wage and win a 'war of inauguration'.

1

COLOSSAL HEAD,
SAN LORENZO MONUMENT 4
OLMEC

1200 – 900 BC
San Lorenzo Tenochtitlan
stone
h. 178 cm, w. 117 cm, d. 94 cm, weight 6 tons
Museo de Antropología de la Universidad
Veracruzana, Xalapa
inv.no. PJ 336

The Olmec rulers have bequeathed their
portraits to posterity, in the form of
colossal heads. A former theory suggested
that they represent decapitated ballgame
players but there is no evidence to support
this. This potentate wears a helmet with
two straps hanging from it on either side.
The face has the characteristic Olmec
features, with the thick-lipped drooping
mouth of a jaguar, a flat broad nose, and
slightly slanting eyes. There are large
earplugs and on the reverse of the head are
26 holes and three grooves, the latter
possibly used to attach ropes for trans-
porting the sculpture.
 So far 17 colossal heads have been found,
each one individually illustrating the
'colossal' power of the ruler.

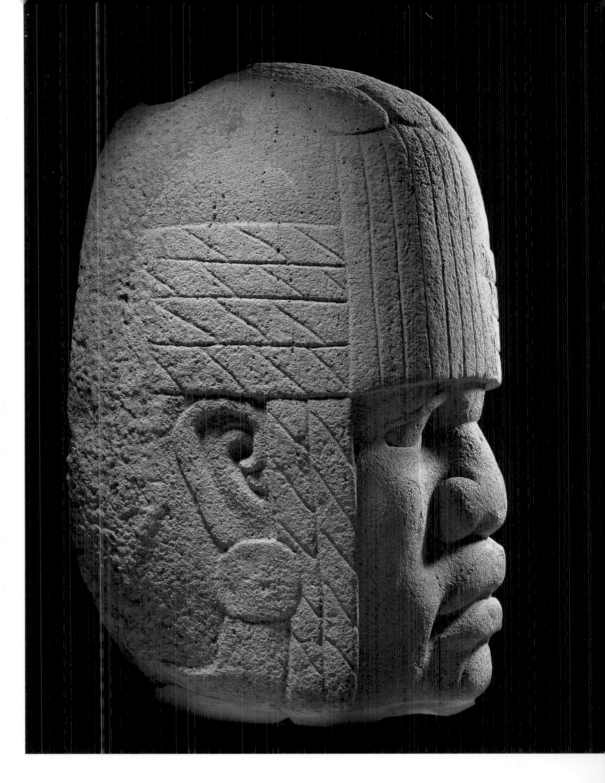

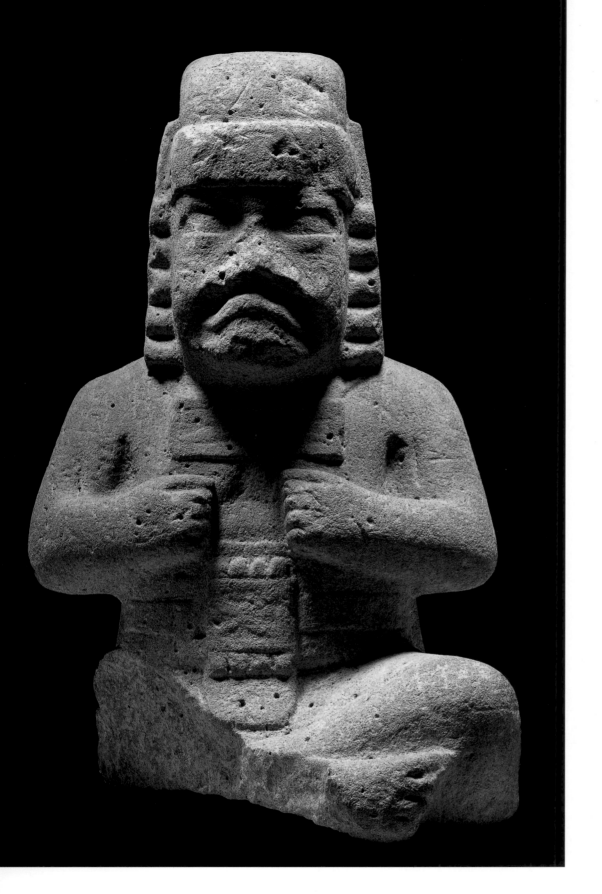

DEIFIED KING
OLMEC

1200 – 900 BC
South Veracruz
stone
h. 127.0 cm , w. 73.0 cm, d. 50 cm
Museo de Antropología de la Universidad
Veracruzana, Xalapa
inv.no. PJ4020

The figure is seated cross-legged, both
hands in front of his chest. He wears a
loincloth and a square-shaped ornament on
his chest. It is decorated with crossed lines,
signifying the four points of the compass,
origin of the Aztec word *ollin*, meaning
movement. From beneath his turban, his
hair falls to his shoulders. He has the typical
drooping jaguar mouth of Olmec statues.
This suggests the figure is a priest or king,
connected with the jaguar god. The Olmec
culture did not draw a sharp distinction
between spiritual and temporal power:
a ruler functioned as a 'holy king'.
 The figure is badly damaged, the right leg
destroyed, with the exception of its foot.

3
STANDING FIGURE
OLMEC

900 – 500 BC
Acatlan (Puebla)
jade
h. 52.5 cm, w. 29 cm
Museo Regional de Puebla, Puebla
inv.no. 10-203321

The head has vertical 'oblong' ears and
somewhat slanting eyes. The stones once
set in the eye sockets to represent eyeballs
have been lost. The mouth has the familiar
jaguar appearance. All these features are
characteristic of Olmec work. The figure
wears short trousers and a loincloth, both
garments having engraved markings. On
the loincloth flap is a bundle of arrows or
a flaming torch with a so-called knuckle-
duster pictured above it – a motif
frequently found in Olmec work. To the left
and right of the flap, on the short trousers,
are two virtually identical engravings each
of which appears to represent a small
temple with two roof crests.These
engravings may also be seen in relation to
the four compass points, whereby the
figure assumes the function of a great ruler.

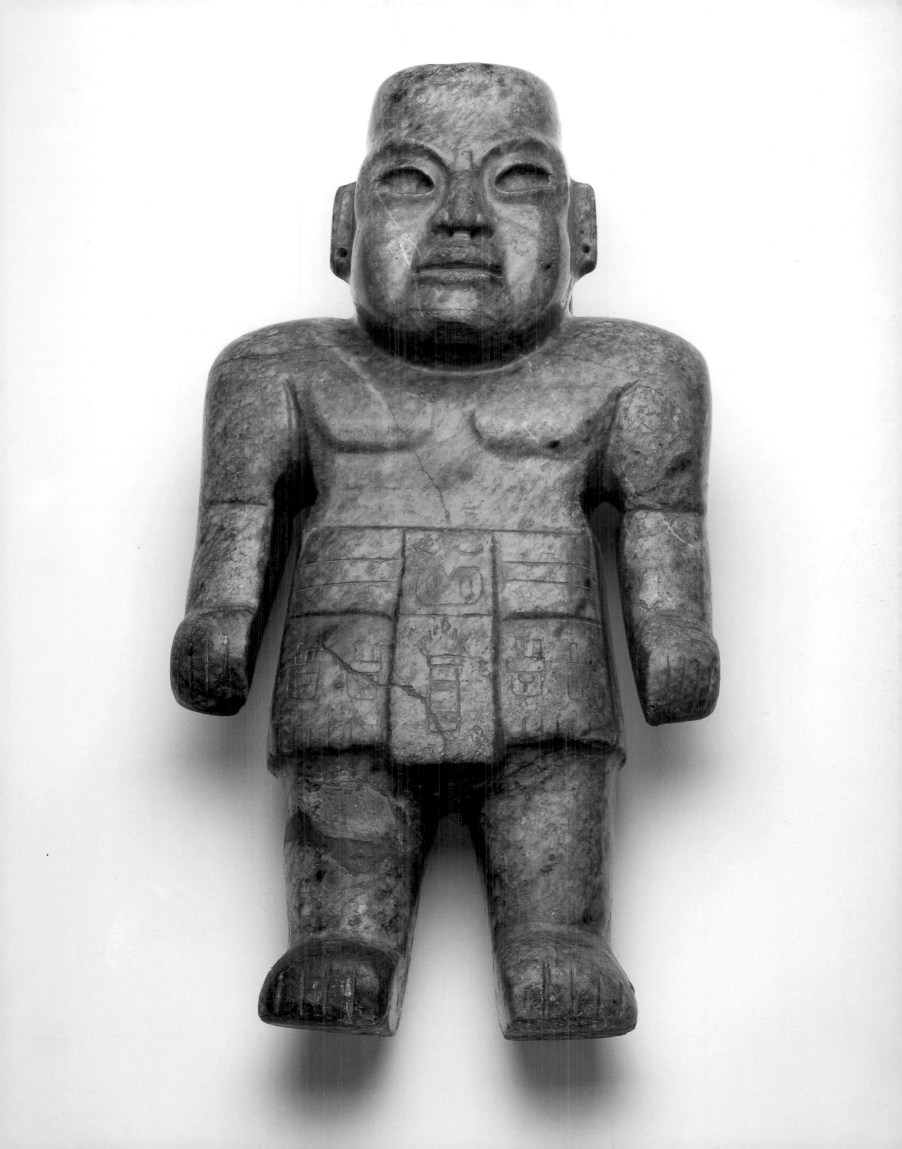

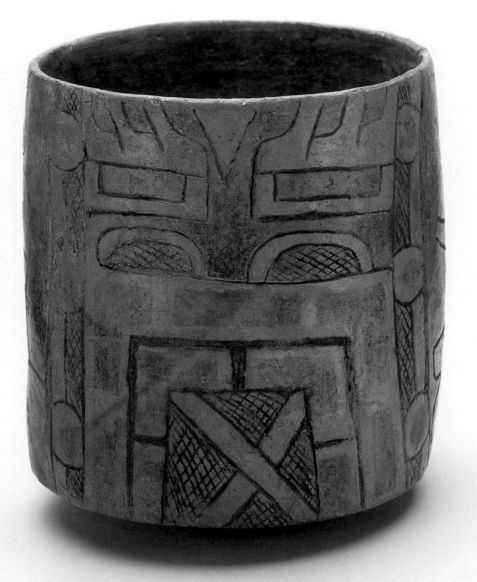

4
VASE WITH INCISED WORK
OLMEC

1200 – 600 BC
Central Highlands
terracotta
h. 16 cm, diam. 14.7 cm
Museo Nacional de Antropología,
Mexico City
inv.no. 10-77761

This creamy pottery vase has a scene
engraved on it showing the jaguar god with
'flaming eyebrows', a slit in the head and
mouth, beside 'crossroads' representing the
four cardinal points. The god is shown
frontally, while the other side presents the
jaguar god in profile with the mouth and
split in the head full-face. The scoring on
the skull is characteristic of Olmec work,
and stands for the earth springing open as
the maize grows out of it. The jaguar
symbolizes the earth. The incised vase
expresses the involvement of the Olmecs
with the fertility of the earth, in a human-
and-divine context.

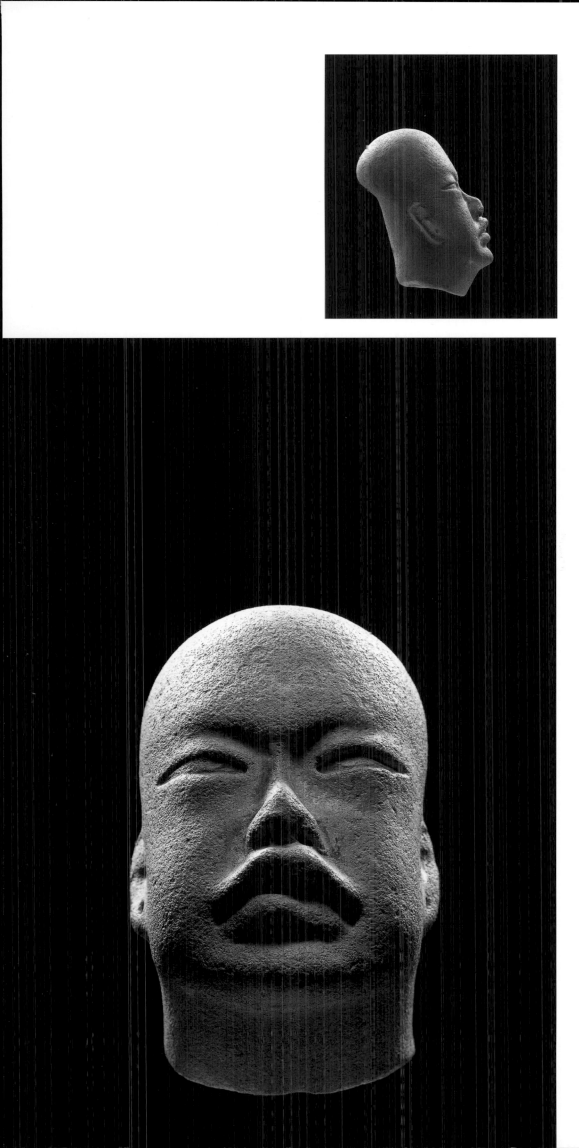

5
BABY FACE
OLMEC

1200 – 900 BC
South Veracruz
terracotta
h. c. 15 cm
Museo de Antropología de la Universidad
Veracruzana, Xalapa
inv.no. uv 100

Large quantities of hollow terracotta
figures have been found in Olmec tombs,
and their childlike aspect has caused them
to be given the name of *Baby Face*. This
fragment shows a head with the
characteristic Olmec jaguar mouth, the
slightly slanting eyes and the high forehead
created by deformation of the skull. The
newborn babies had their heads placed
between wooden boards whereby the still-
soft skull gained an elongated shape. A long
head, or high forehead, was considered
a sign of beauty among the Olmecs and
later on also among the Maya.

In the Olmec culture babies played an
essential part in rituals associated with the
dynasties and the rulers.

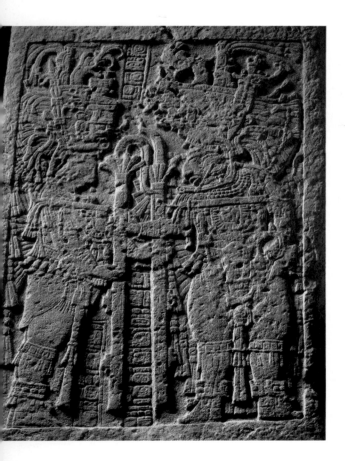

6

LINTEL 9

MAYA

AD 768
Yaxchilan
limestone
h. 227 cm, w. 75 cm, d. 36 cm
Museo Nacional de Antropología,
Mexico City
inv.no. 10-80369

This panel is from a carved lintel at the
entrance into Temple 2, and so anyone
entering the temple would have this scene
above their head. The scene represented is
the so-called flap-staff ceremony taking
place between, on the right lord Bird Jaguar
and on the left lord Great Skull,
representing the family of the queen, wife
of Bird Jaguar, and her brother. Bird Jaguar
appoints his brother-in-law in the
succession to the throne, as uncle to the
heir, Bird Jaguar's son Chel Te. In the
cartouche to be seen in front of Great
Skull's leg, in the second and third glyph
(reading from top to bottom) it reads *yichan
ahau*, literally, the brother of the mother of
the heir (*ahau*). By means of this ceremony
Bird Jaguar attempted to secure the
position of his son as the heir apparent. In
this he succeeded: Chel Te followed his
father as king, assuming the name of his
famous grandfather, Shield Jaguar.

Lintel 9 shows the last flap-staff ritual in
a series started in AD 736 and completed in
AD 768.

7

STELE

MAYA

AD 600 – 900
El chicozapote
earthenware
h. 137 cm
Museo Amparo, Puebla
inv.no. 57 PJ 1363

The relief shows two eminent persons
seated cross-legged on a throne. They are
wearing wide loincloths – or possibly a wide
waistband to hold up their trousers. Both
wear a tall headdress adorned with
feathers, a bead necklace and earplugs with
a bar-pendant. Archaeological finds reveal
that such jewellery was frequently made of
jade. To judge from their gesticulating
hands, the two figures are engaged in
conversation. The throne on which they are
seated has the picture of a mask, probably
showing the *Cavac* monster. This
emphasizes the religious nature of the
event. The banderole above between the
two heads has been damaged and the names
can no longer be deciphered. Thus it is
impossible to date the stele precisely. This
type of polychrome-painted stele was
often made by the Maya during the Classic
period, in commemoration of an important
event. There are traces of paint, mainly blue
and red, on the earthenware.

The style of this relief is reminiscent of
the reliefs on lintels and stelae from
Yaxchilán, although some influence from
Palenque can be detected in the treatment
of the faces. El Chicozapote lies in the basin
of the river Usamacinta, not far from
Yaxchilán.

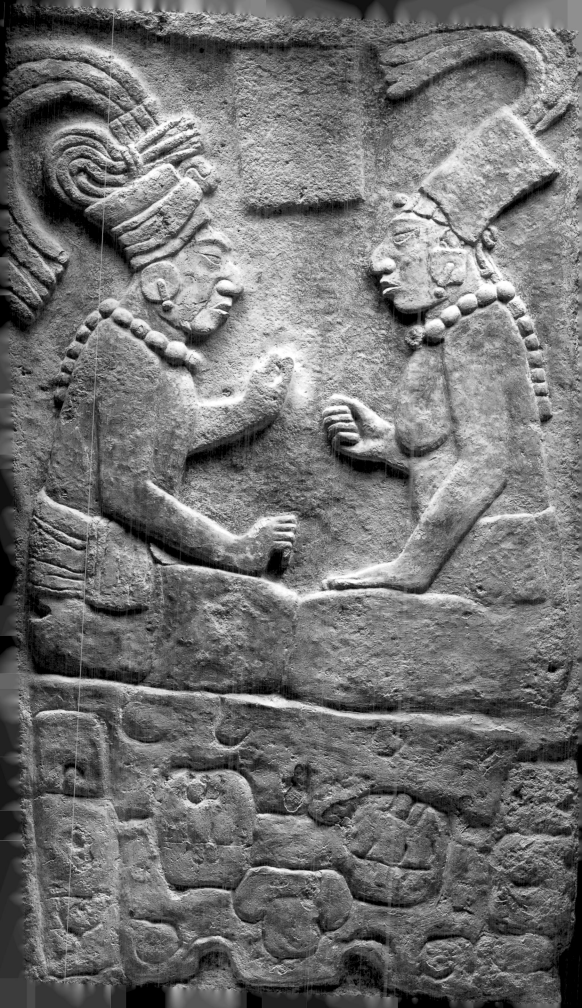

8

INCENSE BURNER STAND

MAYA

AD 600 – 900
Palenque
terracotta
h. 84.5 cm, w. 30 cm
Museo de Sitio 'Alberto Ruz Lhuiller',
Palenque
inv.no. 10-479190

On the cylindrical body of this incense
burner several masks can be seen set above
each other, and almost at the top the
mythical bird of God κ with head pro-
truding 'full face'. This god is associated
with power. On the upper rim in the centre
is a bracket without the vertical edge, on
which usually an unadorned censer would
be placed. Equally, it could hold a small
terracotta figurine such as cat. no. 11,
representing a dignitary seated cross-
legged. It is curious that the main part of
the censer does not show the face of a god,
but instead that of a man. Possibly this is a
deified ruler or dignitary from Palenque.
The face has a finely modelled mouth, half-
closed eyes, an eagle nose and slightly
rounded cheeks. He wears large earplugs
with rods in them and a nose jewel. The
wings of the stand denote the four cardinal
points in a crossing shape, with the central
axis at the crossing point. Such stands have
been interpreted as representing a cosmic
tree covered by divine, mythical symbols.
During the extensive excavation project of
the early 1990s more than a hundred
incense-burner stands were found in the
Group of the Crosses, one of Palenque's
major ceremonial centres.

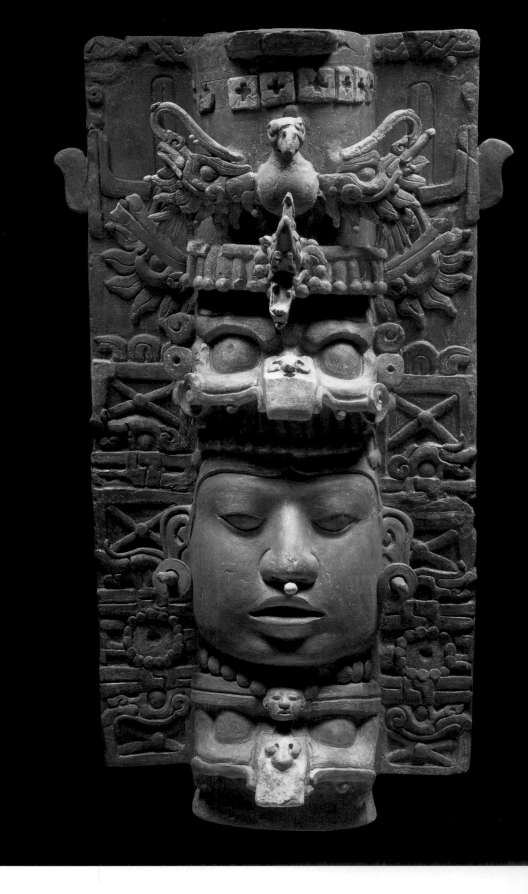

9

THE DUPAIX PANEL

MAYA

AD 625
Palenque
limestone
h. 41.2 cm, w. 26.8 cm, d. 6.5 cm
Museo Nacional de Antropología,
Mexico City
inv.no. 10-224213

The relief is named after Guillaume Dupaix who discovered it in 1807 in the rooms beneath the palace in Palenque. It shows six hieroglyphs of which the top two, from left to right, give the date: 12 *ahau* 8 *ceh*. This corresponds to the year AD 625, the end of *katun* 11 during king Pacal's reign (AD 615 – 683). A *katun* is a period of 7200 days and in the Classic period both the beginning and end of a *katun* would be celebrated. Under king Pacal in the 7th century AD, Palenque reached a pinnacle in its cultural achievements. At that time it was the trend-setter for plasterwork and carved reliefs.

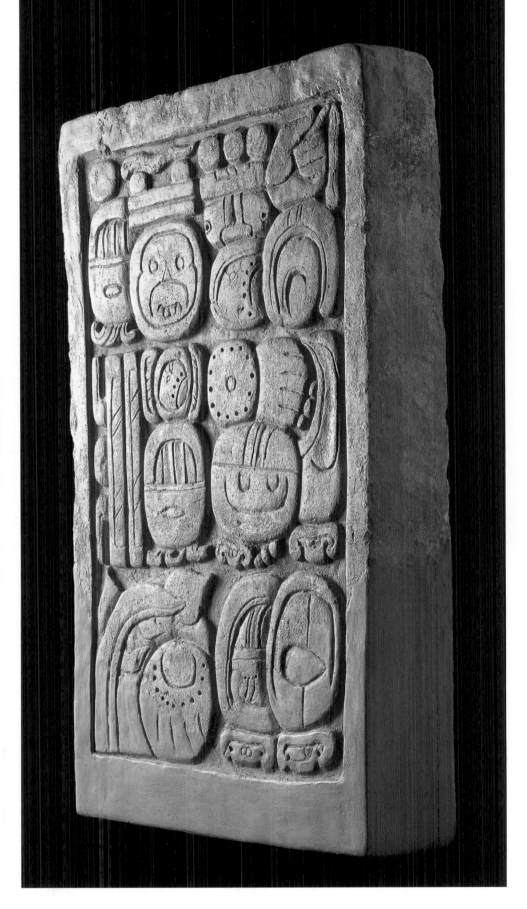

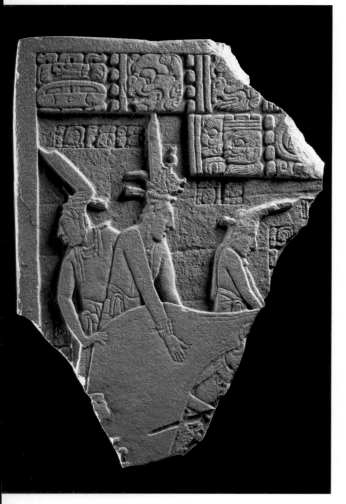

10
RELIEF SHOWING BEARERS
MAYA

AD 600 – 900
Palenque
limestone
h. 40 cm, w. 29 cm
Museo de Sitio 'Alberto Ruz Lhuiller',
Palenque
inv.no. 10-479218

This fragment from a larger relief found in
the Group XVI in Palenque shows five
figures dragging a heavy load and probably
coming down a staircase. Little is preserved
of the two lower figures, but those in the
upper region show considerable detail such
as headdresses, pectorals and loincloths.
The figures are absorbed in transporting
their burden. The central bearer, wearing
the finest headdress depicting God K, the
pattern of dynasties, is the leader. The date
is given in a hieroglyph, and corresponds to
1 April.

11

SEATED DIGNITARY

MAYA

AD 600 – 900
Palenque
terracotta
h. 16.5 cm
Museo de Sitio 'Alberto Ruz Lhuiller',
Palenque
Inv.no. 10-458662

The man sits cross-legged, dressed in
a type of loose corset falling from waist to
below the knee. The flap of his loincloth,
painted in the famous Maya blue, falls over
his crossed legs, upon which his left hand is
resting. He holds his right arm in front of
his waist, as if to support his left arm by the
elbow. He wears a bead necklace. His hair is
styled in short tufts with a centre parting,
and is crowned with a tall feather
headdress. The face has the shape of eyes
and nostrils typical for the Mayan ideal of
beauty. The whole appearance of the figure
defines him as one of the Palenque elite.
The figurine was found only about ten
years ago, in a residential district of
Palenque.

12

ENTHRONED RULER

MAYA

AD 600 – 900
Jaina
terracotta
h. 21.2 cm, w. 15.5 cm, d. 5.5 cm
Museo Nacional de Antropología,
Mexico City
inv.no. 5.1372

The ruler is seated on a throne placed in an
alcove. This setting is part of an
architectonic whole with an ornate
architrave and a ridge or crest. The ruler
wears wide protective guards round his
waist which makes him resemble a ballgame
player. Two dwarfs are seated at his feet.
Dwarfs are often found in Maya courts
where they acted as intermediaries
between people and the world of the gods.
They had strong links with the earth and
thus in particular with the gods of the
Underworld. Incidentally, the presence of
dwarfs and their role in royal courts is not
restricted to the Maya culture. Other
peoples such as the Olmecs and the Aztecs
also endowed dwarfs with special
significance.

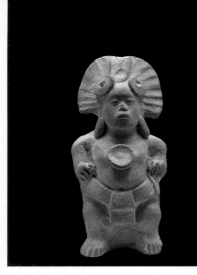 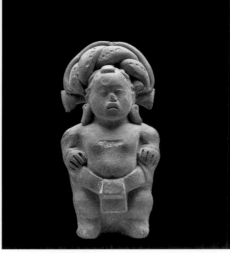 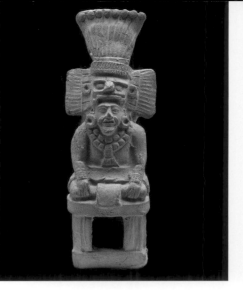

13a

DWARF

MAYA

AD 600 – 900
Jaina
terracotta
h. 10.5 cm, w. 5.5 cm, d. 4 cm
Museo Nacional de Antropología,
Mexico City
inv.no. 10-6305

The dwarf stands with bare torso, wearing a heavy *rodete*, earrings and a *maxtlatl*, loincloth. The pectoral has been lost. The eyes are closed, implying he is dead.

Many terracottas have been found in the Maya graves on the island of Jaina and the nearby mainland of Campeche that tell us about Mayan civilization. Dwarfs, for instance, would be asked to establish contact with the world of the gods and the Underworld. Many of the funerary objects found can be blown like a whistle or pipe. This is also true of the dwarf figurines. Possibly the Maya hoped that by playing on the dwarf-pipe they could summon their ancestors and the gods of the Underworld.

13b

DWARF

MAYA

AD 600 – 900
Jaina
terracotta
h. 10.4 cm, w. 5 cm, d. 4.3 cm
Museo Nacional de Antropología,
Mexico City
inv.no. 10-79526

The dwarf stands bare-breasted, wearing a a fan-shaped headdress made of *amate* (bark-paper) and two circular clips on his forehead. He also has earrings, a pectoral from which the inlay work has been lost, and a loincloth. The eyes are closed, implying he is dead.
Many terracottas have been found in Maya graves on the island of Jaina and the nearby mainland of Campeche; they tell us much about Mayan civilization. Dwarfs, for instance, would be asked to establish contact with the world of the gods and the Underworld. Many of the funerary objects found can be blown like a whistle or pipe. This is also true of the dwarf figurines. Possibly the Maya hoped that by playing on the dwarf-pipe they could summon their ancestors and the gods of the Underworld.

14

ENTHRONED DIGNITARY

MAYA

AD 600 – 900
Jaina
terracotta
h. 17 cm, w. 6 cm
Museo Nacional de Antropología,
Mexico City
inv.no. 5.155

Seated cross-legged on his throne is a man holding very high office. He wears a loin-cloth, wristbands and an elaborate necklace. The feather headdress together with the mask, form his magnificent headgear.

Hanging from his pectoral is a skull, reminder that life and death are inseparably one. This terracotta figure was made as a funerary gift.

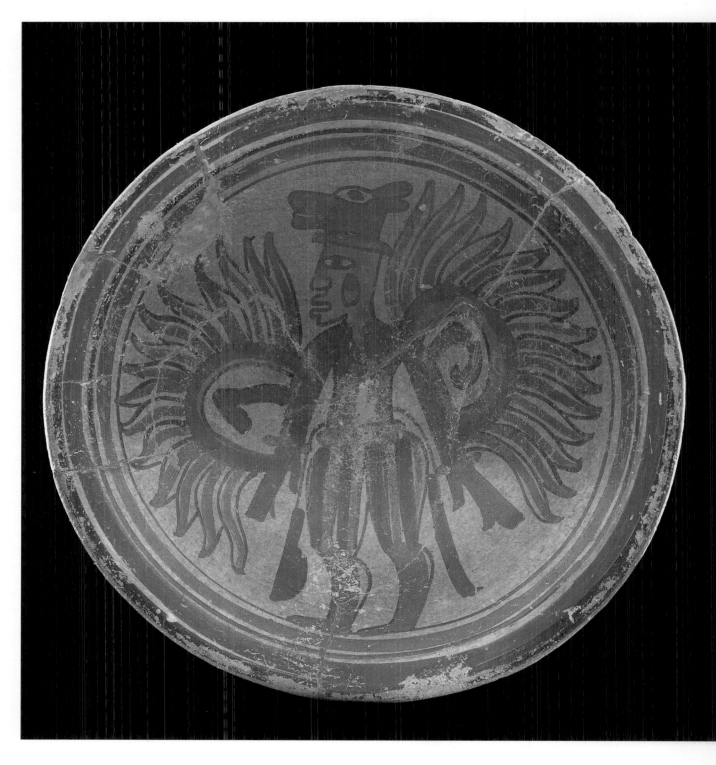

15
DISH

MAYA

AD 600–900
Jaina
earthenware
h. 7.3 cm, diam. 27.6 cm
Museo Nacional de Antropología,
Mexico City
inv.no. 10-94528

This polychrome painted dish shows a
huntsman wearing a stag's head as
headdress. His skin is coloured black as so
often with hunters and warriors. He is
carrying two shields decorated with
feathers, and thus appears to combine
aspects of the huntsman and warrior.

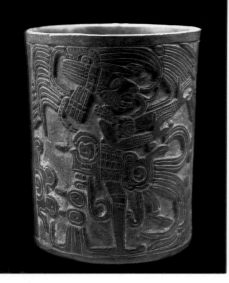

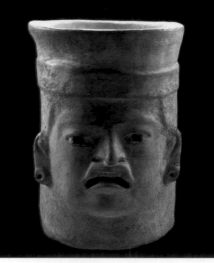

16

VASE WITH ENGRAVED SCENE
MAYA

AD 600 – 900
Yucatan (?)
terracotta
h. 16.5 cm, diam. 13.6 cm
Museo Nacional de Antropología,
Mexico City
inv.no. 10-077413

Against the dark background of the vase, a figure standing in profile is engraved on the rounded surface. He is a man wearing an exuberant feather headdress, earplug, pectoral, a necklace, wrist- and knee-guards, and a corset-like garment falling from waist to mid-thigh, decorated with a shield which, unlike the rest, is presented frontally.

On the vase's other side is a long panel bearing glyph-like symbols that, in fact, have no meaning but function merely as decoration – a commonly-found feature.

The exact spot where this vase comes from is not known, but it is possibly from the Maxcanuc region of Yucatán.

17

DIGNITARY
MAYA

AD 600 – 900
Jaina
Terracotta
h. 18.0 cm, b. 14.3 cm
Museo Nacional de Antropología,
Mexico City
inv.no. 10-4210

This standing figure, hands by its side, is adorned with a looped headdress above a 'page-boy' hairstyle that falls on either side of the ears. The jewellery consists of earrings and pectoral. The clothing is suggested by geometric patterns on a woven jacket tied round the waist and with a loop at the front. The jacket is worn above a 'kilt' and the jacket flaps can be seen near the hands. It is somewhat difficult to decide the gender of this figure, which was found in a grave in Jaina.

18

BRAZIER EFFIGY
ZAPOTEC

300 BC – AD 100
Monte Alban
terracotta
h. 19 cm, diam. 12,3 cm
Museo Nacional de Antropología,
Mexico City
inv.no. 10-2665

The brazier has a face pictured on it, showing the typical Olmec feature of a thick-lipped mouth with turned-down corners. The teeth are visible. Considering the Olmecoid aspect of the face, this brazier can be dated to the early Zapotec period of Monte Alban, about the beginning of the Christian era. In this Proto-Classic age the Olmec civilization was beginning to decline, although it still retained its stylistic influence in large regions of Mesoamerica.

The brazier was found in a grave in Monte Alban.

19

STELE OF NORIEGA

ZAPOTEC

AD 600 – 900
Noriega, near Cuilapan
stone
h. 91 cm, w. 61,5 cm
Museo de las Culturas, Oaxaca
inv.no. 10-104365

This stele, or stone slab, takes its name from the place where it was found, on the Noriega farm, or *hacienda*, near Cuilapan, in the Oaxaca valley. The stele is decorated with three horizontal scenes, carved in low relief. The lower scene – reading from bottom to top – depicts the parents of prince 6 Buho, Owl, with his father left and his mother right. The central picture shows the birth of Buho, Owl, on the left, with Lady 3 Water who is seated in front of a flowering agave plant, symbol of fertility. On the right, 6 Buho accompanied by Lord 2 Water, makes an offering to Lady 8 Water. The top section pictures 6 Buho twice: as an adolescent and as an adult, both figures looking left towards Lady 6 Rod (Furball?).

The women in this genealogical representation are wearing only the *quechquemitl*, a characteristic woman's garment.

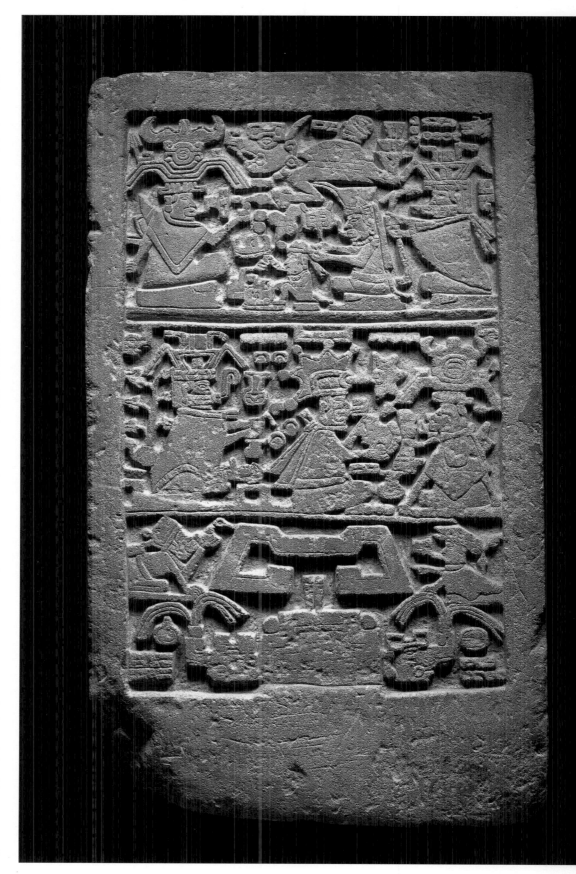

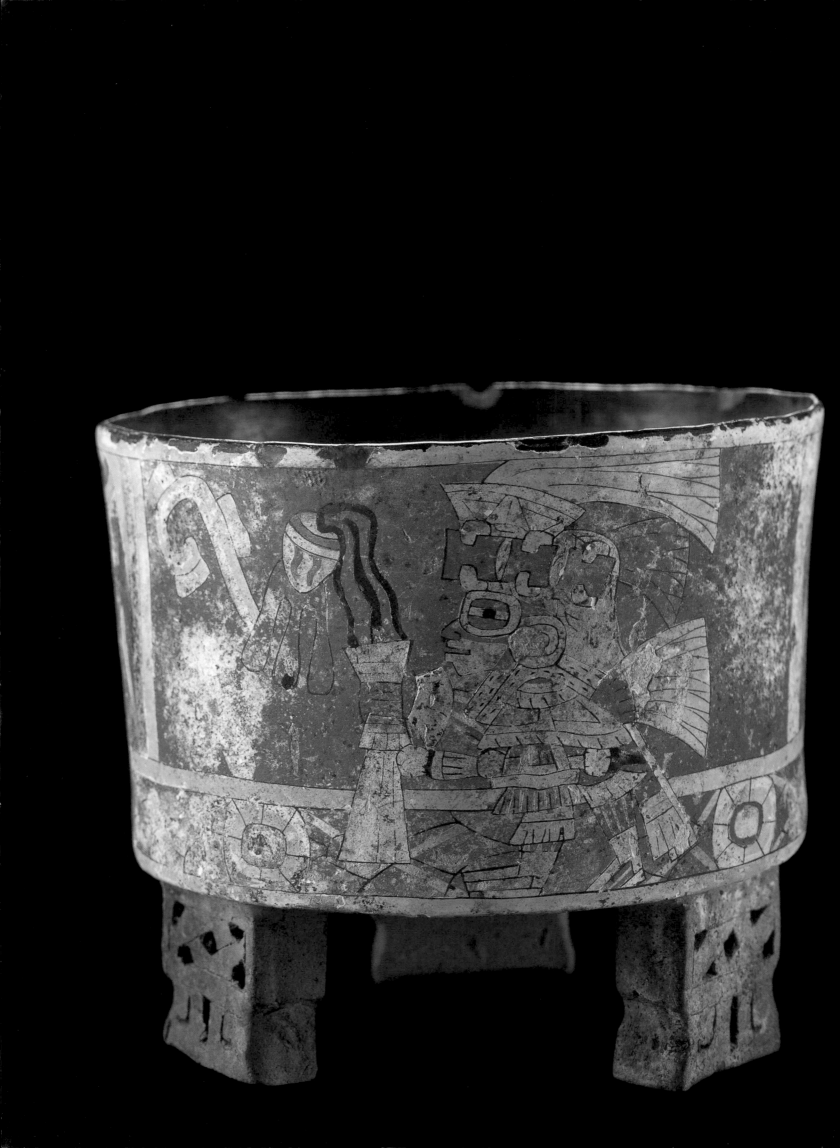

20

TRIPOD

TEOTIHUACAN

AD 300 – 650
Teotihuacan
terracotta
h. 14.3 cm, diam. 16.7 cm
Museo Nacional de Antropología,
Mexico City
inv.no. 10-79930

A tripod with applied plaster, the
polychrome painting showing a sacrificial
offering. A priest with an immense head-
dress is holding a knife made from
obsidian, volcanic glass, with which he has
cut out the victim's heart. Blood streams
from the sacrificed organ. On the lower
band, captured between green lines and
interrupted by the priest's figure, are
turquoise-coloured discs, a reference to the
'precious' and remarkable nature of the
scene.

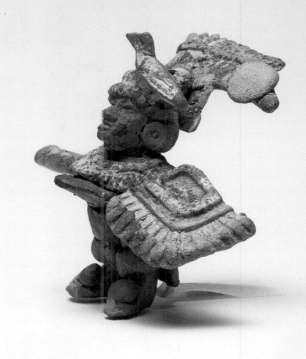

21

WARRIOR

TEOTIHUACAN

AD 300 – 650
Teotihuacan
terracotta
h. 5 cm, w. 5.5 cm, d. 3 cm
Museo de la Cultura Teotihuacana,
Teotihuacan
inv.no. 10-4112632

This warrior figurine was made using
a mould and applied work. He wears
ceremonial battle dress with a headdress
and leg guards. In his left hand he carries
a shield decorated with feathers. Huge
numbers of small terracotta figurines have
been found in Teotihuacan. There was
clearly a vast production going on from
about 150 BC until the fall of the city in
around AD 650. Initially the figures were
hand-formed solid terracottas but after
around AD 250 moulds began to be used,
giving a further impetus to production.
The headdress and other details would be
applied later. The Teotihuacan figurines
have been found chiefly in dwelling
complexes and not in graves or temples.
This suggests a function during religious
ceremonies in the home.

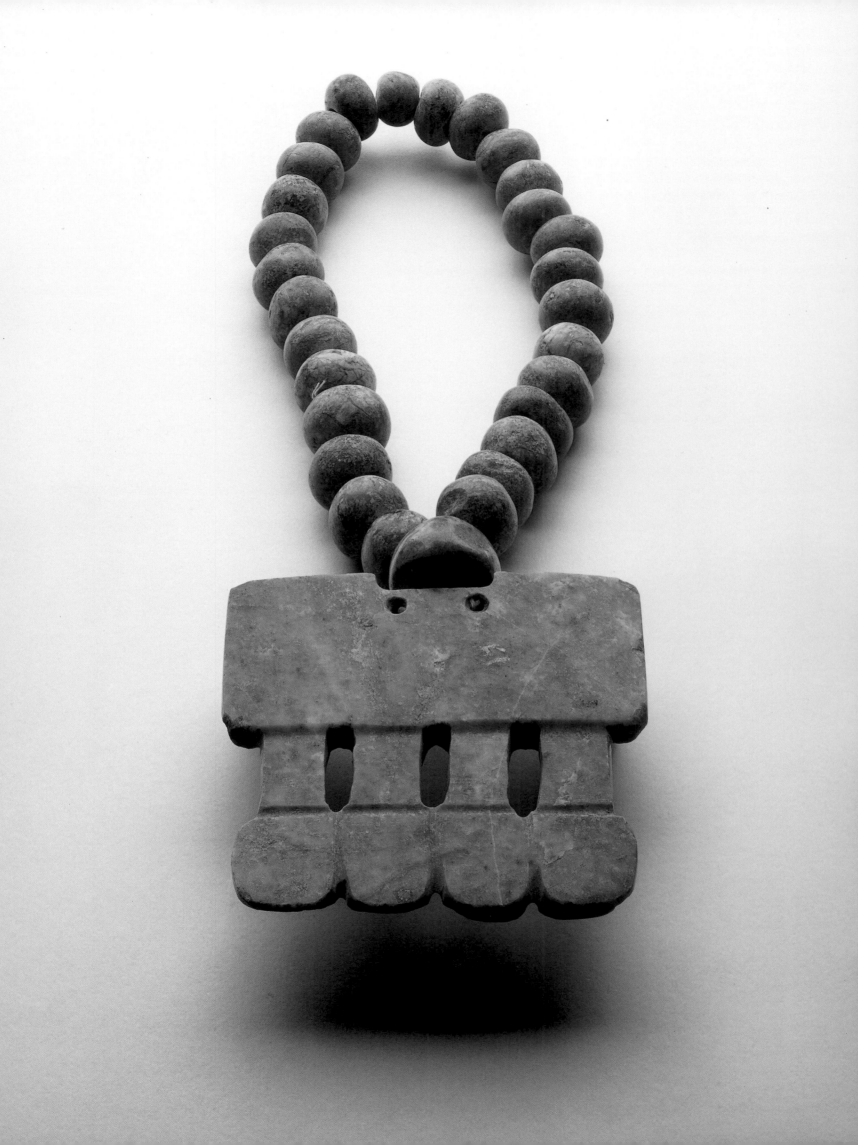

22
NECKLACE WITH PENDANT
GUERRERO

AD 300–1521
Mezcala region
jade and calcite
h. 20.0 cm
Museo Nacional de Antropología,
Mexico City
inv.no. 10-77303

The Aztecs would often use offering gifts
taken from older civilizations, thereby
bestowing greater significance on the act of
offering and the object sacrificed. Objects
dating as far back as the time of the Olmecs
were found in Aztec sacrifices during
excavations of the Templo Mayor project.

Jade objects such as beads with absolutely
no markings are extremely difficult to date.
However, the small model of a temple
hanging from this jade necklace, is
characteristic of objects found in Guerrero,
the region of the river Mezcala. These
works can be dated to between AD 300 and
900, and possibly a little earlier. However,
in the absence of scientific excavations, an
accurate dating of Guerrero objects
remains problematic.

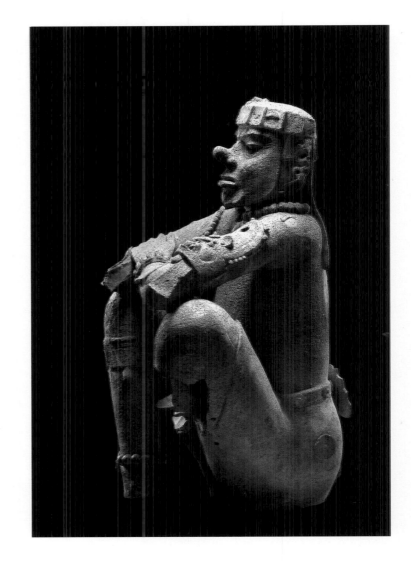

23
SEATED MAN
ZAPOTEC

AD 300–900
Oaxaca
earthenware
h. 66 cm, w. 42 cm
Museo Nacional de Antropología,
Mexico City
inv.no. 10-229754

This person of high rank is seated, knees
pulled up with his bent left arm resting on
them. The right arm has been broken off, as
have the feet. The jewellery consists of
a pectoral, leg bracelets and arm bracelet
showing a picture of a jaguar god. There is
also a mask, either part of or above
a Pinocchio nose. Further, the figure wears
a headband, and trousers with a hip belt
fastened at the back with a large rosette. In
view of the attributes this ceremonially clad
figure could be a warrior or priest.

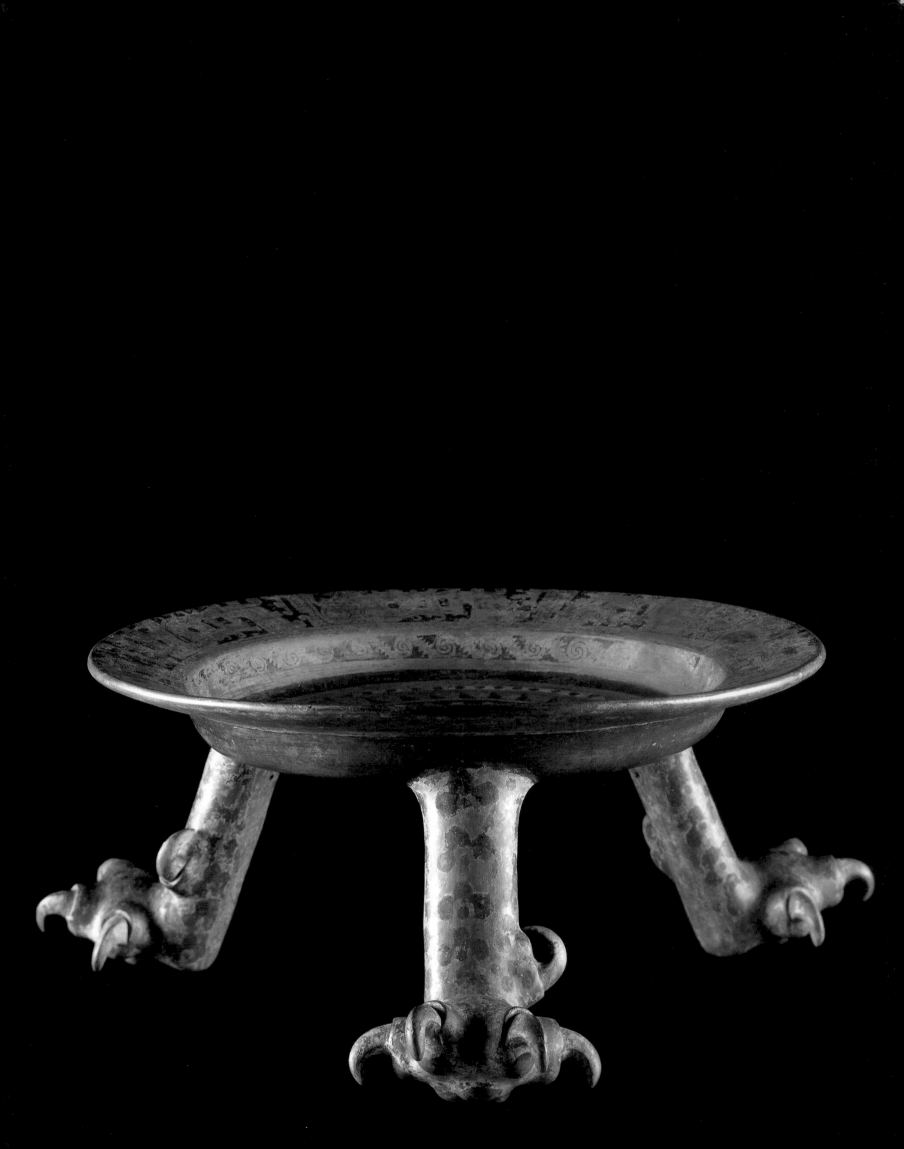

24
JAGUAR-CLAW,
THREE-FOOTED DISH

MIXTEC

AD 900 – 1521
Oaxaca
terracotta
h. 13.5 cm, diam. 34.6 cm
Museo Naciona de Antropología,
Mexico City
Inv.no. 10-79133

This polychrome painted dish rests on
three feet which are modelled in the shape
of a jaguar's claws. On the inside of the dish
is a painting of Ita, butterfly god of the
Mixtecs. There was already an association
between the (night) butterfly, the jaguar
and war in the time of the Zapotecs. It is
known that Aztec warriors clothed in
jaguar costume belonged to the military
elite.

This three-footed dish was possibly used
in ceremonies connected with war.

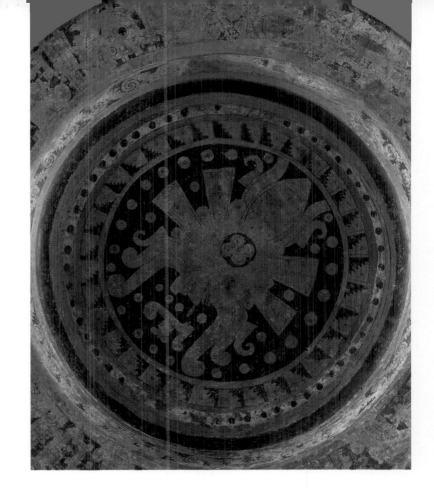

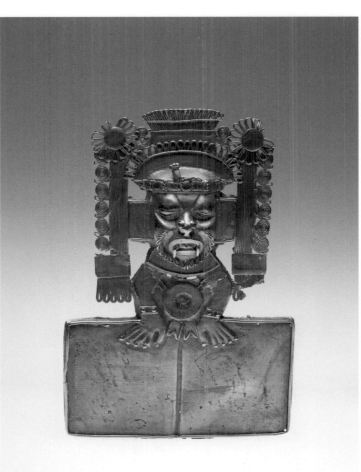

25
PECTORAL

MIXTEC

AD 1250 – 1521
Papantla, Veracruz
gold
h. 10.6 cm, w. 7.4 cm
Museo Nacional de Antropología,
Mexico City
inv.no. 10-9676

The 15th and early 16th century, the Late
Post Classic, saw an increasing use of
precious metals. Outstanding among the
metalworkers were the Mixtecs who, when
conquered by the Aztecs, were also put to
work by them.

This ornament, to be worn as a pendant,
shows the upper torso of a dead person. The
fact that the eyes are half (or completely)
closed, indicates that a person is dead. The
hands are resting on flaps. The figure is also
wearing a pectoral. His headdress is
composed partly of feathers and garlands
with long strands hanging down from them.
The crown is fastened onto the head with
a tape. The dead man has a beard, and,
curiously, two extra eye-teeth. This piece
of jewellery was also a grave gift.

26

EARSPOOLS

MIXTEC

AD 1250 – 1521
Oaxaca
gold
diam. 4 cm, d. 1.3 cm
Museo de las Culturas, Oaxaca
inv.no. 10-105428 1/2 and 2/2

In the 15th and early 16th century the
Mixtec jewellers enjoyed a Golden Age.
Much of their jewellery was made for the
ruling classes, including these two earplugs
or earspools, which formed part of a
funerary offering given to the dead.

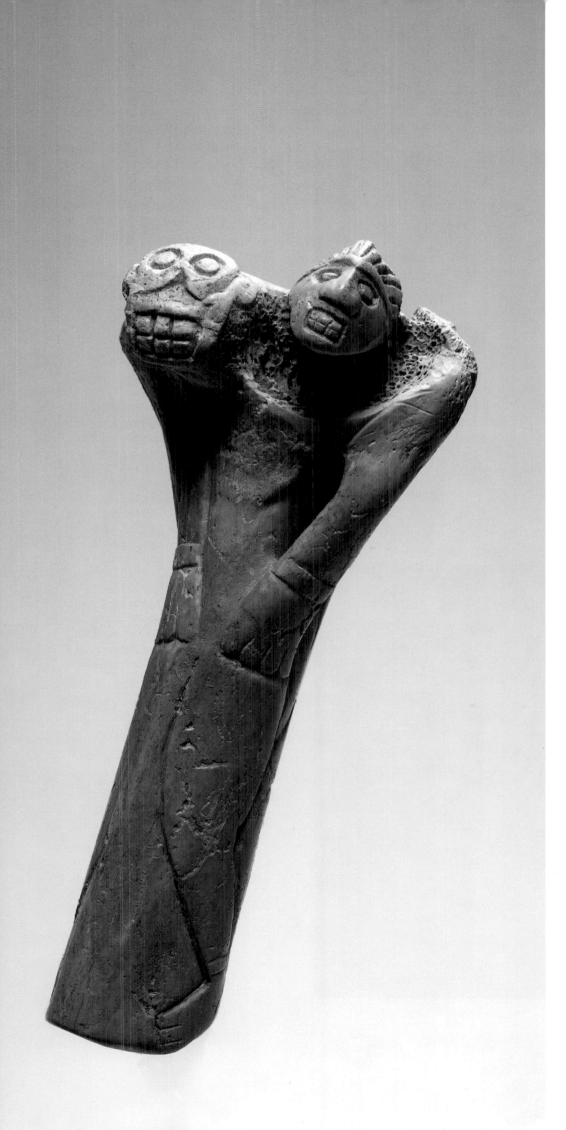

27
ROYAL SCEPTRE

AZTEC

AD 1428 – 1521
Central Highlands
jaguar bone
l. 11 cm
Museo Nacional de Antropología,
Mexico City
inv.no. 10-594850

The sceptre, made from jaguar bone, has
a skull on the left, and on the right the face
of a living person. The rest of the body is
indicated by incising. The material from
which the sceptre is made – the bone of
a jaguar – enabled the strength and power of
the animal to enter the person who held it.

The way in which the two heads are
represented suggests the idea of dualism, so
strong in the Mesoamerican world: life and
death are indivisible, and form one whole.

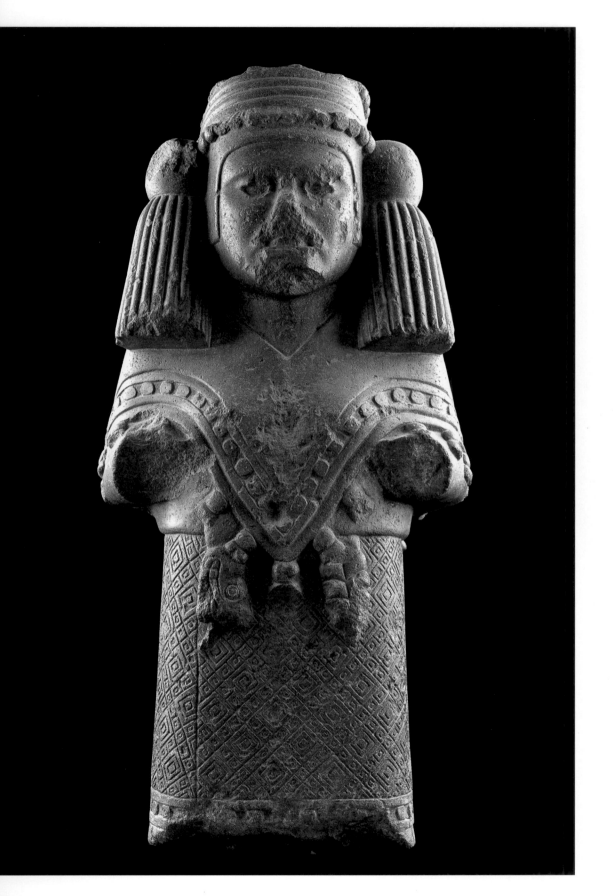

FEMALE DIGNITARY

AZTEC

AD 1428 – 1521
Mexico – Tenochtitlan
stone
h. 85 cm, w. 37 cm, d. 25 cm
Museo Nacional de Antropología,
Mexico City
inv.no. 10-82215

The standing female figure wears
a *quechquemitl* or wrap-around skirt. It is
bordered with circular shapes and woven
with geometric patterns. The belt holding
the skirt round the waist is shaped like
a rattlesnake. The statue has lost both its
arms. The hair has two tight braids at the
back ending in a kind of ball. Over the skirt
another piece of cloth has been draped and
the braids hang against this. The back of the
hair is covered with a piece of pleated
amate, that is, paper made from the bark of
the ficus tree. At the front the long hair
hangs in a heavy swathe on either side of
the face, falling below the waist. The figure
wears a kind of cap surmounted by
a headdress that has four bands resting on
a row of beads made from precious stones.
The rattlesnake belt suggests that the figure
represents the goddess Coatlicue, 'she of
the serpent skirt', who was an important
fertility goddess in the Aztec pantheon.

WARRIORS

With the rise of state societies in ancient Mexico, which started around the second century AD, came the gradual appearance of military groups. Towards the close of the pre-Columbian era they had total control. Their weapons were spears and arrows with the heads made of obsidian (volcanic glass) or flint. They also used bow and arrows, and instruments for throwing spears. Their armour consisted of a kind of suit made from tough fibres and wooden shields covered in leather or feathers.

The warriors distinguished themselves from ordinary people with their special coiffure and flamboyant headdresses. These headdresses would often symbolize the gods, taking the form of a wild animal's head, like the eagle, the jaguar or a snake. In this way the power and strength of the animal was transmitted to the human wearer.

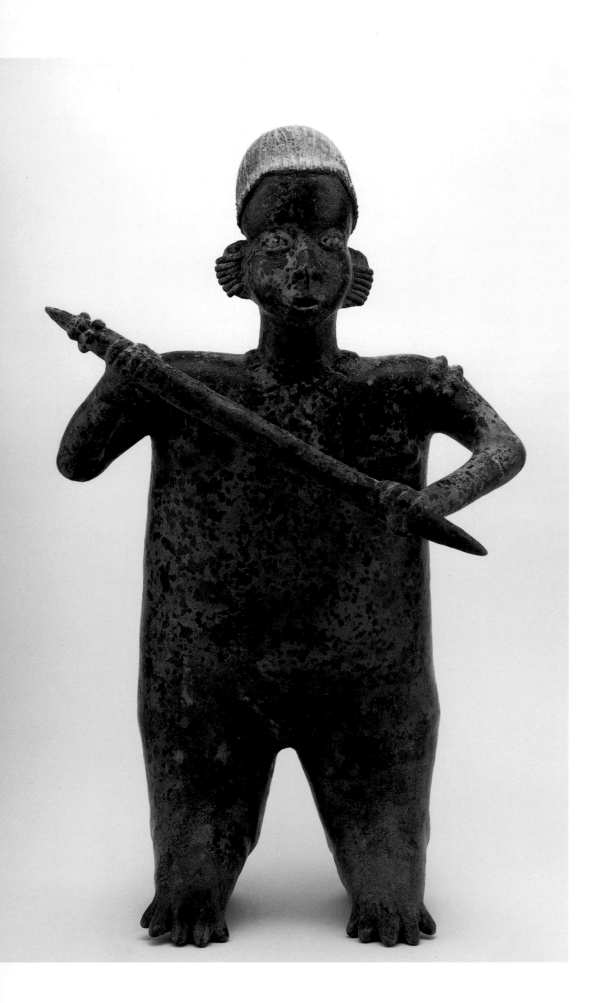

29
WARRIOR
PROTO CLASSIC

300 BC – AD 300
West Mexico
terracotta
h. 72.0 cm, w. 43.0 cm
Museo Nacional de Antropología,
Mexico City
inv.no. 10-222299

Quantities of grave gifts have been found in
the shaft-tombs of Jalisco, which like the
excavations of Nayarit and Colima often
found their way onto the international art
market. This hollow earthenware figure
carries a stick with a pointed tip. Two bands
of beads have been applied onto his upper
arms. In his ears he wears horizontal rings
and on his head is a helmet decorated with
lines. One interpretation for the lines on the
head may be that they denote the hairstyle.
This would then represent a ceremonial
warrior, not someone who has seen action
in battle.

The language spoken by the people of
West Mexico in early times is so far
unknown.

30

FRAGMENT OF A STATUE

ZAPOTEC

AD 600 – 900
Valley of Oaxaca (?)
terracotta
h. 28 cm
Museo de las Culturas, Oaxaca
inv.no. 3201 (MF)

This is a fragment of a large hollow terra-
cotta statue representing an important
dignitary. He wears a pectoral and nose
ornament. The hair is styled eccentrically
on the left of the head in a quiff or crest.
A thick cord runs round the back of the
head via the left cheek and under the chin.
Probably this decoration has been broken
above the right ear and originally the cord
would have encircled the whole face. Its
significance is not clear. Possibly this
terracotta represents a ruler or some high
dignitary who was taken captive.

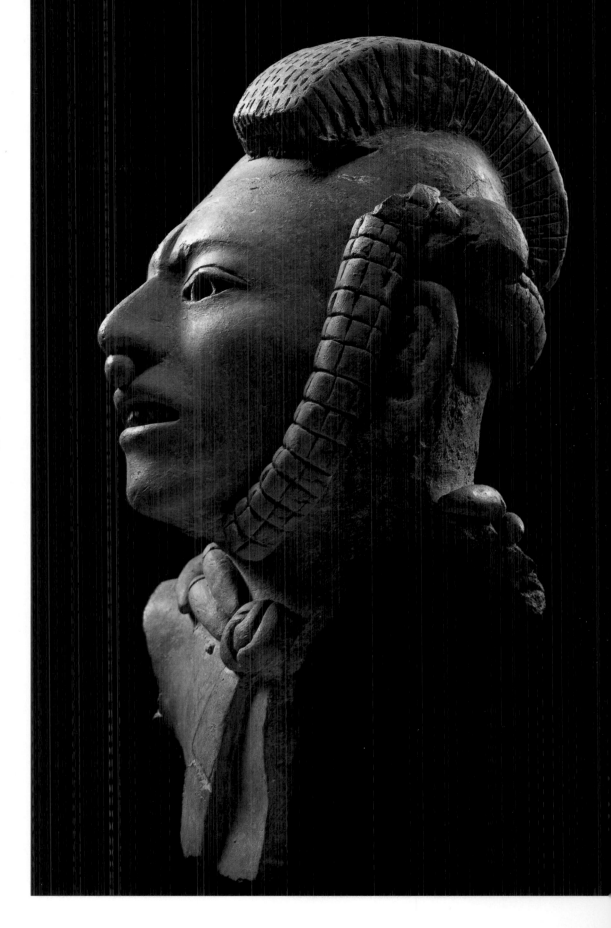

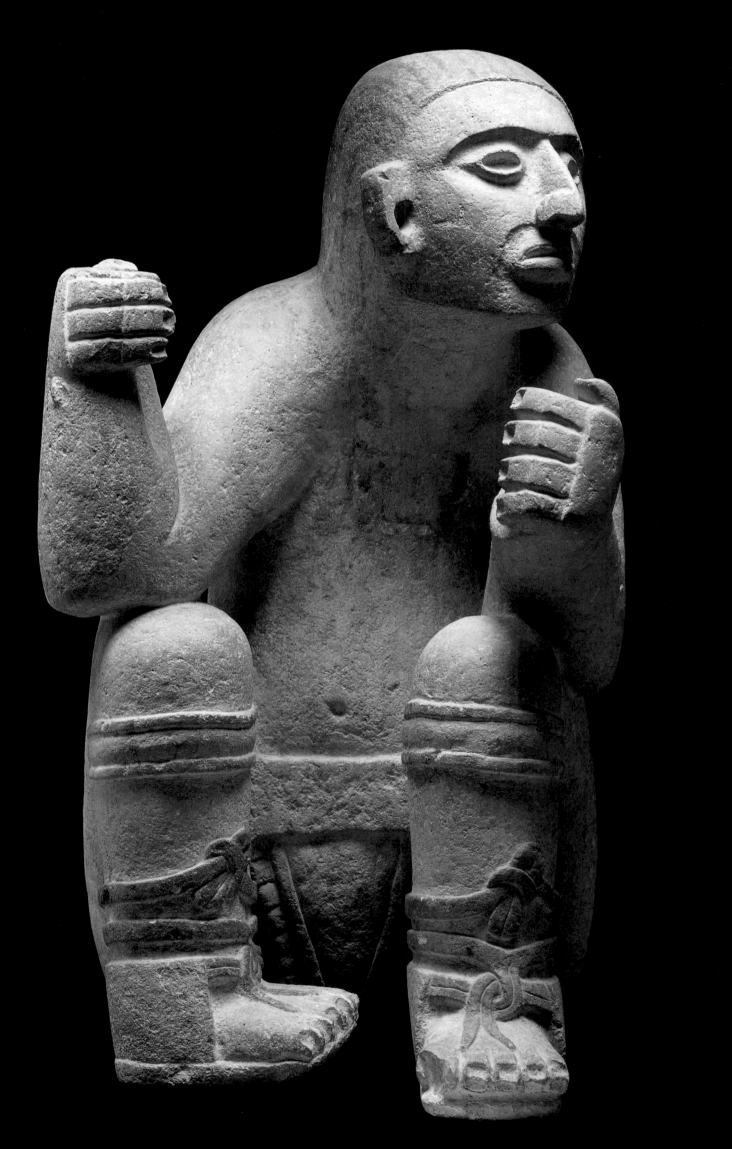

31
STANDARD BEARER
MAYA

AD 900–1000
Chichén Itzá
limestone
h. 94.0 cm, d. 62.0 cm
Museo Regional de Yucatán 'Palacio Cantón',
Merida
inv.no. 10-290459

Seated male figure, the hands shaped to
hold a flagpole, or standard. The twisted
right foot is remarkable, turned so that the
sandal is clearly shown. The figure wears
the leather sandal called *cactles*, which has
a protection for the Achilles tendon. The
sandals may also be made from *ixtle*, strong
fibres from the agave plant, still worn today
by Maya high officials living in Chiapas.
Also indicated in the stone are knee-
protectors, a loincloth and a pectoral in the
shape of the *Ik* symbol which represents
strength and is also one of the days in the
Maya calendar. Possibly the figure once
wore a headdress, or the painting represent
the hairstyle. There are remains of paint
visible in several places.

The sculpture was found on the great
square beside the so-called platform of
Venus, in Chichén Itzá.

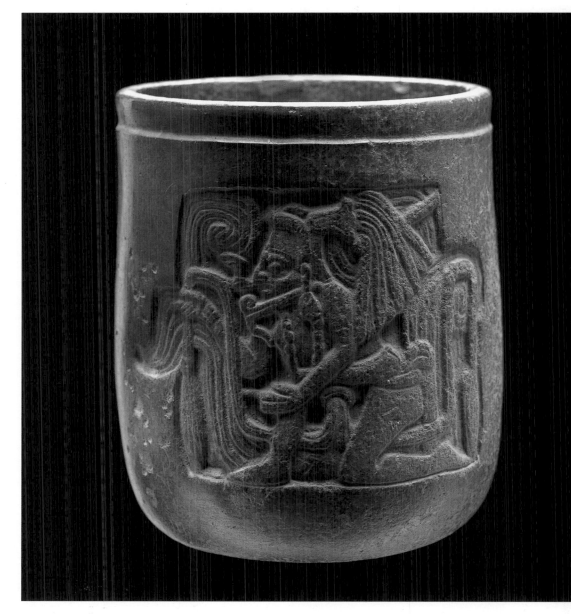

32
VASE
MAYA

AD 600–900
Yucatan (?)
terracotta
h. 15 cm, diam. 13.5 cm
Museo Nacional de Antropología,
Mexico City
inv.no. 10-9828

This cylinder-shaped vase has identical
scenes at each end, showing a person of
importance. The vase was made using
a mould. A black mark from the firing can
be seen on part of it. The scenes show a
richly dressed figure kneeling on one knee,
with a feather headdress, earplugs, a long
staff, a bead necklace and a bracelet on the
left upper arm.

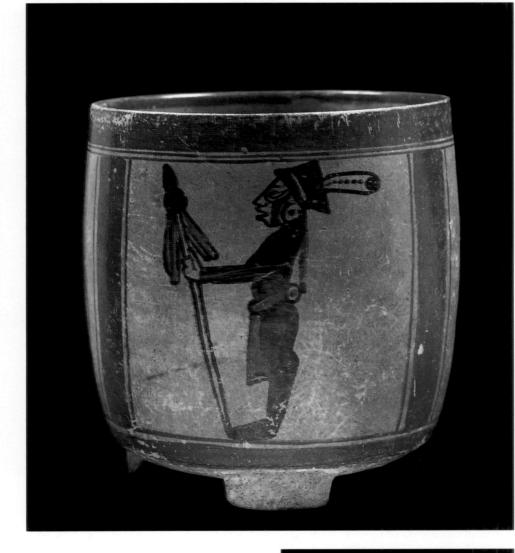

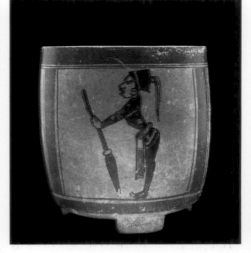

33
THREE-FOOTED BOWL

MAYA

AD 600–900
Campeche (?)
terracotta
h. 19 cm, diam. 18 cm
Museo Regional de Antropología
'Carlos Pellicer', Villahermosa
inv.no. 0071

The bowl, painted in three segments, shows warriors in profile, holding a spear or wooden bat. As is often the case in Maya painting, the warriors are coloured black. Polychrome is only used for parts of the headdress and the loincloth. The bowl has the characteristic terracotta colour often seen in the second half of the Classic period. Against this, the black figures of the warriors stand out dramatically.

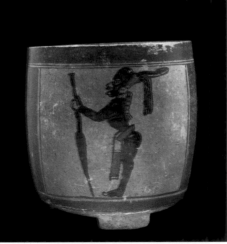

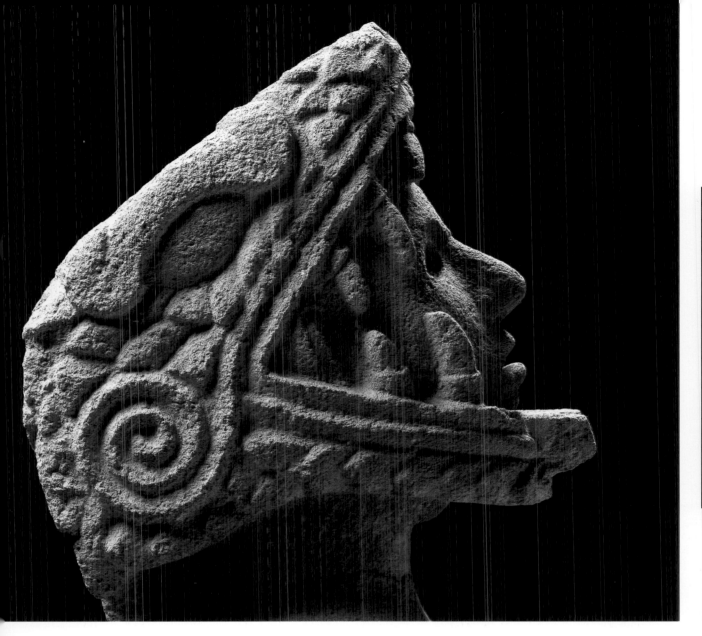

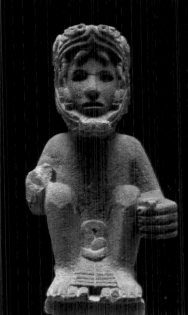

34

SERPENT WARRIOR

AZTEC

AD 1428 – 1521

Teotenango

stone

h. 52.5 cm, w. 29 cm, d. 19 cm

Museo de Sitio, Teotenango

inv.no. A-52207

In the ninth century when the Toltecs began to push outwards from Tula, the Matlatzinca built a walled town, naming it Teotenanco, today Teotenango. In the Nahuatl language the name means 'within the divine enclosure'. The enclosure, or wall, tells us that these were still troubled times. Nevertheless, under the stabilising influence of the Toltecs, a period of cultural burgeoning took place. An example of the early Post-Classic flourishing is this sculpture. A seated figure is shown, knees pulled up towards the chest, the head peering out of a snake's mouth. He wears a *maxtlatl*, or loincloth, knotted at the front, its ends draped over his feet. The left hand of the sculpture is made so that a banner or standard can be slotted into it. In Teotenango there was a so-called Serpent House where possibly this standard bearer was placed in order to keep silent watch.

HUEHUETL (STANDING DRUM)

LATE AZTEC

circa 1520
Malinalco
wood
h. 98.0 cm
Museo Arqueológico de Estado de México,
Instituto Mexiquense de Cultura, Toluca
inv.no. 10-102959

This standing instrument, a *huehuetl*, has lost the skin that would have been stretched across it to form the drum. The relief shows the eagle-warrior above the jaguar-warrior. Warriors in eagle or jaguar costume formed part of the crack troops of the Aztec monarchs. They are pictured in procession around the drum, singing and bearing small tablets made from *amate* (bark) paper. In order for the drum to resonate, a double v-shaped section has been cut away. Tradition has it that the drum was buried by the Indians as the Spanish approached Malinalco. However, the drum is in a good state.

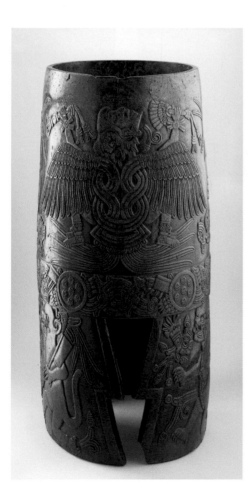

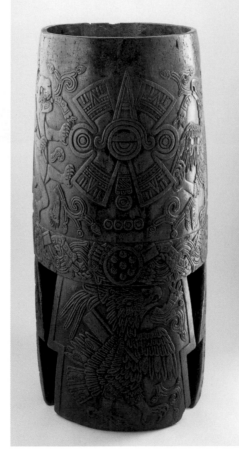

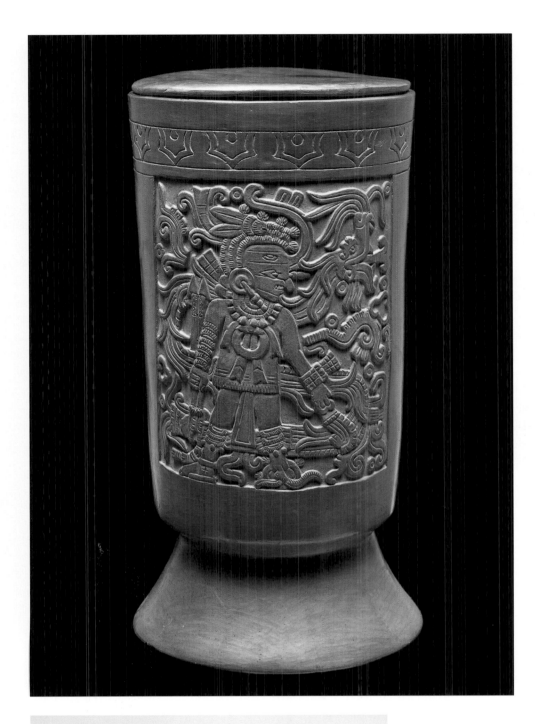

**URN WITH OBSIDIAN DUCKS'
HEADS**

AZTEC

AD 1428 – 1521
Mexico – Tenochtitlan
terracotta
urn: h. 34.1 cm, diam. 17.5 cm;
ducks' heads: l. 1.5 cm, w. 0.5 cm
Museo del Templo Mayor, Mexico City
urn: inv. no. 10-168823.1/2;
ducks' heads: 10-168842/1-14

This urn with relief decoration has a plain
lid and stands on an unadorned ring. It
contained human ash and some funerary
gifts including these 14 ducks' heads made
of obsidian (volcanic glass). The relief,
applied using a template, shows the god
Tezcatlipoca, Smoking Mirror,
recognizable by the smoking mirror that
replaces his left foot. His right foot, shown
in profile, wears the *ixcactli* sandal, made
from agave fibres (sisal). Although the face
is in profile, the body is presented frontally.
The figure wears a magnificent feather
headdress, a nose-ring and an earplug with
pendant. He holds an *atlatl*, or javelin
thrower, in his left hand and in the right,
two javelins pointing upwards. He also
wears a many-stranded necklace, a bead
bracelet round his left wrist and on the
right an armguard decorated with feathers.
The circular pendant on his chest hangs in
front of his *xicolli*, an official garment rather
like a short jacket, which was worn on
special occasions. He wears a loincloth with
the flap showing between the legs, and
a band round each leg. Presumably this is an
important Tezcatlipoca warrior whose
cremated remains were placed in the urn
together with funerary gifts. Although
Tezcatlipoca can be seen in the foreground,
the man stands before the statue of
Quetzalcoatl who, as the Plumed Serpent,
winds his way after him. In typical
Mesoamerican tradition, this relief presents
two gods who were the absolute opposites
of one another.

The shape of the urn copies archaic
Toltec and the imitation 'fine orange'
pottery reveals the influence of the Gulf
Coast in its elaborate ornamentation.
Probably Totonac potters were employed
by the Aztec elite after their territories had
become subsumed into the Aztec kingdom,
in the same way that Mixtec goldsmiths
started working for the Aztecs when they
too were conquered.

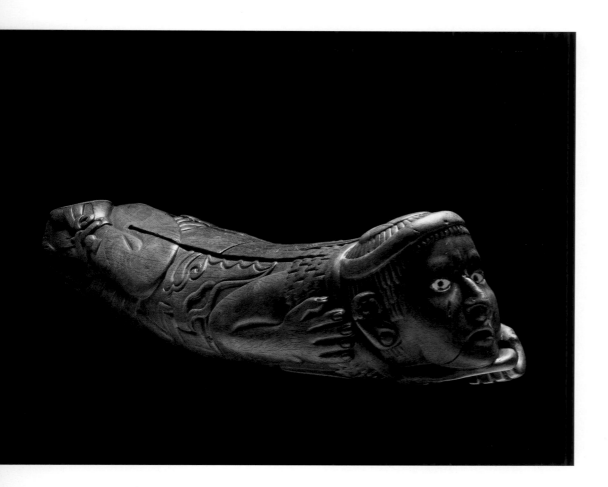

37

TEPONAZTLE

TLAXCALTEC

AD 1450 – 1521
Tlaxcala
wood
l. 60 cm, w. 15 cm
Museo Nacional de Antropología,
Mexcio City
inv.no. 10-81663

Teponaztle is the name of the Mexican
horizontal drum. It is reminiscent of
a xylophone with two tongues fitted into
the wood through notches or grooves.
The wooden drum here shows a reclining,
elaborately dressed warrior, his arms lying
along his body. The eyes are formed from
inlaid shell, the pupils being obsidian
(volcanic glass). The hair, suggested by
grooved lines, is held in place by
a headband. Besides this type of horizontal
drum there was also a standing, vertical
shape known as a *huehuetl* (see cat. no 35).

PRIESTS AND SHAMANS

From the earliest dawn of ancient Mexico there were people who specialized in healing the sick and organizing the agricultural calendars. These people are called shamans. They led the ceremonial festivals that were performed to win the favour of the gods and bring people in contact with supernatural forces. During some of the rituals the shamans would eat psychedelic cactuses and mushrooms. Then they imagined they had changed into animals or into beings who could heal and put spells on people using their own powers.

People who had some physical abnormality, such as hunchbacks and dwarves, were considered to have been 'touched by the gods.' Thus they were thought to possess special gifts enabling them to mediate between the gods and humankind.

Later on, a priestly caste developed from a specialized group of shamans. One of their tasks was to perform the fixed rites, especially those in honour of the higher deities. For these rites they would wear masks identifying them with particular gods.

38

SEATED WOMAN

PRE CLASSIC

1000 – 500 BC
Xochipala
earthenware
h. 10 cm
Museo Amparo, Puebla
inv.no. 57 PJ 754

This figurine shows a richly dressed woman seated with crossed legs, one hand resting on the ground. Her hair is arranged in flat buns, descending to her earplugs. Her cape leaves her bosom uncovered, and her skirt has piping round its hem. The sides of the skirt overlap and are also decorated with piping. The skirt is evidently not of the wrap-around type commonly seen today, but a woven textile draped round the hips. It comes from Guerrero in Xochipala state. Terracotta figurines with Olmec features were also found here. However, this woman resembles another type, not Olmecoid.

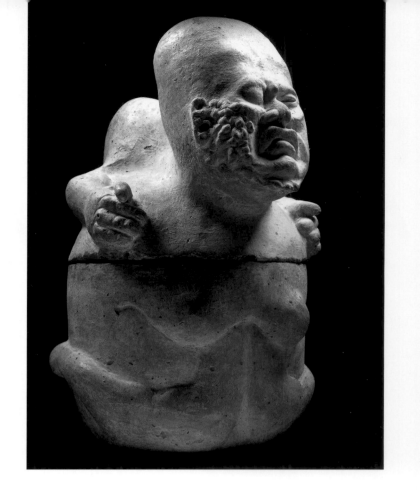

39

POT SHAPED LIKE A HUNCHBACK

OLMECOID

700 – 500 BC
Tabasco (?)
terracotta
h. 36 cm
Museo Regional de Antropología
'Carlos Pellicer', Villahermosa
inv.no. A-0483

The lid of this pot is shaped like the upper torso of a hunchback. The pot itself forms the lower body. The face has the typical Olmec mouth with drooping lower lip while a remarkable skin disease is shown on the right cheek. Like dwarfs, hunchbacks occupied a prestigious position in Meso-american society. They were considered to be mediators between the gods and humans. The deformity was seen as a sign that they had been touched by the gods.

The Olmecs were the first to depict either dwarfs or hunchbacks. They started a new tradition in their country.

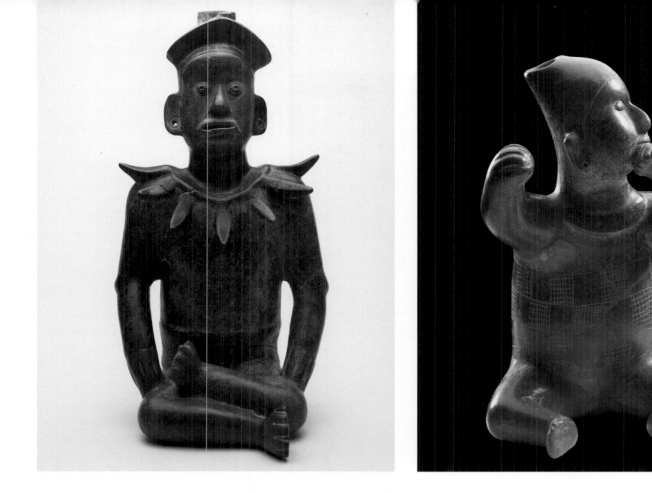

40
SEATED MAN
PROTO CLASSIC

300 BC – AD 300
Colima
terracotta
h. 40 cm, w. 21 cm, d. 20 cm
Museo Universitario de Arqueología,
Manzanillo
inv.no. 10-289162

This vessel is shaped like a man seated
cross-legged, the arms hanging down
beside his body. The spout is part of the
headdress. Large pierced ears frame the
face, and the mouth is slightly open. The
pectoral is remarkable, applied and
resembling a wide collar. In the elements
resembling spoons or boats there is a
reference to shells, which are an attribute of
the shaman. The man wears short trousers.
The vessel is made of polished red slip in the
Colima-Comala style. The marks of black
manganese are the result of lying in a shaft-
tomb for hundreds of years.

41
FIGURE WITH HORNED HEAD
PROTO CLASSIC

300 BC – AD 300
Colima
terracotta
h. 31.4 cm, w. 19.5 cm, d. 13.7 cm
Museo Nacional de Antropología,
Mexico City
inv.no. 10-228041

The seated figure holds his left hand against
his jaw while the raised right hand holds a
ball. His garment resembling a cuirass is
suggested by an engraved pattern of small
squares alternating with larger squares. He
wears a thin headdress with a section
notched out for the horn, which is a symbol
for the shaman, a magician/doctor who
heals by making contact with higher
powers. The face with its closed eyes
suggests someone in a trance.

The figurine is made from polished red
slip, typical of this type of Colima pottery.
It was a funerary gift in a shaft-tomb.

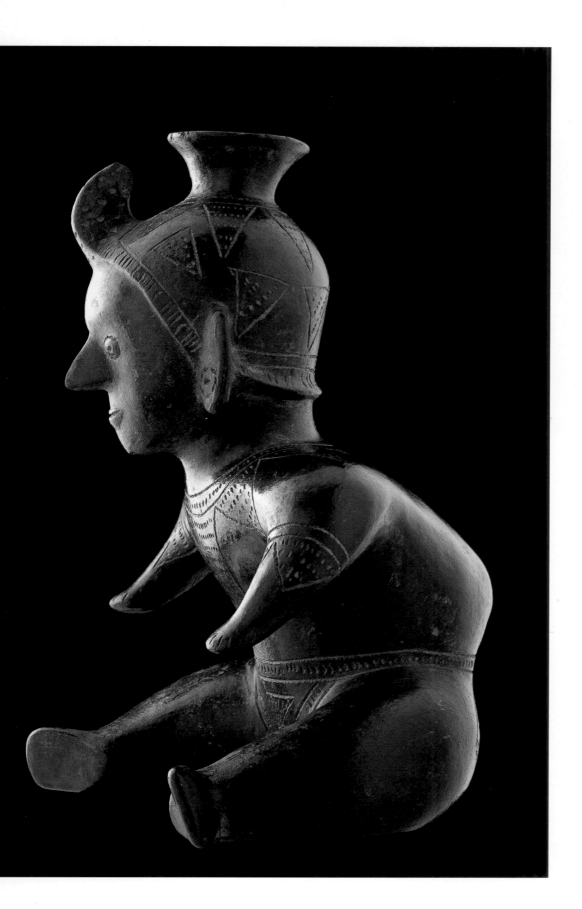

HUNCHBACK
PROTO CLASSIC

300 BC – AD 300
Colima
terracotta
h. 20.3 cm, w. 18 cm, d. 17.2 cm
Museo Nacional de Antropología,
Mexico City
inv.no. 10-222108

This hollow terracotta shows a seated
hunchbacked man. He wears a helmet with
a pattern of stippled triangles incised on it.
This pattern is repeated round the neck and
on the stumpy arms. The spout is modelled
on the top of the head. The loincloth is
indicated with incised lines. The terracotta
has a polished red slip.

 Hunchbacks were thought to have been
touched by the gods and fulfilled the role of
shaman in Mesoamerican society.

 The figurine was a funerary gift in a
shaft-tomb.

43
URN
MAYA

AD 600 – 900
Tapijulapa (Tabasco)
terracotta
h. 43 cm
Museo Regional de Antropología
'Carlos Pellicer', Villahermosa
inv.no. 0202

The urn is shaped like a priest, hands
outstretched and a jaguar mask covering
nose and mouth. A headdress consisting of
three bands has lost the tall section that
should crown the back of it. Around the
head and resting on the shoulders is a wide
decoration resembling a ruff-like collar.
From the shoulders hangs a cape of
feathers. The jewellery consists of earrings,
leg-bands and a pectoral. From the central
medallion of this neckpiece two wide bands
emerge, standing out from the body. The
apron-like garment is decorated with a
geometric pattern of criss-cross lines.

 Traces of blue over-painting can be
detected.

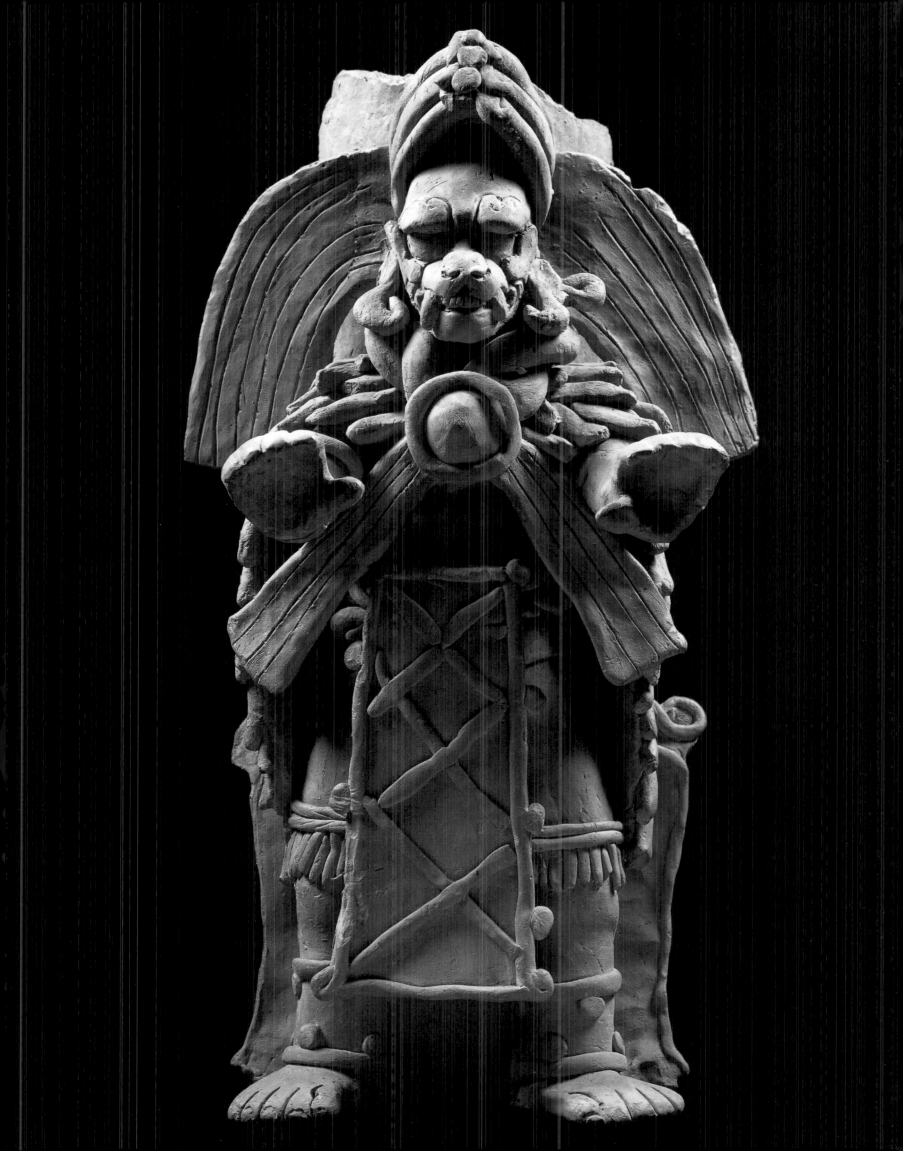

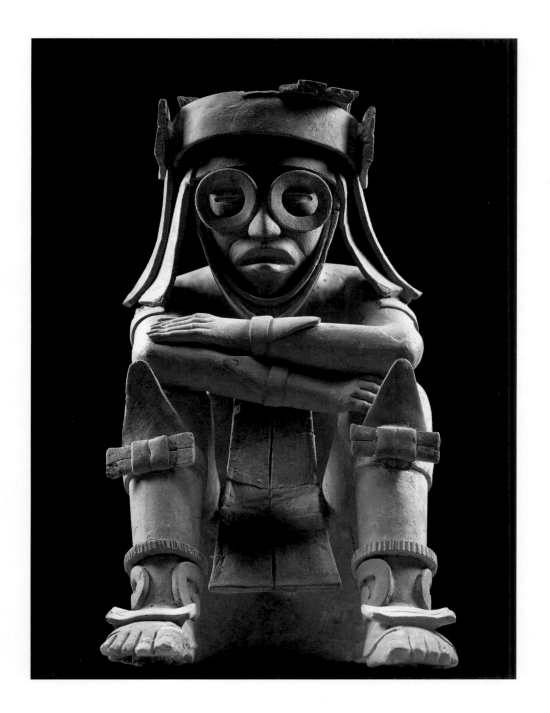

44
PRIEST
PRE TOTONAC

AD 600 – 900
El Zapotal
terracotta
h. 47.5 cm, w. 32 cm
Museo de Antropología de la Universidad
Veracruzana, Xalapa
inv.no. PJ 3991

This large seated figure of hollow
earthenware is elaborately dressed,
wearing a kind of turban which has flaps
hanging on either side of the face. A double
band encircles the face. The eyes have been
accentuated with circles. He also wears
wrist, knee and ankle protection, the last of
these forming part of his shoe, the
traditional sandal. The attire is completed
by a loincloth with an inordinately large
flap. The rings round the eyes are a symbol
of the rain god Tlaloc, a deity worshipped
from Central Mexico as far as the coast of
the Gulf of Mexico. In all probability the
figure represents a priest of Tlaloc.

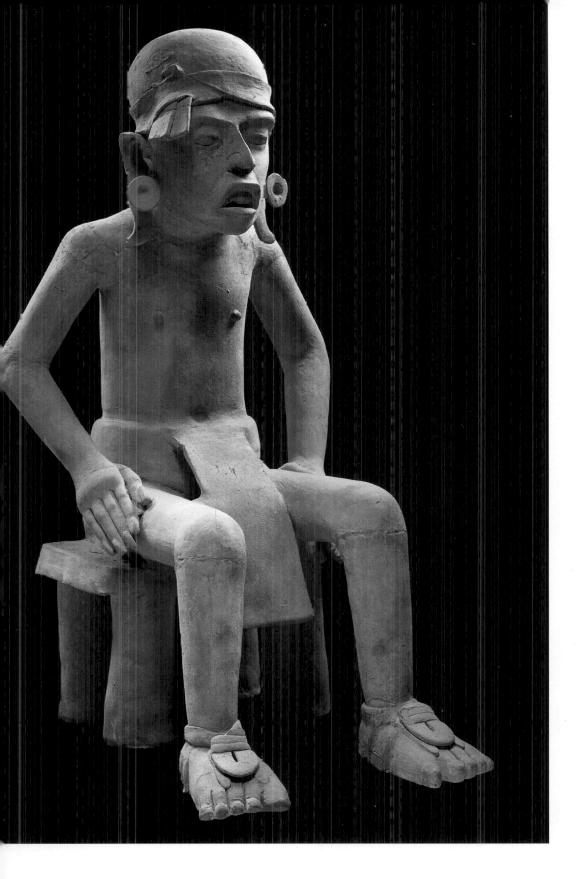

45
SEATED MAN
PRE TOTONAC

AD 600 – 900
Rio Blanco – Papaloapan district
earthenware
h. 67 cm
Museo de Antropología de la Universidad
Veracruzana, Xalapa
inv.no. PJ 4027

The hollow terracotta figurine shows a man
seated in front of a four-legged stool. He is
wearing a loincloth with a long flap and
sandals. Large earplugs adorn his ears and
his head is decorated with a band that has
two flaps made of *amate* paper, stuck in it
near the right ear. The front teeth are
visible in his open mouth.

Large hollow terracotta figures have long
been a speciality of the potters of the
Mexican Gulf region. When this area
became a tributary of the Aztecs in the
second half of the 15th century, the potters
switched to working for the Mexica elite,
whom we call the Aztecs. A similar process
of integration took place with the Mixtec
jewellers who also began working for the
elite of the Mexica.

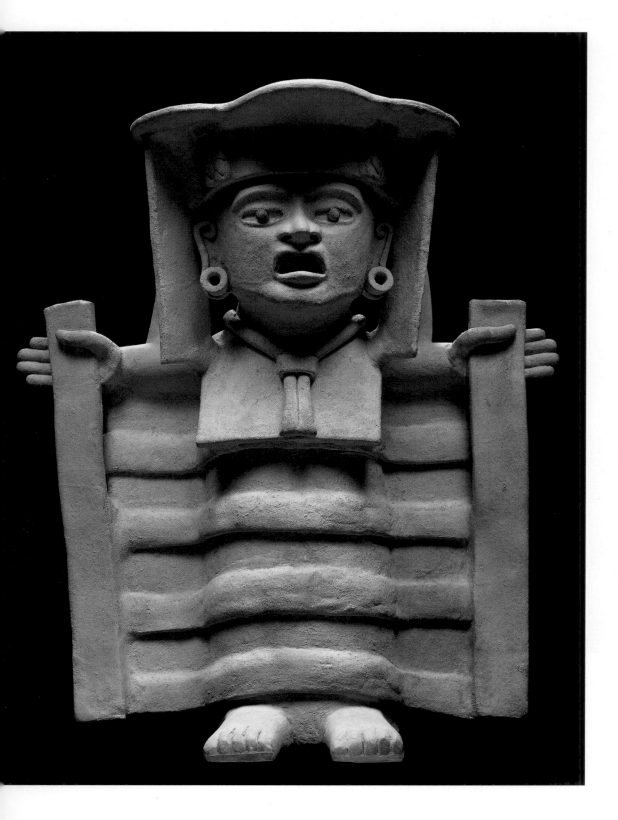

46

WORSHIPPER

TOTONAC

AD 600 – 900
El Zapotal of Las Remojadas
terracotta
h. 50.0 cm; w. 45.0 cm
Museo Nacional de Antropología,
Mexico City
inv.no. 10-79586

This standing female figure is worshipping
the gods. She wears a headdress with a flap
hanging on either side of the face. In each
ear she has a large earplug. The mouth is
open as if in ecstasy, and the attitude of this
worshipper, both arms extended
horizontally, reveals the *huipil* (a tunic-like
garment) with its fold down the centre,
worn just as the twenty-first century *huipil*
is today.

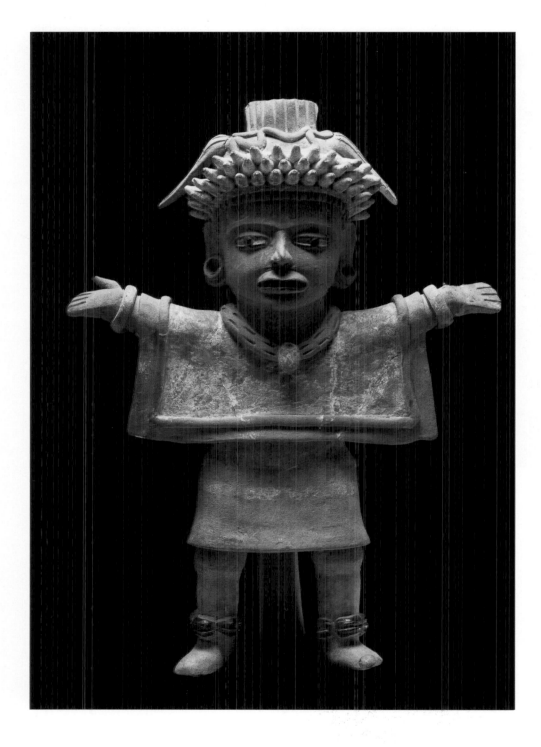

47
WORSHIPPER

PRE TOTONAC

AD 400 – 700
Rio Blanco – Papaloapan
terracotta
h. 42.5 cm
Museo de Antropología de la Universidad
Veracruzana, Xalapa
inv.no. PJ 3911

This worshipper stands, arms spread, in
adoration. The headdress, shaped like
pinecones, is crowned by a comb made of
amate paper, which has a flap of this bark-
like paper hanging on the left and right.
The figure has earplugs, a necklace and leg
and arm bracelets. He also wears a *cotón*,
a short type of poncho bordered by
a separate trimming, and a kilt and loincloth
which has a flap falling at the back between
his legs. On the face, ankle-bracelets and
elsewhere, are traces of painting with
chapopote, a black substance resembling tar
which is found in this part of the Mexican
Gulf coast.

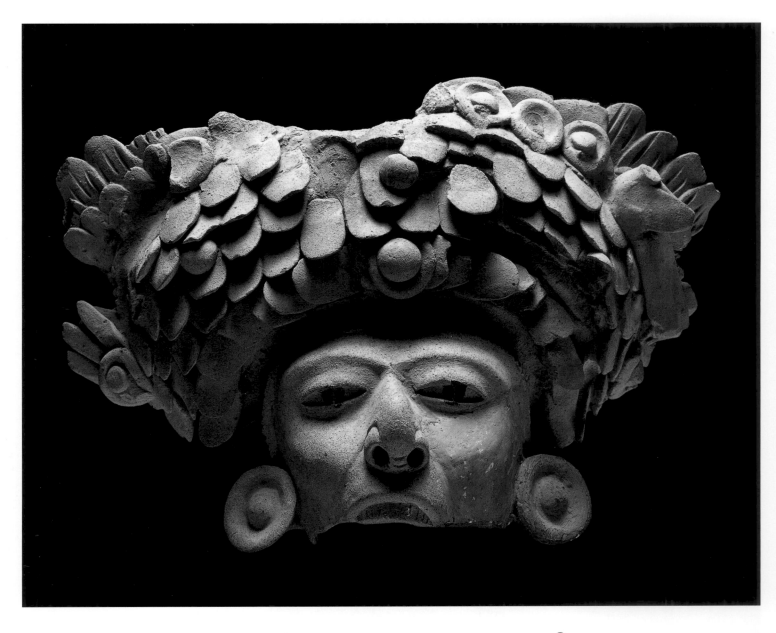

48

HEAD WITH FEATHER HEADDRESS

TOTONAC

AD 600 – 900
Papaloapan, Veracruz
terracotta
h. 17.5 cm, w. 29.2 cm
Museo de Antropología de la Universidad
Veracruzana, Xalapa
inv.no. PJ 143

This fragment of a large terracotta statue
shows a face with a scaly feather headdress.
There are large earplugs and incisions for
the teeth. The pupils of the eyes are
indicated by painting with *chapopote*, a kind
of tar that bubbles up out of the ground. It is
often applied in earthenware sculptures
from the Veracruz region.

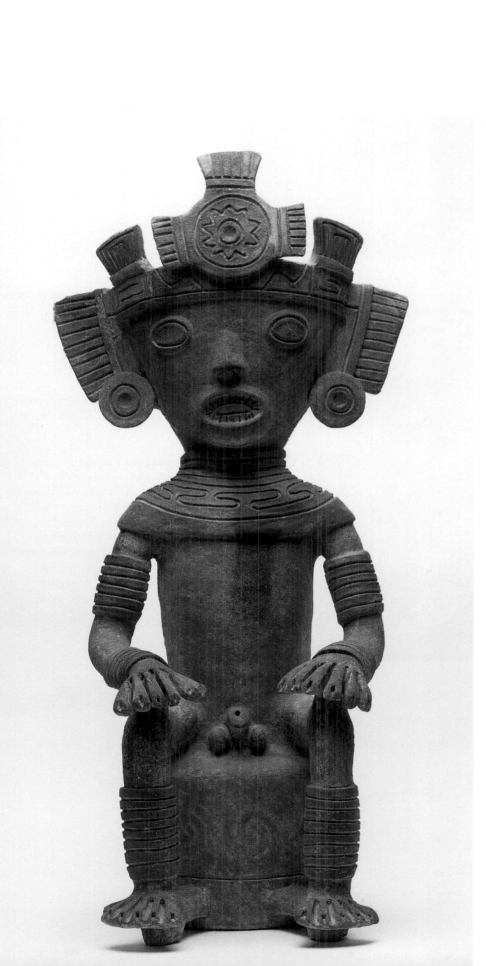

49
PRIEST OR IMPORTANT DIGNITARY
PRE TARASC

AD 600 – 1100
Michoacan
earthenware
h. 71 cm
Museo Universitario de Arqueología,
Manzanillo
inv.no. 10-571688

This man, wearing only some jewellery, is
seated on a tabouret. He has round eyes and
his mouth is open showing the teeth,
indicated by incisions in the clay. He has
large earspools and a tiara with a star or
flower pattern at the centre, indicating
Teotihuacan influence. On either side of the
head the headdress is complemented with
feathers or flaps made from *amate*, a kind of
bark paper. The jewellery includes
a pectoral with a meander motif, and wide
arm, wrist and leg bracelets. The feet are
joined to the tabouret which shows traces
of wave-motif painting. Two striking points
about this figure are that it has six fingers on
each hand, and that it is naked. These
factors, combined with the rich jewellery
that is worn, suggest the person to be an
important dignitary, possibly a fertility
priest.

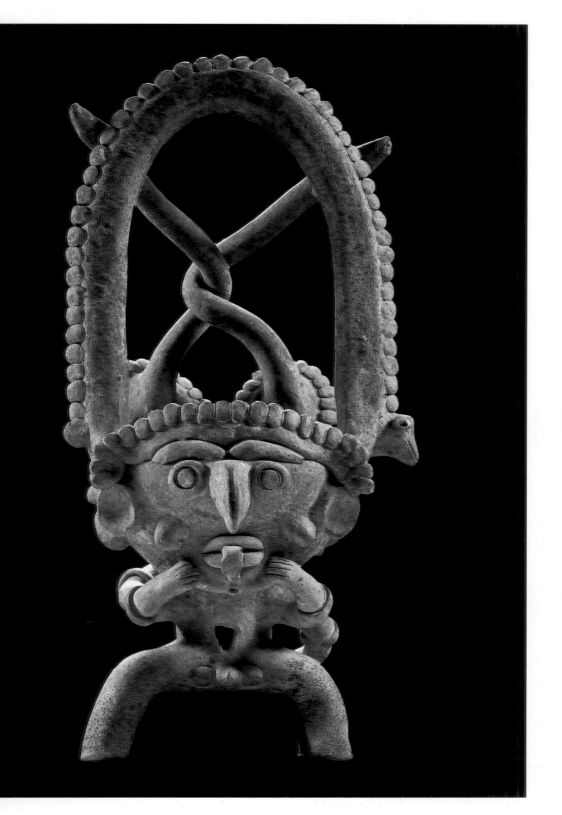

50

FOUR-FOOTED INCENSE BURNER

EPI CLASSIC

AD 800 – 1000
Colima
terracotta
h. 44 cm
Fondación Cultural Televísa, A.C., Mexico City
inv.no. 401

The censer is shaped like a human and
crowned with a 'handle' consisting of
a bird's head and a feathered body. Two
serpents with feathered ruffs adorn the
headdress, the bodies intertwined. The
rings around the eyes are reminiscent of the
rain god Tlaloc, whereby we see here
a combination of the Feathered Serpent and
Tlaloc.

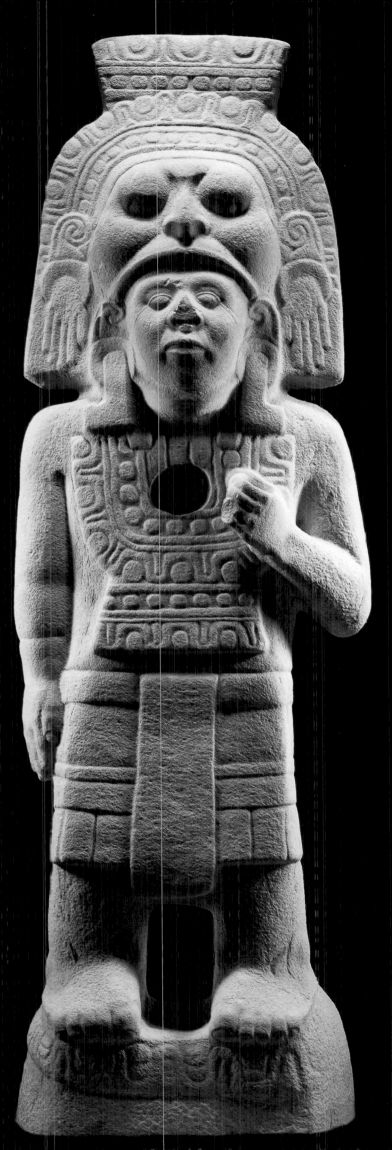

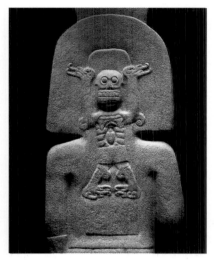

51

PRIEST OR TEMPLE GUARD

HUAXTEC

AD 1200 – 1521
Ozuluama
sandstone
h. 185 cm
Museo de Antropología de la Universidad
Veracruzana, Xalapa
inv.no. PJ 320

Emerging from the head of this tall
standing figure is a divine countenance,
forming the headdress. This includes the
earplugs, within which can be seen
a remarkable representation of a hand. The
figure has large earplugs with L-shaped
pendants. The pectoral has geometric
patterning and an opening that once held
a (semi-)precious stone. The trousers are
three-quarter length, held in place by
a belt-cum-loincloth. The right hand is
shaped to hold a banner. This suggests that
the man was a member of the temple guard.

The reverse of the sculpture has a relief
showing an ape-like person with a skull and
the skeletal representation of the rib-cage
and heart. So far no explanation has been
found for the symbolism of this figure.
Although there is no scientific basis for the
name, the sculpture is widely referred to as
the sun god of Ozuluama, the place where it
was found.

DAILY LIFE

The people of ancient Mexico were chiefly farmers. They would also trade and barter, and fought in the army. Most of the ordinary folk led a simple life. They lived in huts with a hearth in the middle of the floor. The women prepared the meals.

In the Aztec era both boys and girls went to school to learn things that would be useful to them later in life. Boys were expected to marry when they reached their twentieth birthday, found families and so maintain the community.

Ancestor worship and sacrificing to the dead were very important for the ordinary people. The ancestors were linked to higher cosmic rhythms: the spiritual powers of the dead could be summoned to ensure a plentiful harvest, favourable weather, rain when needed and the fertility of the earth.

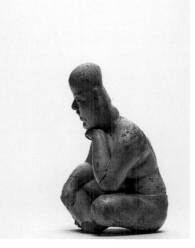

52
'THE THINKER'
OLMECOID

1000 – 500 BC
Las Bocas
earthenware
h. 13 cm
Museo Amparo, Puebla
inv.no. 57 PJ 866

An old man sits cross-legged, one hand under his chin. He appears deep in thought. The model shows the physiognomy typical of a corpulent old man. The solid earthenware figure is covered with white slip that reveals traces of red paint. The slightly slanting eyes and curling lips suggest Olmec influence which was widespread throughout Mesamerica in the Pre-Classic period.

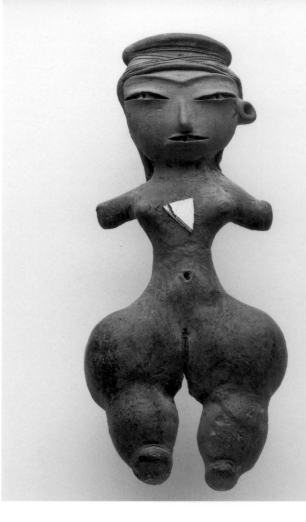

53
FERTILITY IDOL
PRE CLASSIC

800 – 500 BC
Tlatilco
terracotta
h. 10.5 cm, w. 5 cm
Museo Nacional de Antropología,
Mexico City
inv. no. 10-47374

The ample thighs of this solid hand-shaped figurine representing a woman suggest she is a fertility symbol. Traces of red paint can be detected on the earplugs and headdress. The arms are stumpy, almost rudimentary. She has a triangular mica mirror as pectoral, symbolizing the heart. Her eyes are narrow and slightly slanted, her mouth is thin-lipped and her nose straight. Many such female figures have been found in Tlatlico, in the Central Highlands not far from Mexico City. They may be found in graves but also in the *milpas*, or cornfields. It seems likely they were placed there as part of a fertility rite. In the art world these figurines are grouped under the name of Pretty Ladies.

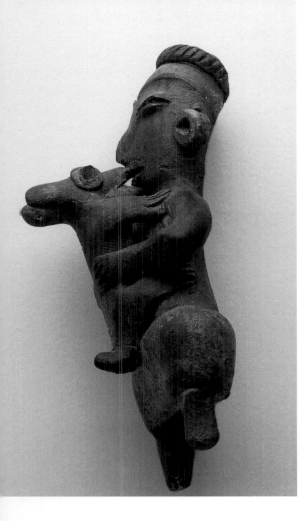

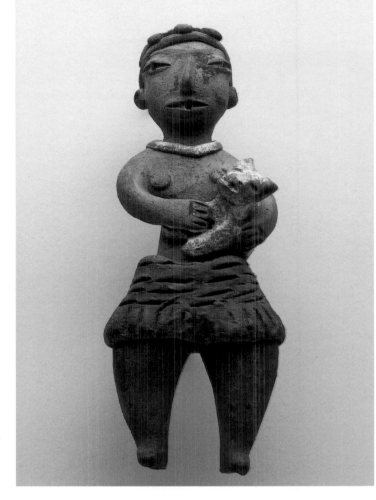

54
WOMAN AND DOG
PRE CLASSIC

800 – 500 BC
Tlatilco
terracotta
h. 9 cm
Museo Nacional de Antropología,
Mexico Stad
inv.no. 10-595267

The standing female figure belongs to the
type known as Pretty Ladies (see cat. no.53)
and this one is carrying a dog. She wears
a necklace and a skirt with a horizontal
pattern cut into the surface of the clay.
A fringe running round the lower edge is
also suggested by a series of incised lines.
The legs are coloured red and there are
traces of red paint on the face and the flat
headdress.
 The figurine was found in a grave.

55
FIGURE WITH OPOSSUM
PRE CLASSIC

800 – 500 BC
Tlatilco
terracotta
h. 8 cm
Museo Nacional de Antropología,
Mexico City
inv.no. 10-47371

The seated figurine holds an opossum. This
creature, known to the Indians as *tlacuache*,
has been domesticated since the Pre-
Classic period and today is still a popular
Mesoamerican pet.

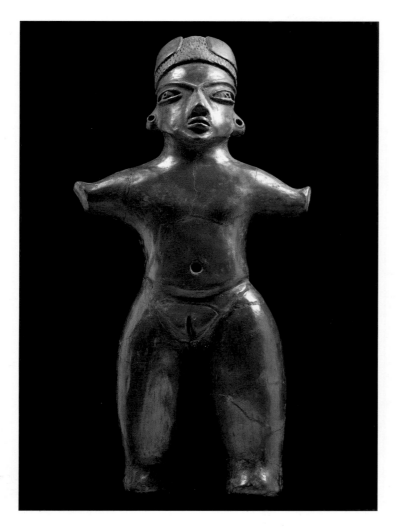

56
STANDING FEMALE FIGURE
PRE CLASSIC

1000 – 500 BC
Central Highlands
terracotta
h. 43 cm
Museo Regional de Antropología
'Carlos Pellicer', Villahermosa
inv.no. 0085

A standing naked female figure spreads out
her short arms. A striking feature of her
face with its slightly slanted eyes, is the
pointed chin. The eyebrows, meeting above
the bridge of the nose, are bushy. Her hair is
parted into two flat wide bunches. This
hairstyle was inspired by the Olmecs whose
cultural influence was widespread – beyond
their so-called 'motherland' on the south
coast of the Gulf of Mexico into other parts
of Mesoamerica. Certainly, olmec
influence was felt in the Central Highlands
of Mexico where this statue was found in a
grave.

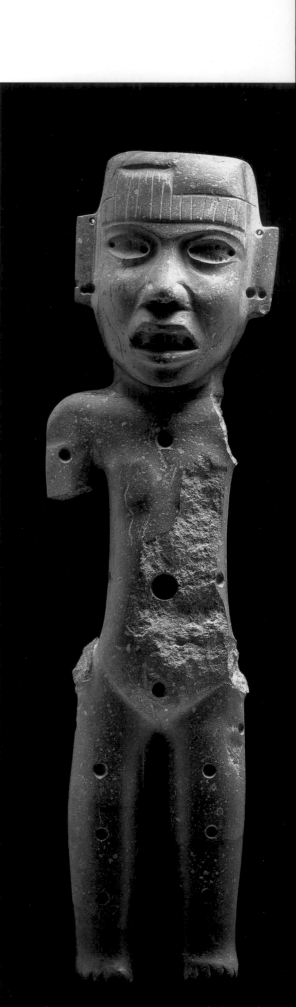

57
MALE FIGURE
TEOTIHUACAN

AD 300 – 650
Teotihuacan
greenstone
h. 75 cm
Museo de la Cultura Teotihuacana,
Teotihuacan
inv.no 10-333079

This stone figure, which has no distinct
gender attributes, was found in Teotihuacan
at the back of the *ciudadela* (fortress or
citadel) during excavations, 1980 – 82.
Several parts of it were broken, probably
when the city was overrun by marauding
tribes in around AD 650.

The face has the rigid features familiar
from Teotihuacan masks (cat. nos 115 – 128).
The long somewhat angular ears have been
pierced to hold pendants. The head
covering is subtly suggested. The curving
mouth is open as if in ecstasy. Holes have
been drilled on the front and back of the
head in which to set (precious) stones. This
suggests that the figure represents a divine
being.

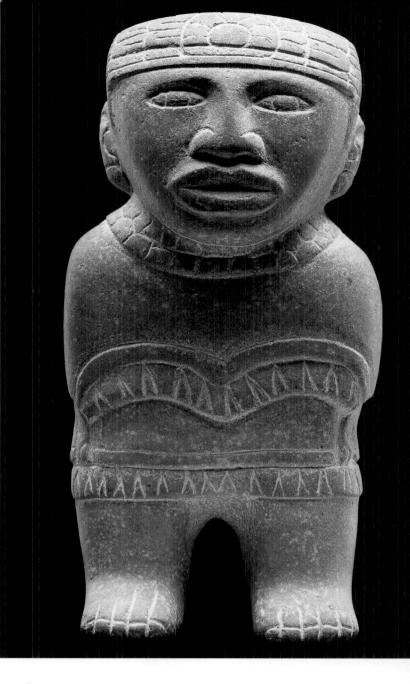

58
STANDING FIGURE
TEOTIHUACAN

AD 300 – 650
Teotihuacan
green stone
h. 28 cm
Museo de la Cultura Teotihuacana,
Teotihuacan
inv.no. 10-411002

The standing figure wears a cape-like
garment above a wrap-around skirt, or
huipil. Both garments are decorated with
the same V-shaped pattern along the edges.
The arms are hidden beneath the cape. The
figure, a woman to judge from the clothing,
also wears a flat head covering and
a necklace.

59 & 60

STANDING FEMALE FIGURES
TEOTIHUACAN

AD 100 – 400
Teotihuacan
terracotta
h. 11 cm (left); h. 8 cm (right)
Museo Nacional de Antropología,
Mexico City
inv.no. 10-848 (left); inv.no. 10-77334 (right)

Each of the two figures wears a wide
headdress and a many-stranded necklace.
The woman on the left is wearing a
quechquemitl above a wrap-around skirt,
while the one on the right wears a cape.
The smaller figure is wearing ankle bands.
The clothing of both women suggests they
belong to the elite.

61

DOLL
TEOTIHUACAN

AD 300 – 650
Teotihuacan
terracotta
h. 35 cm, w. 14 cm, d. 5 cm
Museo de la Cultura Teotihuacana,
Teotihuacan
inv.no. 10-600583

This doll with movable arms and legs is
wearing earplugs, a necklace and bracelets.
Although such figures are generally known
as 'dolls' they have no relation to the toy
dolls of Western countries. Possibly they
were used by shamans in rituals of healing.
In Teotihuacan they are found, usually in
pairs, in graves.

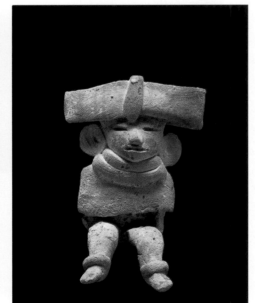
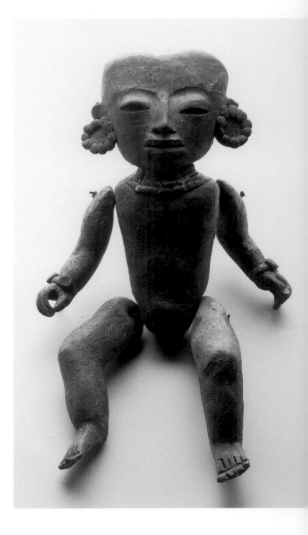

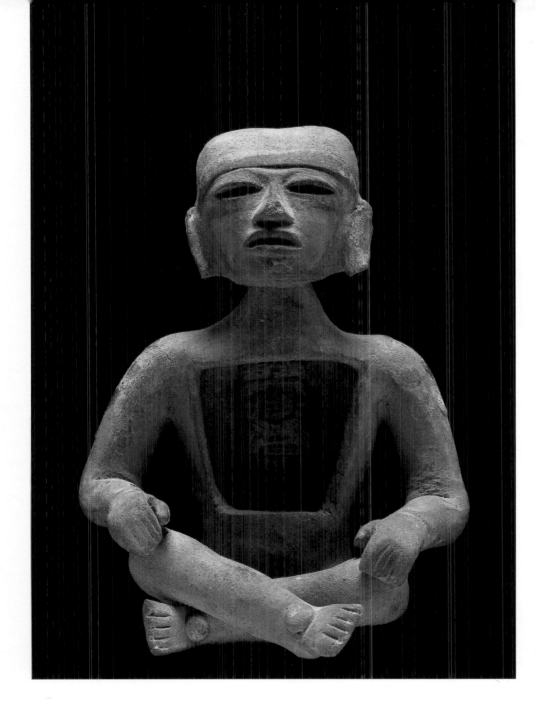

62

FIGURE WITH NAHUAL

AD 600 – 700
Teotihuacan
earthenware
h. 13.9 cm
Museo Nacional de Antropología,
Mexico City
inv.no. 10-223779

The hollow terracotta figurine, seated
cross-legged, has an opening in the chest to
contain a tiny Teotihuacan figure. This may
represent the *nahual*, or 'double' that
everyone is born with. The nahual may be
another person, but could equally be an
animal. Some experts think the small being
here is the earth goddess, patroness of dead
warriors.

The figurine has remains of polychrome
painting. Figures of this type date from the
final phase of the city of Teotihuacan, or
shortly after.

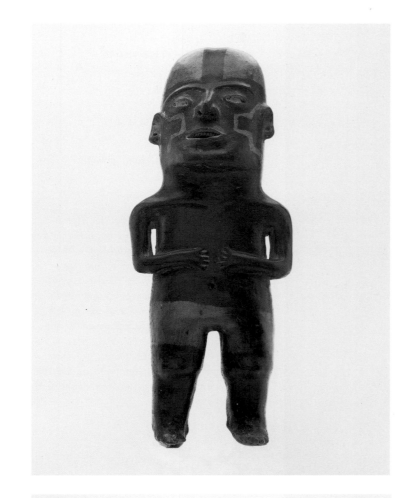

63

STANDING FEMALE FIGURE

PROTO CLASSIC

300 BC – AD 300
Chupicuaro
terracotta
h. 35 cm, w. 11 cm
Museo Nacional de Antropología,
Mexico City
inv.no. 10-1314

This earthenware female figure coated with
red slip is painted with cream-coloured
decoration which also appears as a meander
shape on each cheek. The hands are held
facing each other in the centre. There is no
suggestion of breasts, so that the shape of
the upper torso – framed by the arms and
hands – forms a square, the upper arms
allowing a slight opening.

The use of colour and the meander lines
on the face, in fact the whole physiognomy,
is typical of Chupícuaro style. About four
hundred graves were found here containing
hundreds of funerary gifts, many of which
have found their way to places far beyond
Mexico.

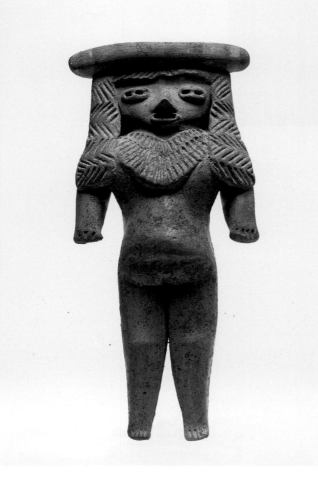

64

FEMALE FIGURINE

PRE CLASSIC

1200 – 800 BC
Mochoacan
h. 12 cm
Museo Amparo, Puebla
inv.no. 57 PJ 809

This female figure with her flat headdress
wears a kind of rudimentary *quechquemitl*.
Her hair is plaited in a zig-zag pattern,
falling in two thick braids below her elbows.
A small head may be detected on her left
hip, possibly representing an ancestor.
There is otherwise no clothing or jewellery.
The lower belly is pronounced, a sign of
fertility.

Figures of this kind would be placed in
graves to accompany the dead in the voyage
through the Underworld.

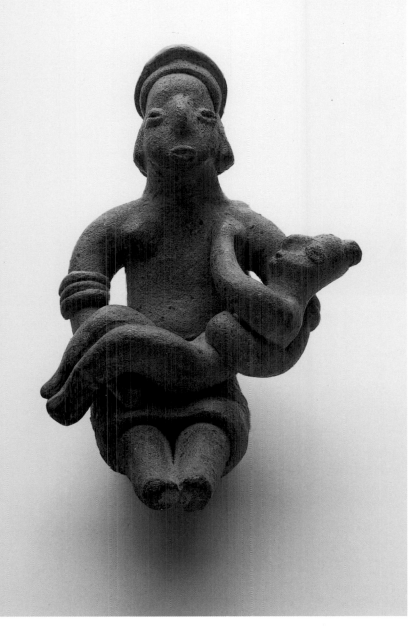

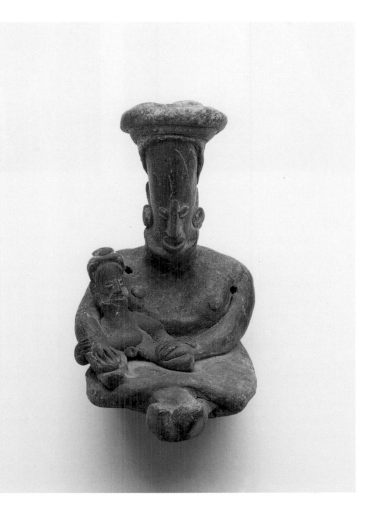

65
MOTHER WITH CHILD
PROTO CLASSIC

300 BC – AD 300
Colima
earthenware
h. 11.7 cm
Museo Nacional de Antropología,
Mexico City
inv.no. 10-37378

Seated with her legs stretched out in front,
the woman wears a wrap-around skirt.
She also has bracelets and a headdress.
The child in her lap grasps at the woman's
breast. The two appear to symbolize female
fertility.

The figurine is a funerary gift from
a shaft-tomb of the type principally found
in West Mexico.

66
MOTHER AND CHILD
PROTO CLASSIC

300 BC – AD 300
Jalisco
terracotta
h. 12.2 cm, w. 7.7 cm, d. 11.6 cm
Museo Nacional de Antropología, Mexico
City
inv.no. 10-78006

The woman, seated with her legs stretched
out in front of her, has a child on her lap,
leaning against her right arm. The woman,
or mother, wears a tall, turban-like head-
dress, earplugs and a wrap-around skirt.

The figurine was a funerary gift in
a shaft-tomb.

 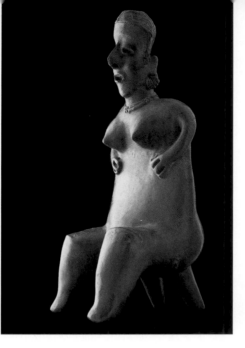

67
MAN RESTING
PROTO CLASSIC

300 BC – AD 300
Colima
earthenware
h. 21.2 cm, w. 21.3 cm
Museo Nacional de Antropología,
Mexico City
inv.no. 10-77612

The man is seated with his right leg pulled
up. His head is resting on the curve of his
right arm, which in turn lies on the right
knee. His left arm is bent, with the hand
supporting his head. The garments are
suggested by incisions in the clay, and
consist of a loincloth and head covering.
The face has a Roman nose, oval eyes and
a closed mouth. Like almost all figures in
this Colima-Comala style, this terracotta
has red slip which has been polished after
drying.
 The hollow statue was a funerary gift in
a shaft-tomb. Having lain two thousand
years in the earth, there are traces of plant
roots and black stains on the surface.

68
SEATED WOMAN
PROTO CLASSIC

300 BC – AD 300
Nayarit
terracotta
h. 50 cm, w. 21.7 cm, d. 22.6 cm
Museo Nacional de Antropología,
Mexico City
inv.no. 10-222224

The naked woman is seated on a stool,
hands against her body under her heavy
breasts. Her jewellery consists of earrings
and a many-stranded necklace. Her hair is
tied in a pony tail at the back. With its full
breasts, the figure might well be associated
with fertility.
 The figurine was a funerary gift in
a shaft-tomb.

69
SEATED FIGURE
PROTO CLASSIC

300 BC – AD 300
Colima
terracotta
h. 19 cm, w. 11 cm, d. 10 cm
Museo Universitario de Arqueología,
Manzanillo
inv.no. 10-571561

The left arm of this seated male figure rests
with the elbow upon his raised left knee,
and the hand on the right shoulder. On his
head is something resembling a helmet.
Arm bands and trousers are indicated by
incised lines. His earlobes are pierced for
jewellery. He is smiling and had closed
eyes, suggesting he is in a trance. Such
a state would be entered in order to mediate
between people on earth and the ancestors
and gods in the Underworld. The figurine
has the typical red polished slip of Colima
work.
 The terracotta was a funerary gift in
a shaft-tomb.

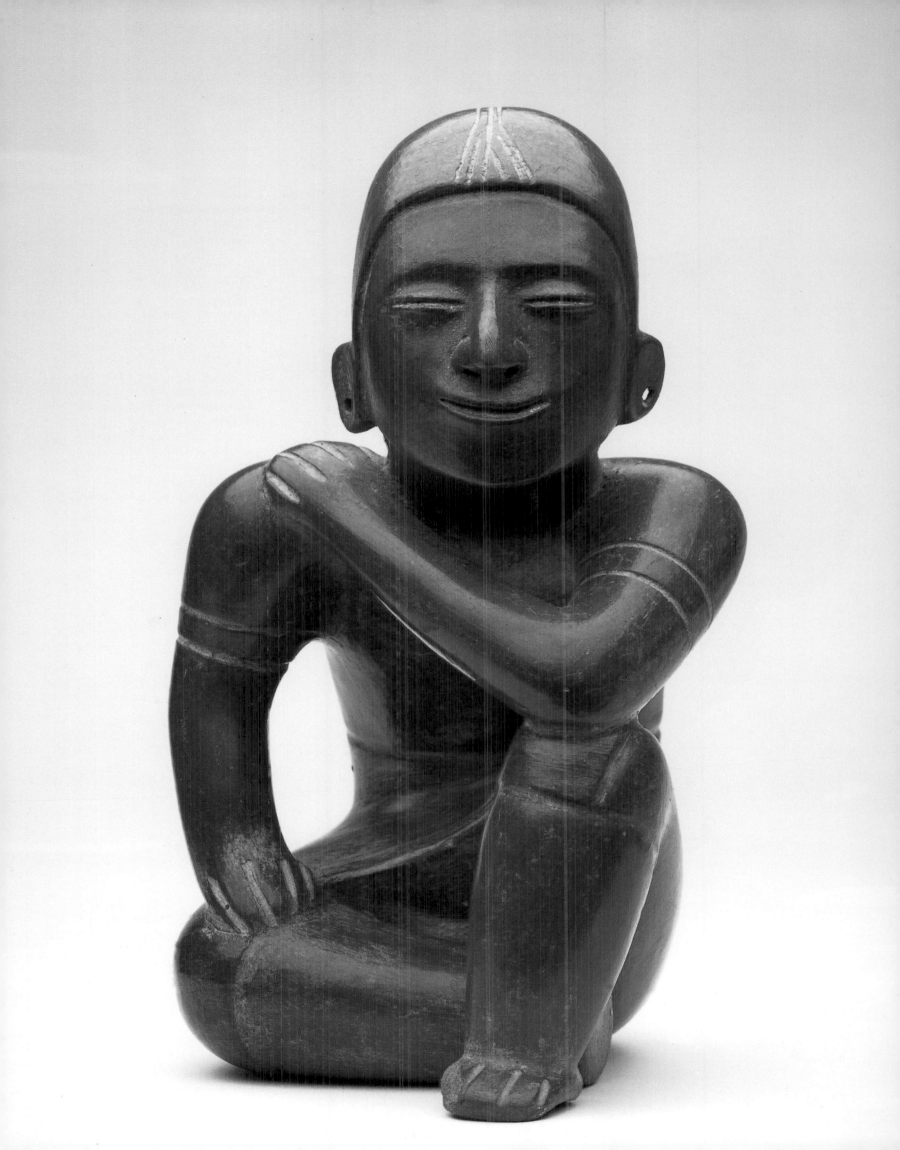

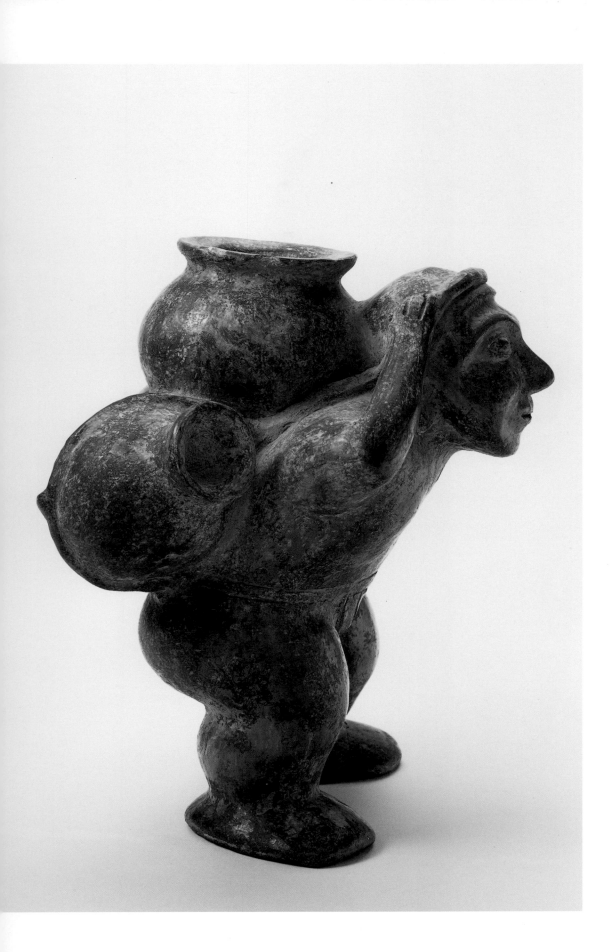

BEARER

PROTO CLASSIC

300 BC – AD 300
Colima
earthenware
h. 24.2 cm
Museo Nacional de Antropología,
Mexico City
inv.no. 10-1456

This hollow terracotta figurine represents a bearer carrying three pots on his back. The pots are carried in the manner typical of Mesoamerica, with the help of a strap round the forehead, to which the burden is attached. Today people can still be seen carrying loads in this way. The bearer is bending forward slightly to help carry the weight, holding the strap with both hands. His open mouth and closed eyes indicate the effort he is making. A *maxtlatl*, loin-cloth, is drawn onto the earthenware with incised lines, and a vest on his upper torso. The potter has rendered this figure in a highly realistic manner; he looks like someone you might meet in Mesoamerica today.

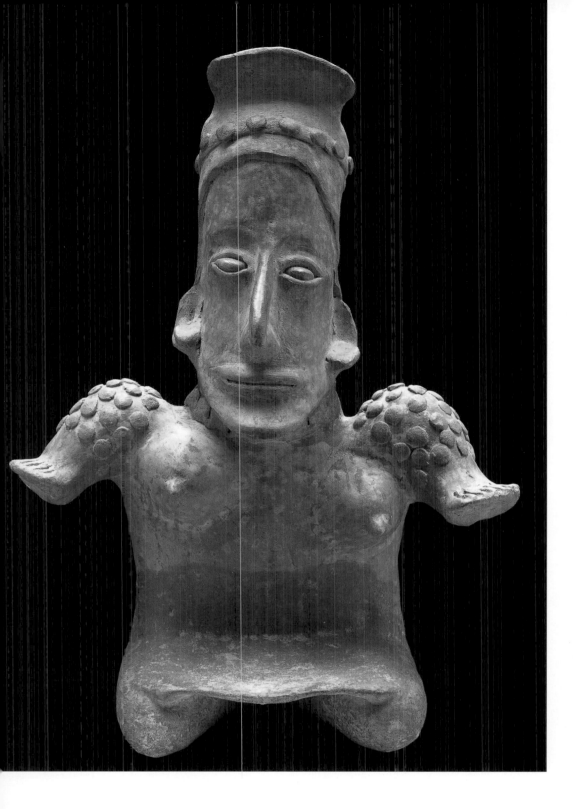

SEATED WOMAN

PROTO CLASSIC

AD 0 – 300
Jalisco
earthenware
h. 43 cm
Museo Nacional de Antropología,
Mexico City
inv.no. 10-58988

The woman is kneeling with outspread
arms. Her long face is of the Jalisco-Ameca
type. The tall headdress, ending at the back
in a pony tail, is decorated with small balls
which also adorn the shoulders and upper
arms. Possibly such decoration was inspired
by the seeds of the *ceiba*, or Mesoamerican
holy bean. Similar decoration is often found
on West Mexican terracottas and
apparently emphasized the religious nature
of the representation. Also, the out-
stretched arms and hands create an
impression of one in ecstasy.

The woman wears a skirt, but her bosom
is bare. There are traces of polychrome
painting. The hollow figure would have
been made using moulds and applied work.
It was found in a shaft-tomb near Ameca.

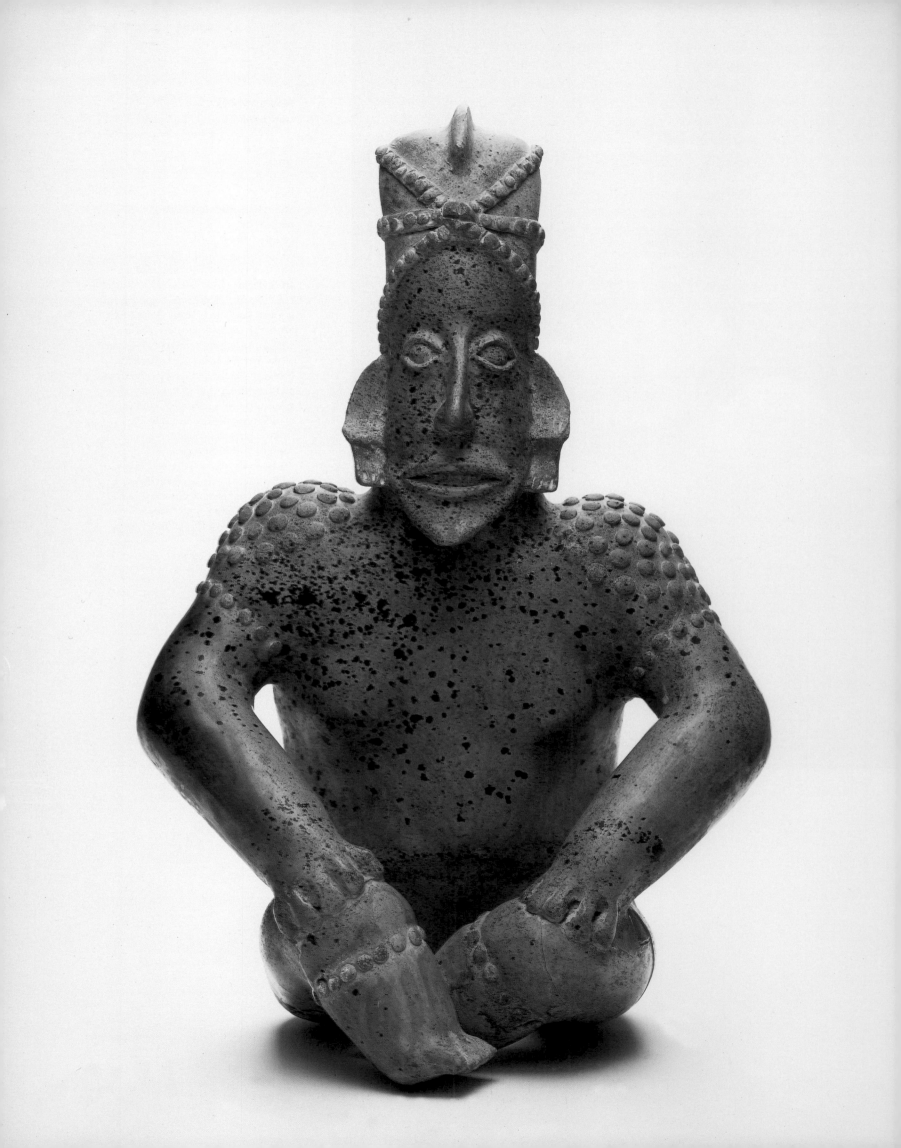

72
SEATED WOMAN
PROTO-CLASSIC

AD 0 – 300
Jalisco
earthenware
h. 55 cm
Museo Amparo, Puebla
inv.nc. 57 PJ 1124

The hollow terracotta figure represents a woman seated cross-legged, hands resting on her lap. She wears earrings, and arm and leg bracelets. Her mouth is slightly open, showing her teeth.

73
FIGURE LEANING BACKWARDS
PROTO-CLASSIC

AD 0 – 300
Jalisco
earthenware
l. 45 cm
Museo Amparo, Puebla
Inv.no. 57 PJ 1089

The hollow statue represents a figure leaning over backwards, the waist somewhat curved outwards, the position supported with the hands. Possibly the figure shows a woman in labour. Arm and leg bracelets are part of the jewellery, together with earplugs and headdress. The elongated face is of the Ameca type. The statue was a funerary gift in a shaft-tomb. It had lain underground for two thousand years, and due to a chemical reaction with the soil, black dotted marks have appeared on the surface.

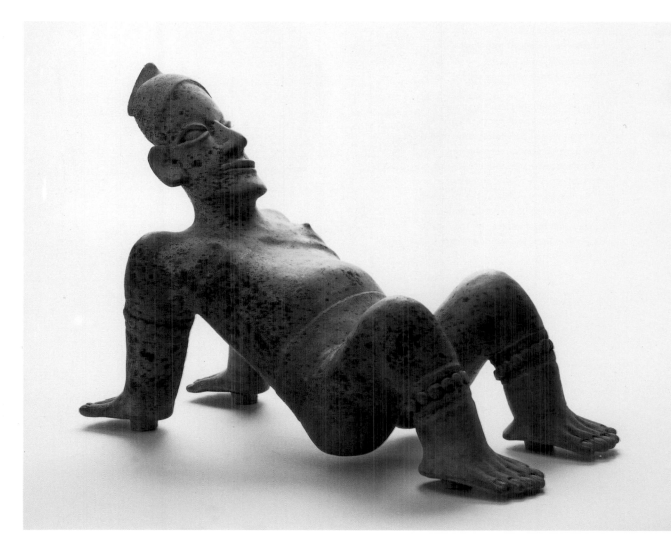

74
SQUATTING MAN
PROTO CLASSIC

AD 0 – 300
Jalisco
earthenware
h. 23.5 cm, b. 22.5 cm
Museo Nacional de Antropología,
Mexico City
inv.no. 10-227427

The man is squatting, back rounded, with
his work-worn hands resting on his feet.
The figure is naked, apart from a little
jewellery – bracelets, earplugs and
a headband with the familiar ball-like
decoration. A (precious) stone can be seen
in the mouth, emphasizing the 'valuable'
– that is, exceptional – nature of the
representation. The face is of the Ameca
type. The statue was a funerary gift
in a shaft-tomb.

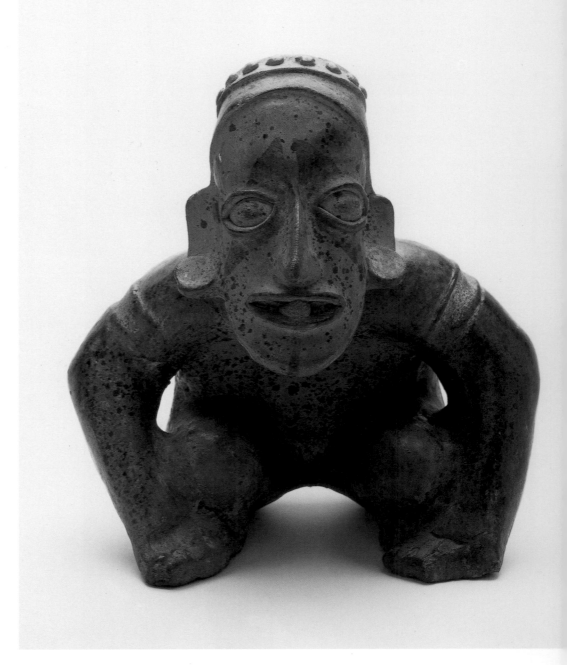

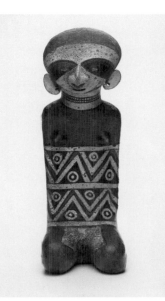

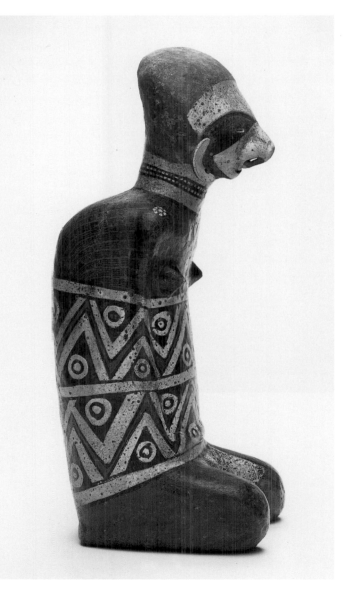

75
KNEELING WOMAN
PROTO CLASSIC

300 BC – AD 300
Nayarit
earthenware
h. 54 cm
Museo Amparo, Puebla
inv.no. 57 PJ 1138

This woman is kneeling in a manner resembling that seen among eastern people. Art historians and archaeologist formerly gave the name 'Chinesco' to figures of this type, due to their Asiatic resemblances. The 'Chinesco' figurines date from the Proto Classic and are found in shaft-tombs in Nayarit.

The pottery is painted in white, black and red to suggest jewellery and mask-like facial decorations. The figure has been polished so that the delicate arms and hands are visible, subtly shaped and held against the body.

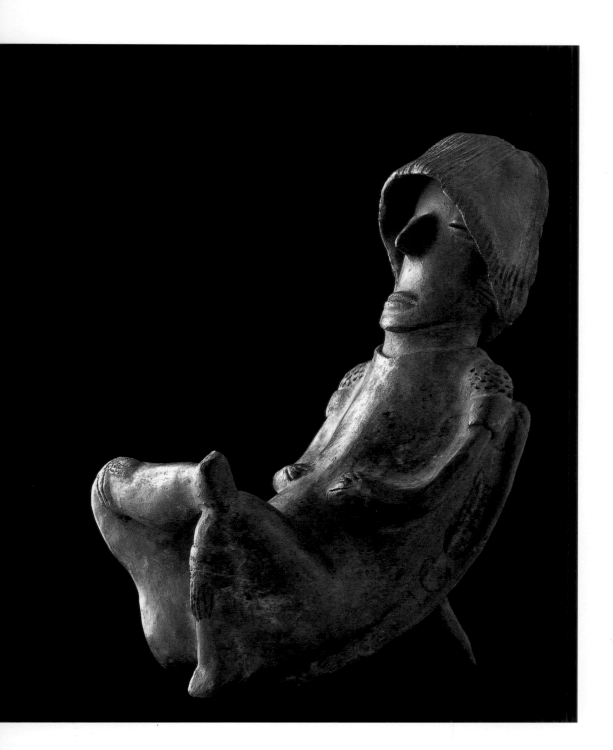

MAN SITTING IN AN EASY CHAIR
PROTO CLASSIC

300 BC – AD 300
Nayarit
terracotta
h. 23.4 cm, w. 10.4 cm, d. 17.3 cm
Museo Nacional de Antropología,
Mexico City
inv.no. 10-396988

A man whose hair resembles a hayrick,
leans back in an armless chair. His left leg is
pulled up with the right foot resting on it.
His jewellery consists of leg bands just
under the knee and bracelets high on the
upper arm. He has scars on his shoulders
from self-inflicted castigation to obtain
blood for sacrifices. The eyes are closed in
(everlasting) sleep and the narrow lips are
sealed.

The figurine was a funerary gift in
a shaft-tomb.

77
SEATED MAN
PROTO CLASSIC

300 BC – AD 300
Nayarit
earthenware
h. 41 cm
Museo Amparo, Puebla
inv.no. 57 PJ 1142

Seated cross-legged, the man holds a small
bowl in his right hand. Painted onto the
figure are a narrow loincloth and a wide
neckband. The hair is suggested by
incisions in the clay, and a bracelet, nose-
ring and headband have been applied, as
has a small goatee beard. On the left cheek
is the painting of a flower, or possibly the
imprint of a hand. The closed eyes give the
man the appearance of one in a trance, or
even dead. There is geometric painting
around the left shoulder and armpit and on
the arms.

The figure was found in a shaft-tomb in
Nayarit, presumably a funerary gift.
Stylistically, it belongs to the type of figure
called 'Chinesco'.

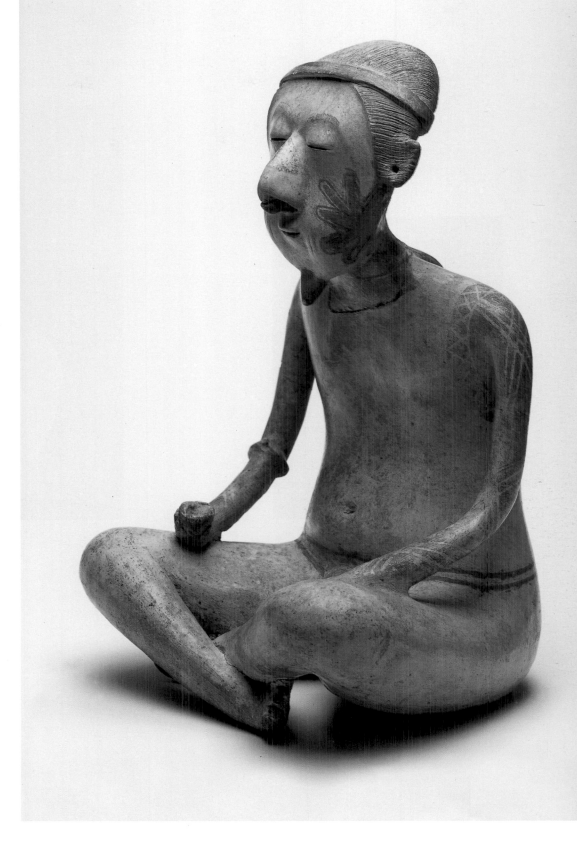

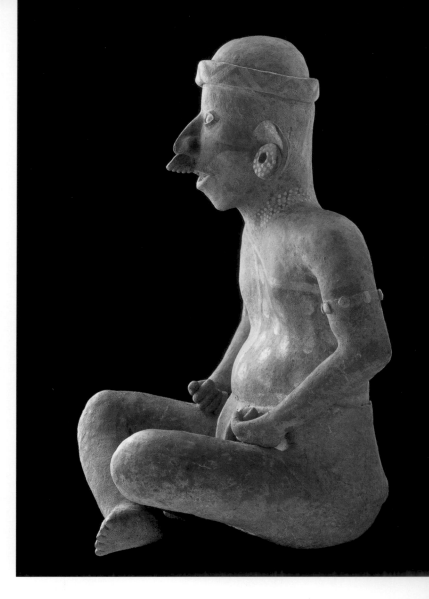

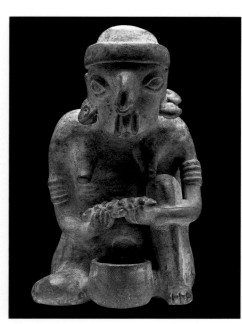

78
OLD WOMAN
PROTO CLASSIC

300 BC – AD 300
Nayarit
terracotta
h. 23.5 cm, w. 15.2 cm, d. 18.9 cm
Museo Nacional de Antropología,
Mexico City
inv.no. 10-619655

An old woman, seated with one leg pulled
up, is cutting off the kernels from a cob of
corn over a bowl. The woman has hanging
breasts and a harelip. She wears a head-
band, bracelets round her upper arms and
decorations in her ears.

The figurine was a funerary gift in
a shaft-tomb.

79
SEATED MAN
PROTO CLASSIC

AD 0 – 300
Nayarit
terracotta
h. 41 cm
Museo Nacional de Antropología,
Mexico City
inv.no. 10-79178

The man sits cross-legged resting his hands
on his thighs. He is wearing a headband,
loincloth and a sort of vest fastened at an
angle under his left armpit, leaving the right
side of his chest bare. His jewellery consists
of large earplugs, bracelets and a nose-ring.
There are traces of polychrome painting on
the mainly cream-coloured figurine.

The terracotta was a funerary gift in
a shaft-tomb in Nayarit.

80

SEATED WOMAN WITH BOWL
PROTO CLASSIC

300 BC – AD 300
Nayarit
terracotta
h. 39 cm, w. 25 cm, d. 13 cm
Museo Universitario de Arqueología,
Manzanillo
inv. no. 10-291294

The earthenware figurine represents
a woman squatting down, her hands in her
lap. She wears a wrap-around skirt and
a headband round her hair which is
indicated by incised lines. Her jewellery
consists of several earrings, bracelets round
her upper arms and a nose decoration.
Her upper arms also show the scars from
self-inflicted wounds made in order to
obtain blood for sacrificial purposes. There
are many small black manganese stains on
the figurine, the result of its lying
underground for two thousand years.

The terracotta was a funerary gift in
a shaft-tomb.

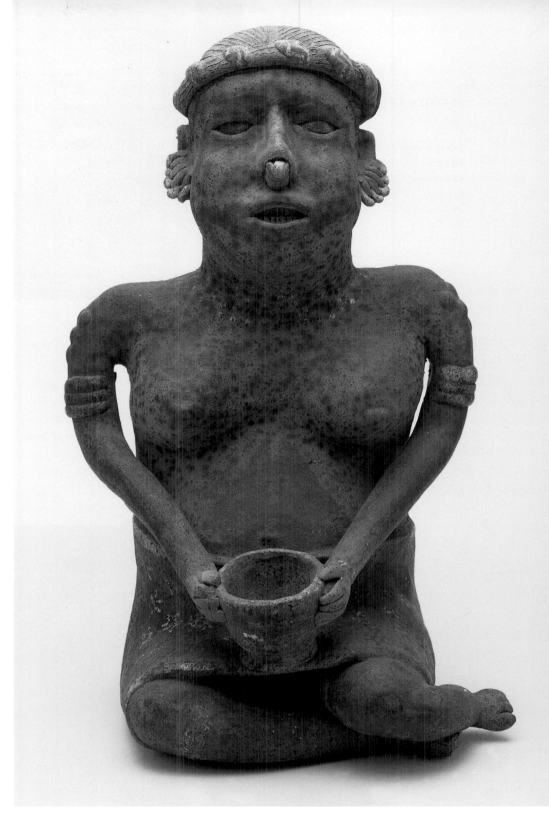

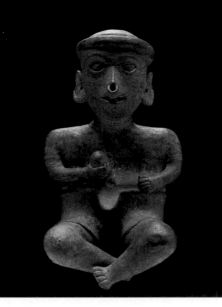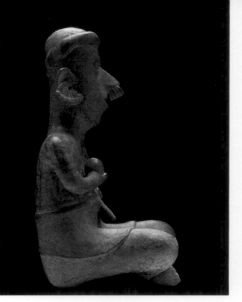

81
SEATED MAN
PROTO CLASSIC

300 BC – AD 300
Nayarit
earthenware
h. 30 cm
Museo Nacional de Antropología,
Mexico City
inv.no. 10-222297

The man is seated cross-legged, holding
a ball in his right hand. He is wearing nose-
and earrings, a headband and short trousers
with the suggestion of a belt. His upper
torso is bare, and painted with largely black
geometric designs. The arms are also
largely painted black with a few cream-
coloured highlights.

The oldest finds in this style are from
shaft-tombs in Ixtlan del Rio, which has
given its name to earthenware sculptures of
this sort.

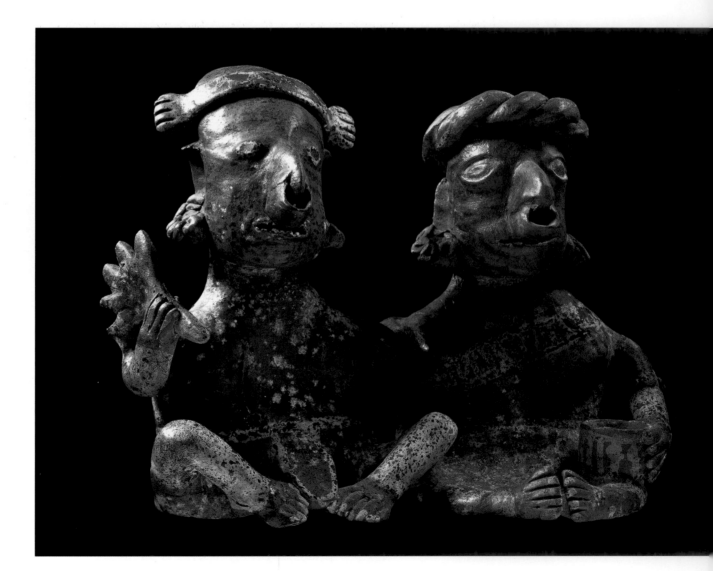

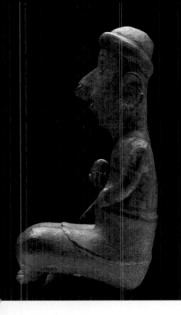

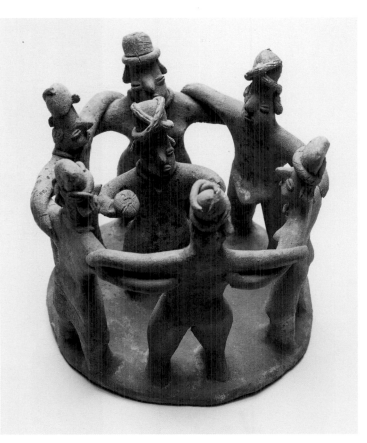

82

A COUPLE

PROTO CLASSIC

300 BC – AD 300
Ixtlan del Rio, Nayarit
earthenware
h. 18 cm
Museo Regional de Antropología
'Carlos Pellicer', Villahermosa
inv.no. 0307

The man and woman are seated with their
bent legs towards each other and their arms
round each other's back. Both wear head-
bands, ear and nose rings, and bracelets.
On her left leg the woman balances a bowl,
while the man holds a boomerang-shaped
instrument or stick in his right hand. He is
wearing short trousers and a loincloth.
The woman has a skirt and a sash worn
diagonally across her breast. Her hair is
braided with cotton strips plaited through
it. From the man's headband three braids of
hair hang at the back of his neck. Both
figures are richly painted and were found in
a shaft-tomb in Nayarit, in or nearby Ixtlan
del Rio, which has given its name to this
style of figurine.

83

GROUP OF DANCERS

PROTO CLASSIC

AD 0 – 300
Colima
terracotta
h. 12.5 cm, diam. 12.7 cm
Museo Nacional de Antropología,
Mexico City
inv.no. 10-1435

At the centre of a group of six dancers
forming a ring stands the 'conductor',
marking the time with an instrument called
maracas, known to us as samba balls. The
dancers have their arms round each other.
They wear tall headdresses constucted
from strips of cotton.

The group was a funerary gift in a shaft-
tomb.

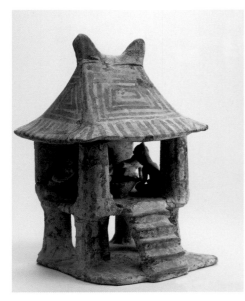

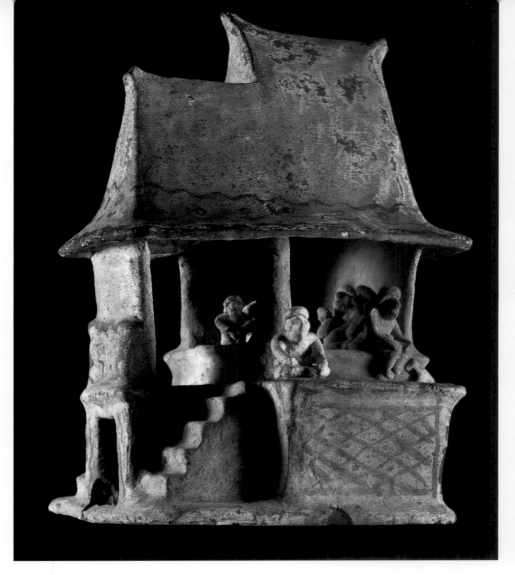

84
HOUSE ON STILTS
PROTO CLASSIC

300 BC – AD 300
Nayarit
terracotta
h. 25 cm
Museo Amparo, Puebla
inv.no. PJ 1704

This miniature pole house has steps leading
to the ground. Inside, a group of people are
sitting eating. The characteristic double-
pointed Nayarit roof – resembling an
Indonesian Batak roof – is painted with
a red geometric design on the tall roof and
blue-black stripes along the edge.

The model was found as a funerary gift in
a shaft-tomb in Nayarit.

85
MODEL OF A HOUSE AND PEOPLE
PROTO CLASSIC

300 BC – AD 300
Nayarit
terracotta
h. 34 cm
Museo Regional de Antropología
'Carlos Pellicer', Villahermosa
inv.no. 0314

This earthenware maquette shows
a miniature house with a group of people
inside it. The dwelling section is on the first
floor and can be reached by an outside
staircase. At the top of the stairs a man is
seated outside the 'room'. The ground floor,
with a large entrance at the left, was used to
store corn (maize) and suchlike. The
complex, with its variations in height, and
black geometric painting the on walls and
part of the roof, is most informative about
the architecture of houses in West Mexico,
particularly in Nayarit.

The model was a funerary gift in a shaft-
tomb.

86
NECKLACE
HUAXTEC

AD 900 – 1521
La Huaxteca
shell
l. 24.5 cm
Museo Nacional de Antropología,
Mexico City
inv.no. 10-79857

The necklace is made of beads and tiny dolls, shaped like schematic male figures which hang from the cord. The necklace comes from the territory of the Huaxtecs, where the most beautiful examples of shell jewellery have been found.

It was found in a grave.

87
PECTORAL SHAPED LIKE A BAT
PROTO CLASSIC

300 BC – AD 300
Colima
shell
h. 9 cm, w. 15 cm
Museo Universitario de Arqueología,
Manzanillo
inv.no.: 10-572052

The pectoral, made of mother-of-pearl, has the shape of a bat with outspread wings, carved in openwork. Because of its habit of frequenting caves and grottos, the bat was closely connected with the Underworld.

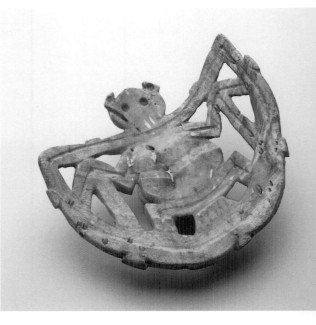

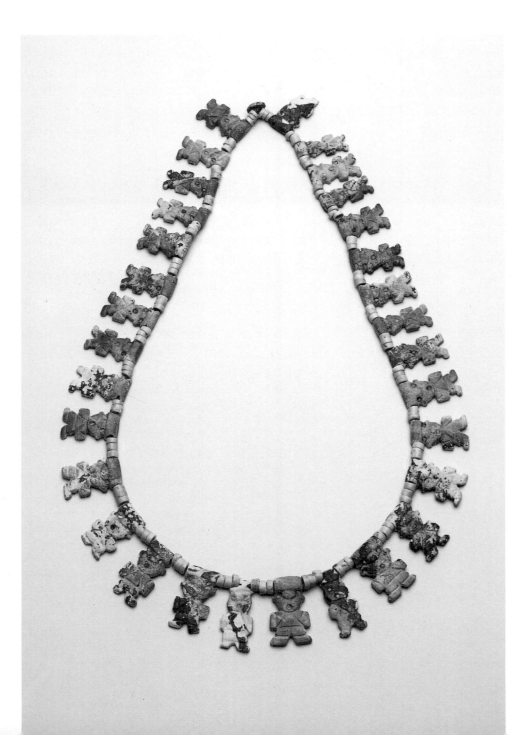

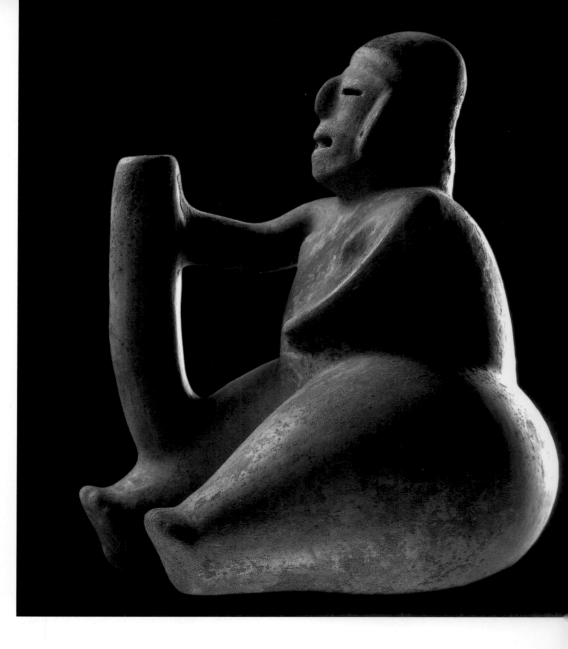

88
PAIR OF EARSPOOLS
PRE-TARASC

AD 300 – 900
Michoacan
shell
diam. 6.3 cm
Museo Nacional de Antropología,
Mexico City
inv.no. 10-79856 0/2

The two earplugs with openwork carving
are from a large shell (spondylus). They
probably come from the coastal area of
Michoacan.
 They were found in a grave.

89
JUG SHAPED LIKE A SEATED WOMAN
PROTO CLASSIC

300 BC – AD 300
Soledad de Doblado/Remojadas
earthenware
h. 15 cm
Museo de Antropología de la Universidad
Veracruzana, Xalapa
inv.no. PJ 08

The jug is shaped like a naked woman
sitting with her feet in front of her. Her
right hand holds a long spout that is
attached to the right leg. She wears nothing
but a headdress which is painted in
chapopote, a kind of tar. This tar is found in
coastal districts and was often used on
pottery from this area. With her ample
thighs, this female jug-figure would appear
to fall into the category of fertility symbols,
in all likelihood a funerary gift for a dead
woman.

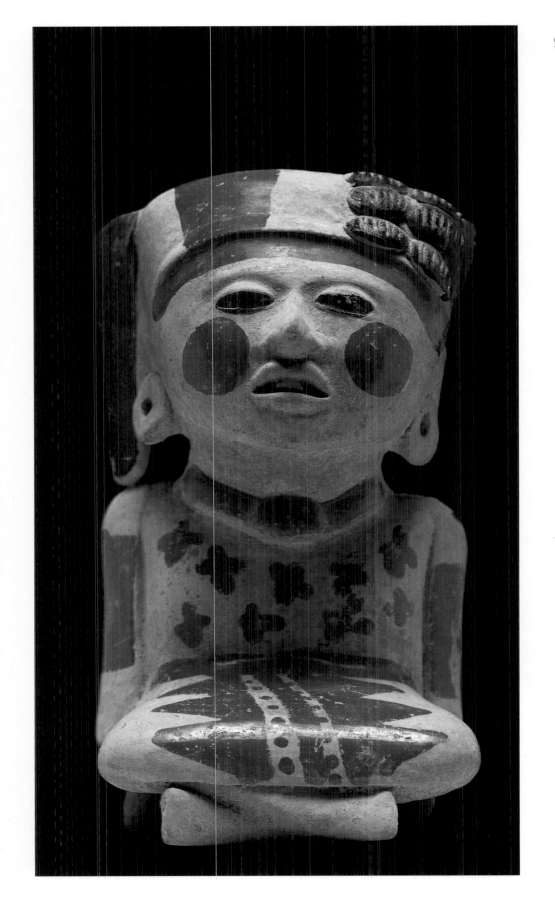

SEATED WOMAN

PRE TOTONAC

AD 600 – 900
El Faisan
terracotta
h. 18.5 cm, w. 12 cm
Museo de Antropología de la Universidad
Veracruzana, Xalapa
inv. no. PJ 3917

The woman is seated cross-legged, wearing
a skirt, a necklace and headdress. Her arms
hang at her sides. The figurine has been
made using a mould, with plaster applied
afterwards. There is decoration in red paint
on the creamy-coloured background and
red paint has also been used to indicate the
patterns on her skirt and to render the
body. Her breasts are decorated with
rosettes and the cheeks are also coloured
red. Her headband is composed of three
serpents and painted both with red and
chapopote, a black paint made from local tar.

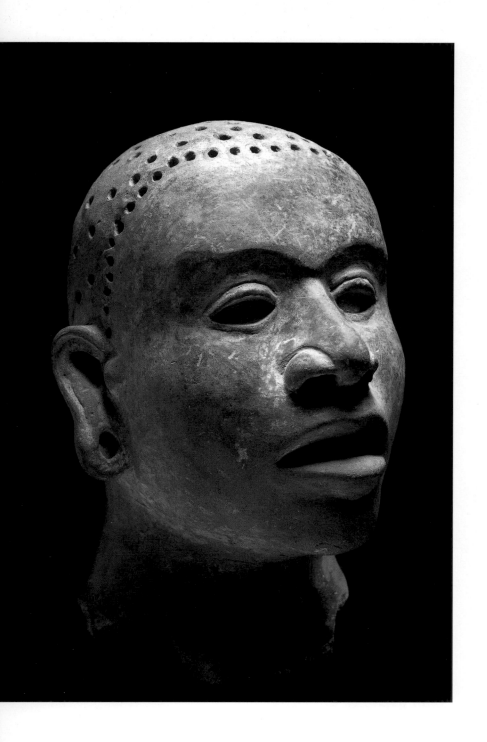

91
PORTRAIT OF A HEAD
PRE TOTONAC

AD 600 – 900
Rio Blanco – Papaloapan
earthenware
h. 25 cm
Museo de Antropología de la Universidad
Veracruzana, Xalapa
inv.no. PJ 143

This fragment from a terracotta picture
shows a portrait of an individual face, with
flaring nostrils, a somewhat pointed chin
and a suggestion of eyes. The mouth is
slightly open to show the upper teeth. The
ear lobes show a piercing for jewellery. The
holes in the head would have been to hold
feathers or possibly natural hair.

The head comes from a grave in the Rio
Blanco-Papaloapan district where many
terracotta pictures, some of them merely
fragments, have been found.

92
'YOUNG MAN OF CUMPICH'
MAYA

AD 800 – 1000
Cumpich (Campeche)
limestone
h. 93 cm
Museo Nacional de Antropología,
Mexico City
inv.no. 10-009788

The young man is apparently having an
orgasm. Like the lower legs and the 'serpent
pectoral', the phallus has been broken off.
His head, according to the Mayan ideal of
beauty, is deformed by elongation. There is
tattooing on the forehead and lower jaw.
During the Epi Classic there was a fertility
cult on the Yucatán peninsula in which the
phallus was shown as a separate sculpture.
This statue, commonly named in response
to the place where it was found, hence the
Young Man of Cumpich, has lost its
presumably erect penis, sign of sexual
arousal, but retains a snake wound around
the neck and body. The serpent is widely
seen as a symbol for the penis, and
consequently is associated with fertility.

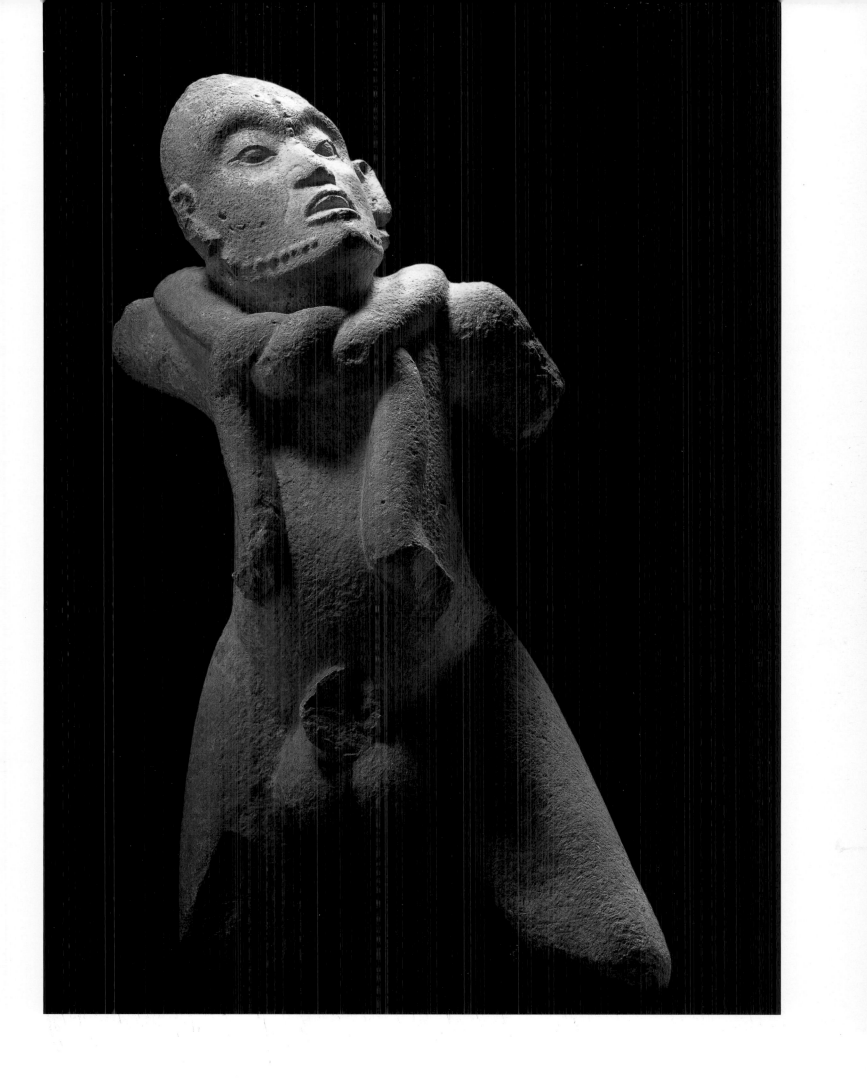

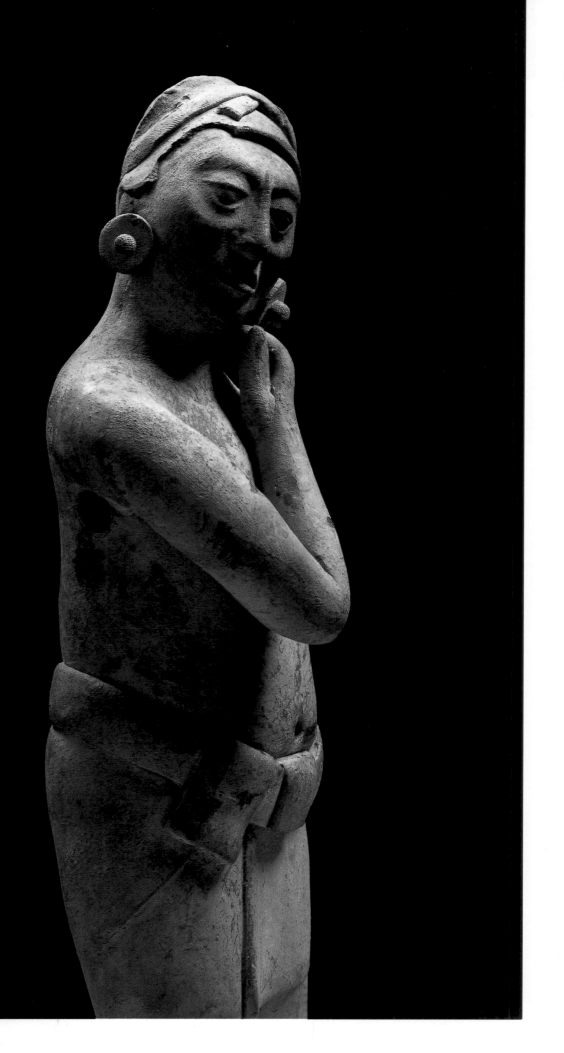

93
PRIEST
MAYA

AD 600 – 900
Jonuta
terracotta
h. 18 cm, w. 7 cm
Museo Regional de Antropología
'Carlos Pellicer', Villahermosa
inv.no. A-0051

This fragment of a figurine represents
a man – probably a priest – holding his right
hand against his left earspool. He wears
a *maxtlatl*, or loincloth, with a small pouch
fastened to it using cord. Even today the
Nahuas of the Sierra Norte of Puebla weave
and use pouches of this kind, called *paltel*.
The man's hair is held in place by a head-
band.

This small statue comes from Jonuta in
the state of Tabasco, which with
Comalcalco forms the northern boundary
of the Maya territory.

94

SEATED WOMAN

MAYA

AD 600 – 900
Jaina
earthenware
h. 19.3 cm, w. 12 cm
Museo Nacional de Antropología,
Mexico City
inv.no. 10-6140

This female figure is almost identical to the
one in cat. no. 95. However, the necklace is
applied on top of the *quechquemitl*, rather
than in front of it. Also, the headdress is
taller. The same mould was used to produce
the two figures. Both also functioned as
a whistle.

95

SEATED WOMAN

MAYA

AD 600 – 900
Jaina
earthenware
h. 15.5 cm, w. 9.3 cm
Museo Nacional de Antropología,
Mexico City
inv.no. 10-223513

The figure sits cross-legged with her
hands resting on her knees. She wears
a *quechquemitl*, probably made using the
shaped-weaving technique, which covers
her chest and falls almost to the sketchily-
suggested wrap-around skirt. Her hair is
decorated with a knop or precious stone
beneath which the locks lie against her high
forehead – its elongated deformation a sign
of beauty. The ridge of her nose extends to
her forehead, an attribute that although
more often seen in Classic Maya
depictions, does not appear to represent
reality. For adornment she wears wide
bracelets, earplugs and a two-stranded
necklace hanging in front of her
quechquemitl. Her necklace and earplugs
appear to be made of jade, a favourite
material of the Maya elite, as seen in grave
excavations. The whole appearance of the
woman suggests she is an important figure,
a high official. There are some traces of
colour, especially blue.

As is so often the case with terracottas
found in Jaina graves, this one too could be
played like a whistle or flute – possibly in
order to make contact with the ancestors.

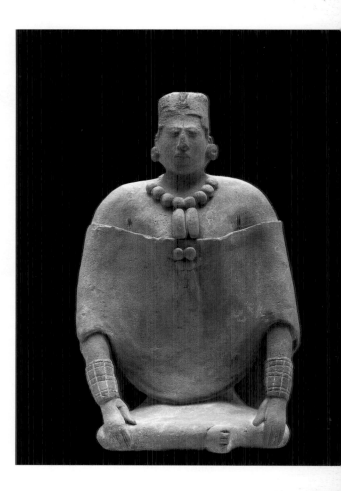

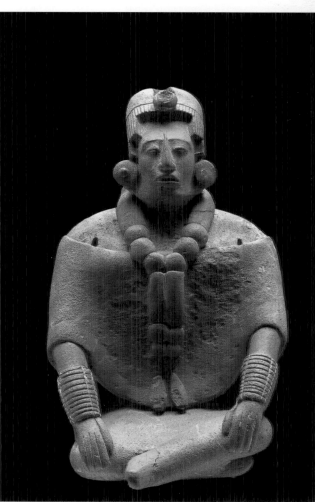

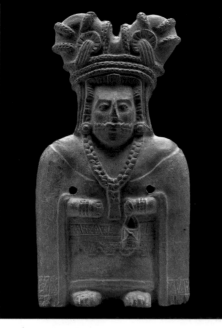
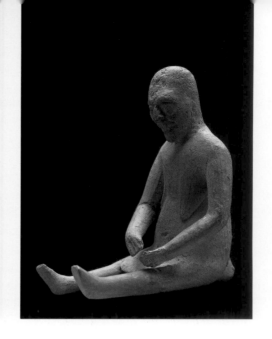

96
DIGNITARY
MAYA

AD 600 – 900
Jaina
terracotta
h. 23.5 cm
Museo Nacional de Antropología,
Mexico City
inv.no. 10-221984

This terracotta figurine with brownish slip
shows an important female dignitary,
dressed in a wrap-around skirt and a wide
belt over which a cape-like coat falls to the
ground. She has a bag in her right hand. For
jewellery she wears earplugs, a double-
stranded necklace, bracelets and a striking
headdress divided into two parts,
composed of cords and rosettes. It looks as
if there is a lock of hair emerging out of
each rosette. On either side of the mouth
are decorative scars: they were caused by
scratching the skin to obtain blood for
sacrifices. The scars had both an important
religious significance as well as an aesthetic
aspect.

97
OLD WOMAN
MAYA

AD 600 – 900
Jaina
terracotta
h. 11 cm
Museo Nacional de Antropología,
Mexico City
inv.no. 10-349296 2/2

The woman, seated with her legs stretched
out, has a wrinkled face and is naked. Her
hands are in front of her lower body. The
figurine has an air vent in the right shoulder
blade. The purpose of this was to allow air
to escape from the terracotta during firing,
and thus prevent the object from
exploding.
 The figurine was found in a grave.

98
VASE WITH FIGURE
ZAPOTEC

200 BC – AD 200
Valley of Oaxaca
earthenware
h. 26.8 cm
Museo Nacional de Antropología,
Mexico City
inv.no.10-357379

On this long-spouted vase a figure with its
back to the viewer is seen leaning, legs
spread wide. The head is deformed by
elongation – for these people an ideal of
beauty – with the hair indicated by incised
lines. The leg bracelets are also suggested
with incised lines, as is a bolero-like
garment on the upper torso. The face has
a pronounced chin and open mouth, a
strong, pointed nose, and slightly bulging
eyes with incised decoration. The ears are
pierced for jewellery. The vase is polished.

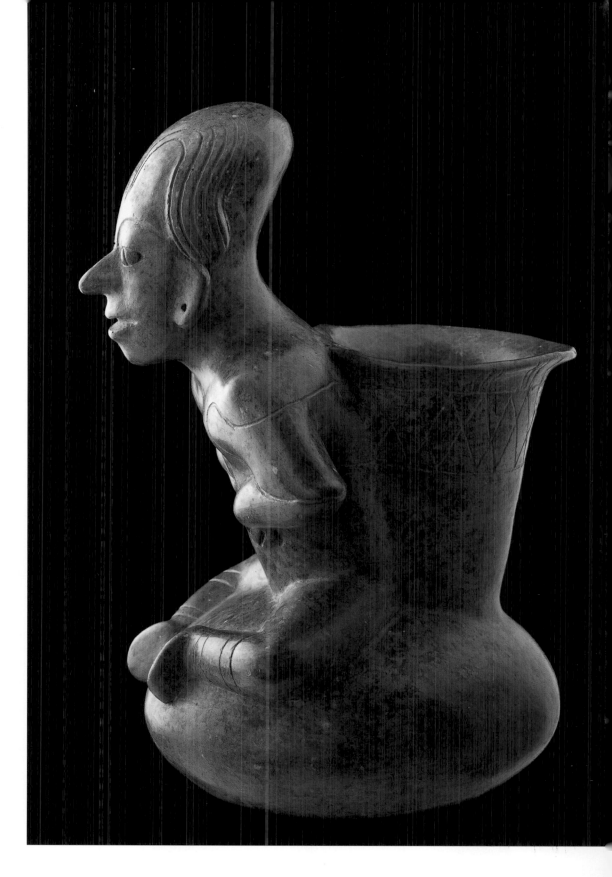

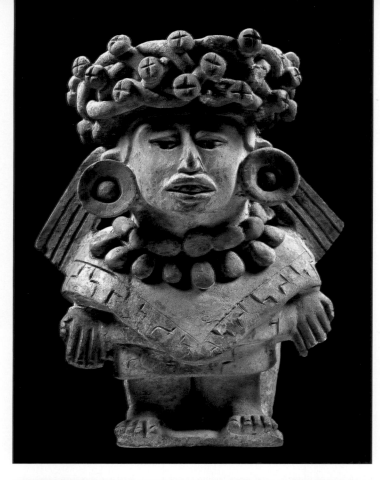

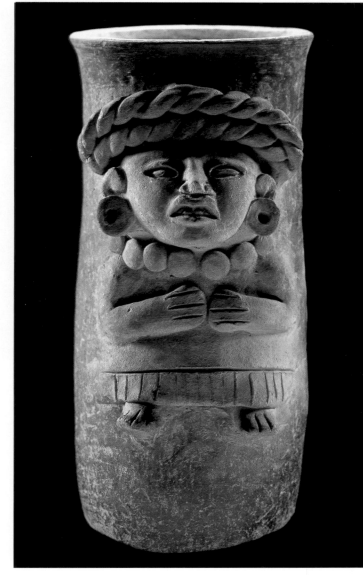

99
URN
ZAPOTEC

AD 600 – 900
Oaxaca
earthenware
h. 34 cm, w. 20 cm, d. 20 cm
Museo de las Culturas, Oaxaca
inv.no. 10-360668

The urn is shaped like a standing female figure wearing a wide headdress adorned with medallions and two prominent flaps hanging at the back. The flaps were made from *amate*, tree-bark paper. The woman wears the typical garments: *quechquemitl* over a *huipil*, or wrap-around skirt, with large earplugs and a bead necklace. The figure provides a lot of information about the clothing worn by a well-to-do woman. The headdress is created by plaiting cotton strips through the hair. Today the Zapotec women from Yalalas still twine plaited woollen strips through their hair, known as *rodete*. Nahua women from the Cuetzalan district in the Sierra Norte de Puebla wear lengths of wool twisted through the hair for parties and sometimes to the market. This is known as the *maxtahual* coiffure (see fig. 24).

Zapotec women acted as guardians of the dead and were sometimes placed above tomb entrances. Human remains have not been found in urns of this type.

100
VASE WITH FEMALE FIGURE
ZAPOTEC

AD 600 – 900
Valley of Oaxaca
terracotta
h. 26 cm
Museo de las Culturas, Oaxaca
inv.no. 10-604187

This vase of greyish earthenware has the applied figure of a woman. She wears a *rodete*, a headdress in which cotton strips are braided in with the hair to make thick locks that are then fastened around the head. The woman has earplugs, a nose ornament and a bead necklace. Her arms and hands are held in front of her breast and she wears a long *huipil* bordered with a fringe at the hem, which is indicated with incisions in the clay.

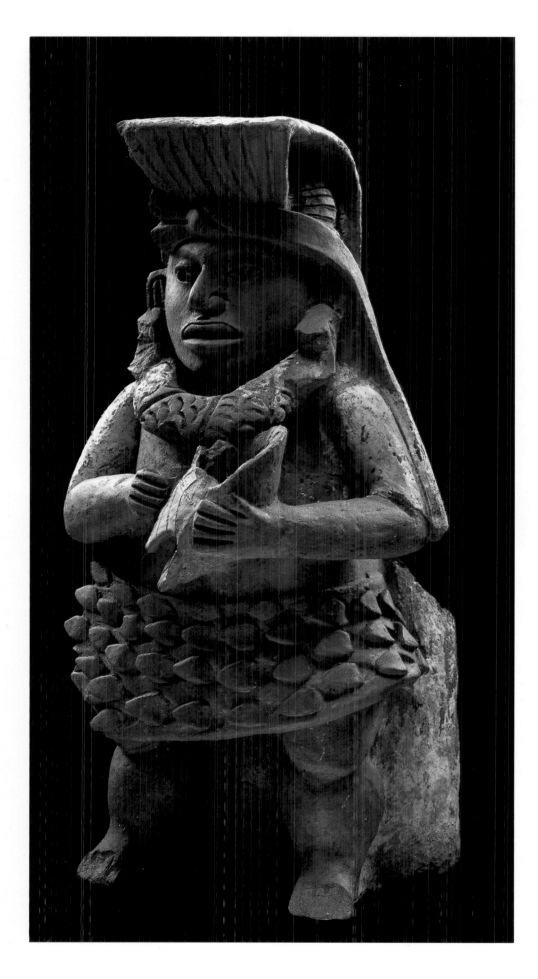

101

MUSICIAN

ZAPOTEC

AD 600 – 900
Oaxaca
terracotta
h. 45 cm
Museo de las Culturas, Oaxaca
inv.no. 3203

This musician has a *raspa* in the shape of
a turtle shell. With the stick in his right
hand he scratches across the instrument.
His hair is in a band falling over his
shoulders, and he has a large pectoral,
earplugs and a small apron decorated with
conch shells. He stands before a barrel or
urn which is also made of grey earthen-
ware. Only the shells are coloured, with
a soft reddish patina.

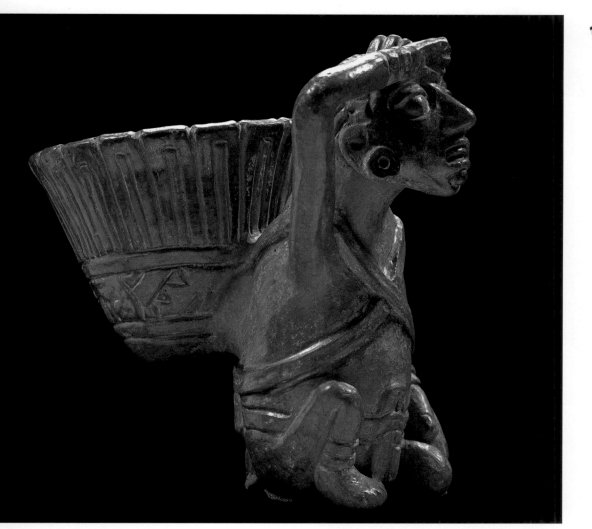

102
BEARER
MIXTEC

AD 900 – 1521
Yagul
earthenware
h. 13 cm, d. 14.5 cm
Museo de las Culturas, Oaxaca
inv.no. 10-104420

The figurine shows a kneeling bearer with a large barrel on his back. The man's right hand is pressed against his forehead, the left hand rests on his bent left leg. Arm and leg bracelets, as well as loincloth, are suggested by applied lines which are outlined in black, thereby heightening the contours. The same is done for the straps which are crossed over the bearer's chest. This method of carrying a heavy weight is different from the *mecapal*, which was a strap around the forehead. The face and barrel are also painted black. The potter has captured the weariness of the bearer in the stance of this figurine. The sense of exhaustion is further shown by the open mouth, the hand against the forehead, and the vacant gaze.

In Mesoamerica the bearers, called *tameme*, fulfilled a major function: the wheel was not used for vehicles to transport heavy burdens. Curiously, miniature objects with wheels have been found in shaft-tombs.

103
MALE FIGURE
AZTEC

AD 1428 – 1521
Mexico – Tenochtitlan
stone
h. 98.5 cm
Museo Nacional de Antropología, Mexico City
inv.no. 10-220145

The legs and arms of this figure are broken off so that only head and torso remain. He wears a loincloth with an elaborate knot in it. Under the breastbone an almost square section has been notched out for a (semi-) precious stone. Probably this would have been jade, because of the position – jade symbolizes the heart. In low relief the head shows the Aztec hairstyle with 'sideburns'. The eyes are inlaid with shell and obsidian (volcanic glass) for the pupils.

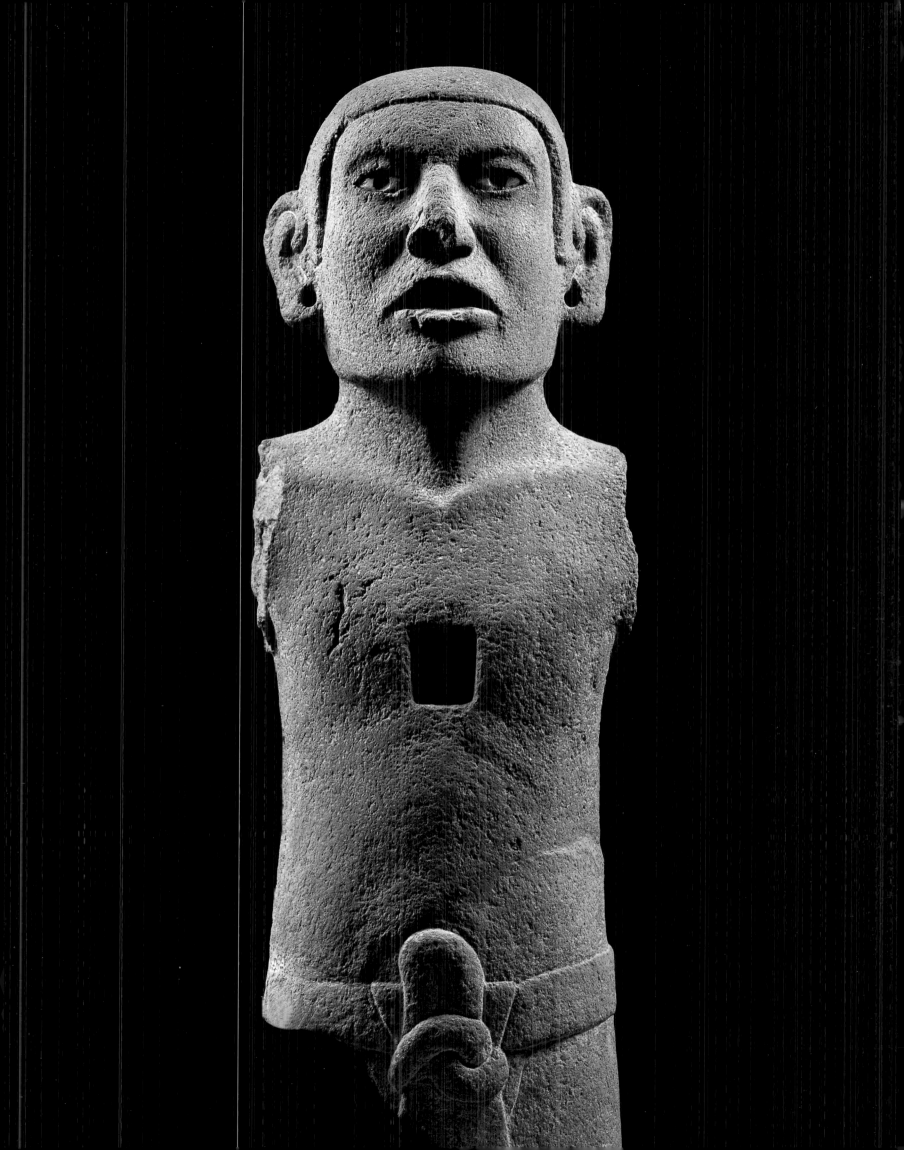

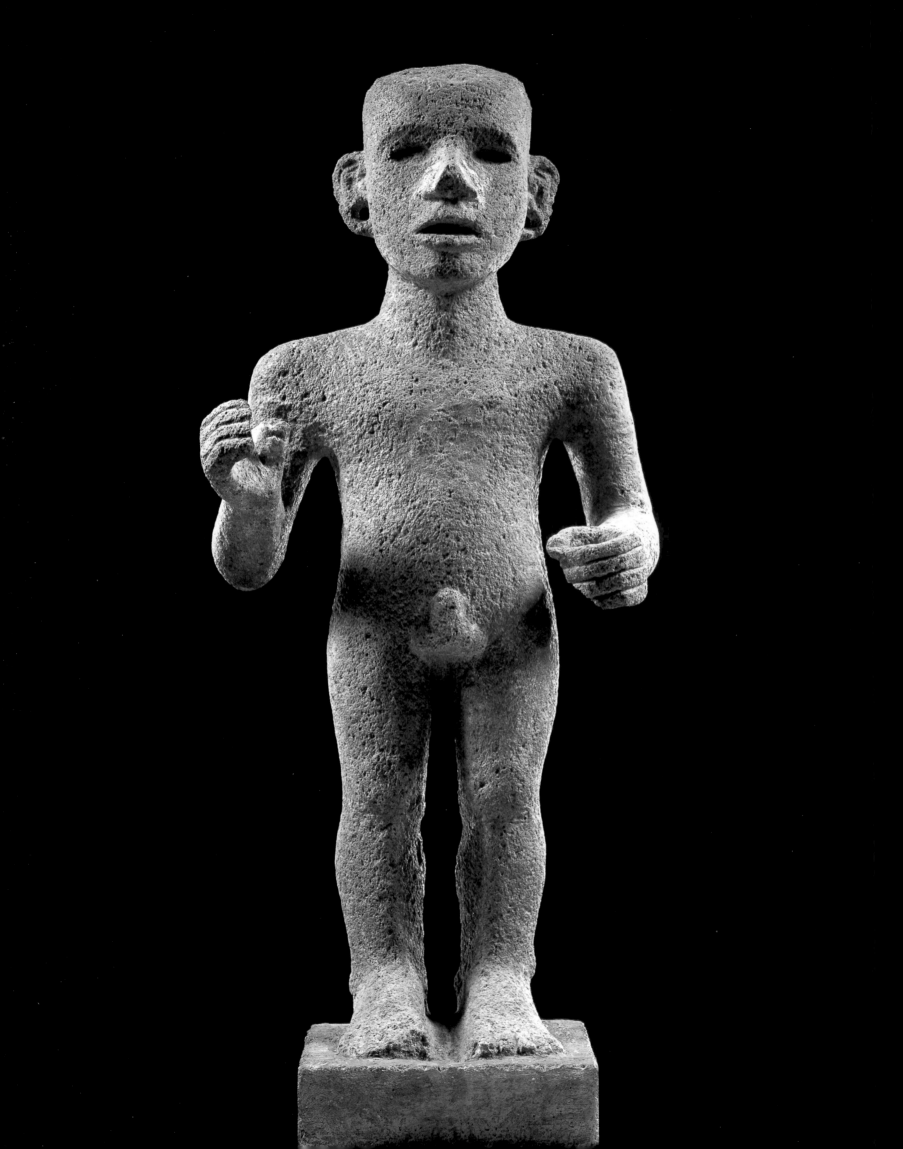

104

YOUNG MAN

AZTEC

AD 1423 – 1521
Texcoco
stone
h. 63 cm, w. 20 cm
Museo Nacional de Antropología.
Mexico City
inv. no. 10-40607

The statue shows a young man with an
erect penis. His rounded, and thus tube-
shaped, hands would have held the staff of
a banner. The boy is represented
realistically. His eyes are oval and his ears
are pierced for jewellery. His mouth is
slightly open.
 The statue is a rare Aztec representation
of a young man on the threshold of sexual
maturity.

105

HEAD

AZTEC

AD 1428 – 1521
Mexico – Tenochtitlan
stone
h. 19 cm, w. 15 cm
Museo Nacional de Antropología,
Mexico City
inv. no. 10-92

The eyes are made of inlaid shell and
obsidian (volcanic glass) in this head of an
Aztec boy. Red shell has been used for the
eyeballs, which may suggest the youth has
become drunk on the lightly alcoholic
pulque, or had eaten the hallucinatory
cactus, peyote. White shell has also been
used for the row of upper teeth which can
be seen in his open mouth. The hair,
complete with what resemble sideburns, is
suggested in low relief. On the base of the
head is a peg or pin which indicates that the
head once formed part of a larger
sculpture.

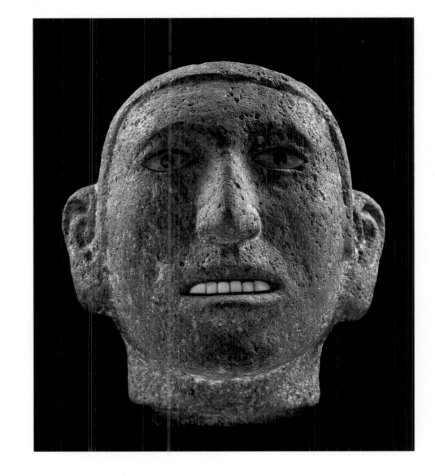

106
MINIATURE SCENE SHOWING KITCHEN ACTIVITY
AZTEC

AD 1428 – 1521
Mexico – Tenochtitlan
terracotta
Woman with *metate* h. 12 cm; *comal* diam.
6,1 cm, h. 1,5 cm; bowl diam. 3,8 cm
Museo Nacional de Antropología,
Mexico City
inv.no. woman with *metate*, 10-79538; *comal*,
10-50337; bowl, 10-141367

A woman grinds corn (maize) using a roller
on the *metate*, or stone board. She makes a
tortilla, a kind of pancake, from the maize-
flour dough. The tortillas are baked on a flat
earthenware tray, the *comal*. The bowl is
used for sauce.

107
MINIATURE HIGHCHAIR
AZTEC

AD 1428 – 1521
Mexico – Tenochtitlan
terracotta
h. 11.5 cm, b. 8 cm
Museo Nacional de Antropología,
Mexico City
inv.no. 10-106088

This baby's highchair employs a clever
device so that the small child can't fall out.
It is a prototype for all times.
　　Possibly this object was a votive offering.

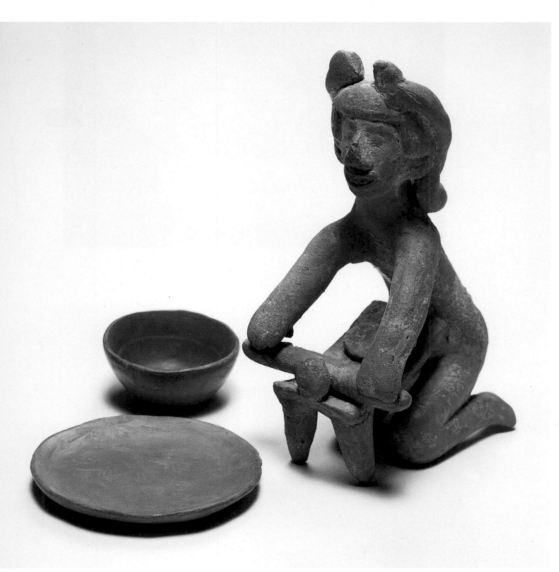

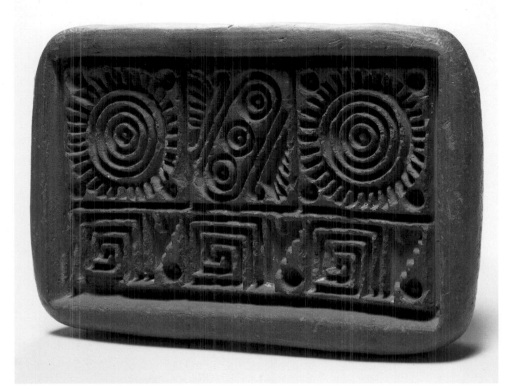

108

STAMP

AZTEC

AD 1428 – 1521
Mexico – Tenochtitlan
earthenware
l. 17 cm, w. 11 cm
Museo Nacional de Antropología,
Mexico City
inv.no. 10-78295

The stamp has a geometric design with two
horizontal sections, each being divided into
three segments. The lowest section is
decorated with the motif of the sun and
curving lines. The largest section shows the
xicalcoliuhqui in the corners; this is the open
shell motif associated with Quetzalcoatl,
the Plumed Serpent. Between the two
xicalcoliuhqui we find the motif of the sun
and the heavens.

Stamps were used when decorating
textile and also to apply patterns on the
body.

109

PIPE

TARASC

AD 900 – 1521
Michoacan
terracotta
l. 27.5 cm, h. 8.2 cm, w. 4.9 cm
Museo Nacional de Antropología,
Mexico City
inv.no. 10-58994

This brownish-black earthenware pipe
ends in a bowl upon two small feet.

110 and 111

TWO PIPES

AZTEC

AD 1428 – 1521
Mexico – Tenochtitlan
terracotta
l. 20 cm, w. 7 cm; l. 17 cm, w. 10.2 cm,
diam. 3.6 cm
Museo Nacional de Antropología
inv.nos. 10-540168 en10-152664

Both pipes are shaped to resemble the
ancient god Hueheuteotl. They differ
from each other in that one god wears
earrings while the other has earspools.
One of the faces has a broken nose.
The pipes were used for ceremonial
purposes during, for example, a rite in
honour of Huehueteotl.

112

PIPE

NAHUA

AD 900 – 1521
West Mexico
terracotta
l. 27.5 cm, h. 13.8 cm, w. 5.8 cm
Museo Nacional de Antropología,
Mexico City
inv.no. 10-1505

The bowl of this white earthenware pipe
gradually grows wider towards the top. It
rests on two feet, and comes from West
Mexico where in the Post Classic, Indians
speaking Nahual and Nahuat settled.
Apparently, pipe-smoking did not become
popular in West Mexico until the Post
Classic.

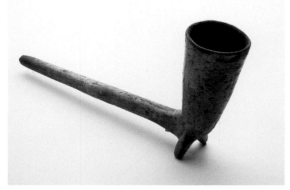

113

PIPE

AZTEC

AD 1428 – 1521
Central Highlands
terracotta
l. 22 cm
Museo Nacional de Antropología,
Mexico City
inv.no. 10-141395

The pipe is shaped like a monkey leaning backwards, supporting itself on the stem. The monkey is an important mythological figure throughout Mesoamerica. In the *Popol Vuh* (Book of Creation), the holy book of the Maya-Quichés, monkeys appear for instance, as Hun Batz, One Howler Monkey, Hun Chuen and One Spider Monkey, patrons of song, dance and writing. In Central Mexico the monkey *Ozomatli* is the eleventh day sign. He is related to Quetzalcoatl in his shape of Ehecatl (see cat. no. 146). It was considered a sign of prosperity and good luck to be born on the day sign of Ozomatli.

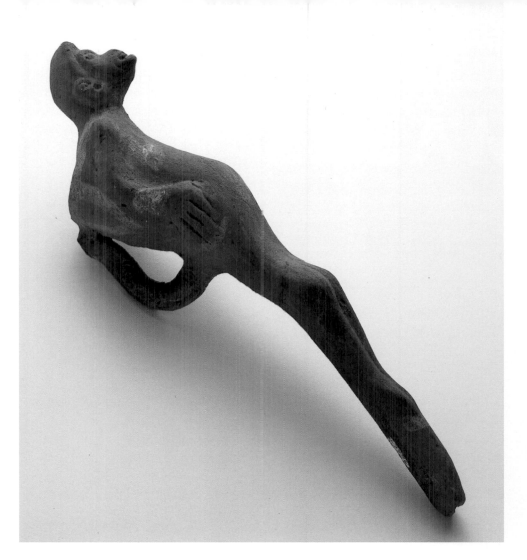

114

PIPE

TARAC

AD 900 – 1521
Michoacan
terracotta
l. 28.0 cm, h. 13.8 cm
Museo Nacional de Antropología,
Mexico City
inv.no. no number

The pipe has a tall bowl showing a pseudo *talud-tablero* relief.

MASKS

Like all peoples of Antiquity, the inhabitants of ancient Mexico created masks. In this way, they made themselves a second face with a ritual significance. The oldest masks were made from clay and represent imaginary animals or supernatural beings.

The Olmecs carved magnificent masks of jade, portraying an idealized human face. These represented the divine powers of nature.

The Teotihuacan masks illustrate their idealization of youth. When these masks have holes for the eyes or mouth it suggests they were worn in processions and at ceremonial festivals. The masks without such openings were presumably laid upon the dead but it is still unclear exactly what function they fulfilled. They were probably crowned with a feather headdress.

The Maya also made masks of jade, the most precious type of stone they knew, and traditionally the symbol of life.

All the masks of ancient Mexico were a type of death mask, made to be placed upon the face of the dead body.

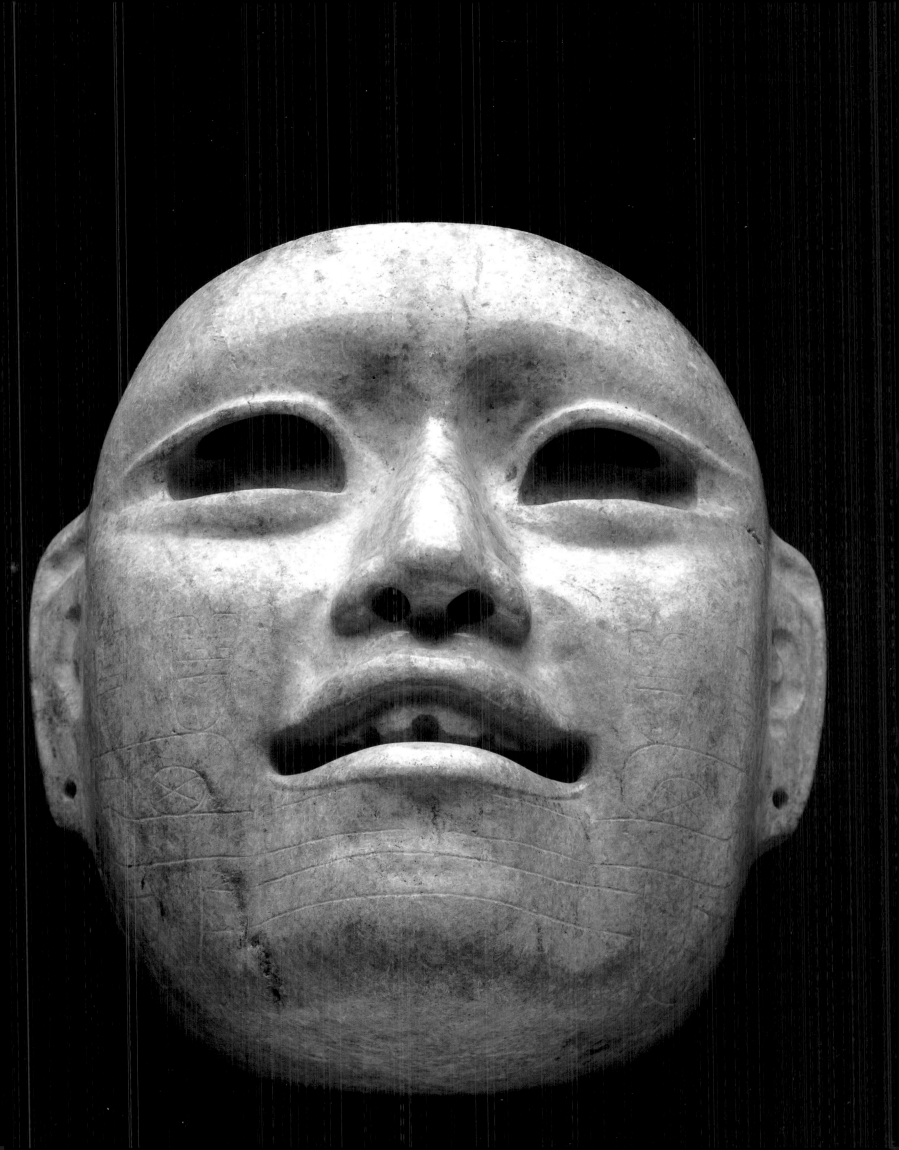

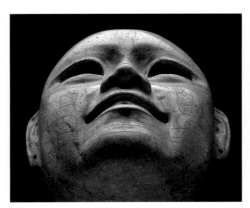

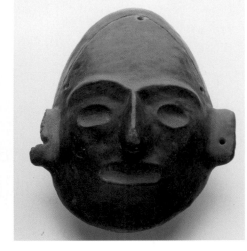

117
MASK
TEOTIHUACAN

AD 300 – 650
Malinaltepec
stone, shell, obsidian and turquoise
h. 21.7 cm, w. 21 cm
Museo Nacional de Antropología,
Mexico City
inv.no. 10-9630

Mask made of volcanic stone with the face
in a mosaic of turquoise and coral. Obsidian
and shell are used for the eyes. The
necklace attached to the mask combines
beads made from red coral. The mosaic of
the face is largely of blue stones with
a meandering line of red coral running
from the upper lip to the middle of each
cheek, suggesting a nose ornament. Coral
runs above the eyes, forming continuous
eyebrows. On the forehead a glyph has
been set using red coral and white shell,
possibly the sign for *malinalli*, grass. This
would coincide with part of the location of
the find, which is called Malinaltepec,
meaning grassy hill, in Guerrero. The
cultural impact of Teotihuacan, the style in
which this mask is made, can also be felt in
this region. Official excavations in
Teotihuacan have so far only come across
three such masks *in situ*. These were in the
rooms and passageways of administrative
and religious building complexes running
along the 'Avenue of the Dead'. So far no
archaeological evidence has been found to
suggest that these masks were placed on
the faces of funerary bundles in a tomb.

115
MASK
OLMEC

900 – 400 BC
Rio Pesquero
jade
h. 15.5 cm
Museo de Antropología de la Universidad
Veracruzana, Xalapa
inv.no. PJ 4013

The mask is made of blue-green jade and
has a striking facial expression. The open
mouth reveals a row of upper teeth that
have been beautified. The nostrils are
flaring, while the eyes, with their somewhat
Chinese appearance, are not filled in,
suggesting that the mask was to be worn.
Together with the open mouth this makes
the impression of a smiling individual.
A pattern of lines is incised on the cheeks,
originally coloured with red cinnabar. It
represents the young sprouting corn. In all
likelihood the person whom this mask
represents had a function connected with
the fertility of the corn and crops. The
mask was not found in a tomb but in
a closed room, from which we conjecture
that it was not intended to be laid upon
a mummy bundle, but was worn in fertility
rites.

About twenty years ago when the course
of the Rio (river) Pesquero in south
Veracruz was diverted, a niche was
discovered containing a quantity of these
jade masks, which had possibly been
ritually buried there. This one now forms
part of the collection in the
Anthropological Museum of Jalapa.

116
MASK
PROTO CLASSIC

AD 0 – 300
Colima
terracotta
h. 24.5 cm, w. 19.8 cm, d. 7.2 cm
Museo Nacional de Antropología,
Mexico City
inv.no. 10-2729

In West Mexico, especially in Colima, stone
and terracotta masks mostly dating from
the Proto Classic are quite common. This
mask shows the deformed elongated head
(a sign of beauty) with a hole either side to
hang it up with or to fasten it upon a dead
body. Above the hole is an indentation
following the shape of the head and behind
this is what may be hair or a fine head-
covering. The ears are vertical and
rectangular with a large hole for jewellery.
The right ear is damaged. The eyes were
probably once inlaid. The mouth is open
but the teeth cannot be seen. Probably these
were made from pieces of shell.

The mask was a funerary gift in a shaft-
tomb.

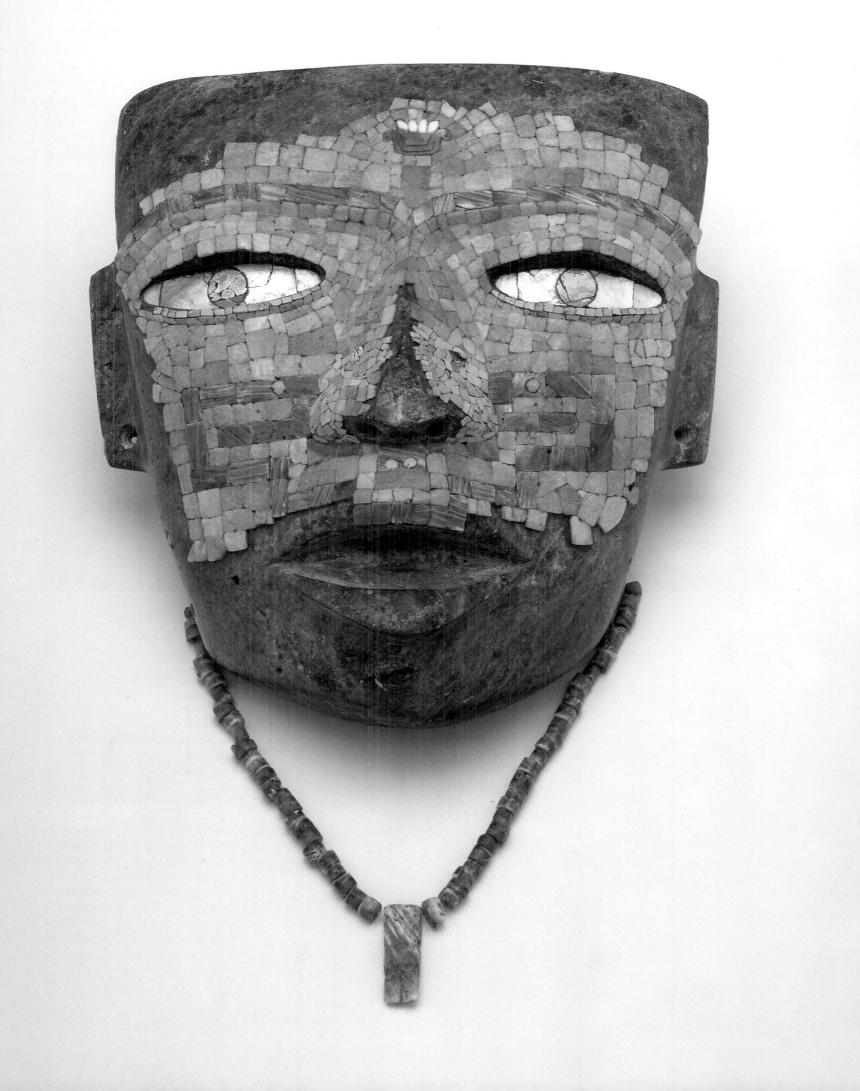

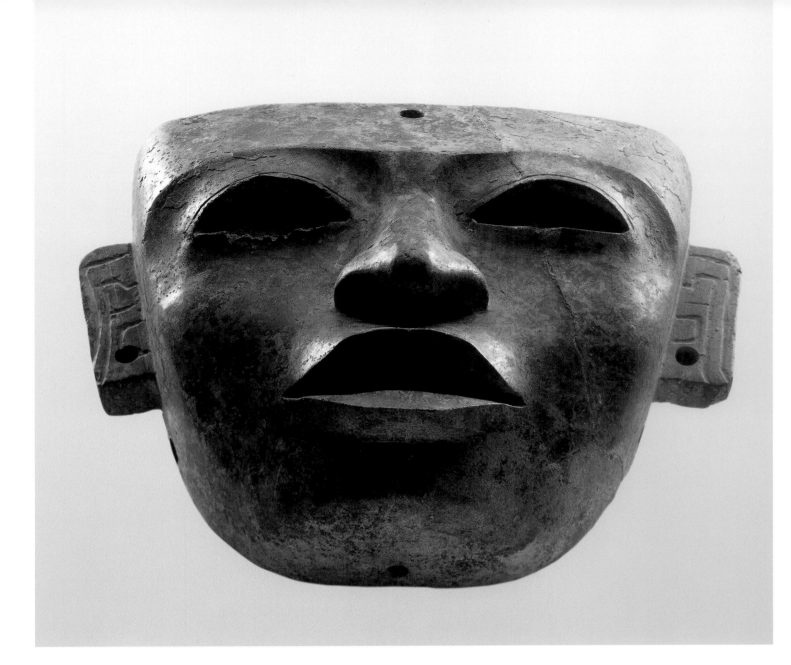

118

MASK

TEOTIHUACAN

AD 300 – 650
Teotihuacan
stone
h. 22 cm
Museo Nacional de Antropología,
Mexico City
inv. no. 10-9628

The mask, made from grey-green stone, is
produced in the typical Teotihuacan style,
with almond-shaped eyes, slightly arched
eyebrows meeting over the bridge of the
nose, the mouth a little open, and vertical
rectangular ears with an opening for inlay
work. A geometric wavy pattern decorates
the ears, betraying the influence of the Gulf
Coast. There is a hole in the centre of the
forehead, presumably to hang the mask on
a wall.

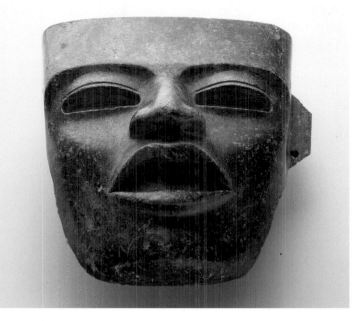

119a

MASK

AD 300 – 650
Teotihuacan
stone
h. 23 cm, w. 22 cm, d. 9 cm
Museo de la Cultura Teotihuacana,
Teotihuacan
inv.no. 10-336635

The stone mask has been sculpted in the
typical Teotihuacan style. The right ear is
broken. The upper lip has a pronounced
curl, and the mouth is open.

119b

MASK

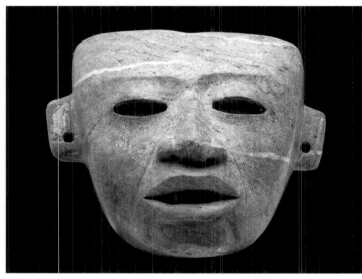

AD 300 – 650
Teotihuacan
stone
h. 17 cm
Museo de la Cultura Teotihuacana,
Teotihuacan
inv.no. 10-411187

120

MASK WITH EARSPOOLS

AD 600 – 900
Calakmul
jadeite, obsidian, mother-of-pearl
h. 23 cm, w. 14 cm
Museo Histórico Fuerte de la San Miguel,
Campeche
inv.no. 10-290537 0/3

A large number of masks have been found
in Calakmul. This one, which has another
small mask on its head, is made of jadeite
with eyes of mother-of-pearl and pupils of
obsidian (volcanic glass). The mask was
found lying on the face of a dead body, as
was customary among the Calakmul elite.
The mask shows individual features. The
open mouth reveals teeth, and out of both
corners flows a scroll, possibly symbolizing
a moustache.

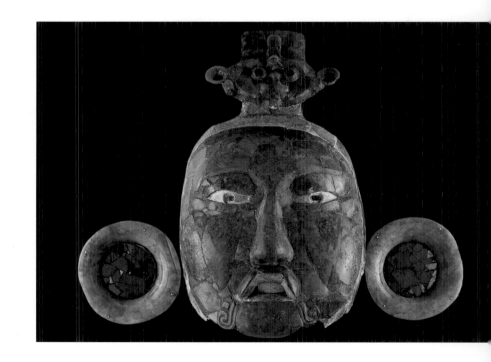

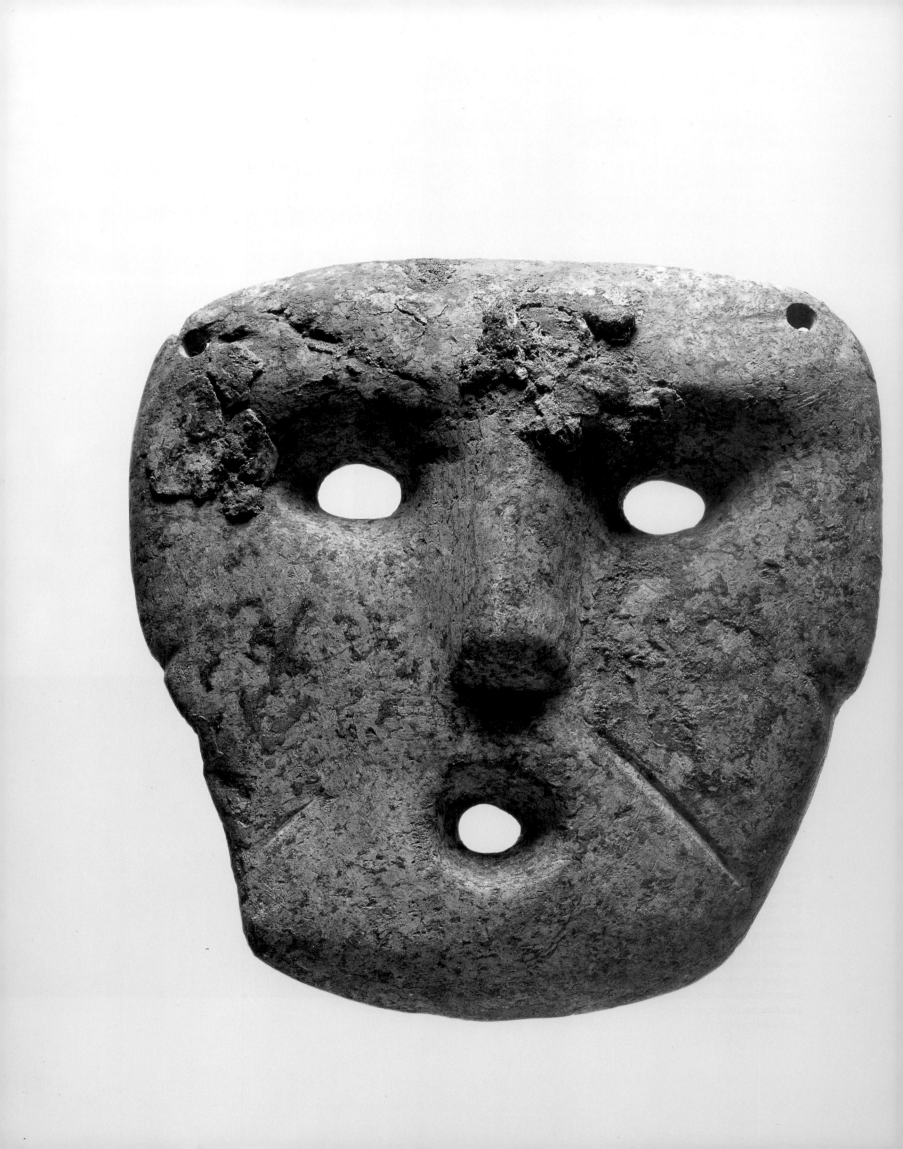

FIVE MASKS

POST CLASSIC

AD 900 – 1521
Guerrero
stone
h. 19 cm, w. 17 cm, inv.no. 10-168796
h. 17 cm, w. 17 cm, inv.no. 10-251594
h. 18 cm, w. 17 cm, inv.no. 10-251614
h. 14 cm, w. 14 cm, inv.no. 10-251724
h. 18 cm, w. 17 cm, inv.no. 10-251840
Museo del Templo Mayor, Mexico City

These five masks of greenstone are termed
Mezcala-type masks after the river
Mezcala in the state of Guerrero. The
Aztecs used them at ceremonies of
dedication and sacrifice which they held in
the Templo Mayor complex in their capital
city México-Tenochtitlan. They would use
many objects brought from other cultures
and often of great antiquity to add weight
and dignity to their rituals. Thus these
masks, although made in Guerrero, were
found in the Templo Mayor complex

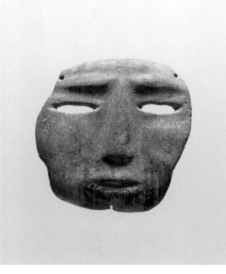
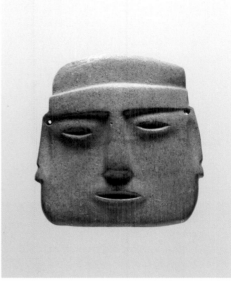
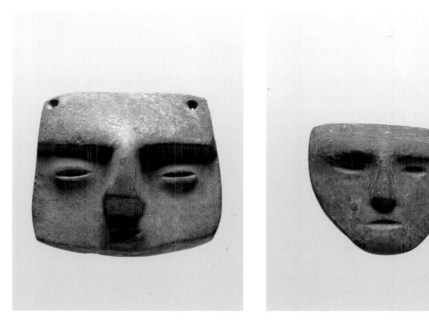

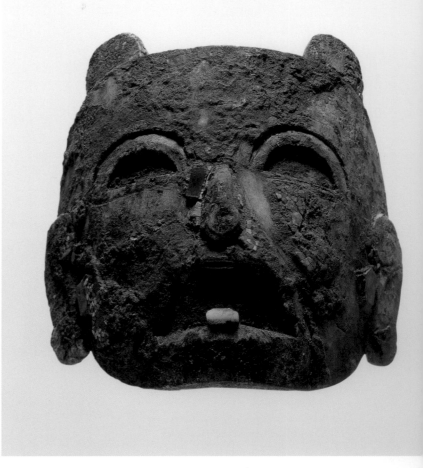

126 – 128

THREE MASKS

POST CLASSIC

AD 1280 – 1521
Tehuacan
wood
h. 17 cm, w. 16 cm; h. 15 cm, w. 17 cm;
h. 15.5 cm, w. 15 cm
Museo Regional de Puebla, Puebla
Inv.no. 10-373011; 10-373014; 10-373009

In the valley of Tehuacan, Puebla, a grave
was uncovered containing three *chimalli*
shields, four tablets and thirteen masks,
three of which are on display here. All the
objects are made of wood covered with
a mosaic of turquoise, shells and other
materials. Traces of these may still be
detected on the three masks.
 Mask 10-373011:
This shows the head of a feline creature,
probably a jaguar. The open mouth reveals
the tongue made of shell. The inlay work of
the eyes has disappeared.
 Mask 10-373014:
On the right of the nose in particular, there
are still several turquoise areas. The inlay
for the eyes has gone, likewise the upper
teeth which were set in the almost
rectangular mouth.
 Mask 10-373009:
This mask, with mosaic inlay, shows the
large upper teeth in the mouth. The inlay
for the indentation where the nose
ornament would be has been lost; only the
right eye still has its inlay work.
 These three masks were probably laid
upon the funerary bundles in which the
dead were wrapped.

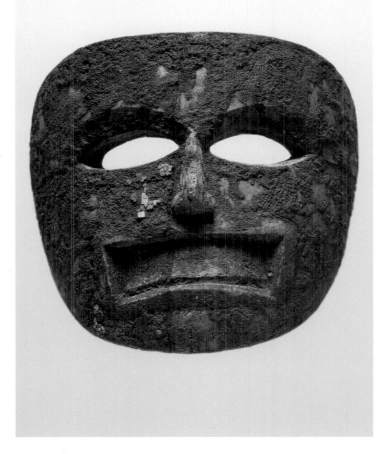 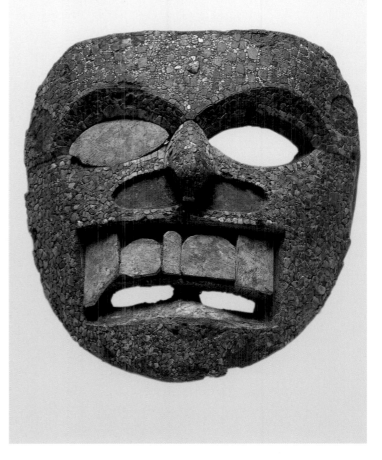

GODS

The religion of ancient Mexico was polytheistic, that is, they worshipped many gods.

It was also a religion worshipping nature. Each element of the universe, the earth where people live, the sun, the moon, animals, plants and natural phenomena such as lightning, rain, wind and plant life – all were linked to the gods.

There was also a mythological aspect: vivid stories accounted for the cosmic creation and explained the function and meaning of the deities.

The most important gods in the pantheon were the following: the sun god, the fertility gods and goddesses, the fire god (also known as the very ancient god), the god of death, the god of war, and the goddess of maize or corn.

One god who figures in a major way in all the cultures, is the rain god. He was someone to treat respectfully, since he could cause not only the refreshing showers but also a devastating downpour.

Numerous festivals were organized annually to honour the gods. People were dependent upon them in every aspect of their existence. So their chief duty was to worship the gods with rituals and ceremonies.

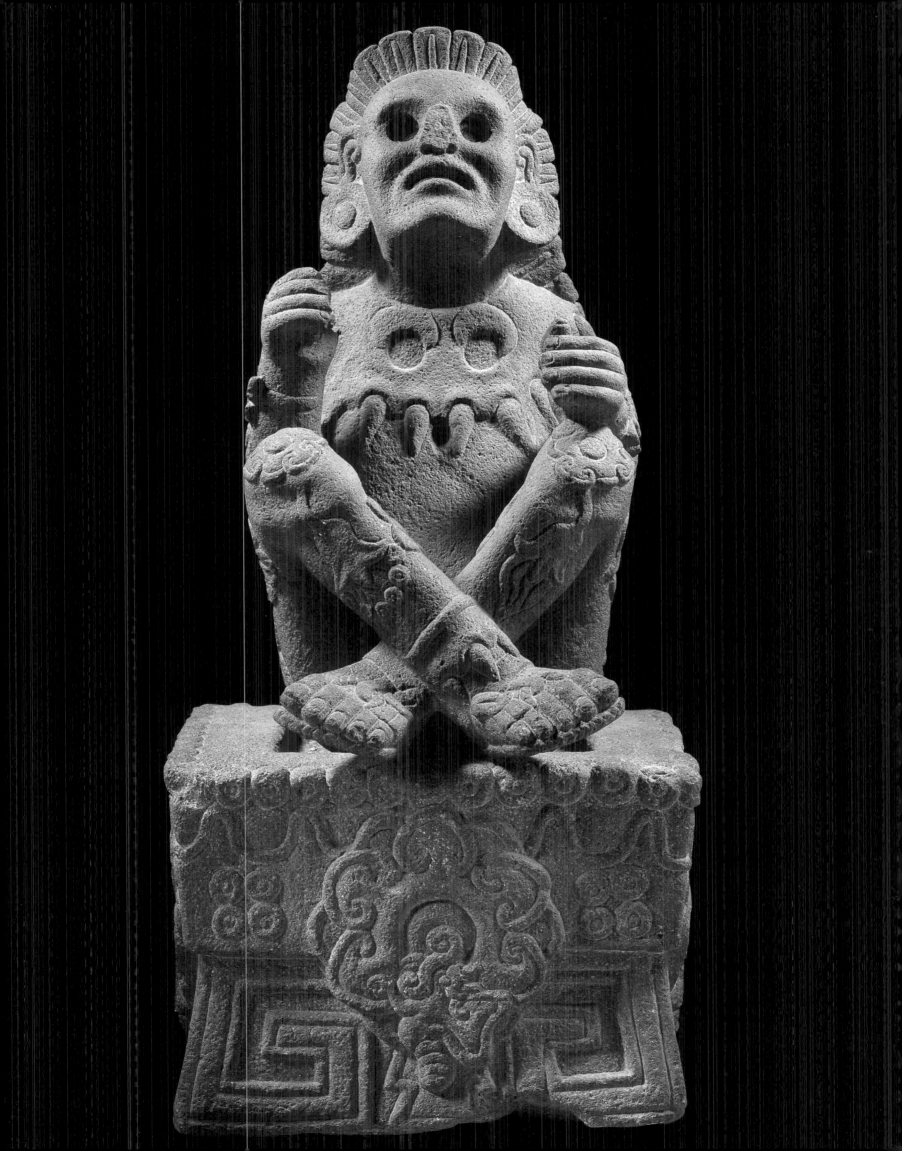

129
XOCHIPILLI, THE FLOWER PRINCE
AZTEC

AD 1428 – 1521
Tlalmanalco
stone
h. 175 cm, w. 107 cm
Museo Nacional de Antropología,
Mexico City
inv.no 10-222116

Seated upon a *talud-tablero* pedestal
decorated with flowers and wavy lines is
Xochipilli, the Flower Son or Flower Prince,
with his legs crossed and pulled up. This
deity is Lord of the dance, music, flowers,
games and, especially in Central Mexico, of
the rubber ballgame. His body is covered in
flower motifs, accentuating his name,
xohcitl, meaning flower. The expression on
his face is ecstatic. He wears a garment like
a burnous decorated with geometric
motifs. In this cloak there is an opening for
his hair which hangs in three bunches over
the burnous. He wears a loincloth and
sandals, large earplugs and a remarkable
necklace of jaguar claws, emphasizing his
divine authority.

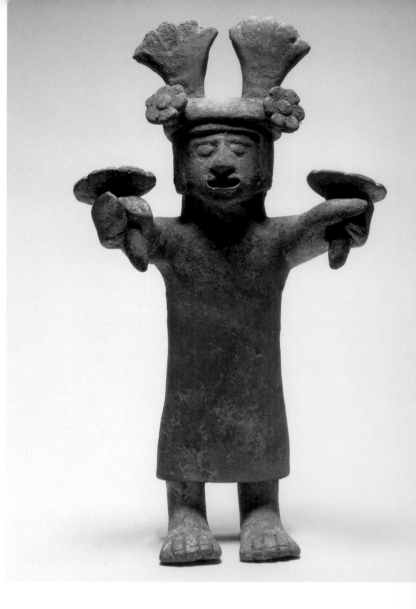

130
XOCHIQUETZAL
AZTEC

AD 1428 – 1521
Mexico – Tenochtitlan
terracotta
h. 22.5 cm
Museo Nacional de Antropología,
Mexico City
inv.no. 10-116782

The figurine represents the goddess
Xochiquetzal, which means 'Flower-
quetzal', or Flower-Feathers. She is the
patroness of young women in childbirth,
weaving and other female activities. Here
the goddess is characteristically adorned
with a flower in each hand, and flowers in
the headband, which also holds two
bunches of feathers. The statuette may
have stood upon a house altar.

FLOWER

AZTEC

AD 1428 – 1521
Mexico – Tenochtitlan
terracotta
l. 20 cm, diam. 8.7 cm
Museo Nacional de Antropología,
Mexico City
inv.no. 10-607776

The flower is an attribute of Xochiquetzal,
goddess of young women (see cat. no. 130).

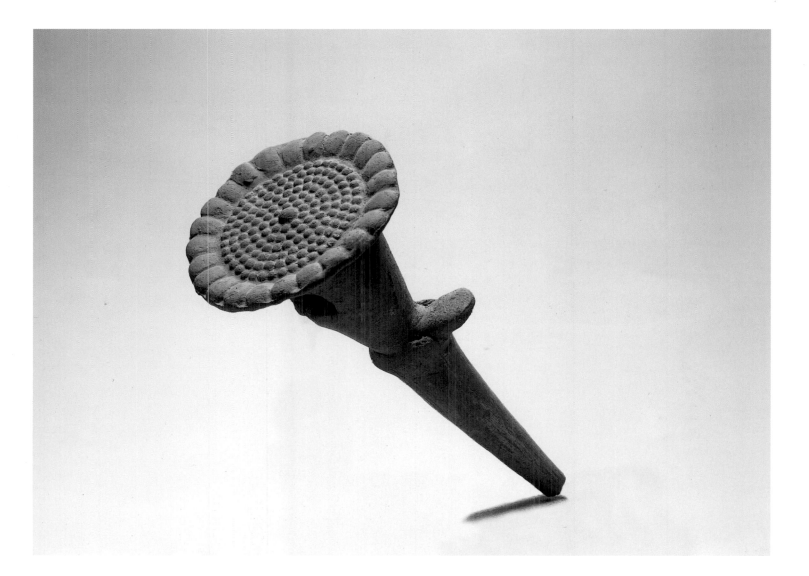

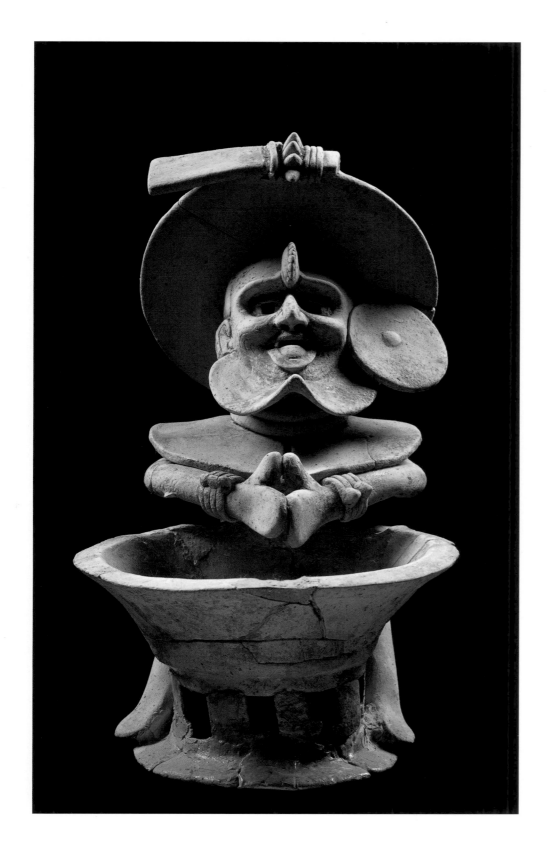

132
HUEHUETEOTL
PROTO CLASSIC

300 BC – AD 300
Laguna de los Cerros
terracotta
h. 26 cm
Museo de Antropología de la Universidad
Veracruzana, Xalapa
inv.no. PJ 290

The ancient god Huehueteotl holds the tips
of his fingers pressed together above
a censer which he clasps between his legs.
Huehueteotl is one of the most ancient gods
of the Mesoamerican pantheon, the god of
fire, essential for mankind. The
Huehuetéotl seen here was found in the
Olmec territories, in South Veracruz, but
shows little sign of the typically Olmec
features such as the drooping jaguar mouth.
The old man has two eye-teeth in otherwise
bare gums. A small jewel resembling
a lizard is set upon his forehead above the
nose. He has a cheerful headdress, with
a wide bow at the edge (left flap broken off),
a large round earplug in the left ear and
bracelets. From his chin flows a wavy beard.
Over his shoulders is a cape-like wide ruff
or collar.

The figurine has the colour of the
orangey-red firing clay.

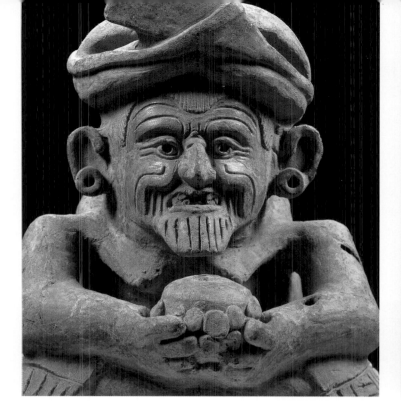

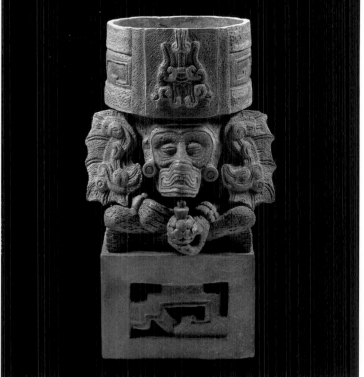

133

URN IN THE SHAPE OF THE GOD HUEHUETEOTL

ZAPOTEC

AD 300 – 900
Cerro de las Minas, Huajuapan
terracotta
h. 32.5 cm
Museo de las Culturas, Oaxaca
inv.no. 10-104322

The urn is shaped like an old man seated cross-legged. His face is wrinkled and he has a goatee beard, which defines him as the 'very old god' Huehueteotl. The deity wears a headdress which has a broken flap, earplugs and a loincloth the ends of which are draped across his knee. His mouth has two incised circles and he is holding a small pot close to his chest, possibly for tobacco.

Like cat. no. 134 this statue was found in the archaeological zone of Cerro de las Minas, in the Mixteca Baja. It seems highly likely that, partly through trading, the Zapotec and Mixtec encountered each other in the Mixteca Baja district.

134

URN REPRESENTING THE GOD HUEHUETEOTL

MIXTEC

AD 300 – 900
Cerro de las Minas, Huajuapan
terracotta
h. 34 cm, w. 22 cm, d. 15.5 cm
Museo de las Culturas, Oaxaca
inv.no. 10-360668

The urn comes from the *ñuiñe* culture, the Mixtec name for the tropical zone or *tierra caliente*, which flourished in the Mixteca Baja, the valley of the Mixtec, between roughly AD 300 and 800/900. The urns found there are constructed differently from those of the Xapotec of the Oaxaca valley. The ñuiñe urn consists of a square base on which the god is enthroned. Here the pedestal has a geometric step-pattern with openwork decoration. Enthroned with his urn, the ancient god sits cross-legged, the Huehueteotl of the Central Highlands. His face is wrinkled, eyes are closed, and he wears a mouth mask somewhat resembling a jaguar, together with large earplugs and bracelets. The urn, as third section in the construction, rests on his head. To the left and right of his face are large flaps with animal and plant motifs. His left hand holds a small lidded jar, possibly a tobacco pot. The urn is decorated with the step motif and a floral design in the centre. There are traces of polychrome painting, with the reddish tones of the terracotta predominating.

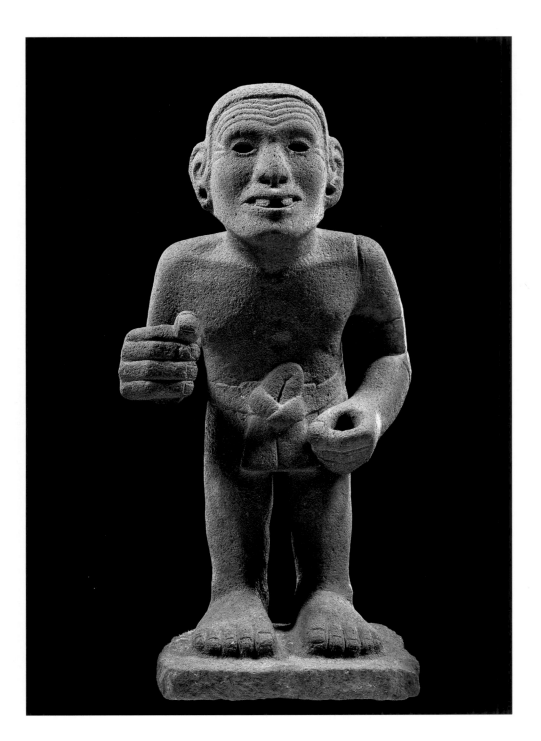

135
HUEHUETEOTL
AZTEC

AD 1428 – 1521
Mexico – Tenochtitlan
stone
h. 55 cm, w. 20 cm, d. 22 cm
Museo Nacional de Antropología,
Mexico City
inv.no. 10-1121

This stone statue has the body of a man but
the head of the ancient god Huehueteotl.
He stands on a low pedestal, hands held as if
to carry a banner or flag. He has the hair-
style and sideburns typical of the Mexica,
the name the Aztecs gave to themselves. He
is wearing only a loincloth, knotted in
front. There is a section cut into his torso
just above the loincloth that looks as if
formerly it was intended to hold a piece of
jade, symbol for the heart and life.

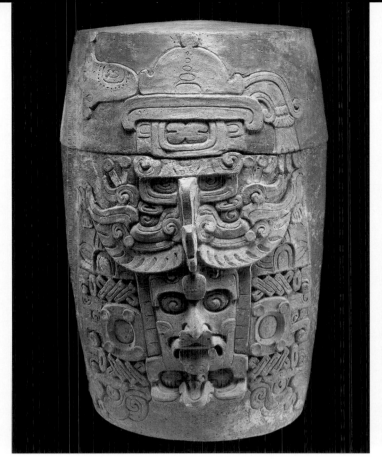 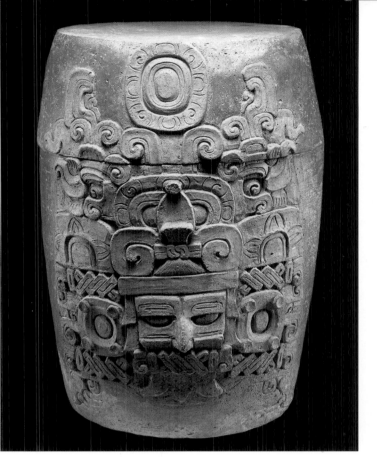

136

URN IN RELIEF

MAYA

AD 600 – 900
Yucatan (?)
terracotta
h. 48 cm, diam. 36.4 cm
Fondación Cultural Televísa, A.C.,
Mexico City
inv.no. 180

The urn shows the sun god Kinich Ahau
with the rain god Chac above. Probably it
was used in fertility rites.
 The provenance is unknown.

137

URN IN RELIEF

MAYA

AD 600 – 900
Yucatan (?)
terracotta
h. 50 cm, ciam. 34.5 cm
Fondación Cultural Televísa, A.C.,
Mexico City
inv.no. 181

The urn shows a relief of the rain god Chac
on the central and lower sections. The
upper section depicts the 'sun-shield'. The
combination of rain and sun stands for
fertility.
 The provenance is unknown.

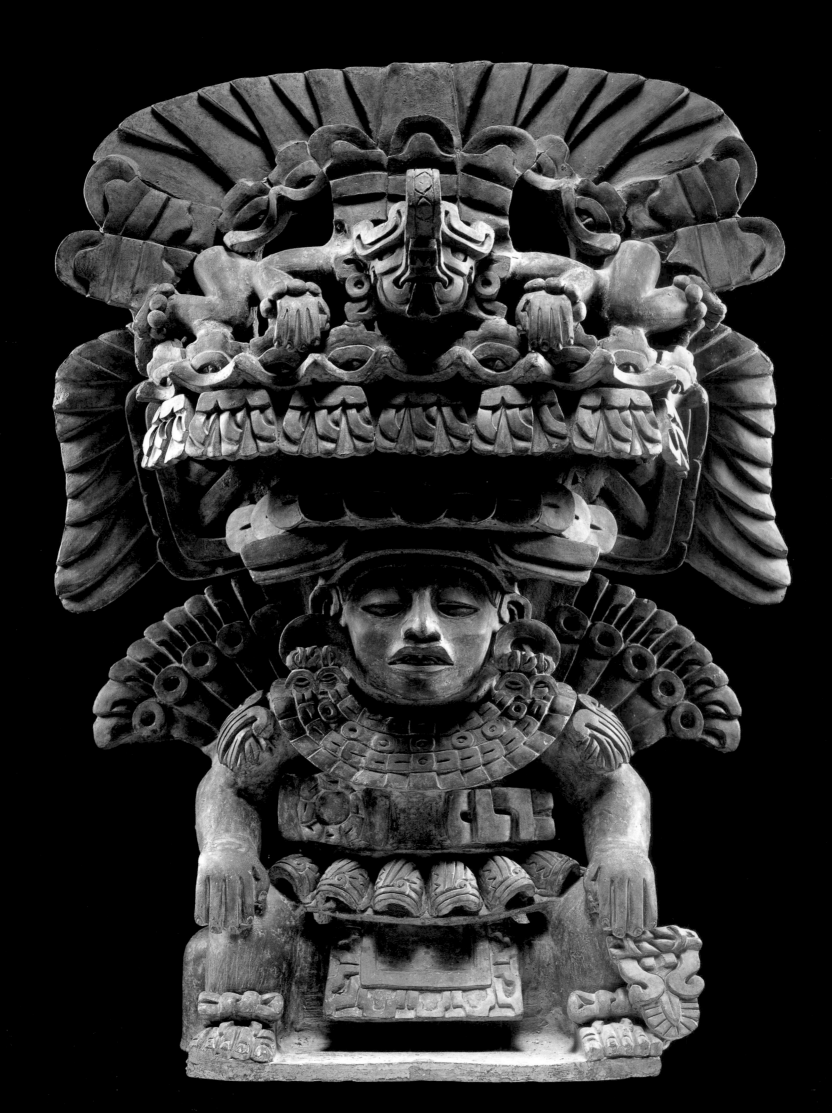

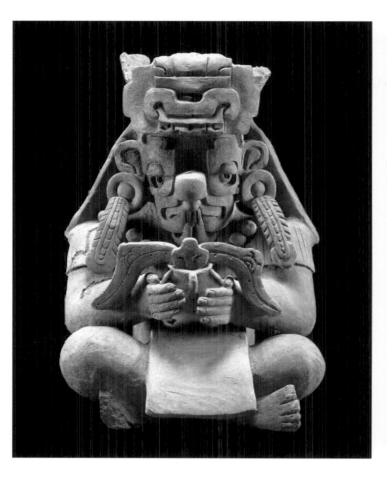

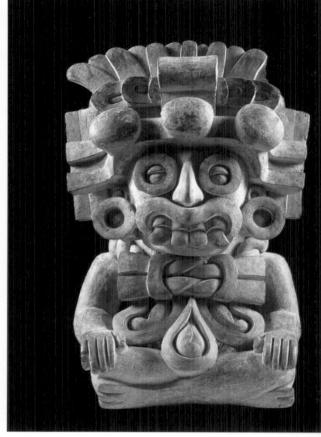

138

URN
ZAPOTEC

AD 600 – 900
Monte Alban
terracotta
h. 59 cm
Museo de las Culturas, Oaxaca
inv.no. 3359

The urn is shaped like a seated priest, with a headdress representing the thunder and rain god of the Zapotecs, Cocijo. The priest sits in a squashed-up manner, his arms in front of him. Cocijo, the Tlaloc of the Central Highlands, can be recognized by his fat 'snout', forked tongue and the lines below and above the eyes, like the god Tlaloc. The priest wears a ruff-like feather collar, ear decorations, large pectoral, a band across his chest and a belt of conch shells. His hands rest on his knees, between which the flap of his loincloth can be seen. It seems from his headdress that the priest was in the service of Cocijo, and stood in the grave beside the dead as sentry above the entrance to the shaft-tomb.

139

COCIJO, THE RAIN GOD
ZAPOTEC

AD 600 – 900
Monte Alban
terracotta
h. 60.5 cm, b. 41 cm
Museo Nacional de Antropología,
Mexico City
inv.no. 10-228149

The urn represents the rain god Cocijo. He can be recognized by some of the attributes commonly given to him by the Zapotecs: the headdress containing the symbol 'c', the broad nose and mouth mask, for instance. The god sits cross-legged holding a bowl from which clouds of steam emerge. The flap of his loincloth rests on his crossed legs. He wears a bead necklace and earplugs decorated with feathers.

Although urns of this type have been found in tombs, they never contain human remains. Probably their function was to hold maize (corn) to sustain the dead on their journey to the Underworld. Possibly they also formed part of the funerary architecture and were placed beside the dead or as guard at the entrance to a tomb.

140

URN
ZAPOTEC

AD 600 – 900
Monte Alban (?)
terracotta
h. 26.5 cm, w. 19.5 cm
Museo de las Culturas, Oaxaca
inv.no. 2270

The urn looks like the Zapotec rain god Cocijo who is the equivalent of the rain god Tlaloc. The face of Cocijo shows the characteristic rings around the eyes; the drooping jaguar mouth is open showing four large teeth. The god, or the rain god's priest, sits cross-legged, his hands on his knees. He wears a headdress with three large balls or rosettes, in his ears large rings and a broad pectoral from which hang three modelled water-drops.

This type of urn would be placed as a 'guard' above the entrance to a tomb; it contained no human remains.

141

TLALOC

TOLTEC

AD 900 – 1200
provenance unknown
terracotta
h. 20 cm
Museo Nacional de Antropología,
Mexico City
inv.no. 10-81700

This figurine representing the rain god
Tlaloc is clothed from head to foot in
feathers. The face has the ringed eyes
characteristic of Tlaloc, a mouth with
drooping corners, and a curling upper lip
emphasized by a serpentine line, similar to
a moustache. The feather and snake
elements, the feathered serpent, are
reminiscent of the pyramid of
Quetzalcoatl-Tlaloc in the Ciudadela
(Citadel) of Teotihuacan, where a
combination of these two gods, of heaven
and earth, is pictured.

The figurine has polychrome painting. Its
provenance is unknown.

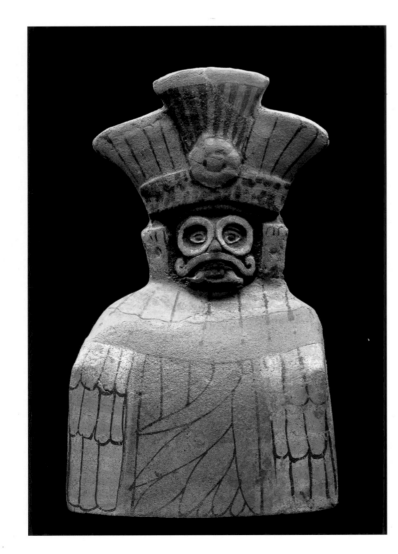

142

VASE WITH MASK REPRESENTING TLALOC

AZTEC

AD 1428 – 1521
Mexico – Tenochtitlan
terracotta
h. 35 cm
Museo del Templo Mayor, Mexico City
inv.no. 10-220302

A bullet-shaped vase with two handles and
a neck gradually becoming wider. The face
of the rain god Tlaloc, with the goggled
eyes so typical of him, is applied onto the
vase. He wears a headband and a tiara
consisting of five truncated pyramidal
tablets, made from amate paper with a
knotted loop on each. The mount with two
tusks and the circular eye sockets form a
long band inspired by the shape of a snake.
The ears are hidden behind large square
earplugs. The chief colours used in painting
are blue and terracotta.

The vase was found during the Templo
Mayor excavations of 1979 – 82, in a cache
of offerings, number 56, behind the temple
pyramid of Tlaloc. The vase contained
mother-of-pearl shells and green stone
beads which symbolize life. Tlaloc was the
rain god of the ancient Mexicans and
therefore the harbinger of life.

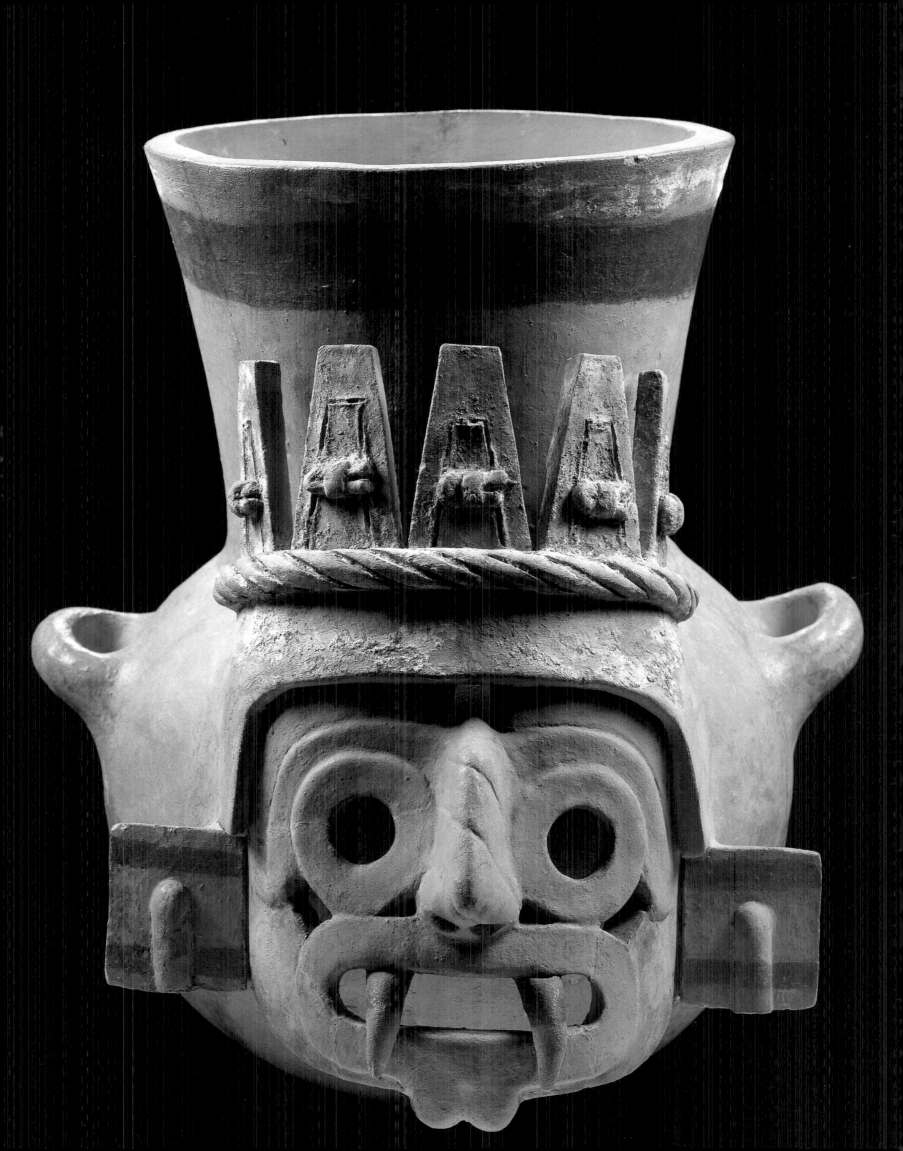

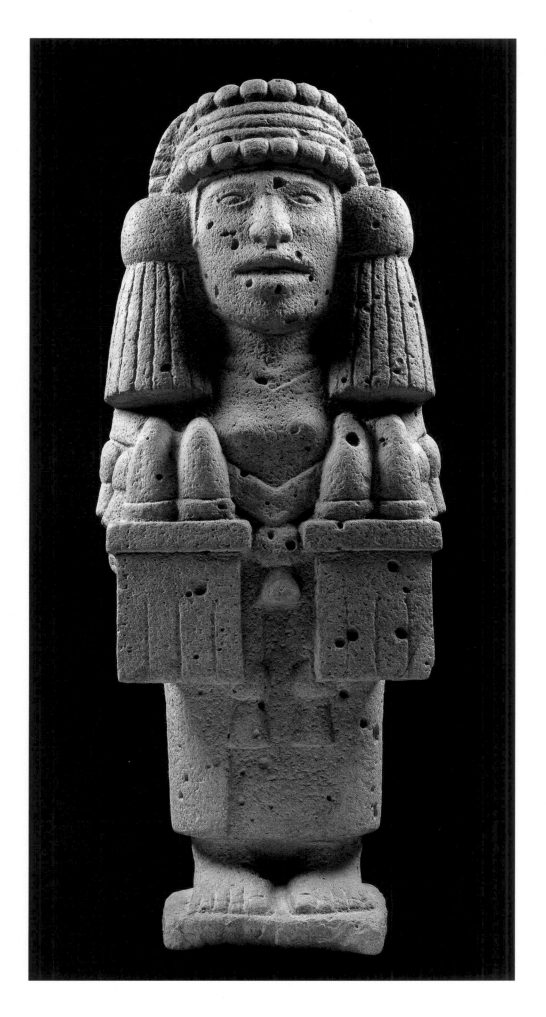

**XILONEN,
GODDESS OF YOUNG MAIZE**

AZTEC

AD 1428 – 1521
Mexico-Tenochtitlan
stone
h. 52 cm
Museo Nacional de Antropología,
Mexico City
inv.no. 10-82209

This standing corn goddess holds a double
corncob with her two hands. She is wearing
a *quechquemitl* with tassels above a belted
wrap-around skirt. The belt fastens at the
front in a loose knot. The headdress is
decorated with knops, or small balls. Her
ears cannot be seen, they are hidden by
large buns beneath which her hair emerges.

144

URN SHAPED LIKE THE BAT-GOD

ZAPOTEC

AD 600 – 900
Monte Alban (?)
terracotta
h. 41 cm, w. 29 cm
Museo de las Culturas, Oaxaca
inv.no. 3160

This urn is shaped like the bat-god wearing
a large pleated headdress made of *amate*-
bark paper. A small box is applied on the
head. The figurine has bat-like ears, an
open mouth revealing deadly fang-like
teeth, and rosettes decorating the cheeks.
He wears a loincloth and a necklace. The
divine nature of the bat is possibly connected
with the species of bat found in this area,
that have vampire-like characteristics.

This type of urn would be placed as
a 'guard' above the entrance to a tomb;
it contained no human remains.

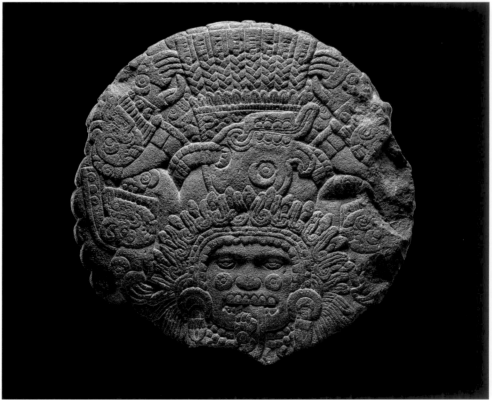

145

QUETZALCOATL, THE PLUMED SERPENT

AZTEC

AD 1428 – 1521
provenance unknown
stone
h. 18 cm, diam. 38 cm
Museo Arqueológico de Estado de México,
Instituto Mexiquense de Cultura, Toluca
inv.no. 10-109302

The stone figure of a coiled rattlesnake
covered with feathers represents the god
Quetzalcoatl, the Feathered Serpent. The
feathers come from the quetzal, and cóatl
means snake. The tongue protrudes from
a mouth full of teeth, bearing a relief of
a claw. Behind the head is a scroll with
the date, *ce acatl*, One Reed. This was also
the year of birth of the lord of Tula and
high priest of Quetzalcoatl, Topiltzin
Quetzalcoatl. At the base of the statue the
Lord of the Earth, Tlaltecuhtli, is pictured
in relief. The snake, the rattles clearly
depicted at the end of its body, symbolizes
the earth, while the quetzal feathers
represent the heavens. This reflects the
Indian idea of the connection between
heaven and earth.

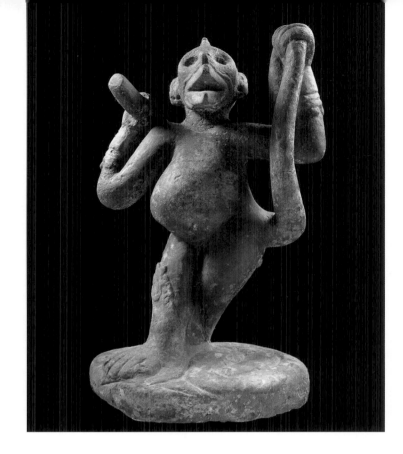

146

EHECATL, THE WIND GOD

AZTEC

AD 1428 – 1521
Mexico – Tenochtitlan
stone
h. 60 cm
Museo Nacional de Antropología,
Mexico City
inv.no. 10-116784

Ehecatl the wind god, recognizable by his
bird's beak with which he creates the wind,
is another form of Quetzalcoatl, the
Plumed Serpent. In this composition two
animals have been fused together. First,
there is the ape, shaped like a tornado.
Then comes the serpent, visibly supplying
the tail end. The raised left hand brings the
serpent-tail across the back to the right
hand. The elegantly placed right leg, and
the circular platform are also decorated in
low relief, with a snake and rattles.

The combination of serpent, closely
related to Quetzalcoatl, and ape, likewise
associated with the Plumed Serpent,
contribute – together with the Ehecatl bird
beak – to a remarkable dynamic whole in
this religious image of the Mexica (Aztecs).

The statue was found during
construction work in connection with the
metro in the historic centre of Mexico City.

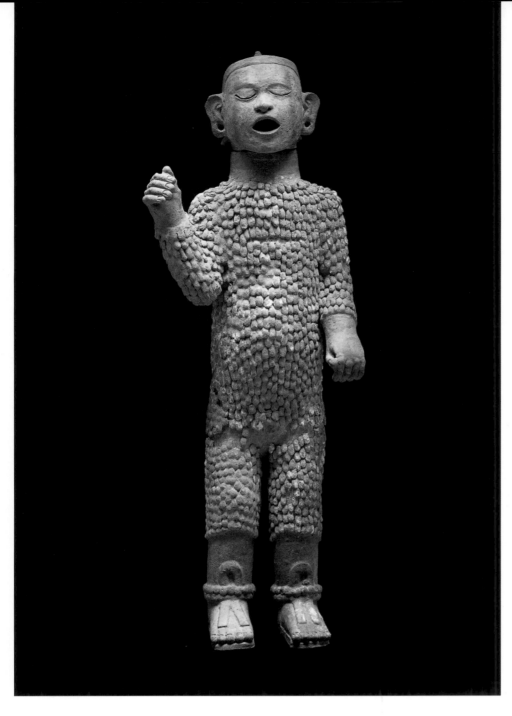

147
XIPE TOTEC
AZTEC

AD 1428 – 1521
Central Highlands
terracotta
h. 97 cm
Museo Regional de Puebla, Puebla
inv.no. 10-203061

This figure represents a priest in the service
of the god of spring and fertility, Xipe
Totec, the Flayed One. He is covered with
the skin, including face and closed eyes, of
the person who has been sacrificed. The
skin falls to just below the knees, and the
legs and sandaled feet of the priest then
become visible. The skin is covered with
bumps. These might represent balls of fat,
but should possibly be seen as grains of
gold, since Xipe Totec is also the patron of
goldsmiths.

In the spring – for us at the beginning of
March – in the 20-day month of
tlacaxipeualiztli, the Festival of Flaying
would be held, in honour of Xipe Totec.
Putting on the skin of the flayed sacrifice
like a garment was seen to represent the
coming of new life, that is, spring.

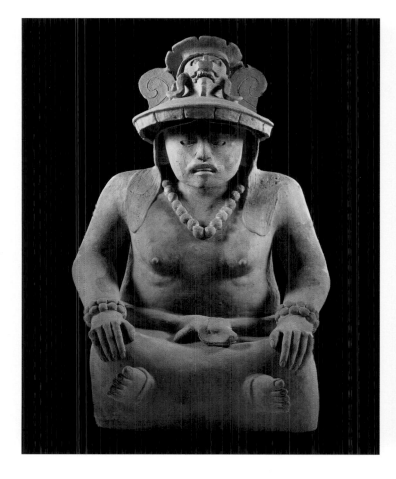

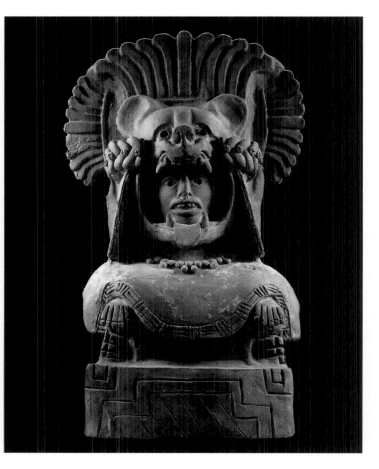

148
FERTILITY GODDESS
PRE TOTONAC

AD 400 – 700
Las Remojadas (?)
terracotta
h. 110 cm, w. 80 cm
Fondación Cultural Televísa, A.C.,
Mexico City
inv.no. 179

This hollow statue of a seated fertility
goddess shows a precursor of Coatlicve,
'she with the skirt of serpents', of the
Aztecs. Under her bare bosom the wrap-
around skirt is held in place with a snake
belt. The feet emerge beneath the skirt,
the hands rest upon the thighs. She is
wearing a necklace and bracelets. A more
or less flat headdress bordered with flaps
crowns her head. There are two scroll
shapes on the 'hat' and a head with open
mouth is seen between them. A long tongue
is sticking out. A beret-like cap is applied
upon the head.

149
URN
ZAPOTEC

AD 300 – 600
Valley of Oaxaca
terracotta
h. 53 cm
Museo de las Culturas, Oaxaca
inv.no. 10-604184

The urn is shaped like a person looking out
of the mouth of a bat. Bats live in caves and
are thus closely associated with the under-
world. The figure wears a cape with geo-
metric patterns on it. His seat is engraved
with a stepped, flattened pyramidal
construction. The bat costume, with flaps
at the side hanging to the shoulders, has
a large feather garland, while above and
below by the mouth two large teeth can be
seen. This person, presumably a priest,
was in the service of the bat god, closely
associated with the cult of the dead.
Such urns would be placed as 'sentries' at
the entrance to shaft-tombs.

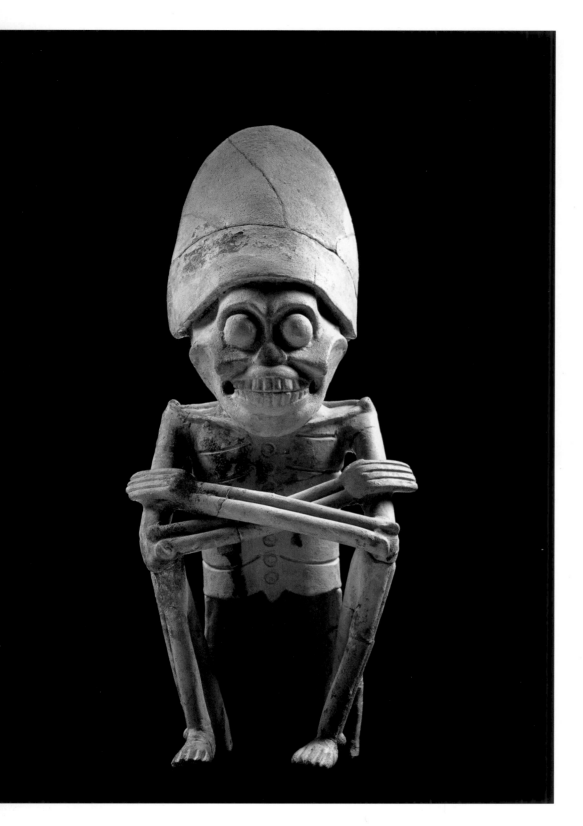

**MICTLANTECUHTLI,
GOD OF THE UNDERWORLD**

PRE TOTONAC

AD 600 – 900
Los Cerros/Rio Blanco – Papaloapan
earthenware
h. 38 cm
Museo de Antropología de la Universidad
Veracruzana, Xalapa
inv.no. PJ 128

Mictlantecuhtli, Lord of the Dead, is shown
as a skeleton seated with his knees pulled
up, his crossed arms resting on them. The
skull grins, the teeth are pronounced, the
eyes bulge. The head is crowned with what
looks somewhat like a mitre. There are
traces of painting on the earthenware,
suggesting the use of *chapopote*, a black
substance resembling tar.

This figure of a god was found on
a garbage dump in Los Cerros in the Rio
Blanco – Papaloapan district.

151

TRIPOD WITH GOD OF DEATH

MIXTEC

AD 1250 – 1521
Zaachila
terracotta
h. 31 cm
Museo Nacional de Antropología,
Mexico city
inv.no. 10-78270

This vase on a tripod has an applied scene
showing the Lord of the Underworld. In the
Nahuatl language he was called
Mictlantecuhtli, while the Mixtecs named
him Coqui Bexelaxo. Apart from his hands
and feet he is represented as a skeleton
holding the sacrificial knife in his left hand,
which rests on his left thigh. His right hand
is raised and holds a slightly curved stick,
possibly a symbol of power. The skull is
movable, the limbs hollow. The fired
terracotta clay bears traces of plaster with
red painting. The inside of the vase also has
traces of red paint. Red stood for blood,
sacrifice and the life that would issue forth
from the sacrificed person.

Curiously, the hands and feet are fully
fleshed, as of a living being. This reflects the
duality of life and death, a theme deeply
rooted in Mesoamerican thought.

The tripod was found in a grave in
Zaachila.

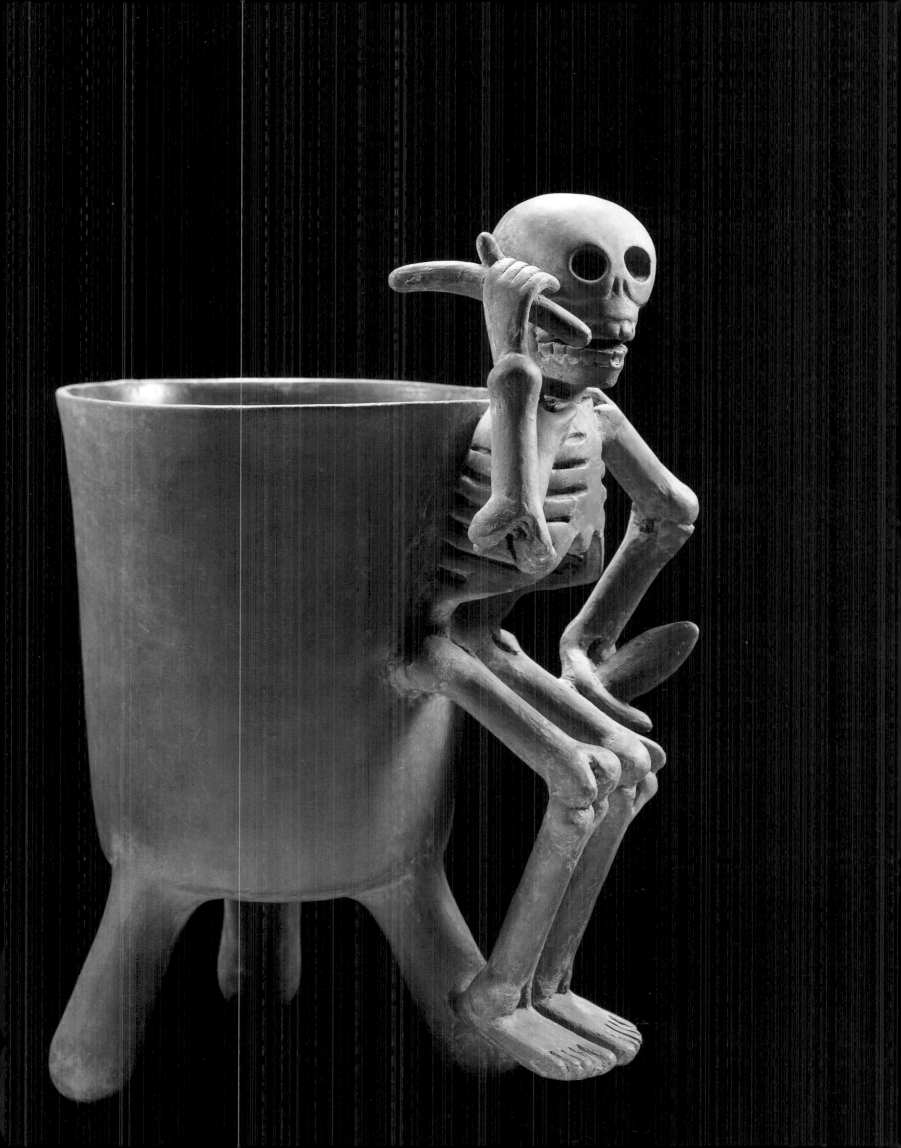

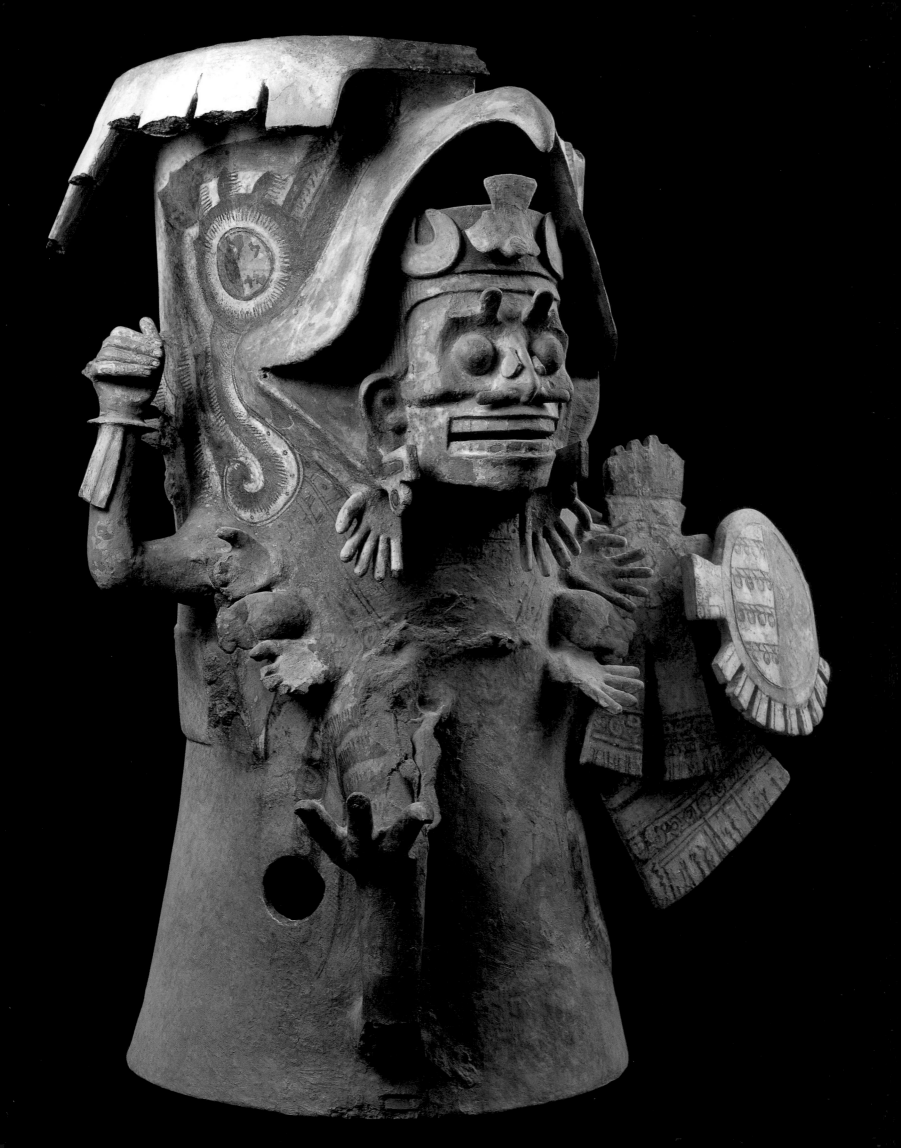

152
LORD OF THE UNDERWORLD
AZTEC

AD 1428 – 1521
Mexico – Tenochtitlan
terracotta
h. 99 cm
Museo Nacional de Antropología,
Mexico City
inv.no. 10-116586

This enormous incense burner has an
applied scene showing the god of Death,
Mictlantecuhtli, as a warrior. His head
looks out from an eagle's beak, and his chin
is framed with hands like earrings. The
eagle's eyes are shown like 'night eyes',
emphasizing the underworld aspect, which
is already present in the skull and the
slightly fluttering hands with open palms.
The shield applied on the left side, together
with the eagle's beak and raised right arm,
all contribute to a military theme. Behind
the head, the censer is modelled with a rim
of agave leaves, some of which are broken
off. This also refers to the blood sacrifice in
which the sharp tips of agave leaves were
used. The censer has clear traces of
polychrome painting.

 Large incense burners of this type were
used in funeral ceremonies.

153
CIHUATEOTL
AZTEC

AD 1428 – 1521
Mexico – Tenochtitlan
stone
h. 73 cm
Museo Nacional de Antropología,
Mexico City
inv.no. 10-220920

This statue of a Cihuateotl is one of a group
representing cihauteteo, or 'women gods'.
The *cihuateteo* are women who have died
during or just after the birth of their first
child, and have thereby attained divine
stature, comparable with warriors who are
killed in battle. The cihuateteo accompany
the sun on its daily journey, from noon to
sunset. Thus they belong to the west. The
dead warriors, on the other hand,
accompany the sun from dawn to noon and
belong to the east. The cihuateteo were
represented according to an established
model: they were shown kneeling, their
faces were skulls, their breasts were bare,
their hands were claws on which sometimes
a drop of blood could be detected. This
particular *cihuateotl* (singular form of
cihuateteo) wears a belt over her wrap-
around skirt. At night the cihuateteo might
return to the world, to steal children and
seduce men. Then they are night demons,
creatures of destruction.

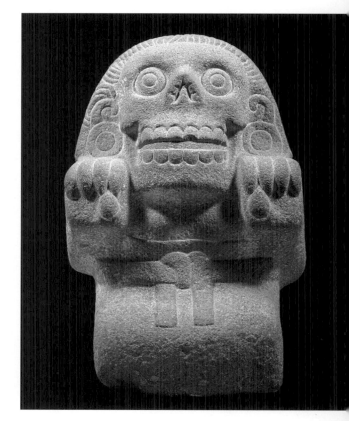

154
VASE
MAYA

AD 600 – 900
Campeche (?)
terracotta
h. 24.3 cm, diam. 19.5 cm
Museo Nacional de Antropología,
Mexico City
inv.no. 10-77455

The hatching on the vase provides a
background for, on one side, an engraved
crossbones indicating the four cardinal
points, and on the other side an engraved
serpent or possibly tadpole.

 The provenance of the vase is unknown.

RITUALS AND WORSHIP

Life in ancient Mexico was saturated with religion. Even the most simple everyday activity could be an occasion for gifts or offerings which would create a bond between the gods and people. Thus the fruits of the first harvest would be offered to the Sun and the Earth, by throwing small chunks of food into the air and onto the ground. And at fixed times incense would be burnt on domestic altars and in the temples, honouring the gods.

The rituals were often very complex. For example, there was the joint celebration of festivities connected with the patron gods. At these, the upper echelons of society would perform elaborate group dances.

The celebration of ritual activities occurs in all the civilizations of ancient Mexico. Such ceremonies took place several times a year.

Like those of the Aztecs, the major ceremonies of the peoples of West Mexico were connected with ancestor worship. Food and drink would be offered to the dead for their journey through death's kingdom. Such ceremonies brought the living and the dead close together. Some of the rituals involved the ballgame, blood sacrifice, and human sacrifice.

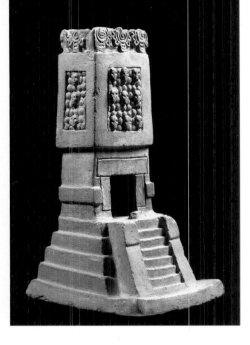

155

MODEL OF A TEMPLE PYRAMID

AZTEC

AD 1428 – 1521
Mexico – Tenochtitlan
terracotta
h. 32.2 cm, w. 15.8 cm
Museo Nacional de Antropología,
Mexico City
inv.no. 10-223673

This model represents a Post Classic
truncated temple pyramid, with the various
indented levels clearly shown. Beside the
steep staircase run two 'paths' surmounted
by panels, which closely resemble those in
the model pictured in cat. no. 156. These are
strongly reminiscent of the *talud-tablero*
architecture of Teotihuacan. The altar
stands at the temple entrance, framed by
side posts and a lintel. The high roof has
panels decorated with skulls, symbols for
Huitzilopochtli, war god of the Aztecs. The
roof itself is edged with shells cut in cross-
section, the so-called *xicalcoliuhqui* pattern
characteristic of Quetzalcoatl, the Plumed
Serpent.

Models of temples like this one and cat.
no. 156 provide a good impression of Aztec
temple architecture. They proved very
useful in the restoration and reconstruction
of temple pyramids such as the one in Santa
Cecilia Acatitlan.

156

MODEL OF A TEMPLE PYRAMID

AZTEC

AD 1428 – 1521
Cholula
terracotta
h. 39 cm
Museo Nacional de Antropología,
Mexico City
inv.no. 10-496915

This model shows a temple pyramid from
Post-Classic times. The steep staircase is
bordered on each side by a 'path' crowned
with a panel, reminiscent of *talud-tablero*
architecture in Teotihuacan. On the top
step in the centre and on a level with the
temple floor, is the place for the incense
burner or altar. Two pillars guard the
entrance to the temple. The roof edge has
two applied *acroteria*, or roof decorations.
There are clear traces of polychrome
painting on the model.

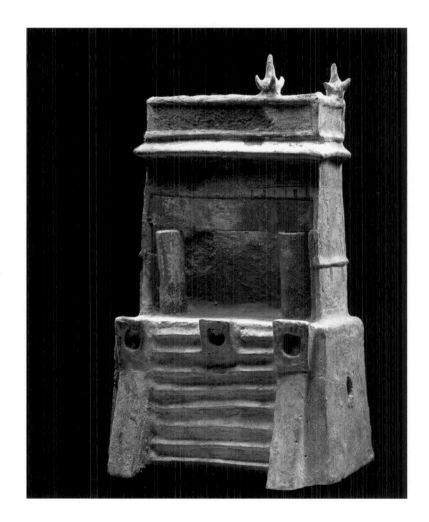

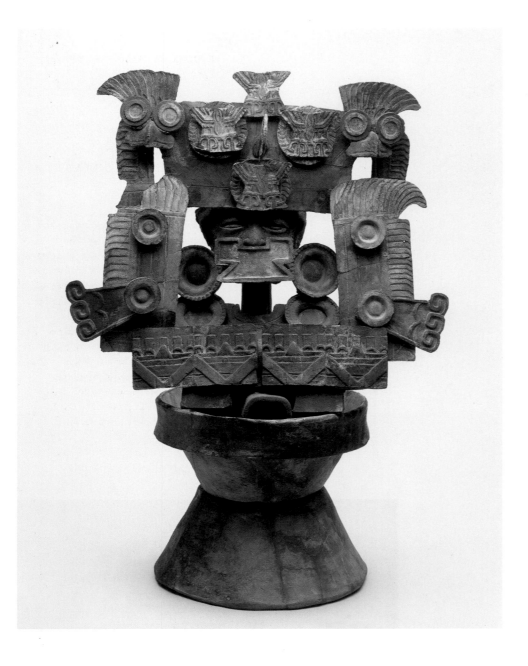

157
INCENSE BURNER
TEOTIHUACAN

AD 300 – 600
Teotihuacan
terracotta
h. 55 cm, b. 35 cm, d. 25 cm
Museo Universitario de Arqueología,
Manzanillo
inv.no. 10-446858

This polychrome painted censer is
composed of a bowl with an opening in its
elaborately decorated lid for the smoke to
exit through. The central section is formed
by a face with a large nose-pendant in *talud-
tablero* shape, and earplugs. The frame
around the face has owls' heads applied on
it. They have large ringed eyes, symbol of
the rain god Tlaloc. The lower part of the
frame is formed by four tablets inspired by
temple architecture. Such incense burners
have been given the name 'theatre type'.

Thanks to the widespread influence of
the culture of Teotihuacan, incense burners
of this type were made and have been found
as far afield as the Pacific Ocean coast of
Guatemala.

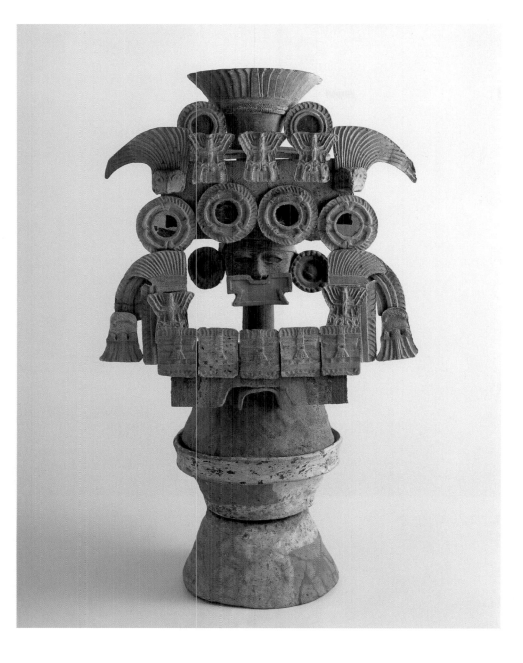

158

INCENSE BURNER

TEOTIHUACAN

AD 300 – 650
Teotihuacan
terracotta
h. 70 cm, w. 44 cm, d. 22 cm
Museo de la Cultura Teotihuacana,
Teotihuacan
inv. no. 10-411168

This censer has two sections: a lower,
conical part to hold the smouldering pieces
of incense, and an upper part consisting of
a lid with openings to let the smoke
through. The lid looks like a large stage
decor in which is set the face of the priest.
Such censers are called 'the theatre type'
and are inspired by the façade architecture
of the Teotihuacan temple. The priest's
nose ring has the *talud-tablero* shape. There
are also five tablets acting as a kind of
doorstep on which an almost square
construction stands. It is composed of
elements based on birds, flowers, butterflies
and feather headdresses. Censers of this
kind have so far been found only in
residential districts and not temple
pyramids.

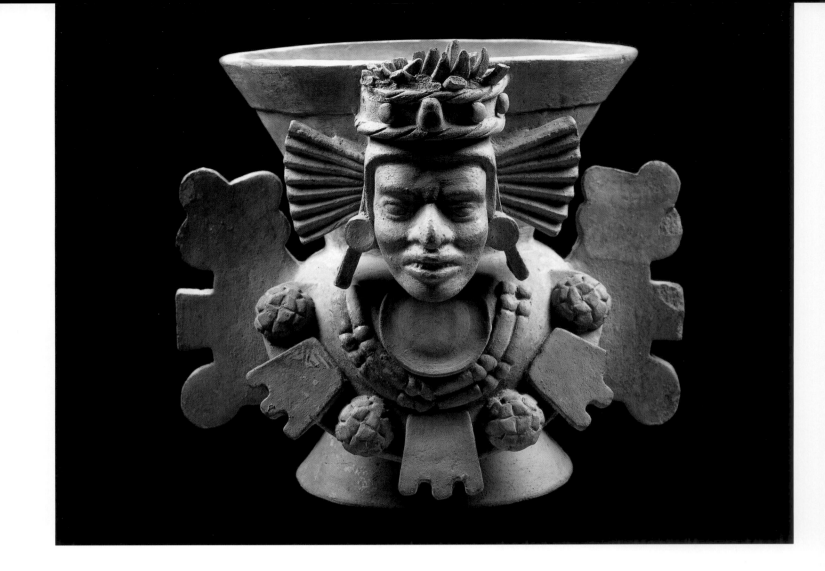

159
INCENSE BURNER EFFIGY
AZTEC

AD 1428 – 1521
Mexico – Tenochtitlan
terracotta
h. 35 cm, diam. 35 cm
Museo del Templo Mayor, Mexico City
inv.no. 10-220302

The censer has the shape of a vegetation deity. The headdress consists of two tresses of hair, with dotted decoration. On each side of the head a fan-shaped structure emerges from the back of the neck. Made of *amate*, bark-paper, it is characteristic of fertility gods. The outfit includes large earplugs, a double strand of beads, and a pectoral bearing a symbolic reference to the green stone *chalchihuitl*, or life itself.

The censer has circular, slightly spherical rosettes, attributes of the corn goddesses. Some remains of the hard aromatic resin copal were found inside the burner. This resin was burnt during ritual ceremonies for the rain god Tlaloc, or another guardian of fertility.

The piece formed part of a funerary gift.

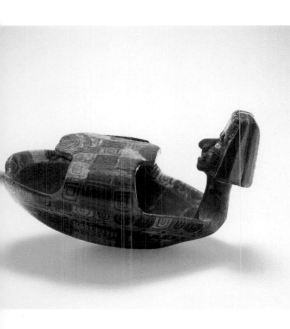 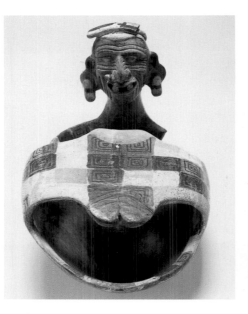

160 & 161

TWO MUSICAL INSTRUMENTS
AZTEC

AD 1428 – 1521
Mexico – Tenochtitlan
terracotta
l. 19.0 cm, w. 13.5 cm; l. 19.5 cm, w. 13.0 cm
Museo del Templo Mayor, Mexico City
inv.no. 10-263537 [Huehueteotl];
inv.no. 10-263534

The two drums are painted in polychrome
in the Cholula style. Both have the shape of
a turtle lying on its back, and the head of
a deity. One head has a very wrinkled face,
typical of Huehueteotl one of the oldest
gods in the Mesoamerican pantheon;
he was the protector of hearth and home.
The other head is more difficult to describe.

The two drums were found along with
three others during the restoration of the
cathedral on the Zócalo, Mexico City's
historic central square.

162

MAN WITH SMILING FACE
TOTONAC

AD 600 – 900
Las Remojadas
terracotta
h. 37 cm
Museo de Antropología de la Universidad
Veracruzana, Xalapa
inv.no. PJ 3985

A man standing naked with a face deemed
to be either 'smiling' or 'laughing'. He wears
a tall headdress with the step-meander
motif on it influenced by architectural
designs. The smiling face has close-set eyes
in oval sockets. The mouth is open,
showing the teeth, and the cheeks are
pronounced. The flared nostrils increase
the jovial aspect.

Figures such as this have been found in
large quantities, though often only the
laughing head remains, which has caused
speculation about a beheading ceremony.
The faces seem to be in a state of ecstasy,
inspired by the gods, possibly after eating
hallucinatory plants. These figures may be
interpreted as mediators between the
worlds of gods and of people. Sometimes
they have a musical instrument which
suggest associations with the gods of dance
and games.

Laughing face figurines are always
connected with the oldest excavation site of
Las Remojadas, also called simply
Remojadas. However, they have also been
found on sites such as Nopiloa, Los Cerros
and Dicha Tuerta. The figurines are hollow,
made with a mould, and date to between
AD 600 and 900.

SEATED WORSHIPPER

TOTONAC

AD 600 – 900
Rio Blanco – Papaloapan district
terracotta
h. 31.5 cm, w. 27 cm
Museo de Antropología de la Universidad
Veracruzana, Xalapa
inv.no. PJ 3979

This terracotta shows a naked man seated
with his arms raised in worship of the gods.
He wears a pectoral, earplugs and a head-
dress with a Tajin spiral shape on it. The
plump figure is emphasized by the way
the potter has suggested rolls of fat on the
thighs by pinching folds in the clay.

164

INCENSE BURNER

TEOTIHUACAN

AD 300 – 650
Teotihuacan
terracotta
h. 29 cm, w. 20 cm
Museo de la Cultura Teotihuacana,
Teotihuacan
inv.no.: 10-336685

The censer is shaped like a face on a circular
stand. A skull can be distinguished within
the face. Characteristics of Tlaloc the rain
god, such as the goggle-ringed eyes and
forked tongue, can be clearly seen.
 The censer was found in a grave.

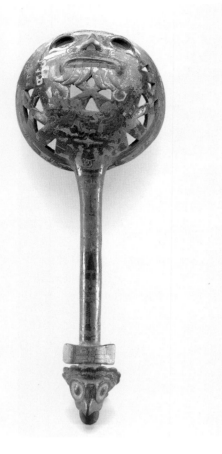

165

INCENSE BURNER

AZTEC

AD 1428 – 1521
Mexico – Tenochtitlan
terracotta
l. 62.8 cm, diam. 27 cm
Museo Nacional de Antropología,
Mexico City
inv.no. 10-220158

This censer is shaped like a saucepan. In the
base of the 'pan' triangular sections are cut
out to allow oxygen through so that the
smouldering grains of incense will burn.
The Aztecs called such censers the 'hand of
fire', *tlemaitl*, and this one has a long handle
ending in the shape of an animal head.
 There are traces of polychrome painting.

166

INCENSE BURNER

AZTEC

AD 1428 – 1521
Cholula
terracotta
l. 32 cm, diam. 19 cm
Museo Nacional de Antropología,
Mexico City
inv.no. 10-393489

The incense burner is shaped like a
saucepan, and is painted in various colours,
with sepia-black predominating. The
'night-eye' in the centre has a terracotta-
coloured pupil. The reference to night is
painted on a white background with four
agave tips symbolizing the blood sacrifice
and, because of their position, also
referring to the four cardinal points. The
symbols on the central and outer ring are
puzzling, although the dots might be
interpreted as drops of blood. The areas
outlined with white and a black line could
be seen as eagles' feathers. This would
connect the censer to the *cuauhxicalli*, the
bowl in which the Azecs placed the
sacrificial blood and heart. The incense
burner, or 'hand of fire' (see cat. no. 165) is
much more like a dish than a censer and in
this case could be described as a sacrificial
dish in which to place heart and blood.
Alternatively, the painting on the object
may be seen in the light of page 34 of the
Codex Borbonicus. This shows the
ceremony of the New Fire, held once every
25 years on the *citlapetl*, or Star Mountain.
The spot is also called the Place of the Thorn
Trees, Uixachtecatl or Uixachtecatlan,
the emblem of which is a 'night eye' on
a white ground with four thorns in the
corners. The circular shapes (precious
stones) with the feathers around them
would then refer to the remarkable nature
of this phenomenon. Some experts see the
emblems as referring to Tlillan, the Black
Place, where the New Fire ceremony was
enacted. In any case, this incense burner
was closely connected with the ritual of
the New Fire.

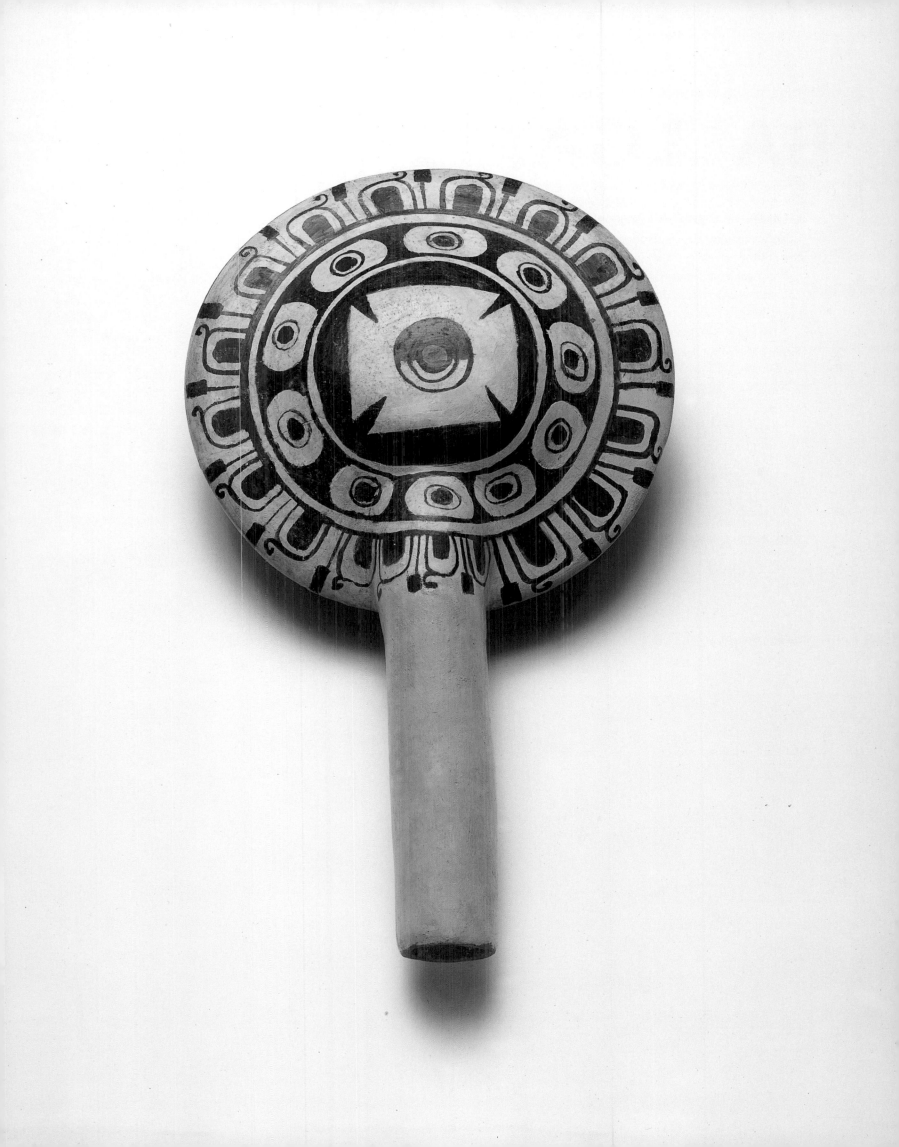

BALLGAME

The rubber ballgame occupied a special place in the official rites. This holy sport had a primarily religious significance. The game was an act of worship, celebrating the sun's movement, and thereby the eternal cycle of life and death. The ball, symbolizing the sun, was kept moving by supernatural, divine powers, and human strength. The stadium where the game was played, symbolized the world.

The ballgame had a second symbolism, being also linked with fertility. The game guaranteed that the seasons – dependent on the sun and rain gods – would occur regularly. Thus the game was essential to maintain the harvest, the life of people, and the universe.

It was played in an open-air I-shaped ballcourt. The team, wearing protection on their hips and/or arms, played with an immense solid rubber ball that might weigh up to three kilos.

The result of a match could have great political and religious significance. The captain of the losing team would be sacrificed at ceremonial games. The blood that spurted out when he was beheaded was a symbolic libation for the gods of fertility.

167

BALLGAME PLAYER ON RELIEF

TOTONAC

AD 600 – 900
Papantla
stone
h. 145 cm, w. 72.5 cm
Museo de Antropología de la Universidad
Veracruzana, Xalapa
inv.no. PJ 49

This relief pictures a ballgame player with a
yugo (yoke), in which are depicted a skull-
shaped axe (*hacha*) and a palm frond (*palma*)
shaped like a seated human figure. The
ballplayer's right hand wears a protective
glove, while a kneepad is also worn for
protection on the right knee. The head is
shown in profile and has a helmet shaped
like a bird of prey. The figure stands within
a frame decorated with characteristic Tajin
scrolling and meanders, inspired by the
architecture of the city of El Tajin. The
right hand emerges out of this frame while
on the upper side the relief of a reclining
jaguar can be seen.

The gear worn by this figure, such as the
yugo, *hacha* and *palma*, identify him as a
ballgame player, a cultural phenomenon of
Mesoamerica.

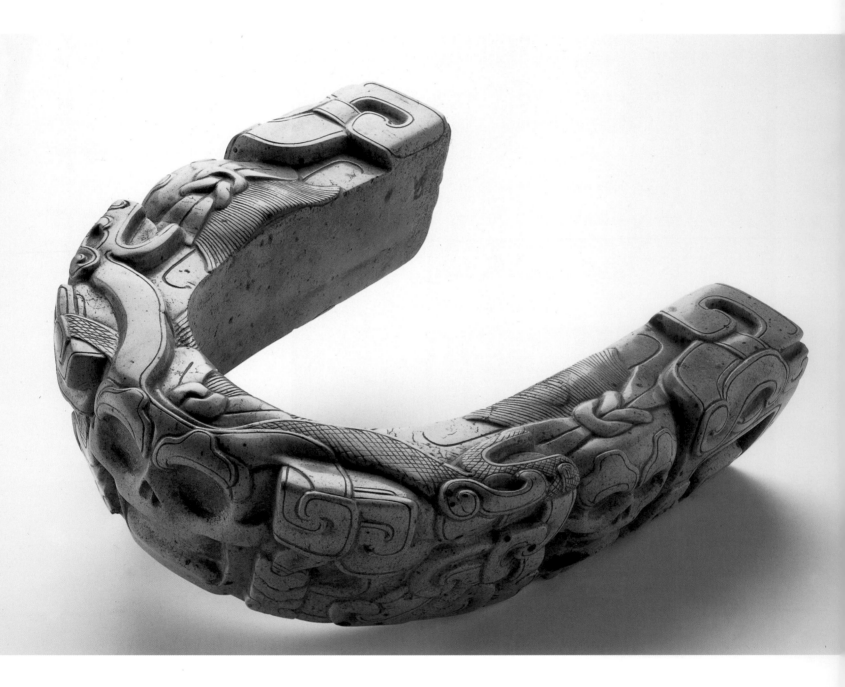

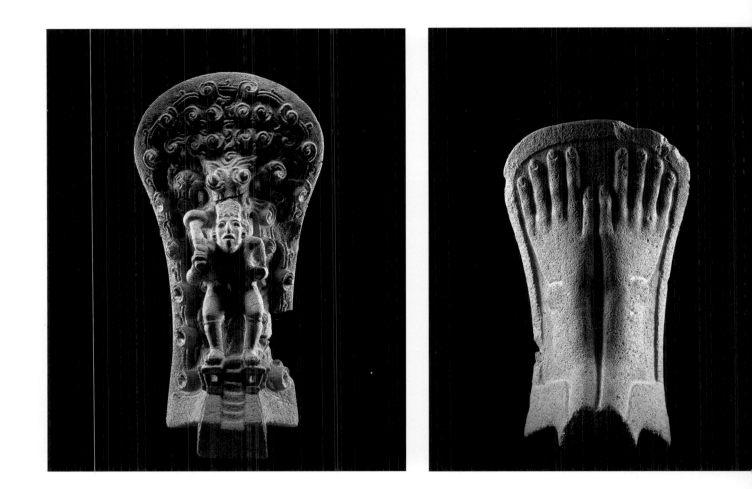

168

YUGO

TOTONAC

AD 600 – 900
El Tajin
stone
l. 41.5 cm
Museo Amparo, Puebla
inv.no. 57 PJ 1301

This *yugo* is decorated with Tajin
scrollwork, enclosing three skulls, one in
the front centre and one on either side. The
ends of the *yugo* take the form of human
skulls, the profile turned outwards. The
central skull is surrounded by the tail of
a rattlesnake whose head is carved in profile
on either end. Skulls alternating with the
Tajin scrolls that symbolized life, together
with parts of a rattlesnake, form the
decoration of this *yugo*. It illustrates death,
the sacrifice connected with the ballgame
and the life that emerges from that
sacrifice.

169

PALMA

TOTONAC

AD 800 – 1000
Banderilla (Veracruz)
stone
h. 43 cm, w. 23 cm
Museo de Antropología de la Universidad
Veracruzana, Xalapa
inv.no. PJ 85

The *palma* is decorated with the figure of
a naked man, holding a club and bowing as
he stands on a pyramid inspired by El Tajin.
It has also served as inspiration for the
scrolls on the palma, against which the man's
figure is shown. The naked man would have
been a prisoner of war or the captain of
a ballgame team that has just lost a match.
At the top of the temple pyramid the
sacrifice would be offered to the gods.

170

PALMA

TOTONAC

AD 600 – 900
Tlacolulan
stone
h. 43 cm, w. 23 cm
Museo de Antropología de la Universidad
Veracruzana, Xalapa
inv.no. PJ 3983

Two hands decorate this *palma*. Their backs
face us, and they point upwards – a symbolic
reference to the creative forces. The limbs
of conquered opponents would be ritually
eaten, the idea being that their strength
would be absorbed into the bodies of the
victors. This is known as ceremonial
cannibalism.

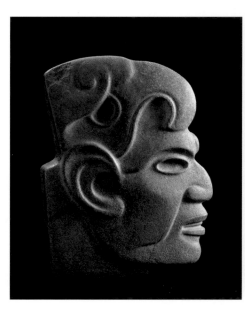

171

HACHA (AXE)

TOTONAC

AD 600–900
El Tajin regio
stone
h. 22 cm
Museo de Antropología de la Universidad
Veracruzana, Xalapa
inv.no. UV 62

This *hacha*, or axe, is shaped like a human
face in profile. The head has a Roman nose,
thick lips, large ears and a helmet like
a bird's head. This method of rendering
a bird's head with the scroll-shaped beak is
characteristic of the Tajin. The axe would
not have been fastened in the yoke during
rituals; rather, it is a tetoned head type,
which would have been placed in the wall of
a ballcourt.

172

MANOPLA

PROTO CLASSIC

AD 0–300
Veracruz
basalt
h. 32 cm, w. 32 cm, d. 9.8 cm
Fondación Cultural Televísa, A.C.,
Mexico City
inv.no. 423

This *manopla* (bat or racket) bears a relief
showing a monkey whose tail ends at the
handle. *Manoplas* are thought to be the
stone bats used in the rubber ballgame
ceremonies. There is a large opening in the
monkey's body and possibly this bat was
fastened with a stick or a pin in the wall of
a ballgame court.

173
MINIATURE BALLCOURT

AZTEC

AD 1428 – 1521
Mexico City
stone
l. 36 cm, w. 22 cm
Museo Nacional de Antropología,
Mexico City
inv. no. 10-222324

The miniature ballcourt has I-shaped
closed ends. There is a staircase on the
outside, evidently the means of entering the
court. A written source from the 17th
century, Ixtlilxochitl, throws a remarkable
light on the function of this type of
ballcourt. Ixtlilxochitl recounts how at the
close of his reign, Topiltzin, lord of Tula,
was threatened by three rivals. He adopted
the following strategy: he presented a small
model ballcourt to each of his three
opponents, with a carbuncle as the ball.
Then Topiltzin proposed that they rule the
kingdom between the four of them and the
one who had the carbuncle-ball would act
as first among equals, *primus inter pares*.
Thus the miniature ballcourt represented
the entire kingdom. This explanation
illuminates the background to some of
these tiny ballcourts on show in various

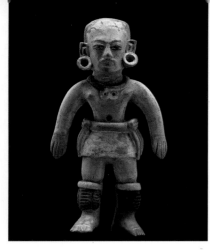

174
BALLGAME PLAYER
TEOTIHUACAN

AD 300 – 650
Teotihuacan
terracotta
h. 15 cm
Museo de la Cultura Teotihuacana,
Teotihuacan
inv. no. 10-411369

It is remarkable that no architecture
connected with ballcourts has been found
in Teotihuacan, although this is the case for
many other parts of Mesoamerica. It is
known from wall paintings at Tepantitla-
Teotihuacan that various types of ballgme
were played. The game using a stick
(similar to hockey) as well as the ballgame
using the hip (on which to catch the ball) are
clearly illustrated in the paintings. Further-
more, certain terracottas bear witness to
the fact that the Mesoamerican ballgame
was known to the people of Teotihuacan.
In all probability, the ballgame was played
in Teotihuacan just as at the dawn of its
existence, about four thousand years
earlier. There would be smooth lawns, no
walls at the sides, but probably portable
goalposts and other perishable items.
It remains a mystery why a city such as
Teotihuacan with its penchant for
architectural exuberances remained
without any ballcourts preserved in
architectural form.

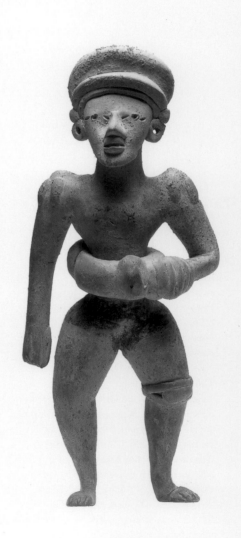

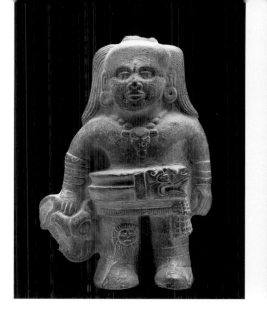

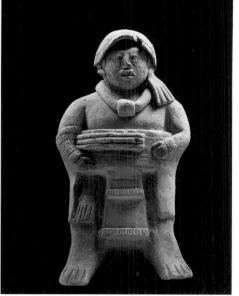

175
BALLGAME PLAYER
HUAXTEC

AD 100–300
Panuco
terracotta
h. 15 cm
Museo Amparo, Puebla
inv. no 57 FJ 1170

The standing ballgame player wears a *yugo*, or yoke, gauntlets, arm and knee protection, a tall headdress and earplugs. His pupils are painted with *chapopote*, a type of tar that is found in the Gulf Coast area; the upper thighs are also coloured with it.

176
BALLGAME PLAYER
MAYA

AD 600–900
Jaina
terracotta
h. 15 cm, w. 10 cm
Museo Nacional de Antropología, Mexico City
inv. no. 10-222314

The standing ballgame player wears armguards. A small head can be seen on his right kneepad. His *yugo*, yoke, ends in a serpent's head. In his right hand he holds a *manopla*, or bat, with the shape of an animal's head. His hair is parted in two bunches falling on either side, and a skull is suspended from his pectoral, emphasizing the ritual nature of the Mesoamerican rubber ballgame.

177
BALLGAME PLAYER
MAYA

AD 600–900
Jaina
terracotta
h. 20 cm
Museo Regional de Antropología 'Carlos Pellicer', Villahermosa
inv. no. 0540

This standing figure wears the body protection of a Maya ballgame player players. He also has a kind of helmet on his head, a pectoral and earplugs, the left one decorated with feathers falling to below the collarbone. The loincloth is marked with incisions suggesting a fringed border falling between the legs. He wears a garment round the hips, reaching to the knees; the right thigh and knee are protected by a guard indicated with incised lines. The lower right arm also has a form of guard, the left arm only a wrist band. One of the Maya versions of playing the rubber ballgame was to 'throw' or push the ball using the side of the body. However, they also played the version whereby the hip was used to 'throw' the ball. But it is only in Maya territory that terracottas have been found showing ballgame players wearing body protection. Thus it seems accurate to speak of a Maya variation of the rubber ballgame.

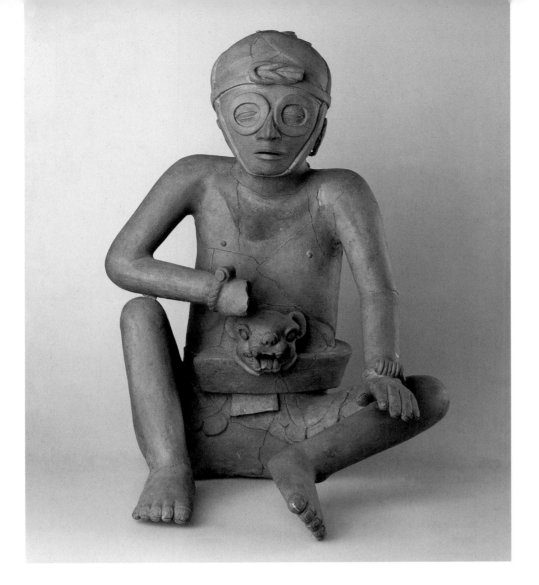

179

SEATED BALLGAME PLAYER

ZAPOTEC

AD 300 – 600
Oaxaca
terracotta
h. 14.6 cm, w. 14.8 cm, d. 15.1 cm
Museo Nacional de Antropología,
Mexico City
inv.no. 10-222350

This seated ballgame player is wearing
a form of protection round his right lower
arm. On his right hip he wears a leather
yoke-shaped band, called a *yugo*. He also
has a trophy-headed *hacha*, or axe,
suggesting the link between the rubber
ballgame and human sacrifice. Under the
cord that holds the wide yoke in place can
be seen the edges of a loincloth. The
hairstyle has a piece of hair fastened with
string and hanging vertically. Earplugs and
a pectoral form the jewellery. The forehead
has a groove in it, reminiscent of the
Olmecs, while the shape of the mouth
suggests an early dating for this ballgame
player: possibly first half of the Classic or
even a Proto-Classic work.

Only four such ballgame players have so
far been found.

178

SEATED BALLGAME PLAYER

PRE TOTONAC

AD 400 – 700
Las Remojadas
terracotta
h. 68.3 cm
Rijksmuseum voor Volkenkunde, Leiden
RMV 4819-2

This hollow figurine represents a ballgame
player. He sits with one leg pulled up in
front of him, wearing a loincloth and a *yugo*
(yoke), and holding a *hacha* (axe) shaped
like a jaguar head. He also wears a helmet
with chinstrap and wristbands. Rings
encircle his eyes, like those of the rain and
fertility god Tlaloc. The jaguar is also
associated with nightly rain, so in this
portrayal of the player there is a clear
association between the game and fertility.
The right hand is broken off at the wrist.

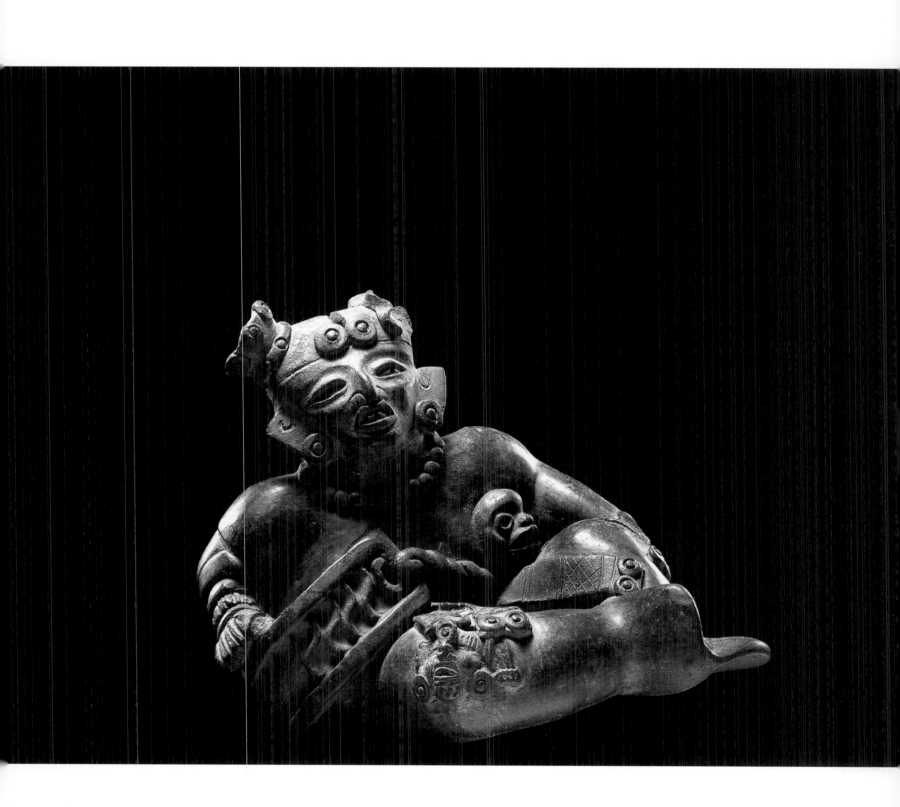

SACRIFICE

Offering gifts to ancestors and deities was one of the common features of ancient Mexico. Generally speaking, the gifts were objects made of earthenware, wood, metal or precious stone. These would usually be placed in a basket in the ground, or inside pyramids or palaces.

Characteristic of all pre-Columbian cultures was the sacrifice of blood and human beings. The mythological stories tell that the gods offered themselves in order to preserve the universe. People, as creations of the gods, were obliged to do the same thing, for the same reason, and offer the most precious thing that human beings possess, that is, their blood, their very life.

Furthermore, the blood offering was used in a magical way to make the earth fertile. People inflicted wounds on themselves and the blood that flowed out was gathered and offered up. Some civilizations, such as those in West Mexico, used certain designs when inflicting wounds upon themselves. The scars created in this way were considered a form of bodily adornment, and increased a person's status.

People would be given narcotic drugs before being sacrificed. The heart would be pulled out of the living body, still beating, still alive and offered to the gods.

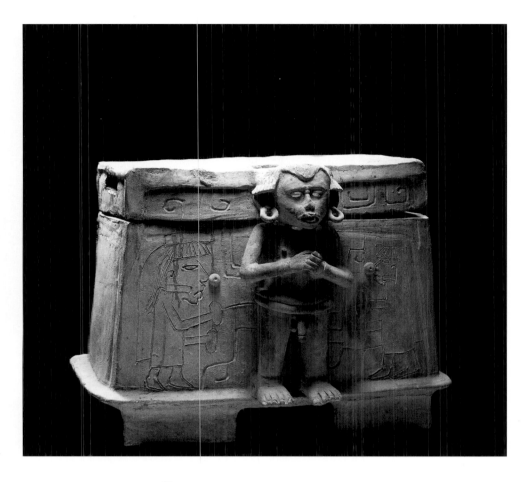

180

LIDDED BOX

TOTONAC

AD 600 – 900
El Zapotal
terracotta
h. 24 cm, w. 42 cm, d. 9 cm
Museo de Antropología de la Universidad
Veracruzana, Xalapa
inv.no. PJ 4028

On a shallow base sits this lidded box with
the applied figure of a naked man. The head
of the figure is at the centre of the long side
of the lid and the body is below on the box
itself. The man has wavy hair, earrings and
a belt round his hips. His genitals are
uncovered. He holds his hands before his
chest, with closed eyes. Tajin meanders are
incised on the lid and on the sides, left and
right of the man's figure is another figure
dressed in robes with a headdress over his
page-boy hairdo that hangs down at the
back. Between these two robed figures, who
appear to be priests, a step-shaped pyramid
or altar is engraved. With his closed eyes,
the naked man appears to be either dead or
drugged prior to being sacrificed.

181

POT

TEOTIHUACAN

AD 300 – 650
Teotihuacan
earthenware
h. 37 cm, diam. 32 cm
Museo Universitario de Arqueología,
Manzanillo
inv.no. 10-571102

This vessel was used, as its blood-drop
motif suggests, to catch the blood of
sacrificial victims. Besides the picture of
dripping blood we may detect, against a
dark square background, the motif of the
sun. The four corners of the square possibly
refer to the four cardinal points, *nahui ollin*,
literally meaning 'four movement', one of
the names given to the sun god in the Post-
Classic period. This could be one of the
earliest references to the name of Tonatiuh,
sun god of the Aztecs.

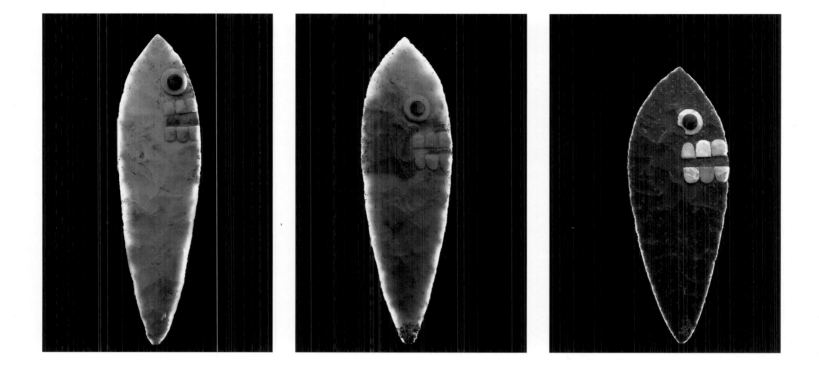

182 – 184
THREE SACRIFICIAL KNIVES
AZTEC

AD 1428 – 1521
Mexico – Tenochtitlan
flint
each h. 15 cm, w. 7 cm
Museo del Templo Mayor, Mexico City
inv.nos 10-20280, 10-252376, 10-252374

These knives, of differing coloured flint,
were used in ceremonial sacrifices. They
have anthropomorphic aspects: shell and
obsidian have been used to suggest eyes,
and only shell for the teeth. There are traces
of red cinnabar painting, especially in the
'mouth' of the pale-coloured knife, the
tecpatl of the Aztecs.

The knives were found during
excavations in the Templo Mayor complex.

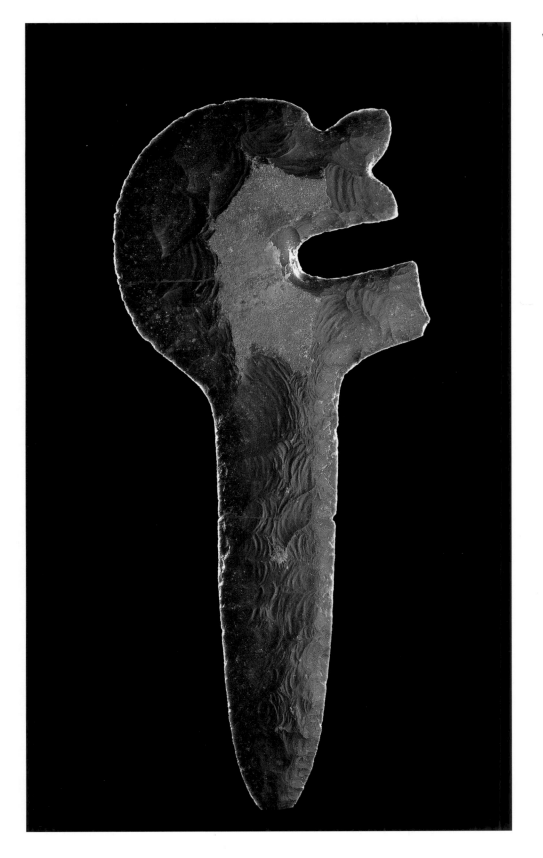

185
SACRIFICIAL KNIFE

LATE POST CLASSIC

AD 1428 – 1521
Aztec
flint
l. 42.8 cm, w. 18.2 cm
Museo Nacional de Antropología,
Mexico City
inv.no. 10-393945

This ceremonial flint sacrificial knife has
the outline of a human face on the haft.
 The provenance is unknown.

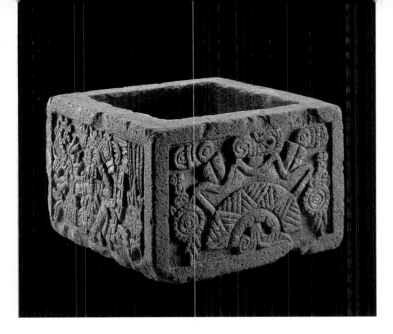

186

BOX OF INSTRUMENTS FOR BLOOD-SACRIFICE

AZTEC

AD 1428 – 1521
Mexico – Tenochtitlan
stone
h. 21 cm, w. 32 cm, l. 32 cm
Museo Nacional de Antropología,
Mexico City
inv.no. 10-466061

This rectangular box of carved stone contained instrument used for inflicting wounds upon oneself in order to make a blood sacrifice. It is called a *tepetlacalli*, meaning, house of rock. The long side of the box depicts a person of high status seated and making the blood sacrifice by piercing his ear. The scene takes place under the auspices of Xiuhcoatl, who, as the Fire-Serpent and patron of the self-inflicted sacrifice of blood, is shown behind and beside the figure making the sacrifice. The short side pictures the 'grass ball' associated with the sacrifice of blood. The original lid is lost.

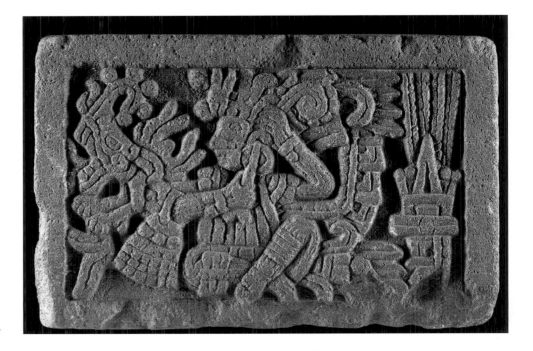

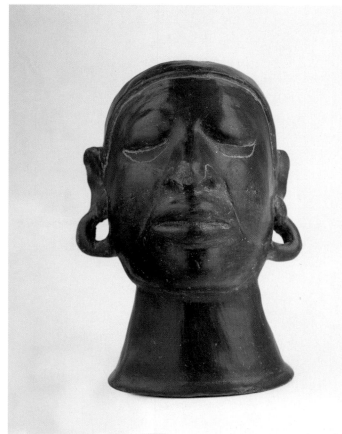

XIPE TOTEC, 'OUR LORD THE FLAYED ONE'
AZTEC

AD 1428 – 1521
Mexico – Tenochtitlan
terracotta
h. 11.2 cm
Museo Nacional de Antropología,
Mexico City
inv.no. 10-116778

The earthenware figurine represents a priest of Xipe Totec, god of spring and goldsmithery. The right arm is broken. The figure wears the skin of a sacrificed victim, thus symbolizing the new life in the spring. The ritual called *Tlacaxipehualiztl*, meaning 'the flaying of people' took place in March. This figurine shows clearly how the second skin is pulled, inside-out, on top of the actual skin, with the surface displaying fat blobs. Possibly these blobs refer to the gold nuggets of the goldsmiths, since Xipe Totec is their patron.

187
PORTRAIT HEAD
AZTEC

AD 1428 – 1521
Mexico – Tenochtitlan
terracotta
h. 15.5 cm
Museo Nacional de Antropología,
Mexico City
inv.no. 10-78291

This portrait head on a tall circular base is made of terracotta with black painting on the headband and the lower part of the face. Large earrings are indicated. The cheeks have been clearly modelled and the eyes are closed, giving a strong impression that the person is dead.

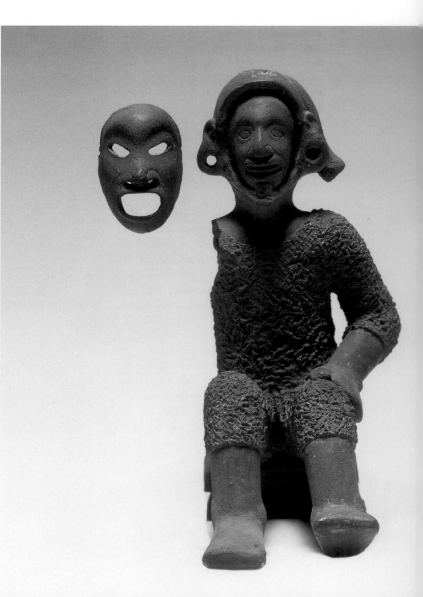

189
VESSEL

AZTEC

AD 1428 – 1521
Mexico – Tenochtitlan
earthenware
diam. 58 cm
Museo Nacional de Antropología,
Mexico City
inv.no. 10-594908

This object was used to store a flayed
human skin. During the spring ceremonies
a young man would be selected to be
sacrificed to Xipe Totec, the Flayed One.
Then the high priest peeled off the skin
from the boy, whereby he symbolized the
renewal of nature and life. The outer
surface of the container looks as if it were
covered with flayed skin.

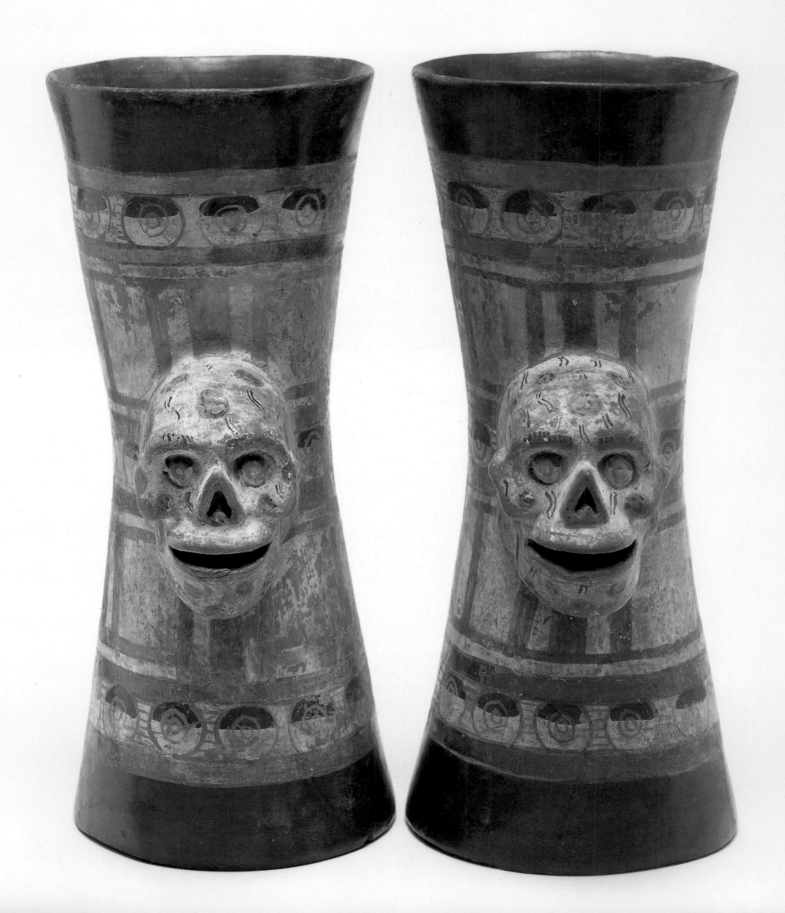

190 & 191

TWO SKULL GOBLETS

AZTEC

AD 1428 – 1521
Cholula
earthenware, polychrome painting
h. 29 cm, diam. ± 12.5 cm
Museo Nacional de Antropología,
Mexico City
inv.no. 10-3344; 10-77820

Two goblets, painted in polychrome,
evidently used in death ceremonies in
connection with human sacrifice. One skull
has applied work on its side, with half-dark
and half-light circles suggesting the stars
and night. The goblets are thus associated
with *Mictlantecuhtli*, the lord of the Night
and of Death and human sacrifice.

 Although the goblets were found in the
historic centre of Mexico City on the
square of the *volador*, or flying man they
were actually made in Cholula, a major
religious centre during the Aztec period.

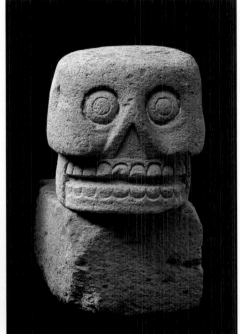

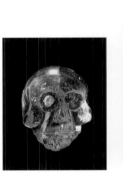

192

SKULL

POST CLASSIC

AD 1250 – 1521
Central Highlands
rock crystal
h. 2.5 cm, w. 2 cm, d. 3 cm
Rijksmuseum voor Volkenkunde, Leiden
inv.no. RMV 3117-1

The skull is made of cut rock crystal with
inlaid black eyes. Miniature skulls of this
type are very common in the Post Classic.
Traditionally, they are attributed to the
Aztecs and Huaxtecs.

193

SKULL

POST CLASSIC

AD 1250 – 1521
Aztec
stone (andesite)
h. 47 cm, w. 48 cm, d. 100 cm
Museo de Santa Cecilia Acatitlán,
Mexico City
Inv.no. 000073

This stone skull once formed part of the
architecture and decorated a temple wall.

ANIMALS AND PLANTS

In ancient Mexico people believed that the universe had been created by the gods on three levels. Below was the Underworld, the kingdom of the dead. Above was the universe inhabited by the gods who had the shapes of heavenly bodies, the sun, the moon and the stars. There too dwelt the warriors killed in battle and women who had died in childbirth. Middle Earth lay at the centre, the domain of humankind, the animals and the plants.

DIt is clear from the huge number of plant and animal figures in their art, how much the ancient Mexicans loved the natural life around them. The objects are rendered with consummate realism. Most famous perhaps is the Feathered Serpent, representing *Quetzalcoatl*, the snake god, symbol of earth and heaven.

The special attachment to the animal world is also seen in the belief in a dual person, the 'other' with whom one is born. This is often an animal.

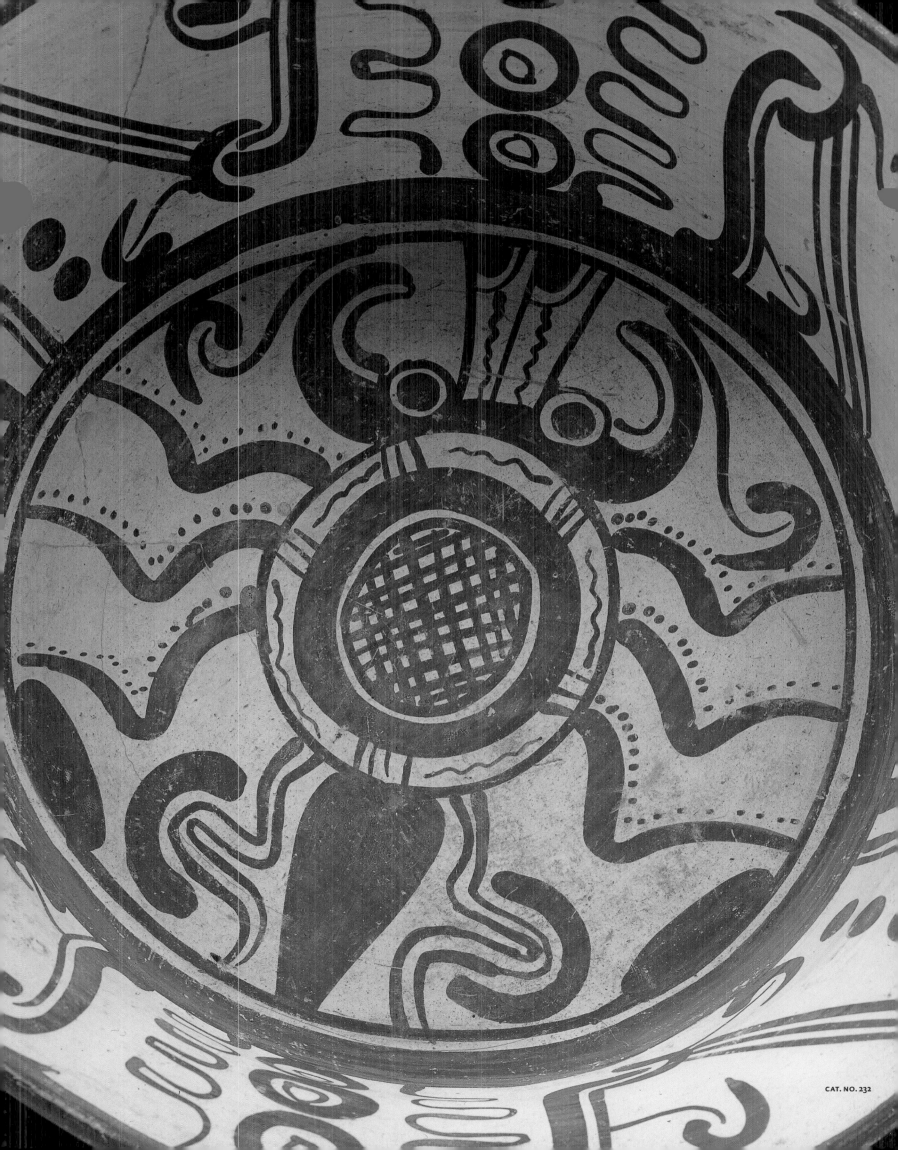

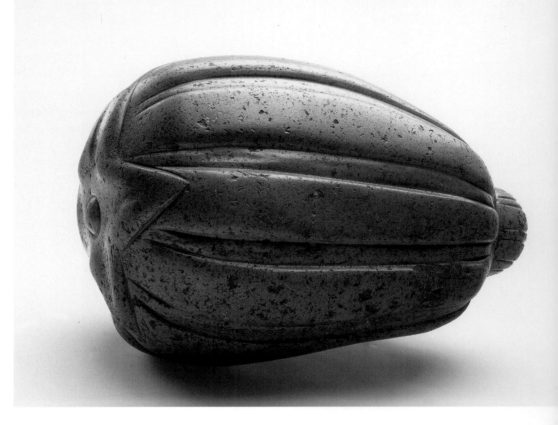

194
MARKER STONE SHAPED LIKE A CACTUS
AZTEC

AD 1428 – 1521
Mexico – Tenochtitlan
stone
h. 99 cm
Museo Nacional de Antropología,
Mexico City
inv.no. 10-220928

This is a stone model of a tall cactus, *genus cereus*, showing its roots below. On the base, in profile, can be seen Tenoch, founder of the city of Tenochtitlan. The shape of the head is shown as if it were a slice of the cactus *tenochtli* (meaning stone cactus). The ear resembles an eagle's beak with a snake inside it, and identifies the relief as being Tenoch, the Aztec leader who fulfilled the prophecy: 'There where an eagle bearing a serpent in its beak shall land upon a tenochtli cactus, shall you build the city of Tenochtitlan.' This took place in 1325. Probably the cactus stone marked the boundary between the twin cities of Tenochtitlan and Tlatelolco, for it was here that the Mexican archaeologist Chavero dug it up in the nineteenth century.

195
CALABASH
AZTEC

AD 1428 – 1521
Mexico – Tenochtitlan
stone
h. 36 cm
Museo Nacional de Antropología,
Mexico City
inv.no. 10-392922

This is a realistic stone representation of a calabash, detailed with care – look at grooves in the rind and the way the stalk is joined to the gourd. The stone, diorite, with its 'salt-and-pepper' appearance, is polished. The calabash, like other vegetables such as the tomato and the chilli, is native to Mexico and was brought to the Old World by the Spanish. The calabash was first cultivated in Mexico about 7,000 years ago.

196
PUMPKIN ON TRIPOD
PROTO CLASSIC

300 BC — AD 300
Colima
terracotta
h. 20 cm, diam. 35 cm
Museo Universitario de Arqueología,
Manzanillo
inv.no. 10-571580

This terracotta is shaped like a realistic
rendering of a pumpkin, set on a tripod. It is
supported by three parrot-like birds which
hold the pumpkin against their breasts.
The pumpkin-tripod has the typical red
polished slip of Colima.
 This piece of pottery was a funerary gift
in a shaft-tomb.

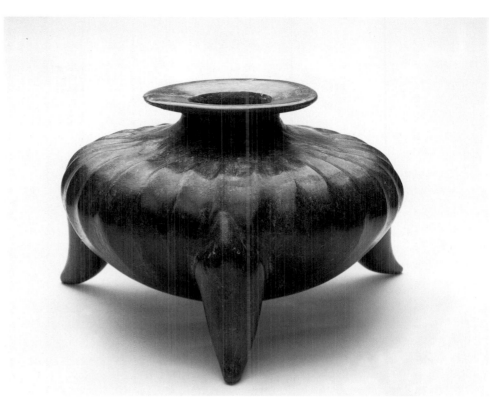

197
FOUR-PART CALABASH
PROTO CLASSIC

300 BC — AD 300
Colima
terracotta
h. 26 cm
Museo Nacional de Antropología,
Mexico City
inv.no. 10-41364

This piece of domestic ware takes the form
of four calabashes, the mouth of the spout
being where the four hollow stems meet.
The staple diet of the Mexicans consists of
corn (maize), black beans and chilli peppers
and if possible, the calabash (or squash) and
tomatoes are added as vegetables. The
calabash has been cultivated by the
Mexicans for at least seven thousand years.
 This pottery has the characteristic
Colima red polished slip. It was found in
a shaft-tomb.

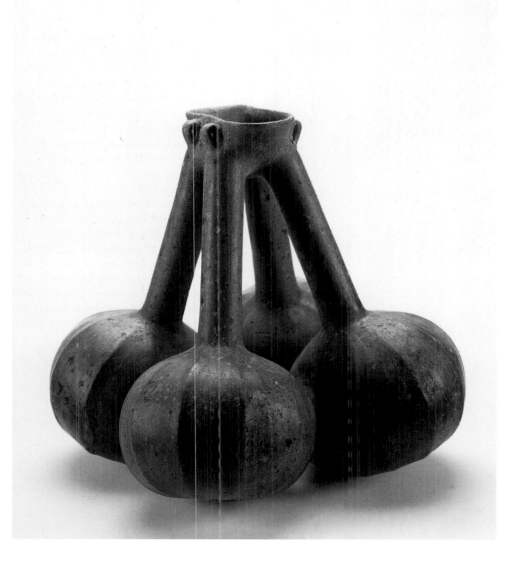

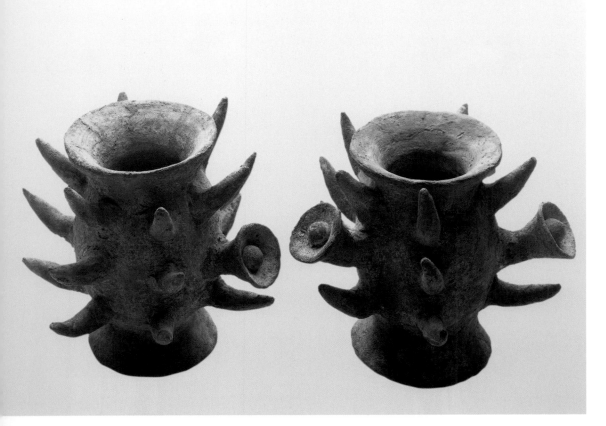

198 & 199
TWO PULQUE GOBLETS
AZTEC

AD 1428 – 1521
provenance unknown
terracotta
h. 45 cm
Museo Universitario de Arqueología,
Manzanillo
inv.no. 10-441533 en 10-441536

The shape of these ceremonial pulque
goblets is inspired by the agave plant,
known to the Mexicans as *maguey*. The
goblets have a circular foot and wide
opening. Traces of polychrome painting can
be detected. The pointed leaves, *pancas*, of
the *maguey* plant are applied onto the
goblets, as is the heart of the plant and the
flower buds. Pulque is made from the
fermented juice, *aguamiel*, of the agave. It
gathers in the heart of the plant over a priod
of three months once the sprouting flower
shoot has been cut out. The juice is
collected using an acocote, a type of
calabash, and stored in ceramic or wooden
barrels. The sap comes in contact with the
saliva of the person sucking it out,
tlachiquero, and the bacteria thus introduced
causes it to ferment and produce a kind of
beer. This method of making pulque dates
to pre-Columbian times, and can still be
found in Central Mexico. In the rest of
Mesoamerica, however, the pulque drink,
known to the former Mexicans as *octli*, is no
longer to be found.

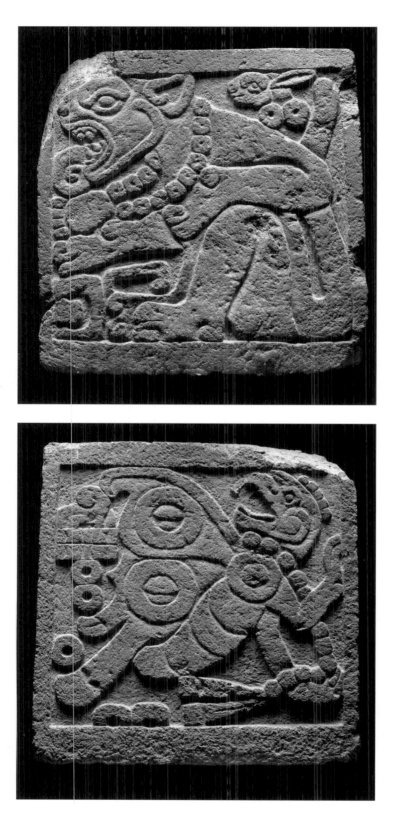

200

RELIEFS WITH CALENDRICAL MARKINGS

MATLATZINCA

AD 850 – 1250
Teotenango
stone
h. 49 cm, w. 57 cm, d. 40 cm
Museo de Sitio, Teotenango
inv.no. A-52206

This block of stone with reliefs on both sides was found in the Building of the Serpent in Teotenango (see cat. no. 34). In the stormy period following the fall of Teotihuacan this city was founded by the Matlatzinca and flourished in the time of the Toltecs (AD 900 – 1200). One side of the block shows the side view of a jaguar wearing a collar of beads. His tongue ends in a 'speech balloon' which may be interpreted as a roar. Above right is the sign of the day, *tochtli*, rabbit, with the number two. The other relief shows a bird-butterfly: a butterfly's body crowned with a bird's head. On the creature's wing a large 'star-eye' can be seen, symbol for the sky at night, and this is repeated below. The bird-butterfly wears a star-studded pectoral and a bead necklace with two ribbons hanging from it. Above left is the sign for a reptile's eye: an eye element with a wavy line over it. After the Toltec period this type of name-day hieroglyph fell into disuse, but is found in Teotihuacan and post-Teotihuacan centres such as Teotenango, Xochicalco, Cacaxtla and also in Tula. Beneath the reptile eye is inscribed the number 13, a combination of the Nahua system which uses one point to indicate the digit 'one', and the Maya system in which a bar signifies the number five. Probably the Maya influence comes from Xochicalco and/or Cacaxtla where the Maya represented themselves in relief and painted illustrations. Also, Teotenango appears to have been a meeting place for ideas and influences of the Nahua of Central Mexico and the Maya of Southeast Mexico.

201
JAGUAR MASK
MAYA

AD 300 – 900
provenance unknown
plaster
h. 60 cm, w. 51 cm
Museo Nacional de Antropología,
Mexico City
inv.no. 10-77187

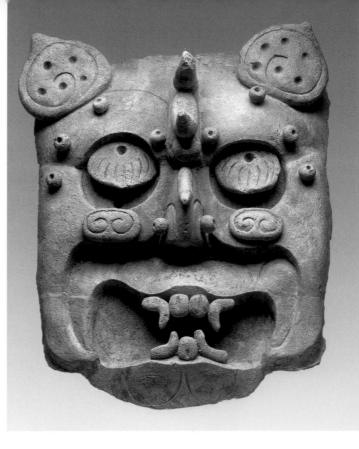

The mask has the features of a jaguar. The ears are pricked up and the eyes are half shut. The whiskers are indicated with incised lines on small oval tablets to the left and right of the nose. The teeth are also shown in the gaping mouth. In the mental world of the Mesoamerican, the jaguar held an important place. It was associated with rain or alternatively with fertility, and also with power and strength. Because of this, it was promoted to the status of deity, as early as the Pre-Classic period during the Olmec era.

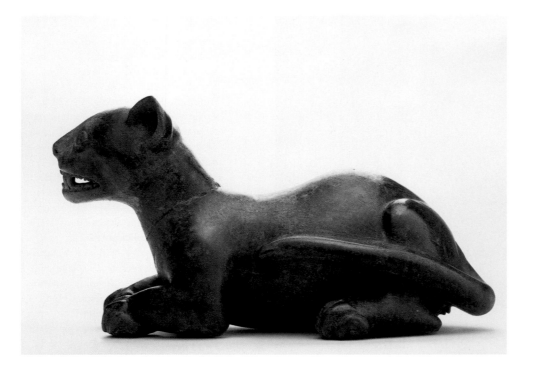

202
JAGUAR
PROTO CLASSIC

100 BC – AD 100
Colima
terracotta
l. 49.7 cm
Museo Amparo, Puebla
inv.no. 57PJ1139

Reclining jaguar with its tail lying along its body. The teeth can be seen clearly in its open mouth. This earthenware sculpture is hollow, like many such (animal) figures which have a type of spout opening and can thus function as a jug.

The shaft-tombs in West Mexico have provided a wealth of objects. Some, given to the dead to accompany them on their journey through the Underworld, illustrate aspects of daily life and the animal world.

This jaguar, made of earthenware covered with polished red slip, a technique common in Colima at this period, is also from a shaft-tomb. The tombs were sometimes as much as 15 metres underground, reached by a shaft which might open onto several grave chambers. This type of burial is typical of West Mexico, that is, today's states of Nayarit, Colima, Jalisco and the periphery.

203
BOWL ON TRIPOD
TEOTIHUACAN

AD 300 – 650
Teotihuacan/Tepeji de Rodriguez
terracotta
h. 13.2 cm, diam. 18.2 cm
Museo Nacional de Antropología,
Mexico City
inv.no. 10-78206

This tripod is made of the fine orange, or
anaranjado delgado type of pottery,
characteristic of Teotihuacan at the peak of
its power. However, it was made in Tepexi
de Rodríguez in South Puebla. Round the
base, the bowl has a row of trophy heads,
shaped with the help of a template. At one
point the row is broken to present an
applied jaguar, sitting up straight with its
head just poking over the edge. The bowl
would probably have been used in
a ceremony connected with the rain god –
the jaguar is closely associated with Tlaloc.
The trophy heads refer to the human
sacrifice that formed part of the fertility
rites.

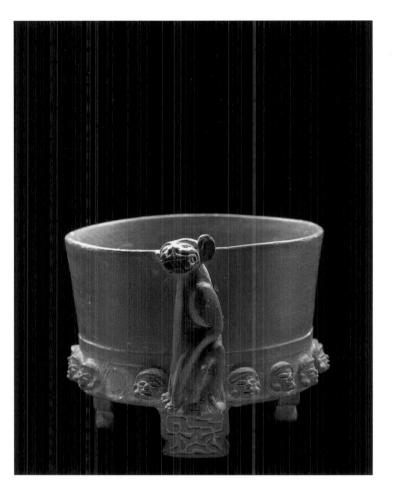

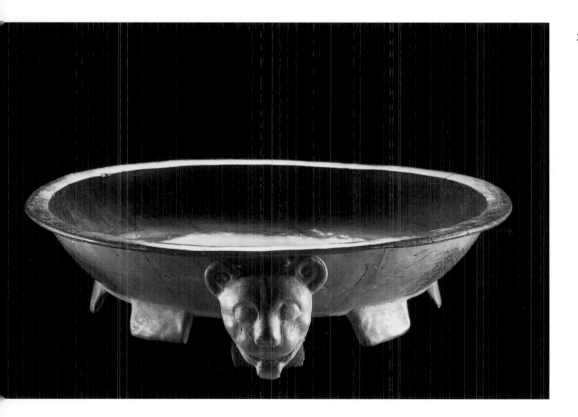

204
DISH
ZAPOTEC (?)

AD 300 – 600
Valley of Oaxaca (?)
terracotta
h. 11.5 cm, diam. 38.5 cm
Fondación Cultural Televísa, A.C.,
Mexico City
inv.no. 255

This four-footed dish has an applied relief
showing a jaguar head. Possibly it was used
in rain and fertility rituals.
The provenance is unknown.

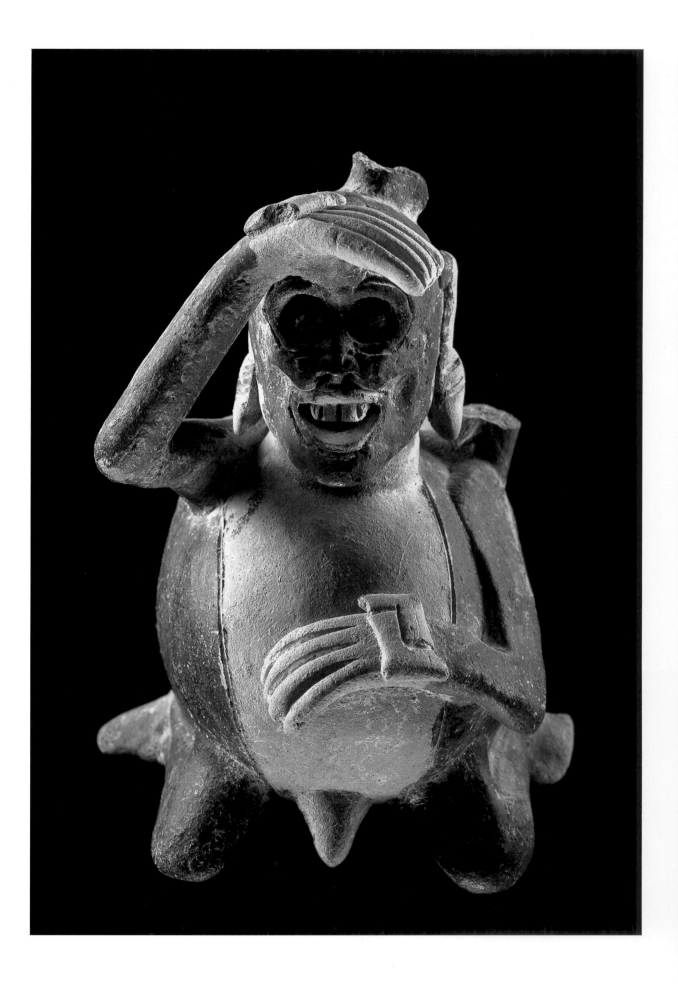

205

MONKEY

PRE TOTONAKC

AD 400–700
Las Remojadas
terracotta
h. 15 cm
Museo de Antropología de la Univers dad
Veracruzana, Xalapa
inv.no. PI 3980

The kneeling monkey with a barrel on its back holds up its right hand as if to shade the eyes from light, or to peer into the distance. The mouth is open and the upper teeth are visible. The creature wears earrings and a wide bracelet round the left wrist. The monkey's body, including the penis and hands, is painted with *chapopote*, a black tar-like substance found along the Mexican Gulf.

In Mesoamerica the monkey is associated with debauchery and undisciplined living.

206

DISH WITH MONKEY

TOTONAC

AD 600–1000
El Tajin
terracotta
h. 20 cm
Museo Amparo, Puebla
inv.no. 57 PJ 1226

This three-footed dish shows a reclining monkey resting on its right side. The creature seems to protect its eyes with one hand. It is worth noting that this gesture occurs elsewhere (see cat. no. 205) although its exact meaning has not been discovered so far. The gesture would not appear to go together with the unbridled sexual passion with which the monkey is usually associated in Mesoamerica. The outside of the bowl is decorated with Tajin loops and geometric patterns, done in sepia on a pale background, a colour scheme first used by the Olmecs, and one that continued until the arrival of the Spanish.

207

DOG WITH MASK

PROTO CLASSIC

300 BC – AD 300
Colima
terracotta
h. 21.5 cm, l. 36.4 cm, b. 19.8 cm
Museo Nacional de Antropología,
Mexico City
inv.no. 10-1458

Pieces of pottery in the shape of a fattened-up hairless dog are frequently found in the shaft-tombs of Colima. Before the arrival of the Spanish the hairless dog was the only breed known in Mesoamerica. It would be fattened up and eaten. The dog was seen as the guardian of the Underworld and accompanied the dead on their journey there. This example of a mask representing a human face has the typical red polished Colima slip. The dog's tail becomes the spout. The human face on the dog's muzzle may refer to the Indian idea of the *nahual*, the dead person's double. The Meso-americans believed, and still do, that every person from birth onwards has a double or counterpart, often in the form of an animal.

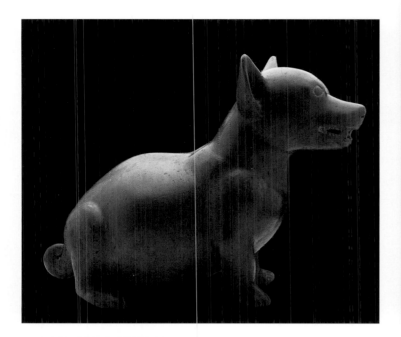

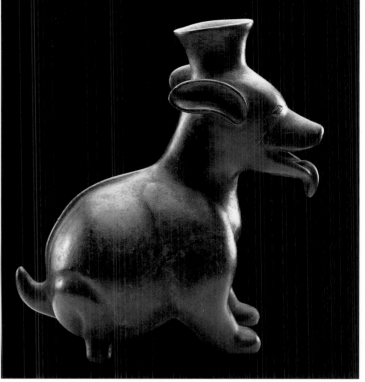

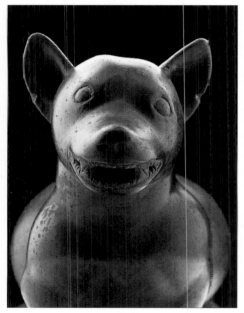

208

DOG

PROTO CLASSIC

300 BC – AD 300
Colima
terracotta
h. 26.7 cm, w. 19.9 cm, l. 37.2 cm
Museo Nacional de Antropología,
Mexico City
inv.no. 10-333164

This hairless dog, fattened up to be eaten, is showing its teeth. The dog was one of the few domesticated animals in Mesoamerica, the others being the turkey, the opossum and the stingless bee (incidentally the only kind of bee in Mesoamerica before the Spanish arrived). Besides being a culinary delicacy, the dog was also seen as the guide of the dead in the Underworld.

This figurine has the characteristic red slip used by Colima potters. When the slip had dried, the object would be polished before firing. The potter's kiln was unknown in Mesoamerica and earthenware was fired in the open, the objects being covered with shards and/or fuel such as wood. This can still be seen today in parts of Mexico.

The figurine was found in a shaft-tomb, and was presumably a funerary gift.

209

DOG WITH ITS TONGUE HANGING OUT

PROTO CLASSIC

300 BC – AD 300
Colima
terracotta
h. 24.7 cm, w. 12.9 cm, l. 22.2 cm
Museo Nacional de Antropología,
Mexico City
inv.no. 10-776675

This hairless dog, fattened up to be eaten, is showing its teeth. The hairless dog was one of the few domesticated animals in Mesoamerica. Besides being a culinary delicacy, the dog was also seen as the guide of the dead in the Underworld.

This figurine has the characteristic red slip used by Colima potters.

The figurine was found in a shaft-tomb, and was presumably a funerary gift.

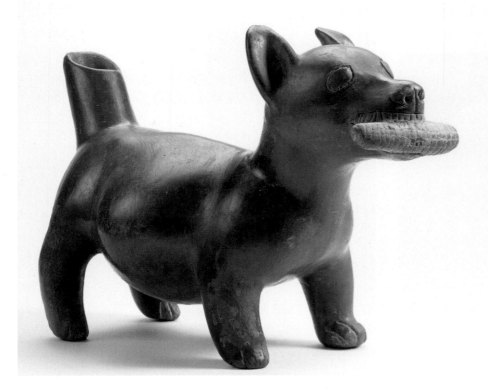

210
DOG WITH COB OF CORN
PROTO CLASSIC

300 BC – AD 300
Colima
terracotta
h. 20 cm, w. 14 cm, l. 30 cm
Museo Nacional de Antropología,
 Mexico City
inv.no. 10-2721

This piece resembles a hairless dog that has
been fattened up (for eating!). In its mouth
is a cob of corn, while the tail functions as
spout. The hairless Mexican dog
accompanied the dead on their journey to
the Underworld. It also appeared on the
menu, especially in West Mexico. This dog
is coated with polished red slip,
characteristic of Colima pottery.
 It was a funerary gift in a shaft-tomb.

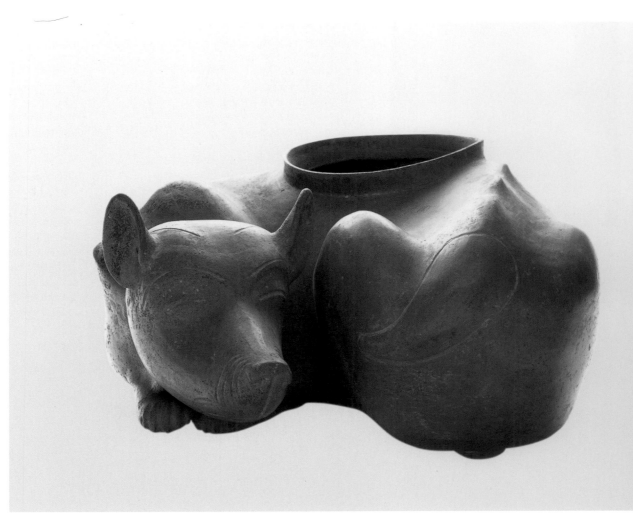

211

DOG

TEOTIHUACAN

AD 300 – 650
Teotihuacan
terracotta
diam. 42 cm
Museo Amparo, Puebla
inv.no. 57 PJ 1322

This terracotta is shaped like a reclining hairless dog, with the opening in the back. Incision has been used to mark certain parts, such as the dog's eyes, whiskers and paws. This type of ceramics is known as *Thin Orange* or *Anaranjado Delgado*. The thin-walled pieces of orangey-coloured pottery were very popular in Teotihuacan although they actually come from Tepexi de Rodríguez in South Puebla state. In the Classic period it was traded throughout Mesoamerica.

212

COYOTE

AZTEC

AD 1428 – 1521
Mexico – Tenochtitlan
stone
h. 38 cm
Museo Nacional de Antropología,
Mexico City
inv.no. 10-47

For the Mexicans of former times the coyote or jackal was closely connected with sexuality. This standing coyote has a very thick coat covering almost the entire body in layers. His tongue can be seen in the open mouth; the ears are pricked up, and realistically rendered.

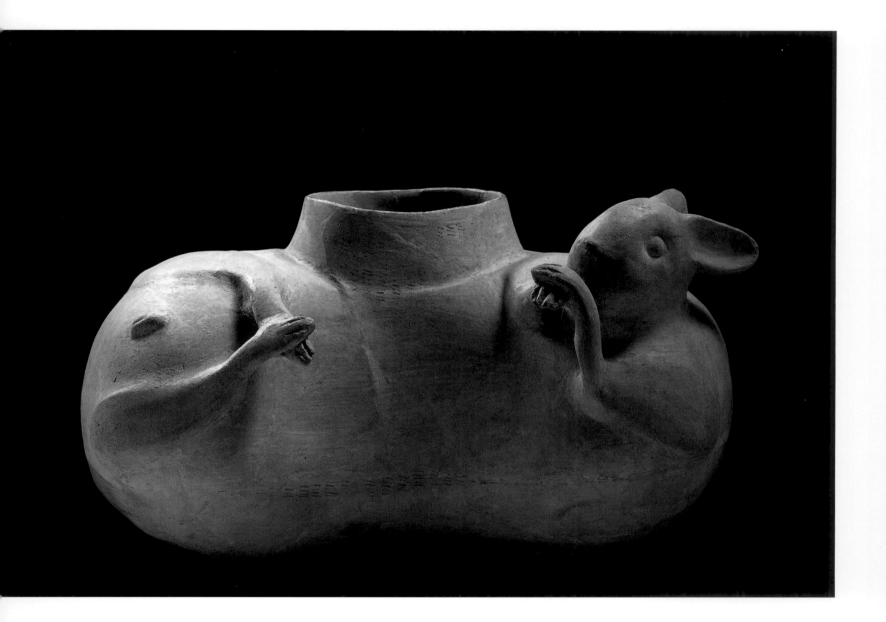

213

RABBIT

AZTEC

AD 1428 – 1521
Mexico – Tenochtitlan
terracotta
l. 42.0 cm, w. 26.8 cm
Museo Nacional de Antropología,
Mexico City
inv.no. 10-564023

This vessel has the shape of a reclining
rabbit, its paws pulled up and crossed. There
is a large opening in the stomach, possibly
for pouring in the pulque drink. The Aztecs
associated rabbits with the pulque gods
who were known as *Centzon Totochtin*, or
400 rabbits. However, in Mesoamerica the
rabbit is primarily associated with the
moon. For the Indians of yore, and quite
likely those of now, the shape of the moon
craters suggested a rabbit.

214

PINE MARTEN

PRE TOTONAC

AD 400 – 700
Rio Blanco – Papaloapan district
terracotta
l. 33.5 cm
Museo Amparo, Puebla
inv.no. 57 PJ 1222

This terracotta figurine represents an angry
marten, baring its teeth. It was found in the
river district of south Veracruz.

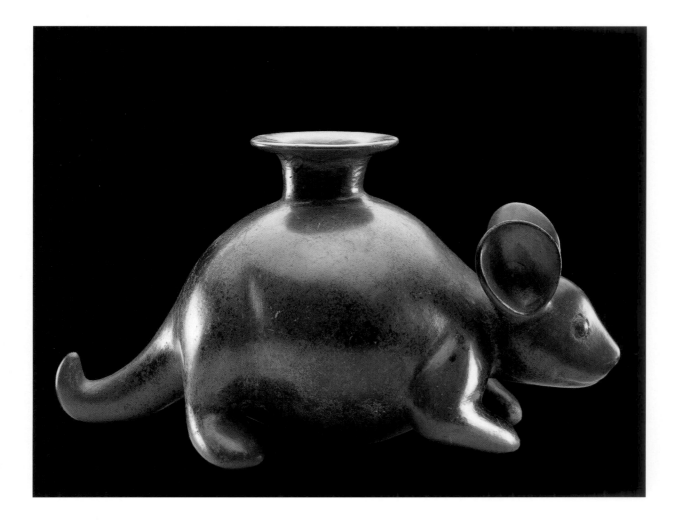

215

MOUSE

PROTO CLASSIC

300 BC – AD 300
Colima
terracotta
h. 17 cm, l. 32.5 cm, w. 13.5 cm
Museo Nacional de Antropología,
Mexico City
inv.no. 10-77611

This piece of pottery resembles a mouse
with large circular ears and a wide spout on
the back. The West Mexicans were
fascinated by the life around them and even
the little mouse became a model for
a potter's skill. This piece has the
characteristic polished red slip of Colima
pottery.
 The figurine was a funerary gift in
a shaft-tomb.

216

ARMADILLO
PRE CLASSIC

800 – 500 BC
Tlatilco
terracotta
h. 16.5 cm, w. 6.9 cm, l. 30 cm
Museo Nacional de Antropología,
Mexico City
inv. no. 10-77581

This piece of black-brown polished pottery
is shaped like an armadillo, with a tall spout
in the middle of the back. The armadillo's
carapace is decorated with incised lines that
create v-shaped motifs.

It was found in a grave in Tlatilco, the
Central Highlands

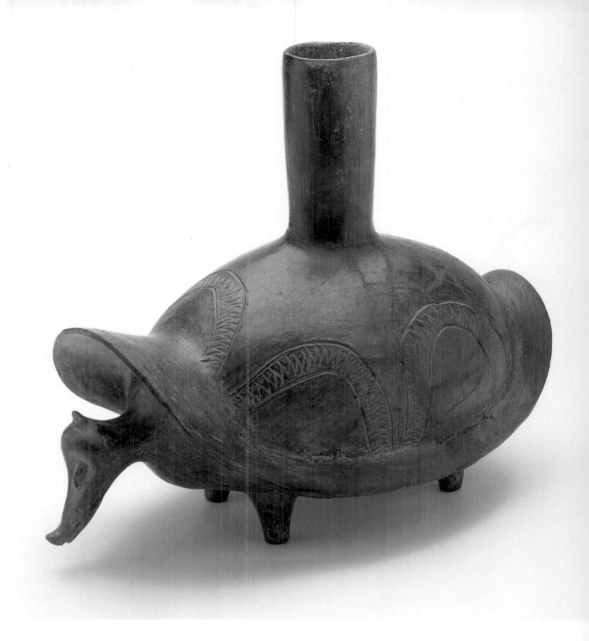

217

INCENSE BURNER
PROTO CLASSIC

300 BC – AD 300
Colima (?)
terracotta
h. 50 cm, diam. 34 cm
Museo Universitario de Arqueología,
Manzanillo
inv. no. 10-571687

The lid of the censer culminates in the head
of a bird of prey. Apart from the spherical
base and a smooth part of the belly, the
surface of the lidded censer resembles
a pine cone. This design is frequently found
in Antiquity and today is still used in
Tarascan pottery (Michoacan).

218

PARROT

PROTO CLASSIC

300 BC — AD 300
Colima
terracotta
h. 20 cm
Museo Amparo, Puebla
inv.no. 57 PJ 1108

The parrot-shaped terracotta bends its
head forward slightly, and the tail forms the
spout. The pottery has the characteristic
Colima red polished slip.

 The potters of West Mexico were
inspired by the animal life that surrounded
them. They have left many terracotta
models of animals.

 This bird was found in a shaft-tomb.

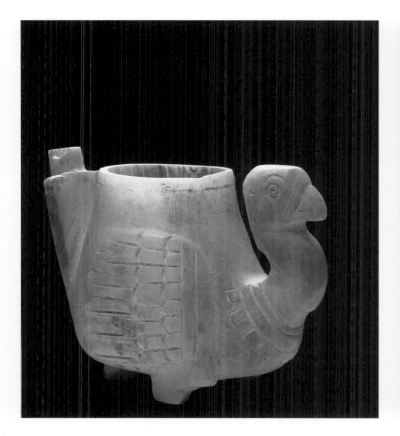

219

TURKEY

MIXTEC

AD 900 – 1521
Valley of Oaxaca, Puebla (?)
onyx
h. 13.5 cm
Museo de las Culturas, Oaxaca
inv.no. 772

This urn, shaped like a turkey, is carved from white onyx. Its wings, eyes and beak are indicated with incised lines. The turkey is one of the few domesticated animals of Mesoamerica and is indigenous to the southwest United States, and North and Central Mexico. There is considerable confusion as to its land of origin. English speakers believe the creature originated in Turkey, hence its name in English. However, the Turks imagine the bird to be a native of India and call it *hindi*. The Portuguese have nearly got it right and call the bird *peru*, acknowledging its New World origin. Meanwhile the Mexicans see the creature as an aged ghost and call it *guajolote*, a Spanish form of the Nahuatl word *huexolotl*, which means something like 'old ghost' – a fine description for the strange appearance of a turkey's head.

220

PAIR OF DUCKS

PROTO CLASSIC

300 BC – AD 300
Colima
terracotta
h. 15 cm, b. 23 cm, d. 35 cm.
Museo Nacional de Antropología,
Mexico City
inv.no. 10-228043

These ducks look like Siamese twins, their sides grown together. They share a tail which acts as a spout. Some of the parts such as beak, eyes and breast feathers are accentuated with incised lines. The pottery has the characteristic polished red slip of Colima ware.

It was found in a shaft-tomb.

221

RATTLESNAKE

AZTEC

AD 1428 – 1521
Mexico – Tenochtitlan
stone
h. 21 cm, diam. 70 cm
Museo Nacional de Antropología,
Mexico City
inv.no. 10-331

The snake lies curled with its belly facing
upwards. Serpents, sometimes shown as
feathered, are an extremely common
feature in Mesoamerican pictures. The
snake was an important symbol of fertility.

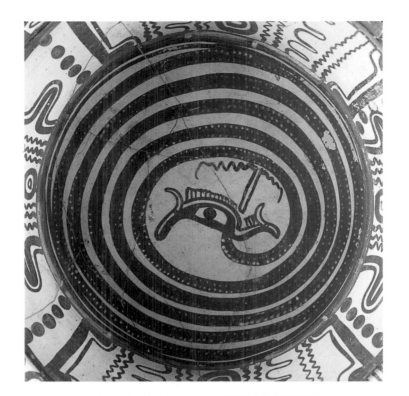

222
DISH SHOWING A SERPENT
OLMECOID

300 BC – AD 100
Mixtequilla, Veracruz
terracotta
h. 10 cm, diam. 35.5 cm
Fondación Cultural Televísa, A.C., Mexico City
inv. no. 237

This three-footed dish has a painting on the
inside representing a snake with a fish-like
head. Geometric motifs have been added in
black and sepia (see cat. no. 232).

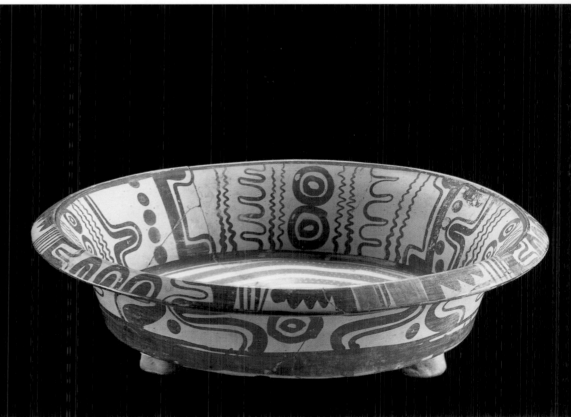

223
TURTLE

CLASSIC

AD 300 – 900
West – Mexico
terracotta
diam. 30 cm
Museo Amparo, Puebla
inv.no. 57 PJ 1111

This container shaped like a turtle has
a wide opening in the short neck. The eyes
and mouth are suggested by incised lines.
The shell is rendered with a bumpy surface.

Turtles, because of the vast number of
eggs laid by the female, were associated
with fertility.

The container was a funerary gift in
a shaft-tomb.

224
TURTLE
PROTO CLASSIC

300 BC – AD 300
Colima
terracotta
h. 11,5 cm, b. 25,3 cm, d. 26,4 cm
Museo Nacional de Antropología,
Mexico Stad
inv.no. 10-228676

This piece of pottery has the form of
a turtle with a large spout on its right side.
Lines and diamond-shaped patterns have
been incised on the shell. Turtles were
associated with fertility – the female lays
countless eggs. Also, the life-giving water
is an essential of the turtle's existence.

The pottery has been coated with the red
Colima slip and polished.

The turtle was a funerary gift in a shaft-
tomb.

225

FROG

MAYA

AD **600 – 900**
Quintana Roo
terracotta
diam. 23 cm
Museo Nacional de Antropología,
Mexico City
inv.no. 10-79423

This pot is shaped like a frog with the
geometric pattern on the skin rendered by
black painting on a terracotta ground.
The frog or toad is always associated with
rain and water, and hence with fertility.
The quantities of eggs – or rather, of
frogspawn – produced by the creature
undoubtedly contribute to this notion.

The pot was found in a grave.

226

**SHELL OF A SEA SLUG,
A QUEEN OR PINK CONCH**

AZTEC

AD **1428 – 1521**
Mexico – Tenochtitlan
stone
l. 101 cm
Museo Nacional de Antropología,
Mexico City
inv.no. 10-213080

This is a stone reproduction of the *strombus
gigas*, or sea slug, commonly found in the
waters of the Mexican Gulf and the
Caribbean. For the Mexicans of old it
symbolized water and life and was closely
associated with the rain god, Tlaloc, and
Quetzalcoatl, as creator of humankind.
The cross-section of the shell *xicalcoliuhqui*,
was also taken as a favourite symbol for
Quetzalcoatl and often used as a motif in
clothing and tattooing. This stone conch
shell has traces of white plaster, probably
formerly mixed with blue, the colour of
water.

The monumental shell was found during
excavations on the Templo Mayor project,
between 1979 and 1982.

227
VESSEL SHAPED LIKE A FISH
PRE CLASSIC

800 – 500 BC
Tlatilco
terracotta
h. 12.8 cm, diam. 11.5 cm
Museo Nacional de Antropología,
Mexico City
inv.no. 10-50

The vessel resembles a heavy fish, gasping for air. The fins, which balance the head, are partly engraved with geometric designs showing traces of reddish painting. Around the fish's eye are the remains of white painting. The vessel is polished ceramic, an old technique in Mesoamerica.

228

VESSEL WITH FISH-SHAPED LID

PRE CLASSIC

800 – 500 BC
Olmecoid
terracotta
h. 12 cm, diam. 20 cm
Museo Regional de Antropología
'Carlos Pellicer', Villahermosa
inv.no. 0455

The lid of this vessel resembles a heavy fish, gasping for air. The vessel is polished ceramic, an old technique in Mesoamerica.

229
NECKLACE OF FISHES

AZTEC

AD 1428 – 1521
Mexico – Tenochtitlan
mother-of-pearl
l. 1 cm (each fish)
Museo del Templo Mayor
inv. nos 10-168842 1/14

The necklace is composed of small mother-of-pearl fishes. It was found in the offering collection no. 41, Templo Mayor complex. This double temple-pyramid in the Aztec capital was dedicated to Huitzilopochtli, Aztec god of the sun and war, and to Tlaloc, god of rain and fertility. Many caches of offerings containing objects connected with rain or fertility have been found close to the Tlaloc section of the temple pyramid. Among them are these outstanding fish, made from mother-of-pearl, (the inner lining of sea shells).

230
CRAB

MIXTEC

AD 1250 – 1521
Valley of Oaxaca
earthenware
h. 10.2 cm, w. 16.3 cm
Museo Nacional de Antropología,
Mexico City
inv. no. 10-17197

This piece of domestic ware is shaped like a crab with a spout on its back. It is hardly surprising that a sea creature such as the crab should be modelled by the people of the Oaxaca valley in pre-Columbian times. Even today, seafood, particularly from the Pacific Ocean, is supplied by small dealers to the markets of Oaxaca and its environs.

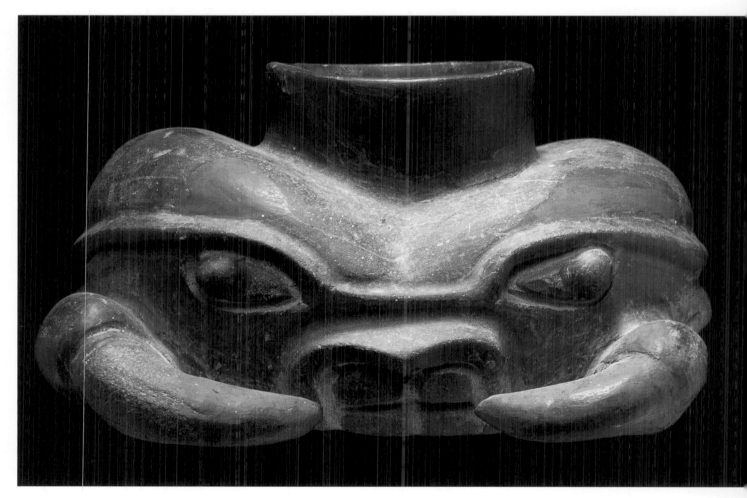

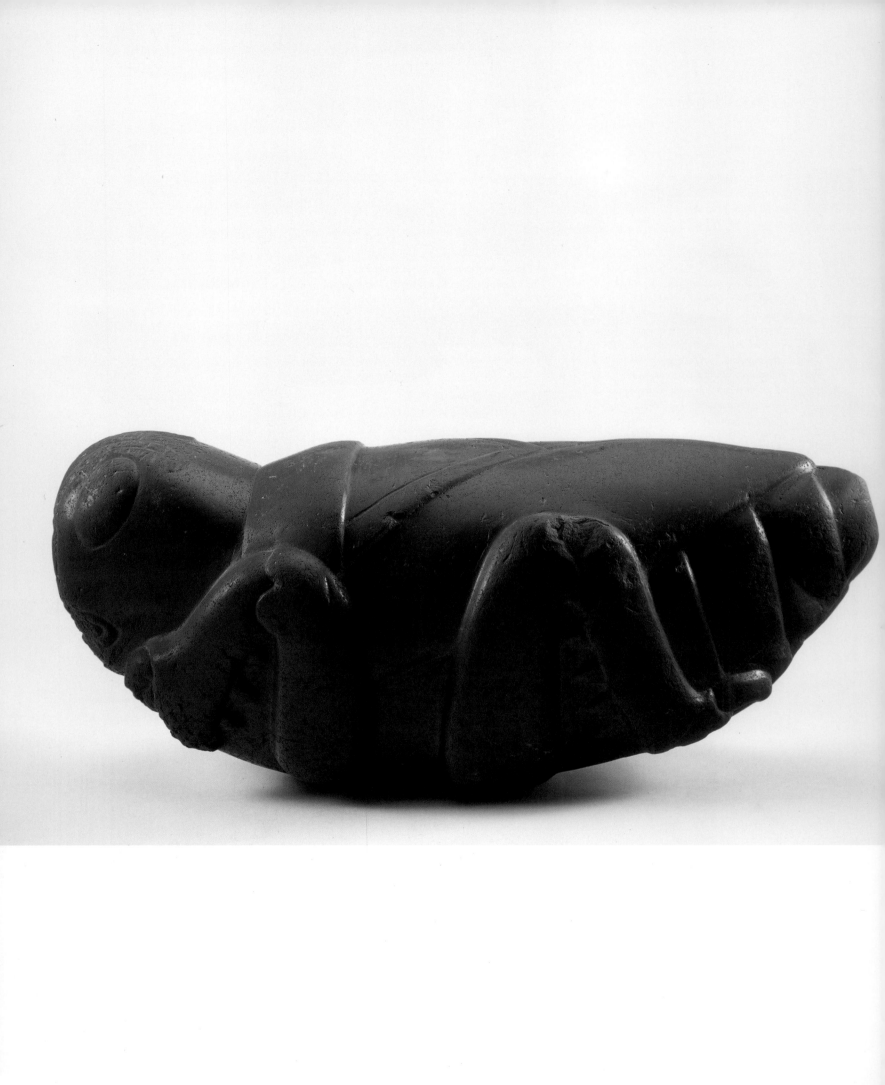

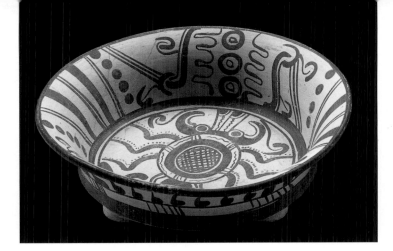

231
GRASSHOPPER
AZTEC

AD 1428 – 1521
Mexico – Tenochtitlan
stone
l. 46 cm
Museo Nacional de Antropología,
Mexico City
inv.no. 10-81671

The stone model shows a grasshopper with four of its six legs folded against its body. The antennae are indicated between the eyes on its head. The orangey-red stone, cornelian, is polished.

The story goes that this grasshopper was found in 1785 during building work on the Castle of Chapultepec, the Hill of Grasshoppers – in Nahuatl the word *chapulin* means grasshopper. What the precise significance of such a stone model would be is not known. There were, however, plagues of grasshoppers from time to time, so it seems not unreasonable to suppose that ritual offerings of grasshoppers might have been made.

And fried grasshoppers are still a delicacy in Mexico today.

232
DISH SHOWING A PICTURE OF A SPIDER
OLMECOID

300 BC – AD 100
Laguna de Los Cerros
terracotta
h. 10 cm, diam. 40 cm
Museo de Antropología de la Universidad Veracruzana, Xalapa
inv.no. PJ 12436

This three-footed dish is decorated with a painting of a spider that has hairy side-legs and front legs resembling crabs' pincers – combining a land creature (spider) and a water creature (crab). The dish has floral and geometric motifs inside and out. The painting is black and sepia on a cream-coloured background. This late-Olmec colour scheme travelled, via examples from Classic times found in the Gulf Coast regions, through to the Post-Classic pottery of the Huaxtecs.

233
BEETLE
PROTO CLASSIC

300 BC – AD 300
Colima
terracotta
l. 15.5 cm, w. 18.5 cm, d. 16.5 cm
Museo Nacional de Antropología,
Mexico City
inv.no. 10-77604

The pottery has the shape of a beetle, possibly a cockroach. The people of West Mexico were fascinated by the teeming life around them and have left many sculptures and pictures of animals, birds and insects. Although the beetle is not common in Mesoamerican coastal regions, there are painted versions of beetles and cockroaches on Maya pottery as well as clay models. This piece has the characteristic red polished slip of Colima pottery.
It was a funerary gift in a shaft-tomb.

POTTERY

Ceramic work was produced in every era and by every people of ancient Mexico. Archaeologists have discovered that pottery was being made in Mexico as long ago as 2500 BC.

Initially the pots were made for daily use, to cook in or to eat from. Later, with the growth of official religions, images of the gods were made in terracotta. So too were ritual objects such as incense burners and sacramental vessels.

The elegant painted services used exclusively by the upper class for meals were extremely costly.

The pots were not fired in kilns, but in open bonfires, covered with shards, wood and other inflammable material.

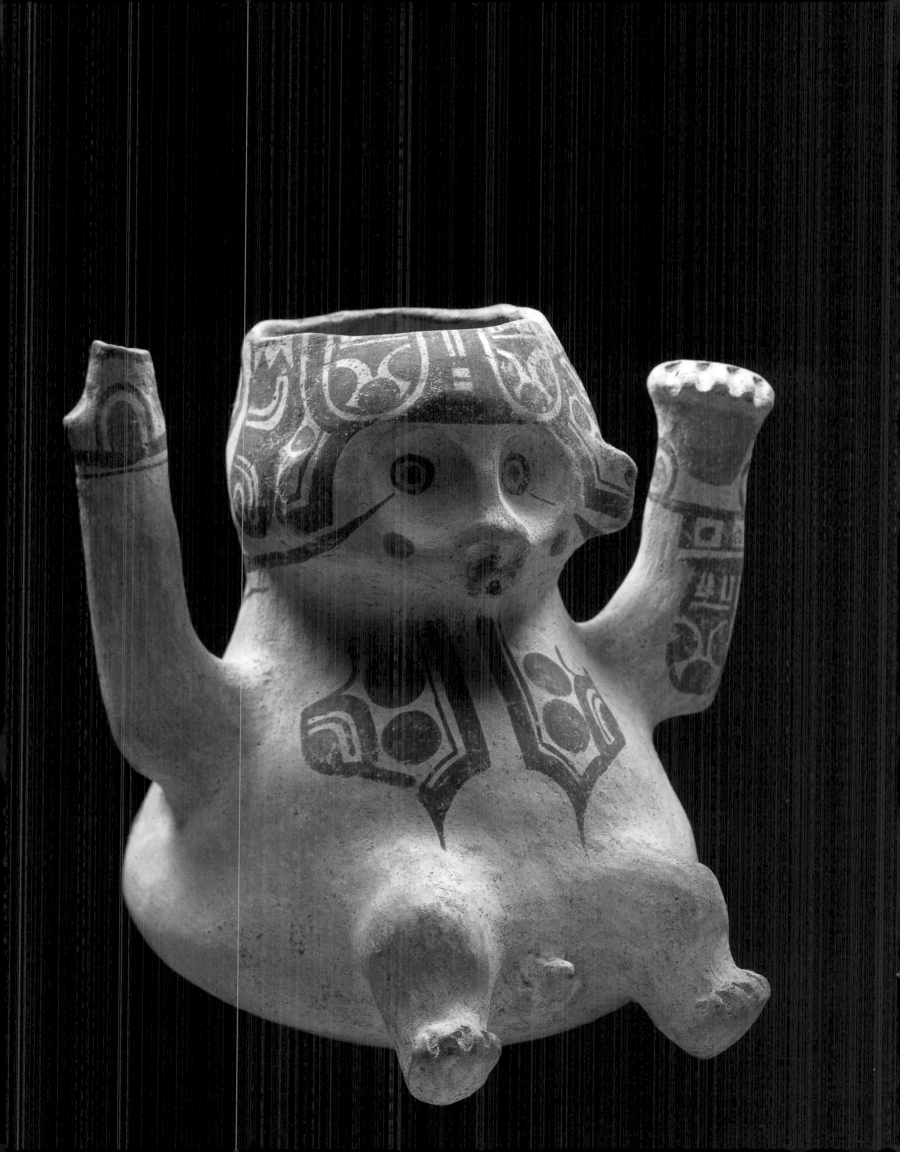

234
ANTROPOMORPHIC VASE
HUAXTEC

AD 1200 – 1521
Pánuco
terracotta
h. 19 cm, w. 18.5 cm
Museo de Antropología de la Universidad
Veracruzana, Xalapa
inv.no. PJ 14904

This piece of pottery is shaped like a seated opossum-man with his arms raised. The head forms the large spout opening. On the reverse is a narrow spout. The pale background of the pottery is decorated in sepia with floral and geometric motifs. The opossum, called *tlacuache* in Mesoamerica, became associated in the Post Classic with the pulque drink, which suggests that this jug may have been used to hold pulque.

235
GOBLET WITH DECORATION IN RELIEF
TOLTEC

AD 900 – 1250
Emiliano Zapata, Tabasco
terracotta
h. 31 cm, diam. 12.5 cm
Museo Regional de Antropología
'Carlos Pellicer', Villahermosa
inv.no. 0064

With the exception of its smooth circular stand, this orange-coloured goblet is decorated in relief which has been incised and hollowed out. It shows a person with face in profile but body seen frontally. He is wearing a luxurious feather headdress, ear and nose rings, a mask covering the mouth and a pectoral with a face engraved on it. The face seems to represent the rain god Tlaloc, though it might be *ahau*, here with the meaning of Lord. This would imply that the figure represents someone important. The shape of the goblet is Toltec and not Mayan, and the same is true of the face with the headdress. The *ahau*-reference come from the Maya.

The goblet was found in Tabasco, which in the Early Post Classic fell under the influence of the Toltecs and Maya of the Central Highlands.

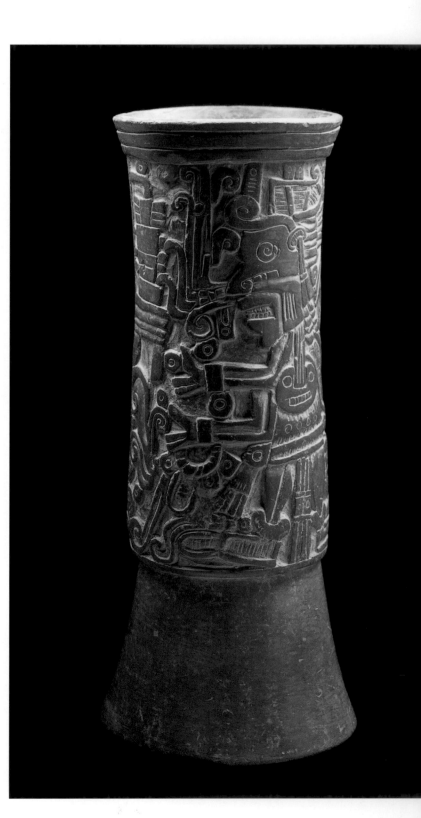

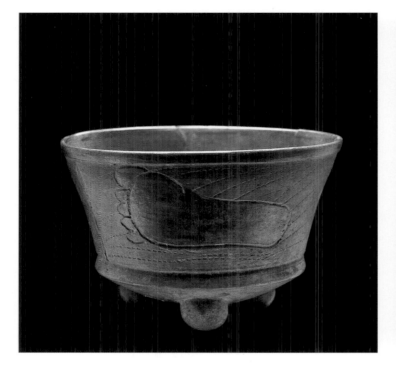

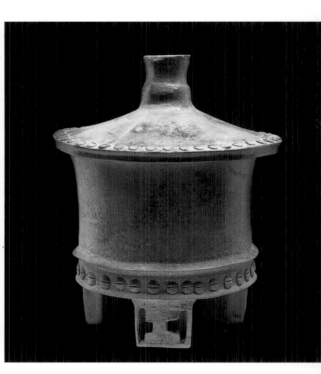

236
BOWL ON TRIPOD
MAYA

AD 300–600
provenance unknown
terracotta
h. 10.5 cm, diam. 16.5 cm
Museo Nacional de Antropología,
Mexico City
inv.no. 10-77441

This three-legged bowl is made of grey
earthenware. The imprint of a human foot,
made with incised lines, decorates the
outside. The imprint of feet form an
intriguing phenomenon in Mesoamerican
iconography. In the codices, or illuminated
manuscripts, the significance of this motif is
known: it represents a relocation or journey
on foot. The footprint is also found on stone
yokes, *yugos*, and axes, *hachas*, as well as on
pottery such as this bowl. Its true meaning
remains a mystery.

237
LIDDED TRIPOD
TEOTIHUACAN

AD 300–650
Teotihuacan
terracotta
h. 23 cm, diam. 19 cm
Museo de la Cultura Teotihuacana,
Teotihuacan
inv.no. 10-226652

The lidded bowl of pale brown earthenware
stands on a tripod. On the lower edge
'coffee bean eyes' have been applied,
formed with a mould. In fact such coffee
bean eyes were rudimentary trophy heads.
The mould has been worn down through
much use and the original trophy-head
imprint has diluted into a coffee bean eye,
which is the name given to this pattern by
art historians. Circular discs have been
applied round the edge of the lid, possibly
also rudimentary trophy heads.

Bowls on a tripod are characteristic of
Teotihuacan, and, during the city's Golden
Age between AD 300 and 650, were copied
and traded throughout Mesoamerica.

238

VASE

MAYA

AD 100 – 300
Yucatan
terracotta
h. 22.5 cm, diam. 13.7 cm
Museo Nacional de Antropología,
Mexico City
inv.no. 10-1184

The cylindrical vase of grey-brown
earthenware has two incised vertical
scenes. One shows the motif of a woven
mat, the symbol of leadership. In
Mesoamerica the mat, known as a *petate*,
was a major item of furnishing: people slept
on it, sat upon it with guests and arranged
alliances. Later, thrones became popular,
but before that, orders and decrees were
issued from the mat. The *petate* motif has
remained associated with leadership.

The other scene has an animal engraved
on it twice, possibly a toad or frog, symbol
of fertility.

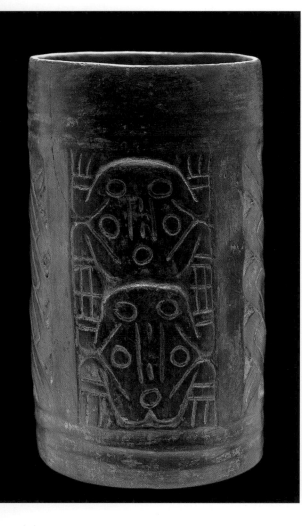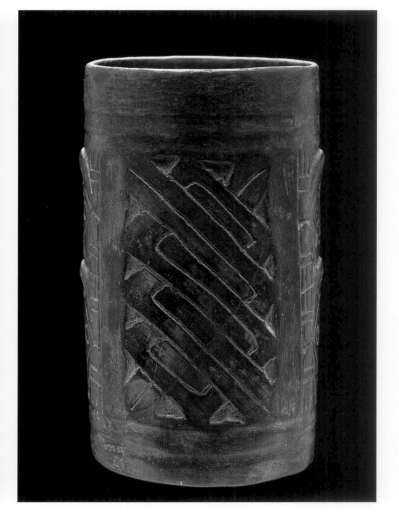

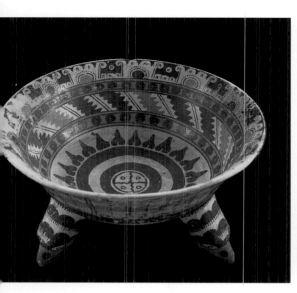

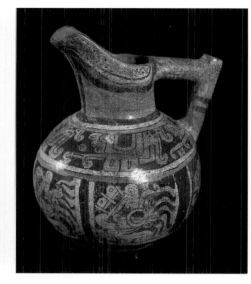

239
DISH ON TRIPOD

MIXTEC

AD 1200 – 1521
Textepec
terracotta
h. 14 cm, diam. 23 cm
Museo de las Culturas, Oaxaca
inv. no. 10-360647

The tripod has polychrome painting in
codex-style and feet modelled and painted
to resemble the heads of birds of prey. This
style of earthenware belongs stylistically to
the Mixteca-Puebla ceramics. The dishes
were only used for ceremonial purposes.

240
JUG

MIXTEC

AD 1200 – 1521
Coixtlahuaca
terracotta
h. 24.5 cm, diam. 18.5 cm
Museo de las Culturas, Oaxaca
inv. no. 10-104338

The polychrome decoration on this jug is
painted in the manner of a codex, or
manuscript, using the same motifs.
Mythological animals, serpents and
dragons, are stylistically represented. The
jug is decorated in the so-called Mixteca-
Puebla style. Initially, this type of ceramics,
which has been found only in Mixtec
territories, was called Mixteca. Later, the
generic name of Mixteca-Puebla was given
to Cholula earthenware from Puebla and
finds in a similar style from elsewhere. This
type of earthenware is dated to the Late
Classic, between 1400 and 1521, but its
origins would seem to stem from as far
back as 1100.

241
DISH ON TRIPOD

AZTEC

AD 1428 – 1521
Cholula
terracotta
h. 6 cm, diam. 16.5 cm
Museo Regional de Puebla, Puebla
inv. no. 10-203376

The feet of this tripod are modelled and
painted to resemble animal heads, probably
those of deer. Two parrots, painted back to
back, adorn the inside of the dish. This type
of pottery – commonly known as Mixteca-
Puebla – was made in Cholula, a major
religious centre in the Epi- and Post-Classic
periods. The dish was not intended for
domestic use, but only for ceremonial
occasions.

242
VESSEL
PRE CLASSIC

1000 – 500 BC
Tlatilco
terracotta
h. 6.5 cm, diam. 5 cm
Museo Nacional de Antropología,
Mexico City
inv.no. 10-342225

The shape of the vessel is inspired by a type
of calabash called the *tecomate*. There are
some traces of firing on the cream-
coloured pottery. Both the colour and the
delicacy of the pottery date it to the Golden
Age of the Olmecs when their influence
was felt throughout Mesoamerica,
including the Mexican Highlands.

This object was found in a grave.

243
VESSEL
PRE CLASSIC

1000 – 500 BC
Tlatilco
terracotta
h. 9 cm, diam. 12 cm
Museo Nacional de Antropología,
Mexico City
inv.no. 10-1696

The shape of the vessel is inspired by a type
of calabash called the *tecomate*. The upper
part is terracotta in colour with a creamy
tone below. There is a decorated rim
separating the two colour areas. Like cat.
no. 242, this can be dated to the Olmec
period when their influence spread as far as
the Central Highlands.

The vessel was found in a grave.

244
TRIPOD

ZAPOTEC

AD 300 – 600
Monte Alban
terracotta
h. 26 cm, diam. 27 cm
Museo Nacional de Antropología,
Mexico City
inv.no. 10-61322

The bowl has three feet shaped like breasts.
Around the rim of the bowl is a geometric
pattern of engraved lines. There are
openings in the feet which presumably
served as air vents during the firing process.

The bowl is made from grey polished
earthenware. This tradition is still
encountered today in the black pottery of
San Bartolo Coyotepec, in the Oaxaca
valley.

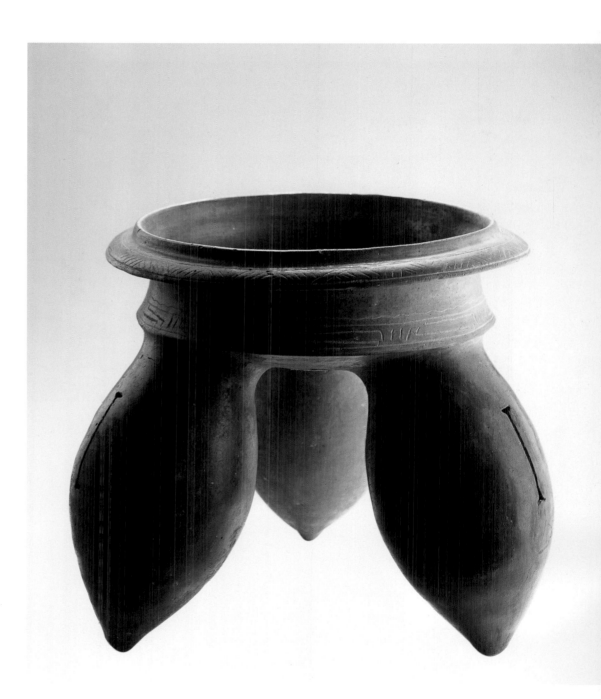

245

BOWL ON TRIPOD

PROTO CLASSIC

300 BC – AD 300
Chupicuaro
terracotta
h. 10.8 cm, diam. 21.3 cm
Museo Nacional de Antropología,
Mexico City
inv.no. 10-43076

The bowl is reddish-brown with white
geometric motifs outlined in black. These
include the so-called step pattern and
square shapes.

 The bowl was found as a funerary gift in
a grave in Chupicuaro where a large
cemetery containing over four hundred
graves from Proto-Classic times was
discovered.

246

BOWL ON TRIPOD

TEOTIHUACAN

AD 500 – 650
Teotihuacan
terracotta
h. 18 cm
Museo de la Cultura Teotihuacana,
Teotihuacan
inv.no. 10-213195

The bowl, with relief decoration, has three
openwork feet. The wide relief has been
applied with a stencil, and runs in a diagonal
line with a pattern of curls and meanders
that is associated with work from El Tajin
near the Mexican Gulf coast. In the
Merchants' Neighbourhood of
Teotihuacan, large quantities of material
have been found pointing to links between
Teotihuacan and the Gulf coast. The bowl
has traces of red paint. It was found in a
residential district in a tomb.

247
BOWL
MAYA

AD 300 – 600
provenance unknown
terracotta
h. 9.5 cm, diam. 23.6 cm
Museo Nacional de Antropología,
Mexico City
inv.no. 10-76882

This grey earthenware bowl is decorated on
its broad rim with incised geometric
patterns, each one within a square. Lines are
engraved on the bowl's curved belly,
meeting on the flat base.

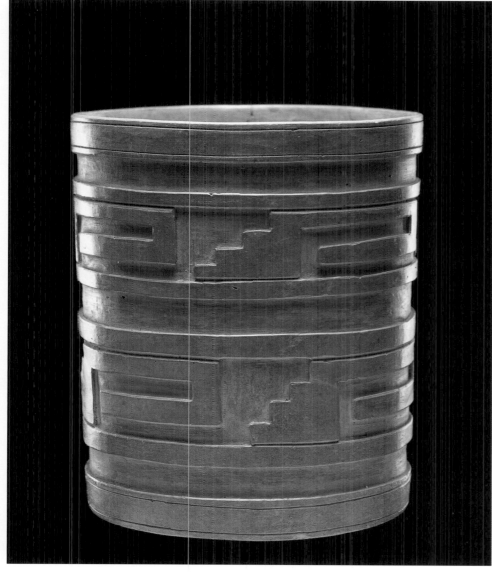

248
VASE
MIXTEC

AD 1250 – 1521
Valley of Oaxaca
terracotta
h. 20 cm
Museo Amparo, Puebla
inv.no. 57 PJ 1526

The reliefs on this vase are reminiscent of
architecture in Mitla, a Mixtec centre in the
Oaxaca valley. The two upper sections of
the vase, one above the other, are decorated
with meanders and step-pattern
decoration, between straight lines.

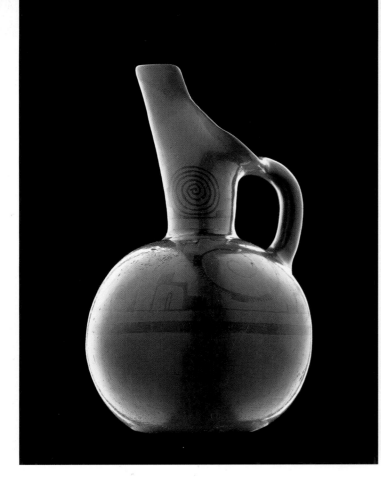

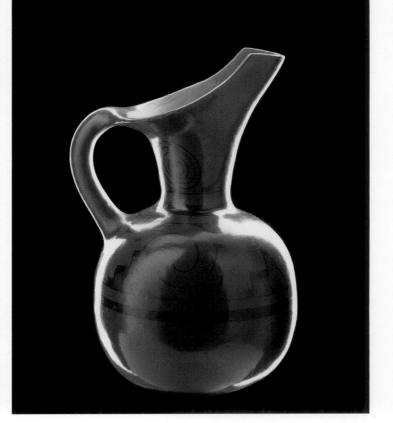

249
JUG
AZTEC

AD 1428 – 1521
Texcoco
terracotta
h. 24 cm
Museo de las Culturas, Oaxaca
inv.no. 10-104214

This jug, made of terracotta-coloured
polished earthenware, is painted with
a black geometric pattern. Jugs of this type
were used by the elite for pulque and made
in Texcoco in the Central Highlands.
Possibly this jug was booty for one of the
Aztec officers when the Zapotec-Mixtec
territories were conquered at the end of the
15th and early 16th century.

250
JUG
AZTEC

AD 1428 – 1521
Texcoco
terracotta
h. 29.5 cm
Museo Nacional de Antropología,
Mexico City
inv.no. 10-78234

This terracotta-coloured jug is painted in
a black geometric design. It has a round
belly and one handle. The polished jug falls
in the category of sophisticated earthen-
ware made in Texcoco for the social elite.
It was used to hold pulque.

NOTES
BIBLIOGRAPHY
AUTHORS AND
COMPILERS
CREDITS

**THE VISUAL LANGUAGE AND THE
IDENTITY OF PRE-COLUMBIAN ART**

1 This English traveller persuaded the Mexican government, freshly independent, to temporarily export some of the archaeological finds and codices, chiefly examples of Aztec culture. With these, he mounted an exhibition in London in 1824, titled *Ancient Mexico*, the first of its kind in modern history (Bullock, 1824).

2 In 1885 president Porfirio Díaz ordered the 'sun stone' to be removed from the cathedral's western tower and placed in the National Museum. In 1888 the 'Gallery of the Monoliths' was officially opened in his presence. Here the major pre-Columbian sculptures that had so far been discovered were assembled (Galindo and Villa, 1897).

3 The expedition led by Francisco del Paso y Troncoso is the most important of the early exploratory journeys in modern Mexico. The purpose of this journey was to discover the exact position of Cempoala, in Veracruz. It was the capital city of the Totonacs, where Cortés resided at the start of the European conquest of Mexico (Bernal, 1992:141–142).

4 At the beginning of the twentieth century the street of the steps was uncovered, offering an impression of the magnificence of the Great Temple of the Aztecs. The first discoveries were also made showing the sacrificial altars and statues that could be recognized, such as that of Xochipilli (Batres, 1902).

5 Ignacio Bernal in his work on the study of the history of Mexican archaeology describes in detail the effect of the discoveries and the value of the research studies carried out in Mexico in the first half of the twentieth century (Bernal, op.cit.).

6 There are numerous publications providing an overview of pre-Columbian Mexican art. The first we should like to mention, because of its importance and wealth of illustrations, is the collective work by Paul Westheim and other authors (Westheim et al., 1969), then the book by Disselhoff and Linné published in Spanish in 1962, and finally the superb overview by Alcina Franch from 1983.

7 It is widely known that George Kubler attributed an exceptionally high aesthetic value to the pre-colonial art of America, in particular that of the highly-developed civilizations of Mesoamerica and the Andes region (Kubler, 1983).

8 Scarcely had the new Mexican government gained control after the Revolution than the authorities responsible for education and culture realized the importance of using their country's art works as a kind of goodwill ambassador. From then on, major exhibitions were organized, of which we should mention in particular those mounted by Fernando Gamboa in the 1950s and 60s, and undoubtedly the *Splendors of Thirty Centuries* held in The Metropolitan Museum of Art, New York, in 1990.

9 The selection of pre-Spanish objects for this exhibition was supervised by Miguel Covarrubias and Alfonso Caso.

10 Fernando Gamboa took advantage of the restoration carried out in the mid-twentieth century in the old National Museum which was then situated in the historic centre of Mexico City. He was able to make an exceptional collection of archaeological objects which he exhibited in 1952 in London, Paris and Stockholm, together with works from the colonial and modern periods. This started a firm tradition of holding international exhibitions dealing with Mexico (Musée National D'Art Moderne, 1952).

11 An unusual fact was that these exhibitions presented archaeological works of exceptional value that came from museums in the United States and Europe. Special mention should be made here of the Robert Woods Blis collection which is of remarkable aesthetic quality (Dumbarton Oaks, 1963).

12 Frederick J. Dockstader dedicated several studies to the techniques of the indigenous artists and artisans (Dockstader, 1967: 15–23).

13 Several of the most illustrious researchers of architecture and urban planning in the American continents before the arrival of the Spanish have found specific characteristics in the planning of human settlements during this indigenous period (Hardoy, 1973).

14 Jorge Hardoy dedicates a separate chapter to Mexico-Tenochtitlan, in which he discusses the planning of the capital city of the Aztecs and its specific characteristics (Hardoy, Ibidem: 121–202).

15 One of the most recent studies of the art and culture of the Olmecs includes

research into the settlements and the natural setting in San Lorenzo, Veracruz. The author detects a connection between the early Mesoamerican architecture and the world of the jungle (Symonds, 2000 : 55–74).

16 Various books dealing with the excavations of the Great Temple illustrate with numerous photographs cases of this indigenous technique of pile foundations. This type of foundation was used with great success into the twentieth century and forms the basis for ancient pyramids as well as colonial palaces (Matos, 1982 : 79).

17 In Sylvanus G. Morley's classic study of Maya civilization the technique used by the indigenous people to acquire and transport huge blocks of stone is illustrated by the artist Jean Charlot (Morley, 1965 : fig. 64–65).

18 Alfonso Caso made a study of the techniques of pre-Columbian artists when painting murals in temples and palaces. He also examined and distinguished between the peculiar characteristics of the various cultures who practised this art (Caso, 1969 : 339–398).

19 The work presenting the most thorough overview of ancient Mexican architecture was compiled over several decades by Ignacio Marquina. This work illustrates the designs and decorations that differentiate various buildings constructed by different pre-Columbian civilizations over a period of 3,000 years (Marquina, 1964).

20 In ancient Mexico, as in many other parts of the world, art was an anonymous enterprise. Sculptures and other works of art were in fact produced in workshops under the direction of one or more experienced people who gave advice and guidance to the many assistants (Solís and Gallegos, 2000 : 40–43).

21 Researchers into pre-Spanish technology hold that the transport of huge blocks of volcanic rock was performed using tree trunks to roll the blocks from the stone quarries to the banks of a river or the sea coast, or, indeed, their ultimate destination, where the indigenous artisans would then craft the stone into sculptures (Pohorilenko, 2000).

22 The important sculpture known as 'The Lord of Las Limas' was hewn out of an attractive green-coloured stone, probably a kind of diorite. Despite its having lain for several centuries buried in the ground in the Veracruz isthmus, this work of art has retained the remarkable sheen it had acquired from ancient polishing methods (Medellín, Zenil and Beltrán, 1965 : 5–16).

23 In the National Museum of Mexico's collection there is a pot made of travertine that reveals traces on its inside of the way in which it was hollowed out. To do this, small tubes made from leaves of metal were used as drills or gimlets (Castillo Tejero, 1970 : 48–52).

24 It seems that generally the pre-Columbian peoples used obsidian as a base material for their tools and weapons, shaping it to their needs by cutting and chipping off pieces. They would also polish this volcanic glass using the Neolithic method in order to make mirrors which fulfilled a magic and ritual function. The masterpiece of polished obsidian is the pot in the shape of a monkey holding its tail in both paws, one of the treasures in the National Anthropological Museum of Mexico (Solís, 1991 : 249).

25 Eduardo Noguera was one of the scholars of ancient Mexican archaeology who was active in the study of the indigenous ceramics of Mesoamerica (Noguera, 1975).

26 As researchers of the potter's art understand very well, the methods used in making modelled pots rely chiefly on the manual skill of the potters. They turn the clay in the palms of their hands, press it out with their fingers, create balls or cylindrical shapes with thin 'sausages' of moist clay, which they then smooth over with the hand (Noguera, Ibidem : 33–39).

27 In this technique moulds or formers have to be prepared in advance. These have printed on them the pattern that is to be copied. The moulds are fired in the kiln and later used to produce a series of pots, or decorative elements. Remarkable for their beauty and complexity are the so-called 'theatre'-torch holders of Mesoamerica, characteristic of the Teotihuacan culture, which distinguish themselves by their numerous panels and decorations (Sejourné, 1966 : 44–52).

28 The ethnic groups of Mexico still employ the traditional techniques when making ceramics (Marin de Paalen, 1974 : 65–78).

29 As in the case of modelling as a ceramic technique, so also with the stamping technique, objects need to be made in advance, such as the stamps or templates. With these, patterns can be made on pots of soft clay, before they are fired. Stamps are also used in decorating the human body and textiles, and for applying motifs in paint (Noguera, 1975 : 193).

30 In the central Mexican areas the ceramics differ from those in the Cholula, Puebla, area. The former have attractive polychrome decoration with motifs and figures, demonstrating a close connection between this work by potters and the painters of codices (manuscripts) (Noguera, 1954).

31 The potters of the Classic period in Maya culture had inherited from their ancestors all the secrets connected with producing art works. They painted scenes from history on the remarkable polychrome-coloured pots they produced, also stories from the mythology of that part of Mesoamerica. And with consummate skill they portrayed the figures of their leaders, warriors and tradespeople (Baudez and Becquelin, 1984 : 181–217).

32 This decorative technique, whereby a layer of plaster (stucco) becomes the base upon which polychrome motifs are painted, after which the pot is fired for the second time, was considered by Eduardo Noguera to resemble the varnishing stage. It gives a particularly thick impasto coating of paint (Noguera, 1975 : 169–171).

33 Among the most famous ceramic objects from Teotihuacan we find vessels bearing motifs that were painted using the secco-fresco technique (dry fresco, that is, pigment painted onto dry plaster or stucco). This repeats in miniature form the visual impression gained by the viewer standing in front of the murals. The remarkable aspect of this is that the entire visual message is concentrated on the outer wall of the vessel, on which the ritual image is repeated two or three times in a precise rhythm (Sejourné, 1966 : 75–83).

34 Eduardo Noguera published one of the earliest studies providing an overview analysis of the techniques and shapes of wooden objects made in pre-Columbian Mexico (Noguera, 1958).

35 The precision and detail of this minute figurine, carved from the bone of an animal, probably a jaguar, reveals the highly sophisticated techniques of the ancient Maya craftspeople. They employed

their tools of flint and obsidian with utmost skill (Baudez and Becqelin, op. cit.: fig. 207).

36 We know that the development of metalwork started among the indigenous civilizations of South America, where it has been dated to 2700 BC. In Mesoamerica, metalwork seems to have begun around AD 800, the first area to adopt this activity from the south being Oaxaca. In all probability the craft was transmitted via the coastal trading routes (Solís and Carmona, 1997: 13 – 23).

37 Very few examples remain of the astonishing gold and silver jewellery that undoubtedly once existed in Mesoamerica. One piece, the most famous, was discovered in 1932 by Alfonso Caso in Grave No. 7 in Monte Alban, Oaxaca. It forms a set with other ornaments made from the precious metal, and jewels of jade, jet, amber and suchlike (Caso, 1969).

38 Exceptional metal objects have been preserved that were produced using the so-called cire-perdu or lost-wax method. Most remarkable of these is the 'treasure of the fisherman' that was recently discovered on the coast of Veracruz (Solís and Carmona, 1995: 77 – 146).

39 In the part of the world where Nahuatl was spoken, the craftspeople who made the striking objects of many feathers were called amantecas. Their activities required the punctual delivery of feathers which were sent as tribute from the conquered provinces of the Mexican empire (Pasztory, 1983: 278 – 280).

40 This chimalli (battle shield) now in a Vienna museum illustrates, as well as the remarkable application of feathers, the use of thin leaves of gold to accentuate the edges of the coyote's feather headdress, and also other details such as the union of water and fire, a symbol of war (Bernal and Simoni-Abbat, 1986: fig. 286).

41 Pasztory op. cit.

MEXICO AND MESOAMERICA

1 see Gerards 2000, p. 236 ff.
2 see Leyenaar 1997, pp. 28 – 31
3 see Taladoire 1981
4 see Ixtilxochitl I, p. 279

SOCIETY AND PHILOSOPHY OF LIFE IN MESOAMERICA

1 see: R. van Zantwijk, 1996, pp. 31 – 38

2 see: R. de Ridder, 1989, p. 79
3 see: R. van Zantwijk, 1996, pp. 29 – 30
4 see: R. van Zantwijk, 1994, pp. 115 – 16
5 translation from the Dutch by Wendie Shaffer

A NAHUATL CONCEPT OF ART?

1 'Prométée enchaîné' (Prometheus Bound) in Eschyle, vol. I, Greek text with French translation by Paul Mazon, Paris, Société d'édition Les Belles Lettres, 1958, 170.
2 Justino Fernández, Coatlicue. Estética del arte indígena atiguo, México, Universidad Nacional Autónoma de México, 1959, 53 – 198.
3 Albrecht Dürer, 'Tagebuch des Reise in die Niederlande, Anno 1520', in: Albrecht Dürer in seinen Briefen und Tagebüchen, zussamengestellt von Ulrich Peters, Frankfurt am Main, Verlag von Moritz Diesterweg, 1925, 24 – 25.
4 Codex Vindobonensis Mexicanus I. History and description of the manuscript by Otto Adler, Graz, Austria, Akademische Druck- und Verlaganstalt, 1963, 48 – 49.
5 Codex Matritensis of the Academy of History, (Texts of the Nahua Informants of friar Bernardino de Sahagún, edited by Francisco del Paso y Troncoso, 3 vols., Madrid, Fototipia de Hauser y Menet, 1907, VII, fol. 144 r.
6 Ibid., VII, fol. 172 v. – 174 r.
7 Ibid., VII, fol. 115 v. – 116 r.
8 Ibid., VII, fol. 300 r.
9 Ibid., VII, fol. 285 r.
10 Cantares mexicanos, facsimile reproduction by Miguel León-Portilla and Jose G. de Alva, México, Instituto de Investigaciones Bibliográficas, 1994, 9 r. – 11 v.
11 Fernando de Alva Ixtlilxóchitl, Obras Históricas, 2 vols., Mexico, 1891 – 1892, II, 17.
12 Codex Matritensis, VII, fol. 116 r.
13 Ibid., VII, fol. 117 v.
14 Ibid., VII, fol. 124 r.

MEXICO TODAY: THE TRADITIONS THAT LIVE ON

1 See Sahagún, figs 21 and 28
2 See Leyenaar 1981, p. 32
3 See Sahagún X, p. 42
4 See Torquemada, vol. III, part X, chapter XXXVIII; Clavijero II, pp. 163, 282 ff.
5 See Sahagún II, pp. 125 and 126
6 See Sahagún II, pp. 7, 23, 29, 54, 121, 133, 140, 147 ff.
7 See Sahagún II, pp. 13, 19, 89, 98 and 110

BIBLIOGRAPHY

a

ALCINA 1983
Franch José Alcina, *Precolumbian art*,
New York, 1983

b

BATRES 1902
Leopoldon Batres, *Exploraciones
arqueològicas en la calle de las Escalerillas,
tipografia y litografia*, 'La Europea', Mexico,
1902

BAUDEZ 1984
Claude François Baudez and Pierre
Becquelin, *Les Mayas*, Paris, 1984

BERNAL 1986
Ignacio Bernal and Mireille Simoni-Abbat,
Le Mexique- des origines aux Aztèques, Paris,
1986

BERNAL 1992
Ignacio Bernal, *Historia de la arqueologia en
México*, Mexico, 1992

BULLOCK 1824
William Bullock, *A description of the unique
exhibition called Ancient Mexico; Collected on
the Spot in 1823, by the Assistance of the
Mexican Government and Now Open for Public
Inspection at the Egyptian Hall, Piccadilly*,
London, 1824

c

CASO 1969A
Alfonso Caso, 'La pintura en Mesoamérica',
in: *Cuarenta Siglos de Plàstica Mexicana*:
339 – 398, Mexico, 1969

CASO 1969B
Alfonso Caso, *El Tesoro de Monte Alban*,
Instituto Nacional de Antropología e
Historia, 1969

CASTILLO 1970
Tejero Noemí Castillo, 'Tecnologìa de una
Vasija en Travertino', in: *Boletín del INAH*, no.
41: 48 – 52, Instituto Nacional de
Antropología e Historia, 1970

CHICAGO 1998
Ancient West Mexico, exhib. cat., ed. Richard
F. Townsend, Chicago, 1998 [Thames and
Hudson, London/New York]

CLAVIJERO 1968
Francisco Javier Clavijero, *Historia Antigua de
México*, 2nd edition, Vol. II, Mexico, 1968

CODEX MENDOZA 1978
Codex Mendoza, Aztec manuscript, K. Ross,
Freiburg, 1978

CODEX VATICANUS A 1979
Codex Vaticanus, A, Graz, 1979 [Akademische
Druck und Verlaganstalt]

CÓDICE FERNÁNDEZ LEAL 1895
Codice Fernández Leal, Antonio Peñafiel,
México, 1895

COE 1966
Michel D. Coe, *The Maya*, London 1966

CUÉLLAR 1976
Elizabeth Snoddy Cuéllar, 'Mexico's many
costumes', *Americas*, vol. 28, no. 5: 5-13, 1976

d

DISSELHOFF 1962
Hans-Dietrich Disselhoff and Linnè Sigvald,
América Precolombina, Barcelona, 1962

DOCKSTADER 1967
Frederick J. Dockstader, *Arte Indígena de
Mesoamérica*, New York, 1967

DUMBARTON 1963
Oaks Dumbarton, *Handbook of the Robert
Woods Bliss Collection of Precolumbian Art*,
Washington D.C., 1963

DUVERGER 1999
Christian Duverger, *Mesoamérica, Arte y
antropología*, Paris, 1999 [Flammarion]

e

EL JUEGO DE PELOTA
*El juego de Pelota en Mesoamerica, Raices y
Supervivencia*, red. Maria Teresa Uriarte,
Mexico/Madrid, 1992

g

GALINDO 1897
Jesús Galindo y Vilas, *Catàlogo del
Departamento de Arqueologìa del Museo
Nacional; Primera parte, Galeria de Monolitos*,
Mexico, 1897

GERARDS 2000
F. Ph.J. Gerards, *Olmeekse Hoofden –
De Omgekeerde Pyramide*, Leiden, 2000
(PhD thesis)

GIRARD 1979
Raphael Girard, *Esotericism of the Popol Vuh,
The Sacred History of The Quiché-Maya*,
Pasadena, 1979

GRAULICH 1987
Michel Graulich, *Mythes et rituels du Méxique
ancien préhispanique*, Académie Royale de
Belgique, Brussels, 1987

h

HARDOY 1973
Jorge E. Hardoy, *Pre-Columbian Cities*,
New York, 1973

j

JANSEN 1982
M.E.R.G.N. Jansen, *Huisi Tacu, estudio interpretativo de un libro mixteco antiguo: Codex Vindobonensis Mexicanus i Cedla*, Amsterdam, 1982

k

KUBLER 1983
George Kubler, *The Art and Architecture of Ancient America*, Middlesex, 1983

l

LÉON-PORTILLA 1963
Miguel Léon-Portilla, *Aztec Thought and Culture, A Study of the Ancient Nahuatl Mind*, Norman, 1963 (reprints in 1970, 1971, 1975 and 1978)

LÉON-PORTILLA 1974
Miguel Léon-Portilla, El Reverso de la Conquista: relaciones aztecas, mayas e incas, 4a ed. México, 1974 [Joaquin Mortiz]

LÉON-PORTILLA 1980
Miguel Léon Portilla, *Native Mesoamerican Spirituality, Ancient Myths, discourses, stories, doctrines, hymns, poems from the Aztec, Yucatec, Quiché-Maya, and other sacred traditions*, translation, introduction and notes by Miguel León-Portilla, Charles E. Dibble, Munro S. Edmonson; foreword by Fernando Horcasitas. New York, Ramsey, Toronto, 1980

LEYENAAR 1980
Th. J.J. Leyenaar, 'The celebration of the days of the dead in Mexico', *From Field-Case to show-case*, ed. W.R. van Gulik, H.S. van der Straaten and G.D. van Wengen: 71-84 Amsterdam/Uithoorn, 1980 [Gieben]

LEYENAAR 1981
Th. J.J. Leyenaar, *Indianen van Mexico, Azteken in 't Verleden, Nahua's van Heden*, Leiden 1981 [Museum of Ethnography, Leiden]

LEYENAAR 1985
Th. J.J. Leyenaar, *De Mexicaanse Keuken*, Leiden, 1985 [Museum of Ethnography, Leiden]

LEYENAAR 1997
Ted J.J. Leyenaar, *Ulama Jeu de Balle des Olmeques aux Azteques/Ballgame from the Olmecs to the Aztecs*, Lausanne, 1997 [Musée Olympique]

LEYENAAR 1998
Ted J.J. Leyenaar, 'El juego de pelota mesoamericano', *Anales de la Academia de Geografía e Historia de Guatemala*, LXXIII, Guatemala, 1998: 105 – 41

LÓPEZ LUJÁN, COBEAN, MASTACHE 1995
L.López Luján, R.H. Cobean T., A. Guadalupe Mastache F., *Xochicalco y Tula*, Milan, 1995 [Jaca Book]

m

MARIN 1974
Isabel Marin de Paalen, *Historia General del Arte Mexicano-Etno-Artesanìas y Arte Popular*, Mexico, 1974

MARQUINA 1964
Ignacio Marquina, *Arquitectura Prehispànica*, Mexico, 1964

MATOS 1982
Eduardo Matos Moctezuma (Cord.), *El Templo Mayor : Escavaciones y Estudios*, Instituto Nacional de Antropologìa e Historia, Mexico, 1982

MEDELLIN 1965
Alfonso Medellin Zenil and Beltrán Alberto, 'La Escultura de las Limas', in: *Boletìn del INAH*, no. 21, Instituto Nacional de Antropología e Historia, Mexico, 1965: 5-16

MESOAMERICAN BALLGAME 1991
The Mesoamerican Ballgame, Proceedings of International Colloquium at Leiden 1988, ed. Gerard W. van Bussel, Paul L.F. van Dongen and Ted J.J. Leyenaar, Leiden, 1991 [Museum of Ethnography, Leiden]

MESOAMERICAN BALLGAME 1991
The Mesoamerican Ballgame, Proceedings of International Congress of Tucson 1985, eds Vernon L. Scarborough, David R. Wilcox, Tucson, 1991 [The University of Arizona Press]

MEXICO 1995
Dioses del Mexico antiguo, exhib. cat., ed. Dolores Beistegui, Mexico City, 1995 [Antiguo Colegio de San Ildefonso, INAH]

MOMPRADÉ DE GUTIÉRREZ 1977
Elektra y Tonatiuh Gutiérrez, 'Mensajeros del cielo, mito y magía de los hombres voladores', *Revista de geografía universal*, vol. 1 (1977) : 78-97

MORLEY 1965
Sylvanus G. Morley, *La Civilización Maya*, Mexico/Argentina 1965

n

NEW YORK 1990
Mexico: Splendors of Thirty Centuries, exhib. cat., Metropolitan Museum of Art, New York, 1990

NIGEL 1987
Nigel Davies, *The Aztec Empire*, the Toltec Resurgence, Norman, 1987

NOGUERA 1954
Eduardo Noguera, *La Cerámica de Cholula*, Mexico, 1954

NOGUERA 1958
Eduardo Noguera, *Tallas Prehispánicas en Madera*, Mexico, 1958

NOGUERA 1975
Eduardo Noguera, *La Ceràmica Arqueològica en Mesoamèrica*, Instituto de Investigaciones Antropológicas, Mexico, 1975

p

PARIS 1952
Art Mexicain-Du Precolombien a nos Jours, exhib. cat., Musée National D'Art Moderne, Paris, 1952

PASZTORY 1983
Esther Pasztory, *Aztec Art*, New York, 1983

POHORILENKO 2000
Anatole Pohorilenko, 'Los Primeros Escultores de Mesoamérica' in: *Los Señorìos de la Costa del Golfo, Pasajes de la Historia V*, Mexico, 2000: 12 - 17

r

RECINOS 1951
Adián Recinos, *Popol Vuh, The Sacred Book of the Ancient Maya*, London, Edinburgh, Glasgow, 1951

RIDDER 1989
R. de Ridder, *The Poetic Popol Vuh. An anthropological study*, Utrecht, 1989 (PhD thesis)

s

SAHAGÚN 1950 – 1969
Bernardino de Sahagún, *Florentine Codex: general history of the things of New Spain*, ed. A.J.O. Anderson and C.E. Dibble, 12parts, Santa Fe, New Mexico

SAHAGÚN 1991
Bernardino de Sahagún, *De Azteken, Kroniek van een verdwenen cultuur*, toegelicht door J. Lechner en Rudolf van Zantwijk, Amsterdam, 1991

SEJOURNE 1966
Laurette Sejourne, *Arqueología de Teotihuacan-La Cerámica*, Mexico/Argentina, 1966

SOLIS 1991
Felipe Solis, *Tesoros Artìsticos del Museo Nacional de Antropología*, Mexico, 1991

SOLIS 1995
Felipe Solis and Martha Carmona Macías, *El Oro Precolombino de Mèxico*, Mexico, 1995

SOLIS 1997
Felipe Solis and Martha Carmona Macías,
'Gold, ein heiliges Metall im Alten Mexiko',
in: *Gold und Silber aus Mexiko*, Milan, 1997
SOLIS 2000A
Felipe Solis and Angel Gallegos Fernández,
'El Taller de Coatlicue' in: *El Reino de
Moctezuma*, Pasajes de la Historia I, Mexcc,
2000: 40-43
SOLIS 2000B
Felipe Solis and Angel Gallegos Fernández, *El
Reino de Moctezuma*, Pasajes de la Historia I,
Mexico, 2000
SOLIS 2000C
Felipe Solis and Anatole Pohorilenko, *Los
Señoríos de la Costa del Golfo*, Pasajes de la
Historia v, Mexico, 2000
SYMONDS
Stacey Symonds, 'The Ancient Landscape at
San Lorenzo Tenochtitlan, Veracruz, Mexico:
Settlement and Nature' in: *Olmec Art and
Archaeology in Mesoamerica*,
Washington/London, 2000
STRESSER-PÉAN 1995
Guy Stresser-Péan, *Le Codex de Xicotepec.
Étude et interprétation*, Mexico, 1995
SUÁREZ DIEZ 1991
Lourdes Suárez Diez, *Conchas y Caracoles,
ese universo maravilloso*, Mexico, 1991
[Banpaís, s.a.]

t

TALADOIRE 1981
Eric Taladoire, *Les terrains de Jeu de balle
(Mésoamérique et Sud-Ouest des États Unis)*
[Etudes Mésoaméricains, Série 11/4] Mexico
City, 1981

v

VENICE 1998
Maya Civilization, exhib. cat., ed. Peter
Schmidt, Mercedes de la Garza and Enrique
Nalda, London, 1998
[Thames and Hudson]
VIENNA 1997
Gold und Silber aus Mexiko, exhib. cat.,
Kunsthistorisches Museum Vienna, Milan,
1997

w

WESTHEIM 1969
Paul Westheim et al., *Cuarenta Siglos de
Plástica Mexicana-Arte Prehispánico*, Mexico,
1969

WASHINGTON D.C. 1996
Olmec Art of Ancient Mexico, exhib. cat.,
ed. Elizabeth P. Benson and Beatriz de la
Fuente, National Gallery of Art, Washington,
1996
WEITLANER-JOHNSON 1976
Irmgard Weitlaner-Johnson, *Design motifs
on Mexican Indian textiles*, 2 vols, Graz, 1976
[Akademische Druck- und Verlaganstalt]

z

ZANTWIJK 1960
Rudolf van Zantwijk, *Los Indígenas de Milpa
Alta: herederos de los Aztecas*, Amsterdam,
1960 [Royal Tropical Institute]
ZANTWIJK 1977
Rudolf van Zantwijk, *Handel en Wandel
van de Azteken*, Assen/Amsterdam, 1977
[Van Gorcum]
ZANTWIJK 1985
Rudolf van Zantwijk, *The Aztec Arrangement.
The Social History of Pre-Spanish Mexico*,
Norman, 1985 [Oklahoma Press]
ZANTWIJK 1994
Rudolf van Zantwijk, *Zegevierend met de Zon.
duizend jaar Azteekse gedichten en gedachten*,
Amsterdam, 1994
ZANTWIJK 1996
Rudolf van Zantwijk, *De Zon en de Arend,
duizend jaar Azteekse vertelkunst*,
Amsterdam, 1996

AUTHORS AND COMPILERS

COMPILERS EXHIBITION

TED LEYENAAR
Former chief curator at the National
Museum of Ethnography, Leiden.
Expert, among other things, on the rubber
ballgame as played in ancient Mexico.

FELIPE SOLIS
Director of the National Museum of
Anthropology, Mexico City.
Professor at the Independent National
University of Mexico (UNAM).
Chair of the board of archaeologists of
Mexico.

JOHN VRIEZE
Chief exhibition curator, Nieuwe Kerk,
Amsterdam.
Author and editor of many publications on
a wide variety of cultural topics.

ABOUT THE AUTHORS

MIGUEL LÉON PORTILLA
Professor Emeritus at the Independent
National University of Mexico (UNAM).
Author of numerous publications including
ones on the philosophy of the Nahua, based
on field studies.

BEATRIZ DE LA FUENTE
Professor Emeritus and former member of
the governing board of the Independent
National University of Mexico (UNAM).
Member of the Academy of Arts and sole
woman member of the National College of
Mexico.
Author and editor of numerous publications,
including a standard work on the art of pre-
Spanish murals.

RUBÉN BERNARDO MORANTE LÓPEZ
Director of The Anthropological Museum of
the University of Veracuz (Museo de
Antropologia de la Universidad
Veracruzana), Xalapa.
Lecturer at the University of Veracruz.
Member of the National Council for
Scientific Research.

RUDOLF VAN ZANTWIJK
Professor Emeritus of Cultural Anthropology
and Ethnohistory of Mesoamerica and the
Andes, at the University of Utrecht.
Expert in Nahuatl, the ancient language of
the Aztecs.
Specialist in Mexican studies, has authored
a large number of publications dealing with
this area.

CREDITS
EXHIBITION

MEXICO

Sari Bermúdez, President of CONACULTA
Sergio Raúl Arroyo, Director General of INAH
Jaime Nualart, Director General of
International Affairs, CONACULTA
José Enrique Ortiz Lanz, National Coordinator
of museums and exhibitions, INAH
Carlos A. Cordova, Director of Exhibitions,
INAH
Felipe Solis, Director of the Museo Nacional
de Antropología, Mexico City
Rubén Bernardo Morante López, Director of
the Museo de Antropología de la Universidad
Veracruzana, Jalapa
Ángeles Espinoza Inglesias, Director of the
Museo Amparo, Puebla
and all other lender museums mentioned on
page 13.

AMSTERDAM

DIRECTOR OF ENTERPRISE
Ernst W. Veen

GUEST CURATORS
Ted J.J. Leyenaar
Felipe Solis

PRODUCTION AND FINAL EDITING
John Vrieze
assisted by Vincent Boele

LOGISTICS AND PERSONNEL
Marijke Gelderman

CONSULTANT
Carmen Aneiros, Mexico

EXHIBITION DESIGN
Architectenbureau Jowa, Amsterdam

**SECRETARIAT/OFFICE, OF
THE NIEUWE KERK**
Paulanha van den Berg-Diamant
Rijkje van Donk
Margreet van 't Hoff
Huibje Laumen
Marianne de Molennaar
Martijn van Seventer
Noepy Testa
Krijn van Veggel
Jacqueline Weg

TECHNICAL ADVISORS
Paul Brekelmans
Nasar Ahmed Qazi
Ad Schmitt

HEAD WARDEN, THE NIEUWE KERK
Roelof van der Kooi

MUSEUM SHOP
Heleen van Ketwich Verschuur
Simone Schaeffer
Judith Mol
Linda Breukels

TRANSPORT
Gerlach Art Packers & Shippers
Cordova Plaza S.A.

INSURANCE
AON Artscope
Grupo National Provincial S.A.
Ministery of Education, Culture & Science

CONSTRUCTION
Vechtmetaal BV

PUBLICITY
Bureau D'Arts, Amsterdam: Rob van Zoest,
Maroeschka Volker and Herbert Mattie

AUDIOVISUAL
EXP, Naarden

TRANSLATIONS
Wendie Shaffer (Dutch-English)
Servicio Comunicacion Hispano-Holandesa
(Spanish-Dutch)

CREDITS
CATALOGUE

AUTHORS
Ted J.J. Leyenaar
Felipe Solis
Beatriz de la Fuente
Miguel Léon Portilla
Rúben Bernardo Morante López
Rudolf van Zantwijk

EDITOR IN CHIEF
John Vrieze

EDITOR
Vincent Boele

PHOTOGRAPHY OF OBJECTS
Michel Zabé
Museum of Ethnography, Leiden (cat. nos 178 and 192)

PHOTOGRAPHY OF ILLUSTRATIONS
Paula and Ted Leyenaar, all illustrations apart from
Ben Grishaaver, fig. 6
Isaac C. Brusse, figs 19 and 20
Museum of Ethnography, Leiden, fig. 21

TRANSLATIONS
Wendie Shaffer (Dutch – English)
Servicio Bureau voor Spaanstalige Dienstverlening (Betteke de Gaai Fortman and Imke Marés Grijpma) (Spanish – Dutch)

PRODUCTION MANAGER
Heleen van Ketwich Verschuur

GRAPHIC DESIGN
UNA (Amsterdam) André Cremer, Mijke Wondergem

TYPE-SETTER
Bij-voorbeeld, Amsterdam

PRINTING
Waanders Drukkers, Zwolle

LITHOGRAPHY
Scanprofile, Oisterwijk

TYPESET IN
DTL Caspari
DTL Dorian

MATERIALS
Hello Matt 135 g/m²
Provided from the collection
Buhrmann-Ubbens BV

Catalogue to accompany the exhibition Mexico, journey to the land of the gods, held in Nieuwe Kerk, Amsterdam from 3 March to 30 June 2002, organized by the Foundation Projects of the Nieuwe Kerk.

First published in 2002 by Waanders Publishers and De Nieuwe Kerk, Amsterdam in association with:
Lund Humphries
Gower House
Croft Road
Aldershot
Hampshire GU11 3HR
and
131 Main Street
Burington
VT 0540
USA
Lund Humphries is part of Ashgate Publishing

DUST JACKET
Cover: cat. no. 171
Back: cat. no. 105

British Library Cataloguing in Publication Data
Library of Congress Control Number: 2002100639
ISBN: 0 85331 858 1
Printed in 2002 by Waanders Drukkers, Zwolle, The Netherlands